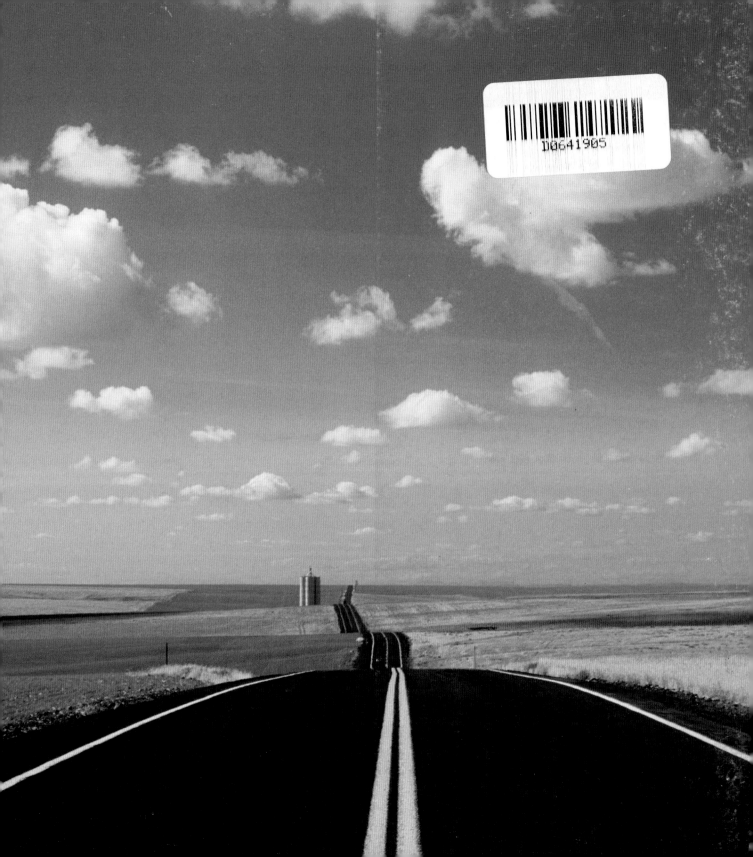

JIM REED

STORM CHASER

A Photographer's Journey

Abrams, New York

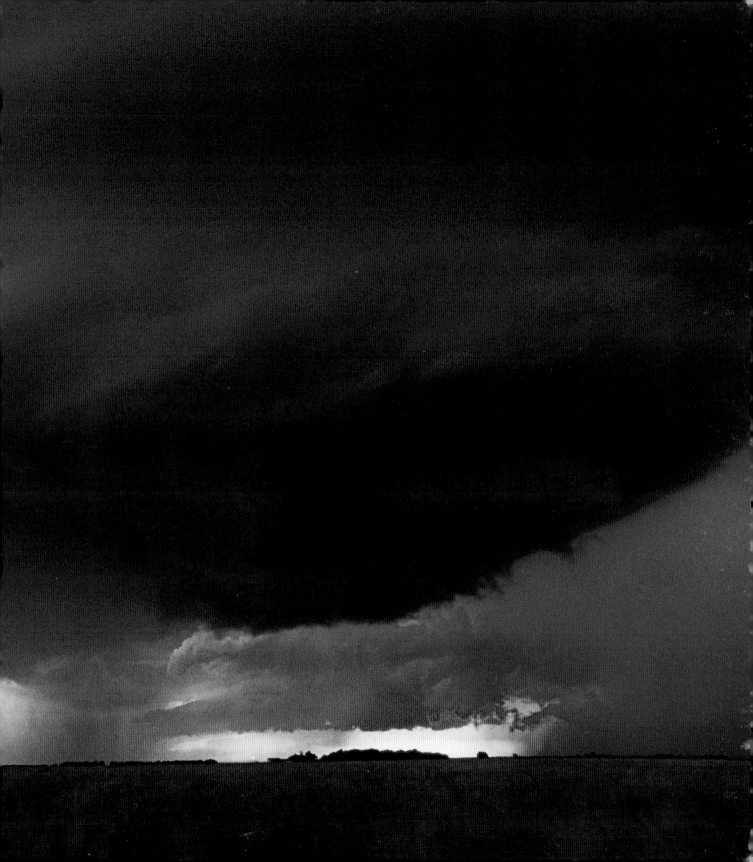

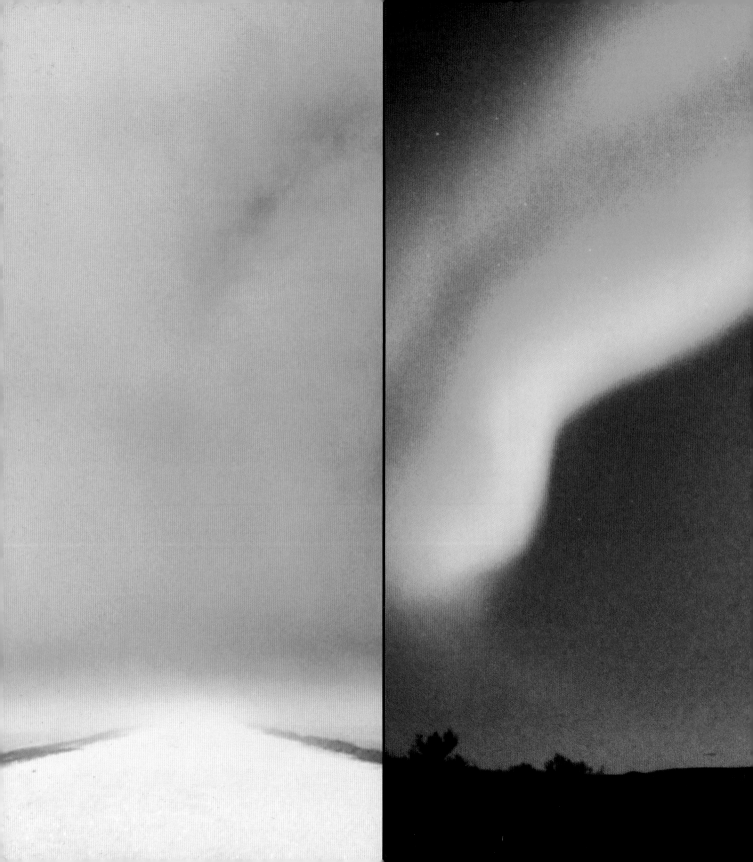

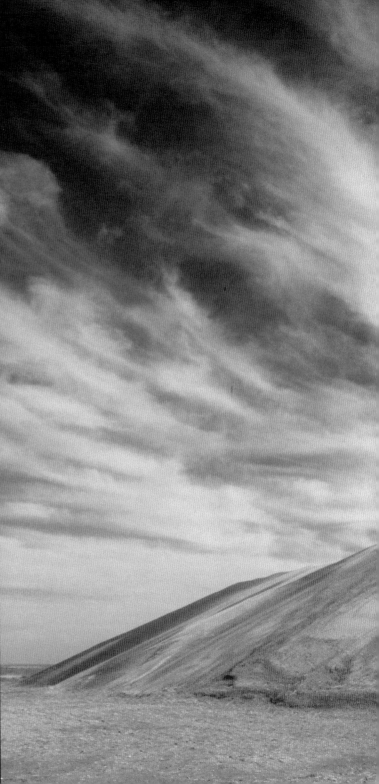

contents

Storm chasing and extreme weather photography, as discussed in these pages, can be very dangerous. Any person should approach these activities with caution and appropriate supervision and training. The publisher and author are not responsible for any accidents, injuries, damages, or loss suffered by any reader of this book.

The publisher and author are not in any way endorsing any of the third-party Web sites referenced in this book, nor can they guarantee the contents, accuracy, availability, or timeliness of any of these Web sites.

Every effort has been made to ensure that the information contained in this book is as accurate and complete as possible. However, our knowledge regarding the climate is changing very quickly, therefore the contents of this book may not necessarily agree with records or data established after publication.

The image on page 84 is a composite created from a high-resolution transparency (shot by Jim Reed) and a low-resolution video grab (shot by Katherine Bay). Except for overlapping the two medias, no manipulation has occurred. Distance, size, shape, and color are authentic.

The image on page 94 is a composite of two images shot only a few seconds apart. Except for overlapping the two images, no manipulation has occurred. Distance, size, shape, and color are authentic.

ENHANCED FUJITA TORNADO DAMAGE SCALE
FUJITA TORNADO DAMAGE SCALE

EF-0	65–85 mph
F-0	72 mph or less
EF-1	86–110 mph
F-1	73–112 mph
EF-2	111–135 mph
F-2	113–157 mph
EF-3	136–165 mph
F-3	158–206 mph
EF-4	166–200 mph
F-4	207–260 mph
EF-5	201 mph or greater
F-5	261–318 mph
F-6	319–379 mph

On February 1, 2007, the National Weather Service began using the Enhanced Fujita Tornado Damage Scale (EF Scale).

of a weakening landspout tornado in western Kansas on May 8, 2008. Video frame grab by Robin Lorenson.
PAGE 1: Fair weather cumulus clouds hover over a freshly made highway in eastern Washington on October 6, 1995.
PAGES 2–3: An isolated mesocyclone rotates over south central Kansas at sunset on June 5, 2004.

Editor: Charles Kochman
Editorial Assistant: Sofia Gutiérrez
Designer: Darilyn Lowe Carnes

Library of Congress Cataloging-in-Publication Data

Reed, Jim, 1961–
Storm chaser : a photographer's journey / by Jim Reed.
 p. cm.
Includes bibliographical references and index.
ISBN 978-0-8109-2147-4 (paperback)
1. Severe storms—Pictorial works. 2. Tornadoes—Pictorial works.
3. Hurricanes—Pictorial works. I. Title.

QC944.R44 2007
779'.955155092—dc22

2007013291

Paperback edition published in 2009 by Abrams, an imprint of Harry N. Abrams, Inc. All rights reserved. No portion of this book may be reproduced, stored in a retrieval system, or transmitted in any form or by any means, mechanical, electronic, photocopying, recording, or otherwise, without written permission from the publisher.

Original hardcover edition published in 2007 by Harry N. Abrams, Inc.

Printed and bound in China
10 9 8 7 6 5 4 3 2 1

Abrams books are available at special discounts when purchased in quantity for premiums and promotions as well as fundraising or educational use. Special editions can also be created to specification. For details, contact specialmarkets@hnabooks.com or the address below.

115 West 18th Street
New York, NY 10011
www.hnabooks.com

HNA
harry n. abrams, inc.
a subsidiary of La Martinière Groupe

ments

To the many storm chasers, meteorologists, and scientists I have worked with over the years, I would like to express my deepest gratitude for their time, cooperation, and contributions.

I am particularly grateful to research meteorologist Jon Davies for sharing in more than a decade of adventures, loyal friendship, helpful direction, invaluable teachings, and tireless generosity. Thanks to meteorologists Michael Phelps and Aaron Blaser for their diligent support and encouragement, wisdom, and laughter during literally thousands of miles of chasing.

A special heartfelt thank you to my full-time storm chasing partner of five years, Katherine Bay, for editing and preparing the images in this book, and for thousands of miles of bravery, patience, creativity, dedication, and life-saving fun and love. A special nod goes out to Greg Zamarripa and Mike Theiss, my storm chase partners in life-changing hurricanes Charley and Katrina.

My appreciation also goes out to the behind-the-scenes people who have provided me with incalculable opportunities, support, and inspiration: Gary Barlough, Paul and Gail Bowen, Marlin Davis, Dorothy Degood, Douglas Photographic Imaging, Richard Elder and the National Weather Service in Wichita, Lynn Elsey and Weatherwise magazine, Mike Farkas, Stan Finger, Thad Halcli, Travis Heying, Craig Hacker, Scott and Tracy Hickman, Phil Hysell, Shannan Keenan, Robin Lorenson, Sharon Moody, John Ogren, Cindy Walker-Rich, Joanne Roberts-Wiles, Jeff Rothberg, Mike Smith and WeatherData, Inc., Rebecca Sperber, Kathy Springmeyer, Barry Tanenbaum, Joe Wasser, Jill Waterman, and Marshall and Norma Williams.

Special thanks to Don and Eleanor Armstrong, Stacy and Diana Childs, Tom Ensign, Stan and Mollie Helfand, Don Holmer, Paul Hochi and his mother, Haruko, Cliff and Sue Kirby, and my mother, Audrey Reed, for providing so much encouragement and unconditional aid over the years.

Thank you to Wanda Britt and Marvin Hoech, two of my earliest and most inspiring science teachers. Special thanks to professor Paul Sirvatka and the College of DuPage chase team. Many, many thanks to Mark and Annette Joy and the gang at Joy's Service Center for serving as my "pit crew" for more than ten years.

I wish to thank my colleagues and friends at NOAA and the innumerable weather forecast offices throughout the United States. I am also very grateful for the extremely reliable photographic equipment and ongoing support provided by Nikon, Kounoshin Shirasaka, and Michael Corrado.

A big thank you to my agent, Jayne Rockmill, for personally making this book happen, from setting up the project to enduring all of my post-traumatic stress disorder moodiness. She contributed her editorial skills to this book, as well as her ideas, above and beyond the call of duty, taking the project beyond the limits of my own expectations.

To Eric Himmel at Harry N. Abrams for embracing and spearheading the project; to Darilyn Carnes for adding her special touch to the look of the book; and to Charles Kochman, my ingenious and patient editor, who has tirelessly supported me throughout the struggle of bringing my journey to the public by his own inspiring belief in its importance.

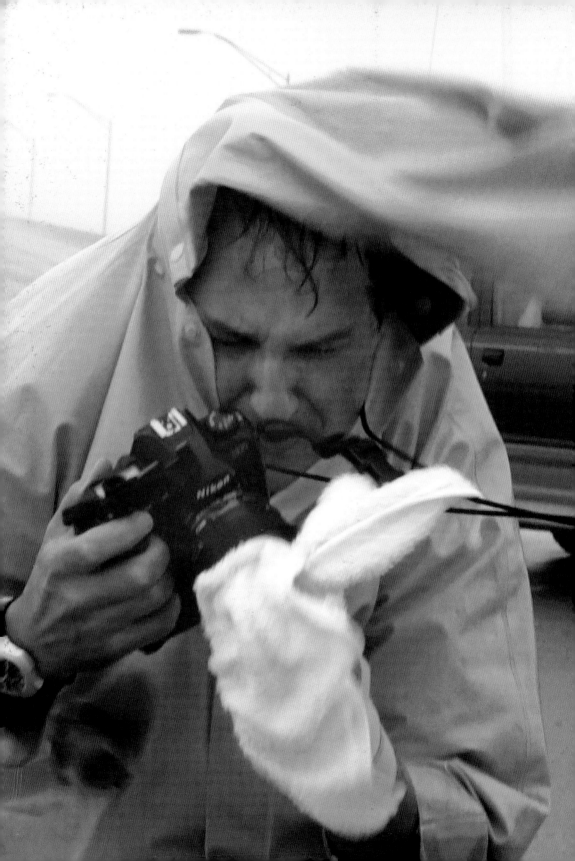

preface

A psychotic rain pounds the windshield. We can't see the hood of the car, much less the road. An eight-year-old boy squints for a better look at the sky through the passenger window.

The car splatters to a stop near a deserted strip mall. Water surrounds the tires. The sound of a demonic jet engine roars beneath us . . . beside us . . . above us.

"We're going to be okay," says Mom, still clutching the steering wheel, both feet on the brake. I manage a smile of forced confidence. Outside our windows, Hurricane Camille, one of the strongest tropical cyclones to directly strike the United States in the twentieth century, is crossing northern Mississippi on August 18, 1969.

A mistimed return trip from a family vacation in Florida to our home in Springfield, Illinois, had placed us in the outer bands of the incredibly powerful and historic storm. Much of Mississippi was flattened. Many were killed. Among those who survived were a little boy and his single mother from the Land of Lincoln.

Mom said very little about the hurricane over the next year, but I could tell she'd been affected. She kept a closer than ever eye on the sky. Central Illinois weather can be very unpredictable, yielding everything from tornadoes and flooding to ice storms and blizzards.

Her behavior changed, too. For my ninth Christmas, Santa brought me a flashlight, G.I. Joe, BB gun, radio, Easy-Bake oven, football helmet, hairspray, Hot Wheels, *Playboy* magazine, Kodak camera, and diary. It was a young man's ultimate natural disaster kit.

On January 3, 1971, I logged my first official weather journal entry: "Today when I woke up it was raining and hail was coming down." But it wasn't hail. It was sleet. Sleet that changed over to snow—and lots of it.

But instead of fearing Illinois's newest winter storm, I embraced it. I was an avid reader, and adventures by Jules Verne and H. G. Wells were fresh in my mind. Heavy snow made our yard look like another planet. Blizzardlike conditions meant no school. On snow days friends would come over to play. We'd build frozen forts and battle the ice with our G.I. Joes. Then we'd bake homemade snacks and unfold Miss January.

Perhaps feeling guilty for having introduced me to Playboy bunnies at such an impressionable age, during the summer of 1972, my mother encouraged me to attend church camp. I heartily resisted until a buddy whispered in my ear that boys were allowed to invite girls to campfire and vespers.

Five days and twenty-two chapters of the New Testament later, I found myself sitting next to Elaine Yutzy and a crackling fire at Lake Springfield Christian Assembly. As I slipped my hand into hers, she smiled. I smiled. And that's when the sirens went off, literally.

"Get the kids into the shelter!" hollered the camp leader. "It's a tornado!"

CLANG-CLANG-CLANG, the camp bell warned as lightning ripped open the night sky. Tree limbs, lawn furniture, and trash cans bounced and swirled about us as we descended into the shelter. That's when I heard it. That same demonic jet engine–like roar I had heard with my mother in Mississippi during Hurricane Camille.

After the fierce winds passed, we emerged unhurt from our holy bunker. The sky was ablaze with wriggles of magenta-colored electricity. Overhead, clouds sizzled with one lightning bolt after another. It was unlike anything I had ever seen before.

A few weeks later, lightning bolts seared in my head, I enrolled in an after-school photography class. It took only seconds for me to fall in love with gazing through a viewfinder. A pursuit in writing soon followed, and I began contributing to the school newspaper.

As my curiosity with photography and literature increased, so did my fascination with Hollywood, science, and disaster. 1969 through 1979 was a terrific period for a kid with an imagination and appetite for adventure. Neil Armstrong's walk on the moon, voyages with Jacques Cousteau, *The Poseidon Adventure, Jaws, Planet of the Apes, Earthquake, Star Trek, Close Encounters of the Third Kind,* and *Jonny Quest.*

Even reruns of *Gilligan's Island* were filled with adventure and, perhaps more important to me, plenty of memorable storms. The minute I heard, "The weather started getting rough, the tiny ship was tossed . . . ," I was hooked.

As a latchkey kid, I'd come home from school every day to an empty house where I would eagerly watch back-to-back episodes of the castaways fighting typhoons, high winds, and rough weather. In season two, Gilligan even gets struck by lightning and becomes invisible! The impractical but imaginative sitcom became my all-time favorite boob-tube babysitter.

Ironically, it took a Walt Disney movie to spark my first true nightmare about weather. It was a film called *The Wild Country*, starring Vera Miles and Steve Forrest. The movie included a very frightening twister that hits a family in Wyoming. It was the most chilling tornado sequence I had seen on film since *The Wizard of Oz*. I couldn't get the images out of my head.

From that point on, any time Springfield was under a tornado warning, I was possessed with protecting my mother. At school, I began brushing through encyclopedias in search of photos of tornadoes. I was terrified, yet obsessed.

But not obsessed enough to study meteorology formally. I was having way too much fun making films with a newly purchased Super 8 movie camera and interviewing the Beach Boys for the school paper.

As senior year in high school swiftly approached, the compass of my soul soon pointed in four distinct directions: weather, women, Hollywood, and art.

Inspired by up-and-coming moviemakers Steven Spielberg (*Jaws, Close Encounters of the Third Kind*) and George Lucas (*THX-1138, Star Wars*), I decided to study filmmaking at the University of Southern California.

During my years at USC I frequently found myself having conversations with classmates who recurrently traveled back home for the holidays. The one subject that kept coming up was "weather." Flights cancelled due to snow. Trains delayed because of ice. Weddings interrupted by rain.

Suddenly, everyday weather felt different.

On January 4, 1981, I wrote in my journal, "I am sitting in Chicago's O'Hare Airport waiting for my flight back to L.A. I have just spent two weeks in Springfield. This trip has been the most painful. It was hard physically due to the severe change in climate. When I left Los Angeles it was seventy degrees and when I arrived in Springfield it was six degrees below zero."

It was a portentous sign of things to come.

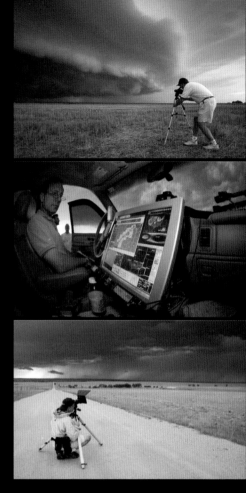

TOP
Meteorologist Michael Phelps documents a severe thunderstorm and shelf cloud in western Kansas on June 25, 2000.

MIDDLE
Storm chaser Tim Samaras monitors radar from inside his chase vehicle on June 8, 2005.

BOTTOM
Documenting a storm in eastern Colorado on May 31, 2006. Photograph of Jim Reed by Katherine Bay.

During my senior year at USC I directed *The Times of Rock 'n' Roll*. The show was an outdoor performing arts extravaganza designed to spotlight the university's best talent during the week of the popular USC and UCLA football game. The live three-hour show was scheduled to take place on a large concert stage in the center of campus. Majors from cinema, theater, music, dance, and journalism were all involved. It was even rumored that Spielberg and Lucas might attend.

Four days of freak heavy rain nearly cancelled the show. Rehearsal conditions were miserable and costly. Local weather broadcasters said it was one of the most powerful California storms in recent memory. The intensity of the event was likely being influenced by two new words that would forever change the way Americans discussed weather:

Global warming.

Simply put, our oceans and land were beginning to show hints of becoming too warm. History and records suggest that when Earth's surface temperature changes, so does our daily weather. What my classmates and I once referred to as "normal" weather was now behaving with greater surprise and ruthlessly delivered results.

The disruptive weather was also a side effect of something called El Niño—an oscillation of the ocean-atmosphere system in the tropical Pacific. But as I stood center stage addressing my cast and crew in a blinding downpour, I couldn't care less about an oscillation. We were soaked to the bone and our show was literally floating away—that's all I understood.

Upon graduating from Southern Cal in 1983 I was hired to associate produce the motion picture *Prime Risk* starring Lee Montgomery, Clu Gulager, and Keenan Wynn. The director had seen *The Times of Rock 'n' Roll*. If I could put on a show like that during such troublesome weather, he thought, I should be pretty good at producing a movie. Our first day of on-location shooting in Washington, D.C., was shut down by snow.

Over the next several years I traveled the United States producing, directing, and writing music videos, TV commercials, public service announcements, even political campaign spots. Four out of every five productions were disrupted by harsh weather. Even getting to and from shoots was tough. In 1984 alone, I endured three consecutive extremely violent flights plagued by thunderstorms and lightning.

Even the West Coast was now getting in on the action. On February 9, 1989, I wrote in my journal, "This past week a freak winter storm hit southern California, causing it to snow several inches as near to L.A. as Thousand Oaks and the San Fernando Valley. It was the worst snowstorm to hit southern California in seventeen years."

Eight weeks later, it was just the opposite. On April 9 I logged the following observation: "From Tuesday through Friday our temperatures topped one hundred degrees. It was the hottest week in April in Los Angeles County history." But the West Coast wasn't the only area heating up.

Just off the southeast coast lurked the most troublesome meteorological monster since Camille.

On the night of September 21, 1989, I watched in horror from my Los Angeles apartment as Hurricane Hugo struck South Carolina. Dozens of people perished during that Category 4 storm. The hurricane maintained exceptionally violent winds all the way

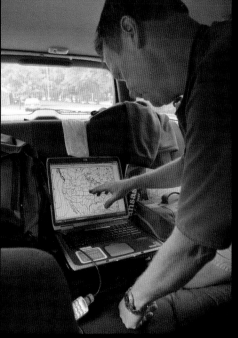

Research meteorologist Jon Davies uses a laptop computer inside his chase vehicle to monitor a developing storm in the Central Plains on May 20, 2004.

to Charlotte, North Carolina, its force destroying more trees than the eruption of Mount St. Helens and the 1988 Yellowstone National Park fires combined.

Hugo was the most catastrophic storm to hit America in thirty years. And nature was just getting started. America had entered a new era of atmospheric confrontation.

On April 26, 1991, one of the largest and most ferocious tornadoes ever witnessed in the US struck Wichita, Kansas, and surrounding communities. Seventeen people lost their lives during the incredible twister, and 225 were injured. The tornado, rated an F-5 on the Fujita tornado damage scale, had been packing winds in excess of 261 miles per hour, and narrowly missed hitting a billion-dollar line of fighter jets at McConnell Air Force Base.

In Los Angeles, I watched in amazement as the tornado passed directly over two Wichita photojournalists tucked beneath an interstate overpass. The video clips airing on network news channels were simply mesmerizing. I was finally convinced that something truly remarkable was occurring—and that's when I had my epiphany.

I had been pointing my camera in the wrong direction; I should be focusing on the sky.

Albert Einstein said, "Look deep into nature and then you will understand everything better." It's one of my favorite quotes. With those words of wisdom in mind, I set out to document America's wild weather and changing climate in pictures and writings.

On June 27, 1992, I moved to Oz.

I chose Wichita, Kansas, as my base camp because of location, topography, and people. Sedgwick County is close to the geographic center of the contiguous US. The vast rolling plains make it easier for me to photograph the sky. And the Central Plains are home to some of the brightest and most accomplished weather forecasters and climate researchers in the business.

Over a fifteen-year period, I logged more than a quarter million miles photographing storms across more than two thousand US counties and parishes. The following pages chronicle some of my most memorable storm chases, cross-country adventures, and unexpected revelations during my Einstein-inspired journey. I hope you enjoy the voyage; as with any successful storm chase, the discoveries you make are up to you.

—Jim Reed

Members of STEPS (Severe Thunderstorm Electrification and Precipitation Study) launch a weather balloon into a tornadic supercell thunderstorm in northwest Kansas on May 29, 2000.

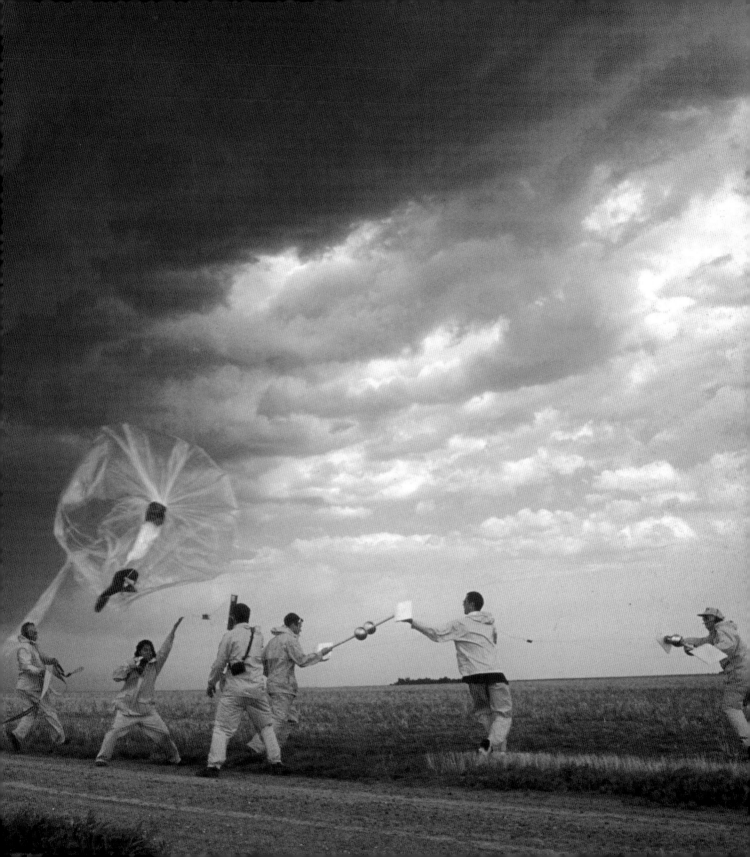

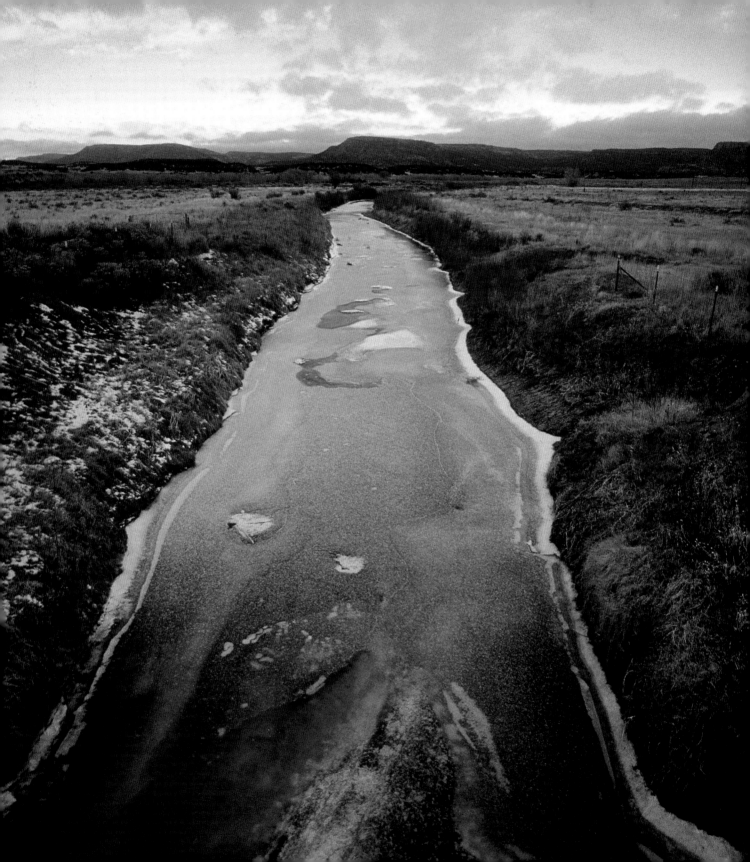

> *I believe in God, only I spell it Nature.*
>
> —Frank Lloyd Wright

Drought conditions and a frozen river in New Mexico, January 1995.

In America, winter conjures up different images to different people. If you live in the Southwest, you likely think of rain and the Santa Ana winds; in the Midwest and Northeast, snow; in Florida, lots of sunshine. But global warming has started to alter the season. Temperatures are flip-flopping, and in some locations, snow is disappearing.

The first winter storm to occur after I started my photographic project came in February 1992. Nearly a foot of sudden and torrential rain inundated the Los Angeles area, resulting in widespread flooding, eight deaths, and a declaration of "major disaster" by President George Herbert Walker Bush.

When I think of winter, I like to picture snow-covered trees, kids sledding, or a crackling fire. But as our climate changes, the season that brings us our most celebrated holidays also yields powerful storms.

Maybe I was in denial, not wanting to believe my favorite childhood season could also bully people. Maybe that's why I was reluctant to focus my camera on the winter season until 1995. During a January storm chase to New Mexico, colleague Joe Wasser and I witnessed severe drought conditions. Ninety miles away, blizzardlike conditions pounded the terrain, making life challenging even for ice fishermen. As Joe and I started our drive back to Kansas, the sun broke through the clouds and spotlighted several picturesque, wind-sculpted snowdrifts. One state, two quirky moments in weather.

"That's why you see so many homes in New Mexico with backdoors facing west," one of the local Navajo Indians once told me with a smile. "All good weather comes from the east." He was referring to the fact that most major storm systems moving across the United States travel from west to east.

In January 1996 folks living along the East Coast watched as a potent nor'easter developed right over them, paralyzing numerous cities. Many snowfall records were broken. Schools in New York City's boroughs shut down for the first time since the Blizzard of 1978.

While it snowed in the Northeast, I was in Kansas documenting subtle yet equally important extremes. On January 17, Wichita saw temperatures reach the sixties, uncommon for winter. That same day, northwest Kansas couldn't escape dangerous cold in the single digits. Meanwhile, the National Weather Service in Dodge City reported an all-time record low-pressure reading for that location. Something peculiar was occurring, I could feel it.

Less than twenty-four hours after enjoying a warm sixty-degree winter day, Wichita's temperature plummeted into the single digits. The windchill became close to minus thirty degrees. Schools and businesses closed. Traffic disappeared.

Wearing arctic gear that I had purchased the year before for an expedition to Alaska (but never used because of record heat at the Arctic Circle), I ventured out to document this remarkable event. Though it was rated down to minus forty degrees, I could tell my gear was nearing its limit. It was tough avoiding frostbite, much less snapping pictures.

Four weeks later, I was standing in short pants and a T-shirt documenting a record high temperature of eighty-seven degrees. It was the warmest February 22 ever recorded in Sedgwick County, Kansas. Dense smoke from a grass fire burning in Oklahoma passed before my lens, yielding a spectacular fire engine–red sunset and wonderful photo op.

The month of January commonly brings at least one ice storm to the mid-Mississippi Valley, and 1997 was no exception. On January 9 I rendezvoused with meteorologist Michael Phelps in northern Georgia. Mike was working at the Weather Channel at the time.

I primarily focused on ice-coated trees. The glistening diamondlike sparkle of the ice was picturesque, but also sad. Numerous trees simply could not take the weight of the ice and snapped to the ground. It produced an immediate flashback to my childhood.

In March 1978 a massive ice storm struck central Illinois. Three of my favorite apple and pear trees, ones I had once climbed as a boy, had fallen, smothered in frozen precipitation. It was the first disaster aftermath I ever photographed, and quickly I realized there was a dark, heart-wrenching side to weather phenomena as well as the entertaining side. One by one, limb by limb, I amputated the fallen backyard trees with a borrowed chainsaw. It's one of the few times I ever cried as a teenager.

But winter isn't only about ice and snow. In February 1998 an El Niño–powered storm slammed into Southern California. Rain fell at two inches per hour, resulting in widespread flooding throughout Ventura County. Homes in Malibu were either flooded, battered by coastal high surf, or both.

For only the second time in twenty years, a hurricane paid an unexpected visit, during the month of December 1998. The United States Atlantic hurricane season officially ends November 30, but someone forgot to tell that to Hurricane Nicole, which formed in the northeast Atlantic. Computer forecast models had predicted Tropical Storm Nicole would weaken, then dissipate. Instead, the tropical cyclone surprised even the National Hurricane Center (NHC) by intensifying into a full-fledged Category 1 hurricane through December 1.

According to the NHC, "Nicole was forecast to dissipate after being hit by strong shear. Instead, Nicole regenerated and reached hurricane status. This reflects once again the uncertainties in intensity forecasting."

Meanwhile, the National Weather Service in Fairbanks, Alaska, was scratching its head.

"Where oh where is winter . . . ?" typed a forecaster in a public weather summary. Normally by December the city has more than two feet of snow on the ground. Not so in 1998, which only saw six inches. Warmer-than-usual temperatures and lower snowfall amounts even disrupted training for the Iditarod.

During the final January of the decade, it wasn't hurricanes or lack of snow that concerned forecasters. This time it was tornadoes. Multiple twisters raked the mid-South from January 17–22. One of the most notorious was a severe tornado that struck Clarksville, Tennessee, at the unusual time of 4:15 A.M. The twister, with winds in excess of one-hundred and fifty miles per hour, ravaged a five-block area of downtown Clarksville, Tennessee's fifth largest city.

A few weeks before the tornado outbreak, an uncommonly destructive ice storm devastated Cleveland County, North Carolina, leaving at least forty-five thousand homes without electricity in the wintry cold.

On February 24, 1999, it snowed in Atlanta, dropping as much as two inches over surrounding communities. The south so rarely receives measurable snowfall that many counties haven't any road salt or snowplows. So, to folks in the South, an inch or more of snow is a big deal.

While people in Atlanta learned how to use a snow shovel, folks in Chicago were

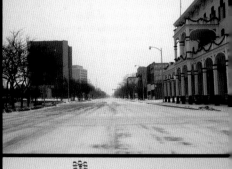

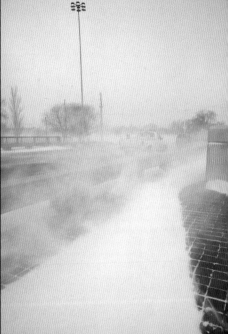

TOP

Downtown Wichita, Kansas, is a ghost town after a winter storm producing windchills close to minus thirty degrees Fahrenheit prompted officials to close city offices, businesses, and schools on January 18, 1996.

ABOVE

A powerful winter storm strikes Wichita, Kansas, on January 18, 1996.

...petering out, blew away. For the first time since recordkeeping began, it failed to snow in the Windy City in November.

"When you see more and more weather extremes over relatively short periods, that may be a preview of things to come as global warming continues," says research meteorologist Jon Davies, who used to live in Atlanta while working for the Weather Channel in 1982.

As we approached the new millennium, the majority of Americans I spoke with were more worried about changing digits and the effects of Y2K than a changing climate. The winter of 1999–2000 was the hottest winter in the United States since our country began keeping track of records 112 years ago. In fact, according to the National Oceanic and Atmospheric Administration (NOAA), more than two-thirds of US winters have been warmer than average since I was at USC.

The folks in International Falls, Minnesota, know what I'm talking about. The city, traditionally known as one of the coldest winter spots in America, experienced their warmest Christmas on record in 1999. The forty-five-degree temperature was also the warmest temperature ever recorded so late in the season. In the old days—or pre–global warming period—the normal low on Christmas Day in International Falls would have been thirteen.

As we entered the twenty-first century, many living in the south needed their Y2K survival kits—not for computer glitches, but for challenging winter weather. On January 23, a remarkable two thousand emergencies were declared in sixteen Georgia counties after an unusually powerful ice storm crippled the state, including Atlanta. Roads glazed over. Structures buckled. More than a quarter million people were without electricity due to toppled trees.

The Atlanta media quickly dubbed the event the "storm of the year." A week later, they were searching for a new title when a second powerful ice storm struck central Georgia with similar results. This storm even disrupted the Super Bowl between the St. Louis Rams and Tennessee Titans scheduled for January 30. Many vendor stands closed the day before. Those that opened had few if any customers. Instead of buying snacks for Super Bowl parties, local residents were scooping up emergency supplies. Thankfully, the game was played inside (the Rams won 23–16).

In December 2001, in the five-day period following Christmas Eve, lake-effect snow Buffalo, New York, had totaled an unbelievable 82.3 inches. Even the local National Weather Service described the snowfall total as "incredible." By comparison, Wichita observed no snow at all in December 2001. It was also much warmer than usual. I remember putting up Christmas lights in shorts and bare feet.

The irony about Buffalo's record lake-effect snow is that the Great Lakes are reportedly shrinking. According to hydrologists, the Great Lakes are at their lowest levels thirty-five years. Experts say the water levels in Lake Michigan and Lake Huron have dropped by more than forty inches since 1997.

My hometown of Springfield, Illinois, also struggled to see the white stuff. The 2001 winter season proved to be the least snowy winter since the mid-1950s. Again, all or nothing.

On January 20, 2002, moisture came back to eastern Kansas in the form of yet another major ice storm. The icy tempest downed trees, damaged crops, and caused roofs to collapse. But ice storms can also provide a bit of fun and entertainment.

While documenting the eastern Kansas ice storm, I discovered a stop sign at a deserted rural intersection. The bright red sign was trapped beneath a thick icy coating, but the sun had come out just long enough to nudge temperatures a degree or two above freezing. As the metal sign warmed, the octagon of ice began slipping. Before it fell completely, it paused, giving me just enough time to snap a picture.

Now, three years into the winter seasons of the twenty-first century, something began to occur to me. Weather in this decade was quickly becoming even stranger than it was in the last.

On January 23, 2003, a winter storm hit the Columbia, South Carolina, area with thick, wet snow. Four inches total! It produced a magnificent winter wonderland. Seeing palmetto trees and tropical plants blanketed in a scenic snow was a rare sight, but the storm was also disruptive. Restaurants and stores closed. Schools cancelled classes. The capital city shut down.

The first month of the 2003 winter season was also extra intriguing. On December , 2003, a gale center in the eastern Atlantic Ocean acquired enough persistent convection and banding features to be classified as Tropical Storm Peter. The week

planet. Alaskans are looking for winter weather, while folks in the once-balmy Southeast are complaining about the cold. Tropical cyclones are now occurring more frequently in December, and the song "It Never Rains in Southern California" isn't true.

Not only does it now rain in southern California, it also rains in the desert! In February 2005 more than six inches of rain fell in Death Valley. The uncommon rainfall resulted in a rare growth of multicolored wildflowers. Many experts said it was the brightest and most vivid display the desert had ever witnessed. I lived in California for ten years and had never seen anything like it.

In neighboring Utah, where temperatures were colder, snowdrifts were setting record heights. A few weeks earlier I had been photographing ice-covered cacti in South Carolina.

On New Year's Eve, warm temperatures and dust particles in the atmosphere resulted in a spectacular sunset in Myrtle Beach. As party music played and the sun dropped beneath the horizon in 2005, I peered out over the open waters of the Atlantic. We weren't alone. A thousand miles off the East Coast a tropical storm churned. Zeta was the twenty-eighth and final named storm of America's record-setting 2005 hurricane season. It's the first time in my life I have ever cheered, "Happy New Year," while knowing a tropical cyclone loomed offshore.

Zeta, one of only two tropical cyclones on record to cross from one calendar year to the next, took us into the new year, and our climate continued to throw us one curve ball after another.

The first month of 2006 was the warmest January ever recorded. Instead of receiving snow, central Kansas was struck with a damaging tornado. It was the first time since 1950 that a twister had hit the Sunflower State in January. Even stranger, the tornado formed *without* thunder or lightning; the twister developed beneath a puffy shower cloud that possessed a strong updraft—but little rain.

A few weeks later, I photographed the effects of subzero temperatures not far from the same location. The winter of 2005 brought Steamboat Springs, Colorado, its snowiest season in ten years, literally burying cars and homes.

On December 1, 2006, the Northeast experienced a record number of severe thunderstorm reports, the most ever for the month. Many residents in St. Louis were without electricity for nearly two weeks as the result of an extra-powerful winter storm.

While on assignment in Myrtle Beach, I watched as a sharp nineteen-degree windchill cleared the normally warm coast. Golfers struggled to decide whether to put on gloves or sunscreen. The erratic beach weather went from record cold . . . to record heat . . . to record cold . . . to record heat again.

The atmosphere was so unusually dry on December 9 that I could actually see the space shuttle *Discovery* climb the night sky from Cape Canaveral, Florida—more than four hundred miles to my south.

As the winter holidays approached, Myrtle Beach was back to record heat in the eighties. In fact, it was uncommonly sunny across much of the US. For the first time I can ever recall, only 10 percent of Americans had a white Christmas. Forty-five out of fifty states were simply too warm.

OVERLEAF LEFT
Ice fishermen battle heavy snow in New Mexico, January 1995.

OVERLEAF RIGHT
Wind-sculpted snowdrift in New Mexico, January 1995.

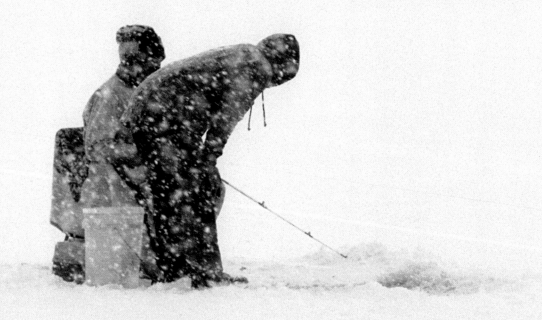

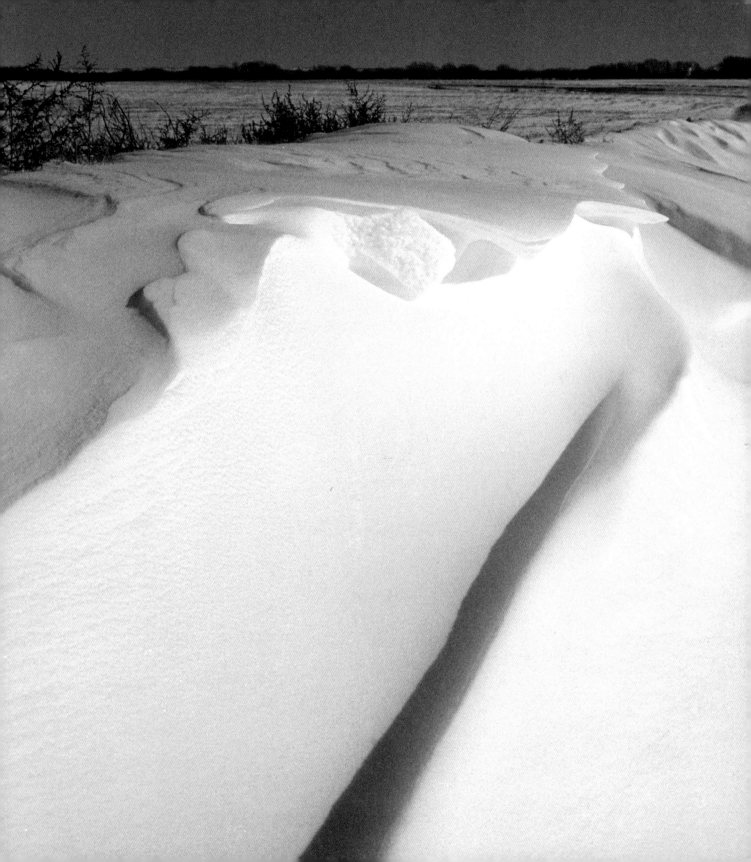

ABOVE
A fiery red sunset during
record heat occurs over
Sedgwick County, Kansas,
on February 22, 1996.

RIGHT
A winter storm with blizzardlike
conditions strikes eastern
Tennessee on January 10, 1997.

OVERLEAF
Trees tumble as an ice storm
strikes northern Georgia
on January 9, 1997.

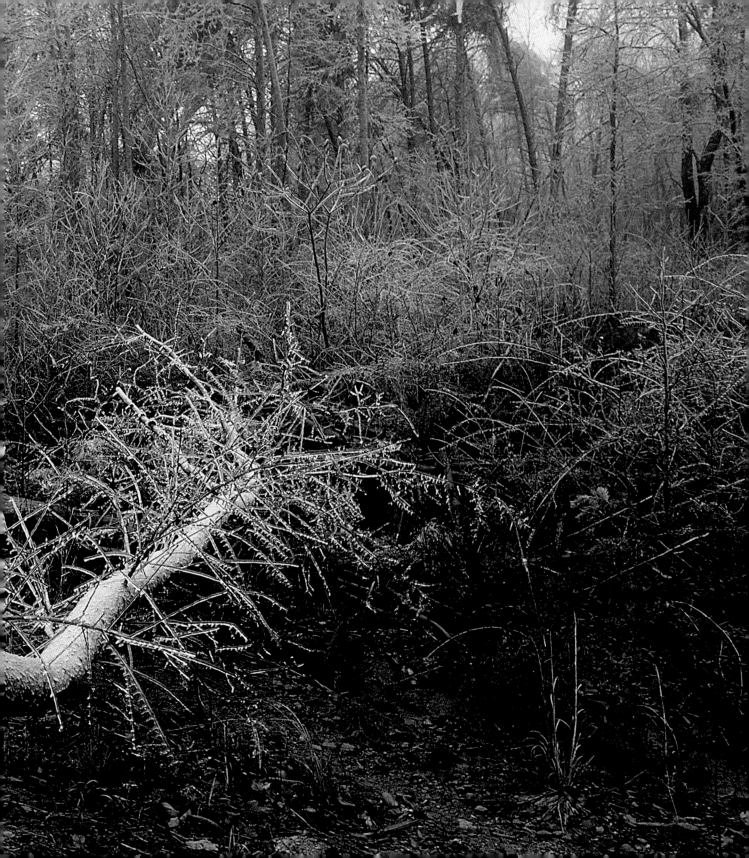

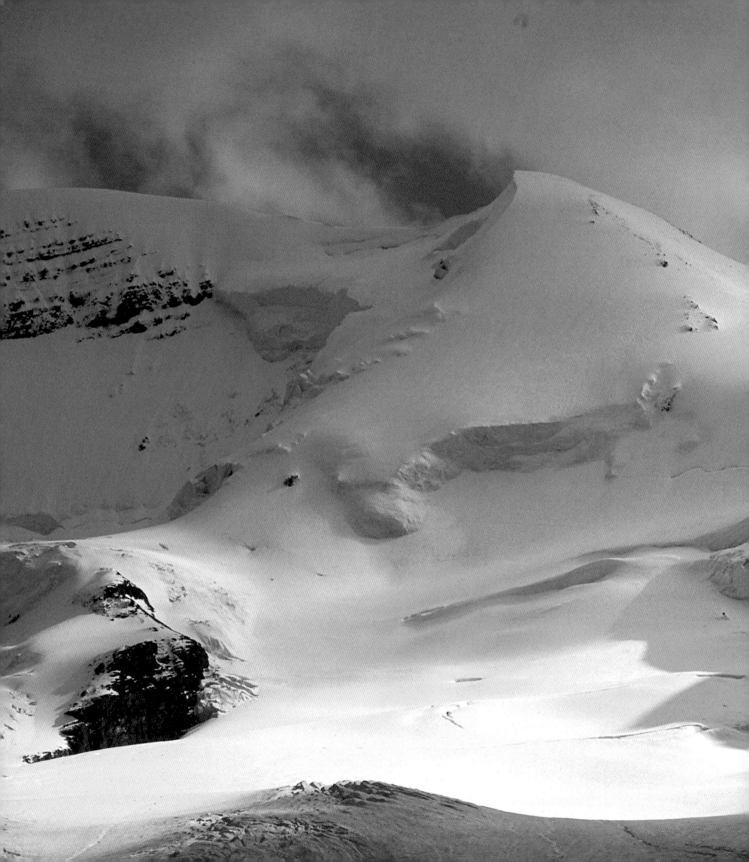

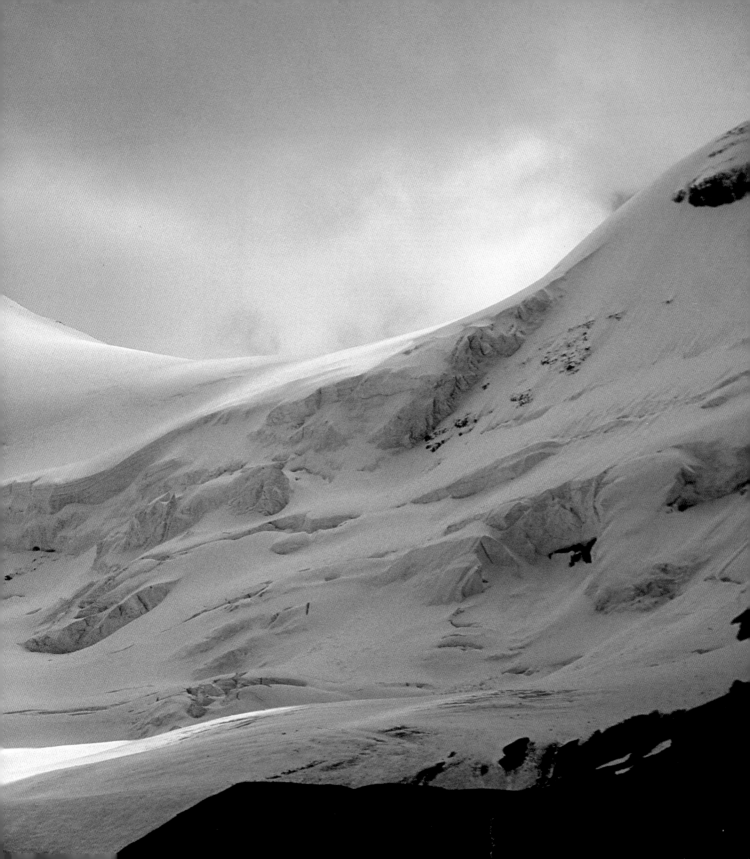

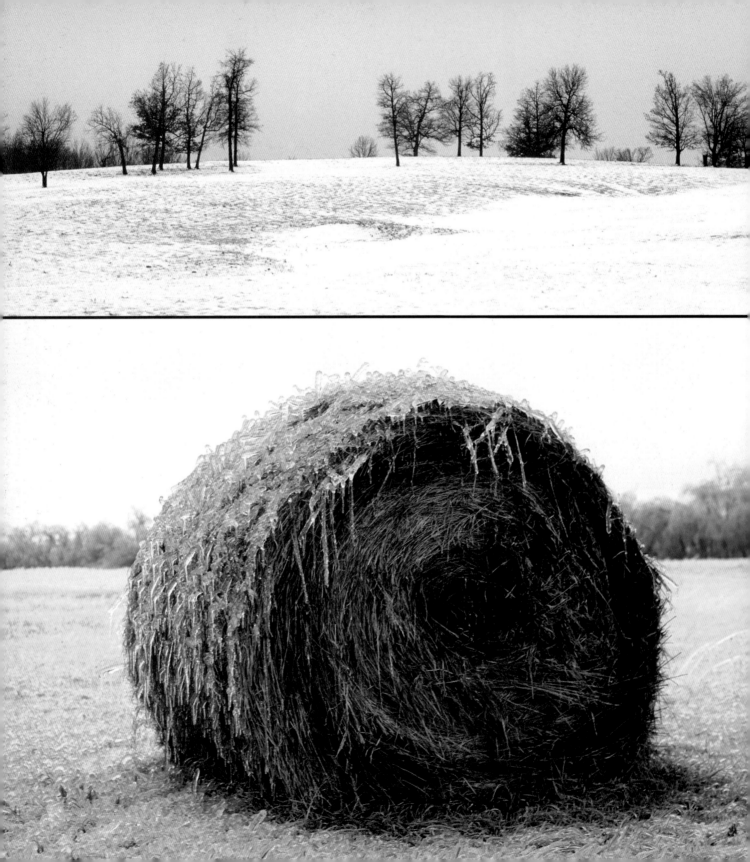

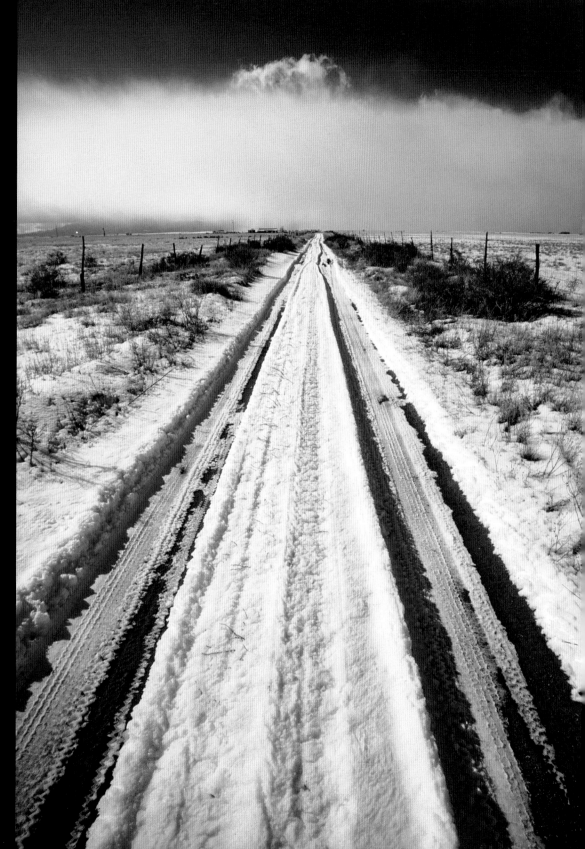

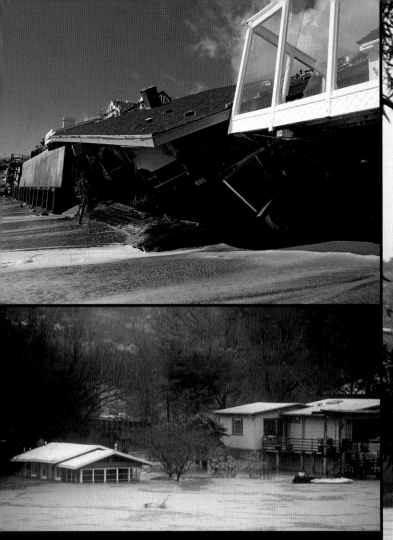

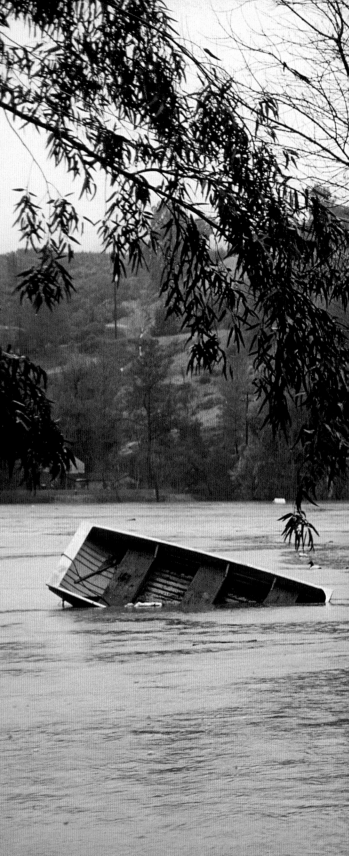

TOP
Homes along the Pacific Coast near Malibu, California, collapse as an El Niño–powered storm slams Southern California in February 1998.

ABOVE
Flash flooding strikes Malibu, California, on February 23, 1998, during a powerful El Niño–influenced storm.

RIGHT
Flooding occurs in Malibu, California, in February 1998.

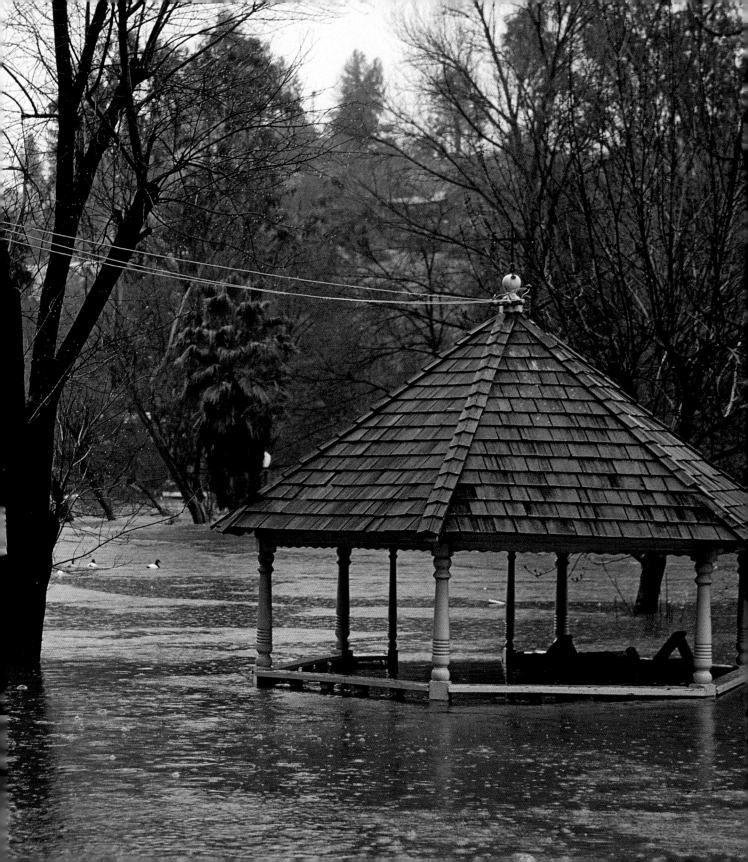

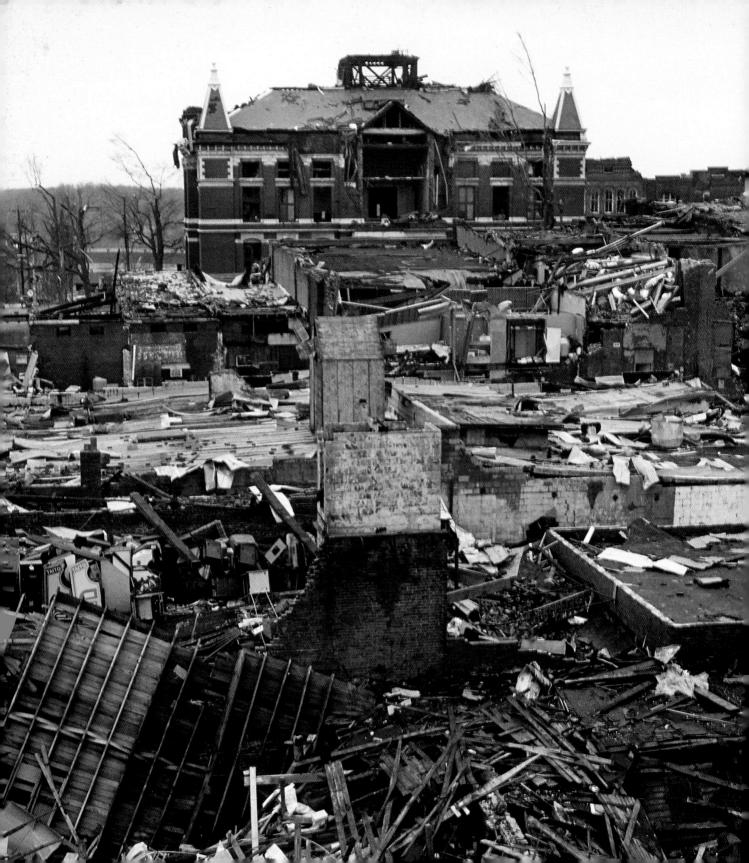

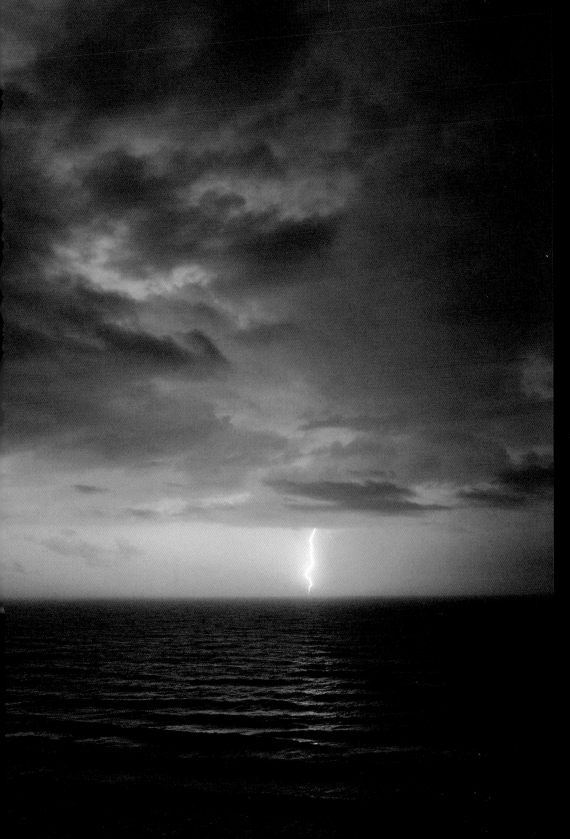

OPPOSITE

Downtown Clarksville,
Tennessee, lies in ruins following
an F-3 twister in January 1999.

LEFT

An isolated lightning bolt strikes
over the Atlantic Ocean near
North Myrtle Beach, South
Carolina, on January 2, 2006.

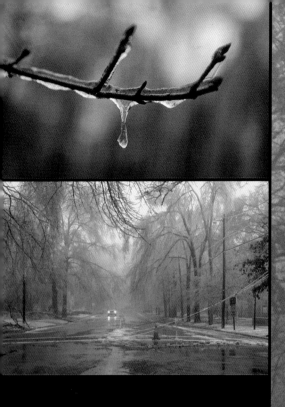

TOP

A tear of rainwater is frozen mid-drop from a branch following an ice storm in northern Georgia on Christmas Day 1998.

ABOVE

A lone motorist navigates a neighborhood street beneath trees coated in thick ice following a major ice storm in Shelby, North Carolina, on January 3, 1999.

RIGHT

Ice storm and fog in northern Georgia on Christmas Day 1998.

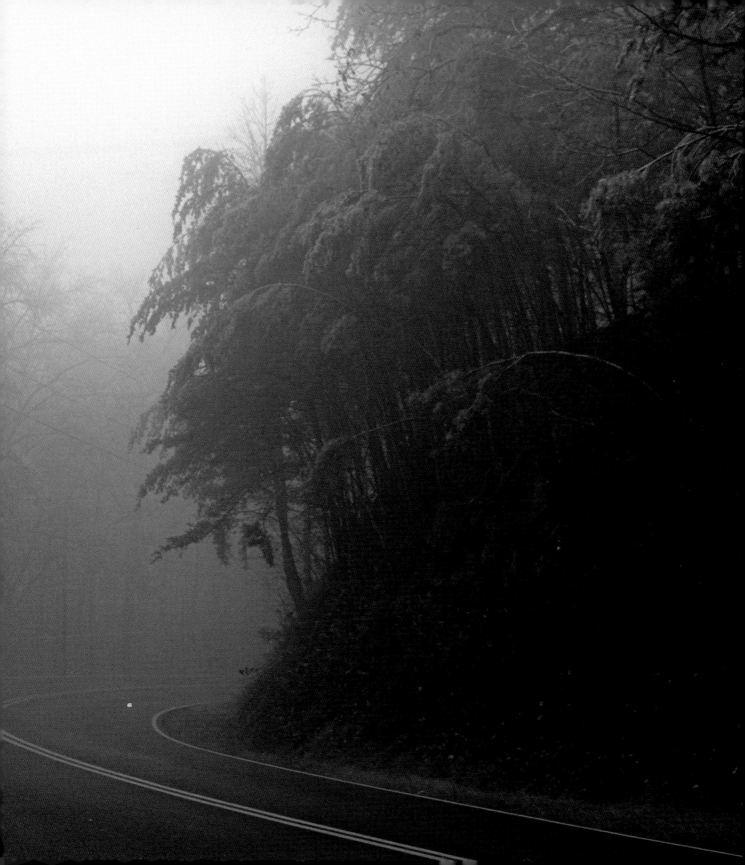

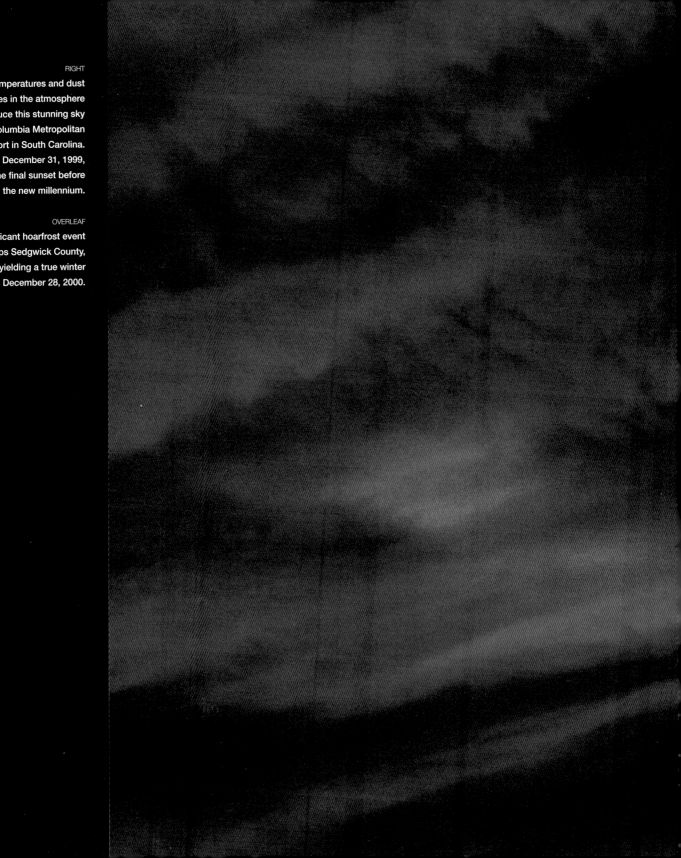

RIGHT

Warm temperatures and dust particles in the atmosphere produce this stunning sky over Columbia Metropolitan Airport in South Carolina. Shot on December 31, 1999, it was the final sunset before the new millennium.

OVERLEAF

A significant hoarfrost event envelops Sedgwick County, Kansas, yielding a true winter wonderland, December 28, 2000.

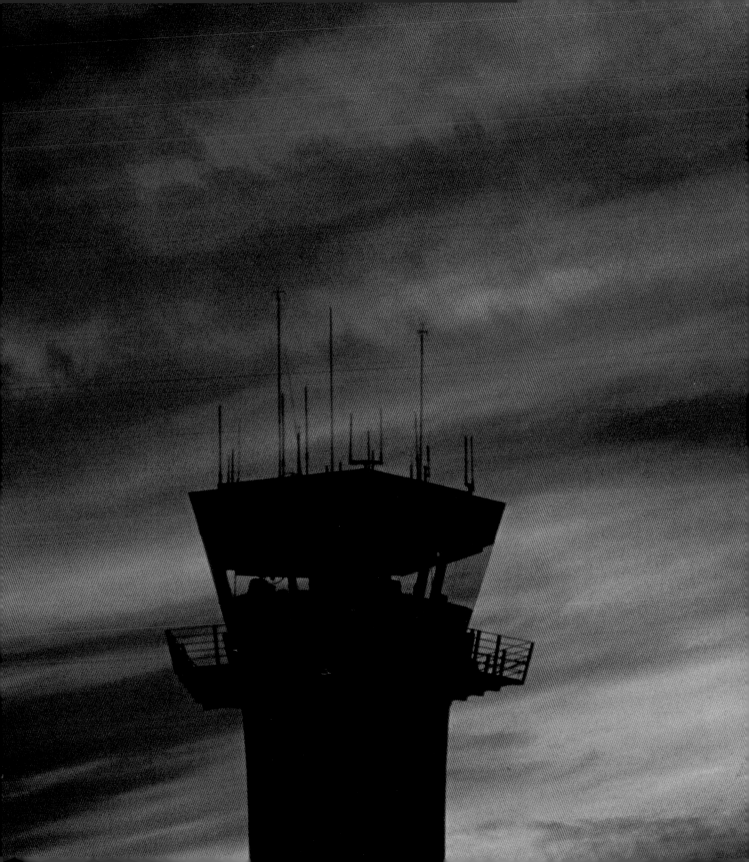

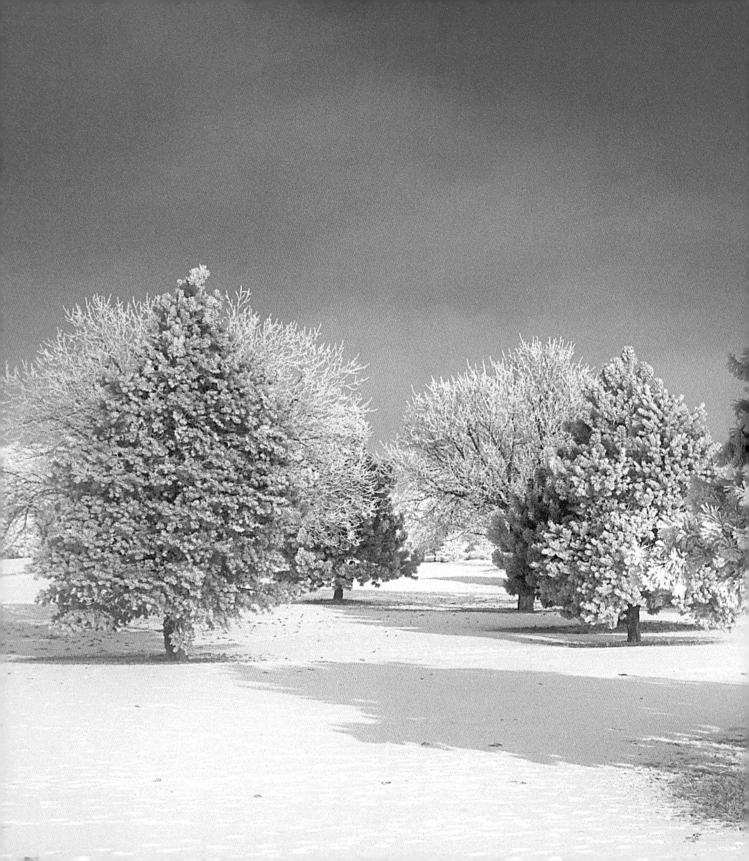

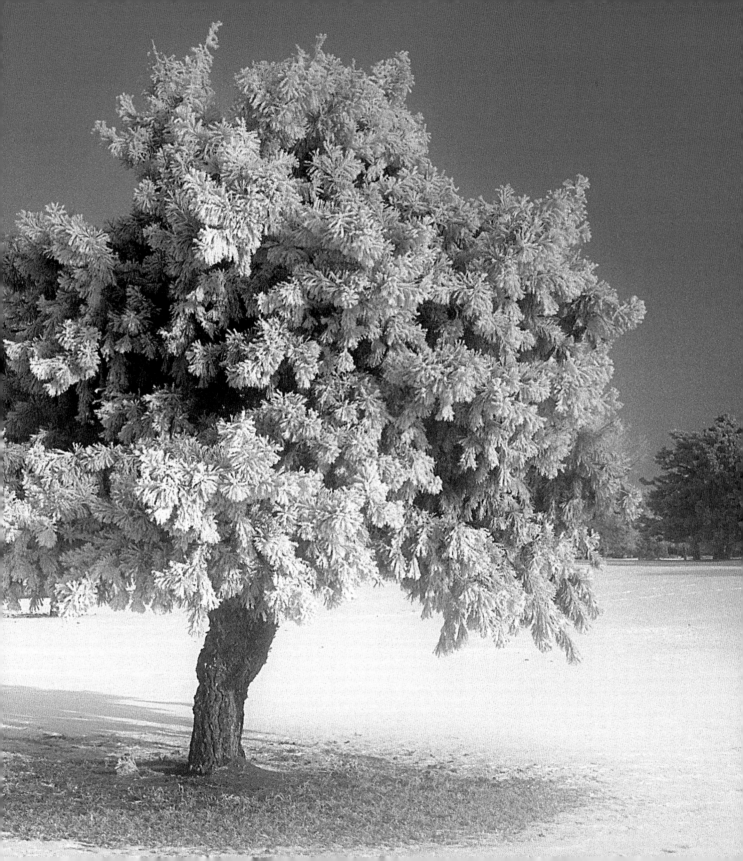

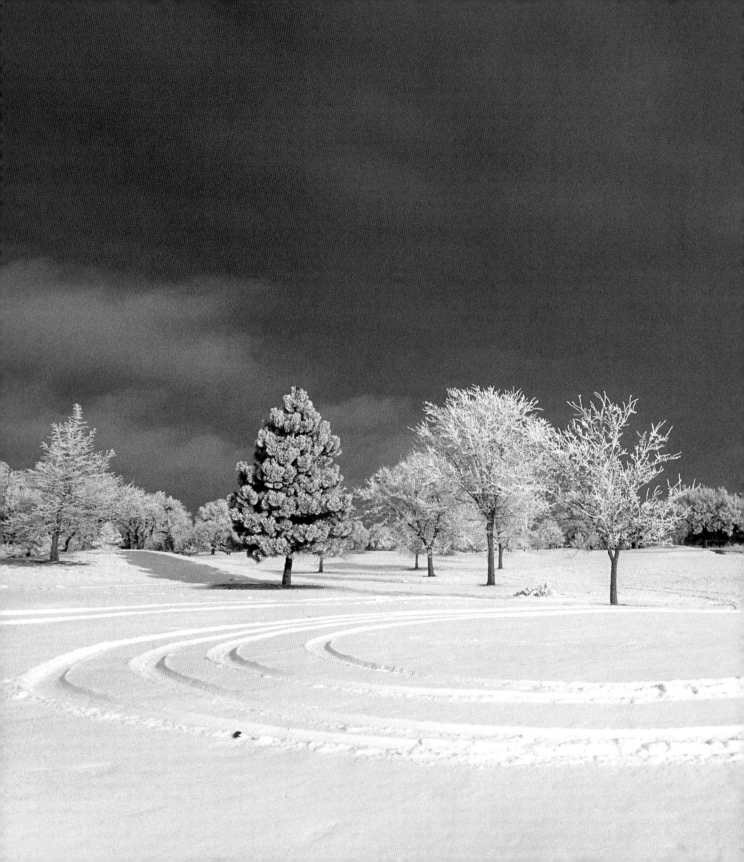

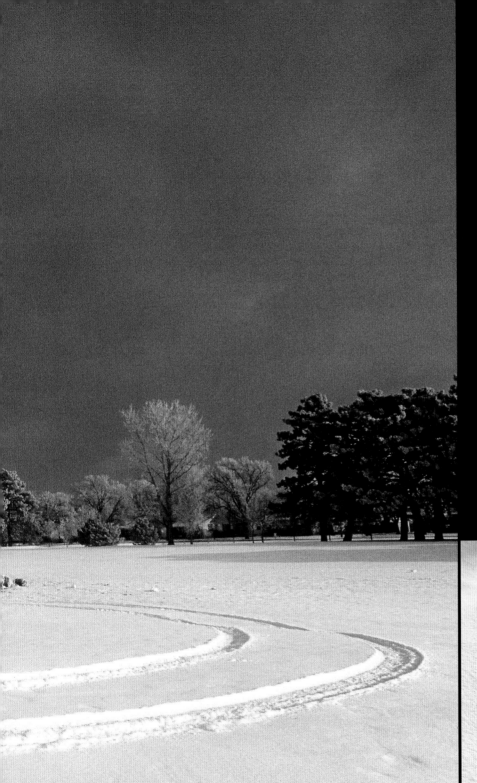

LEFT
Hoarfrost–covered trees
overlook circular tire tracks in
the snow in Wichita, Kansas, on
December 28, 2000.

BELOW
Snow in Wichita, Kansas,
December 13, 2000.

OVERLEAF LEFT
An octagon of frozen
precipitation hangs momentarily
from a stop sign before falling
to the ground following a major
ice storm in eastern Kansas on
January 31, 2002.

OVERLEAF RIGHT
Scattered clouds and a colorful
sunrise over Myrtle Beach, South
Carolina, in December 2002.

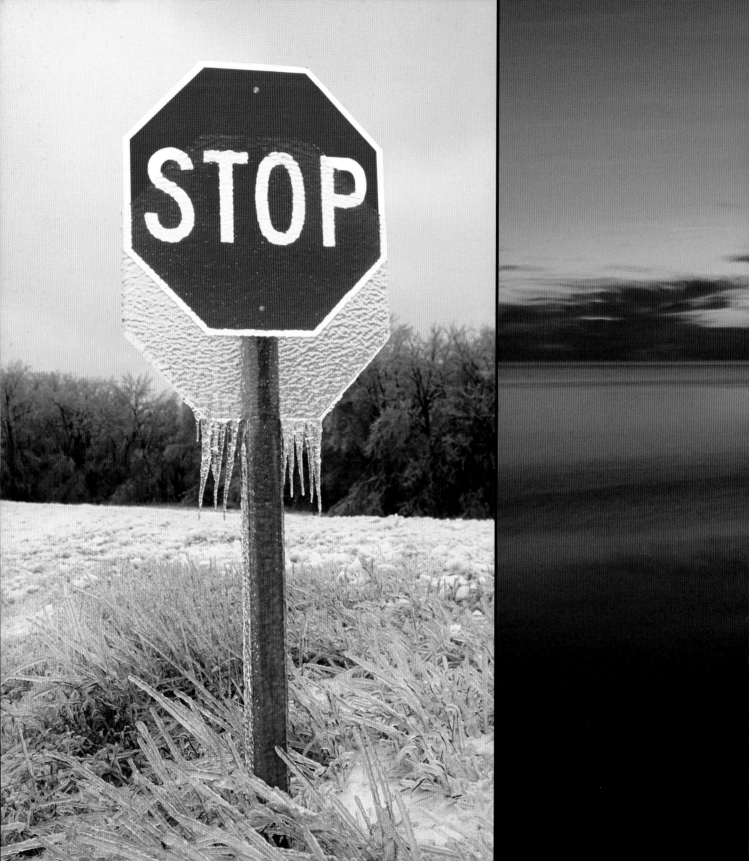

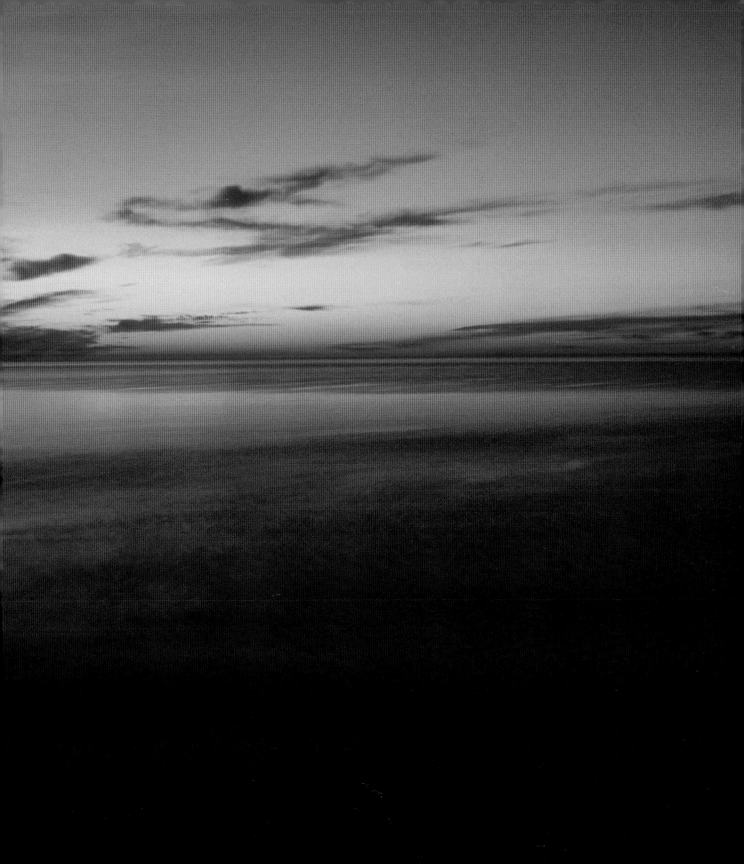

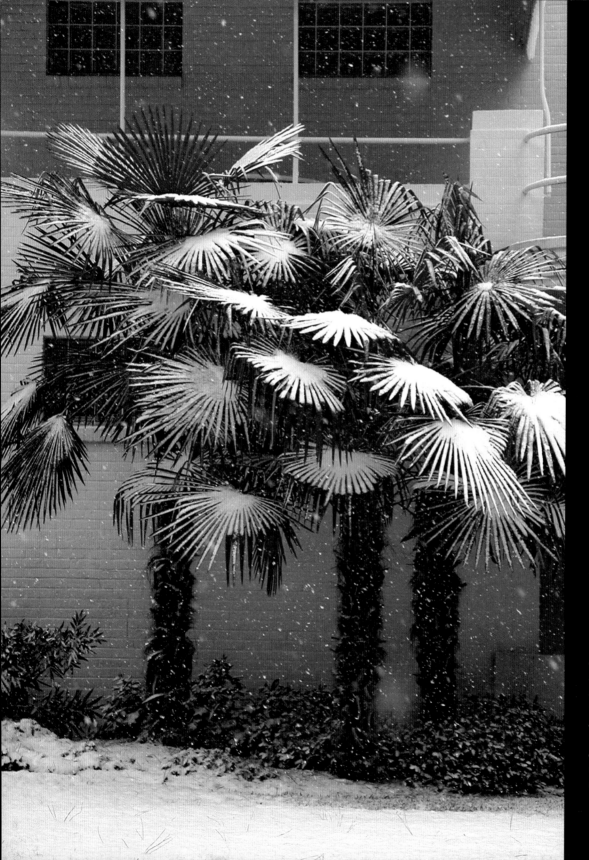

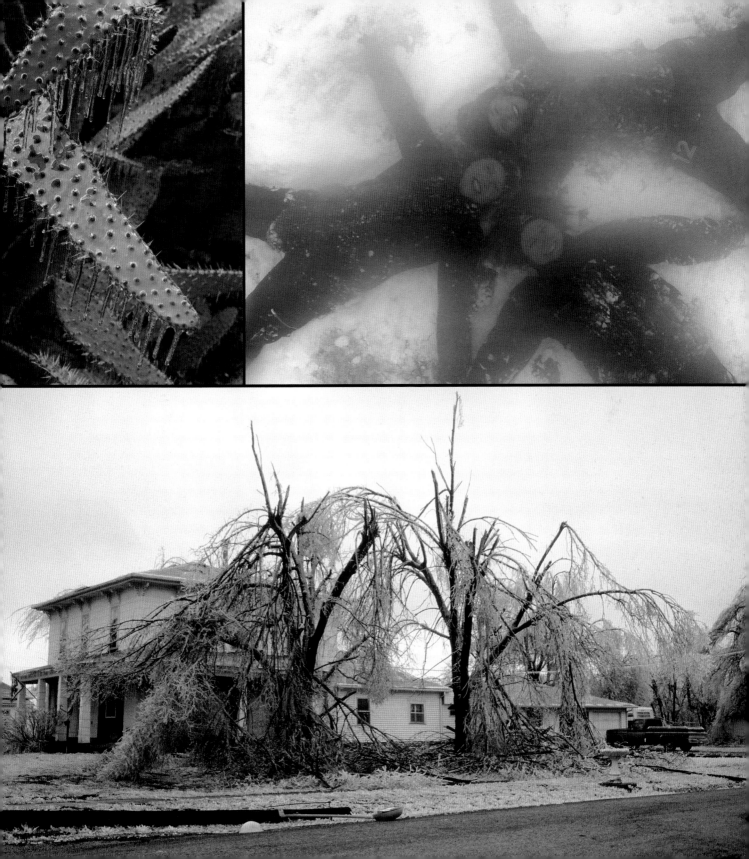

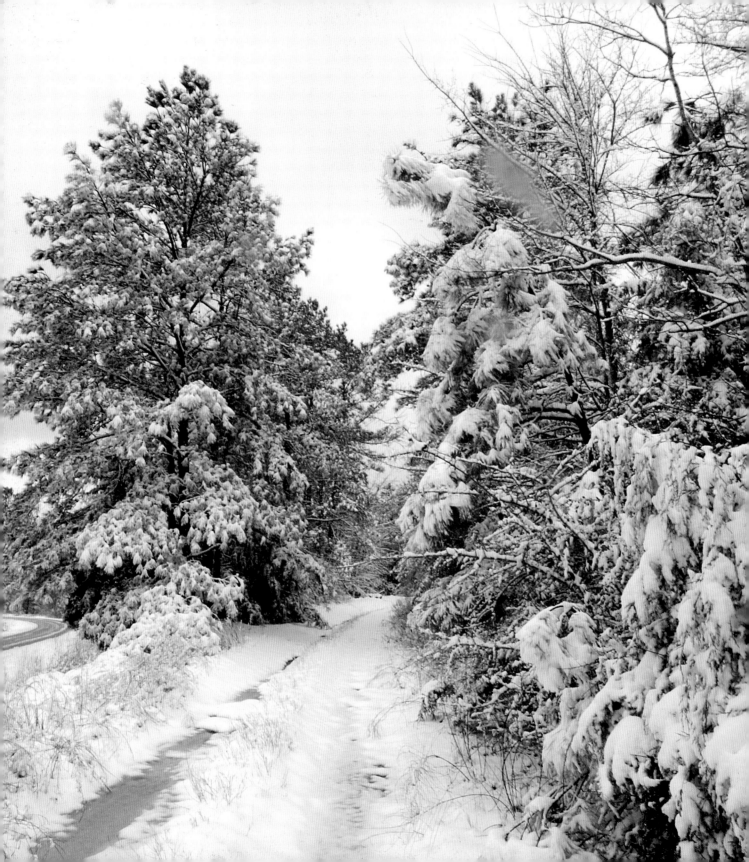

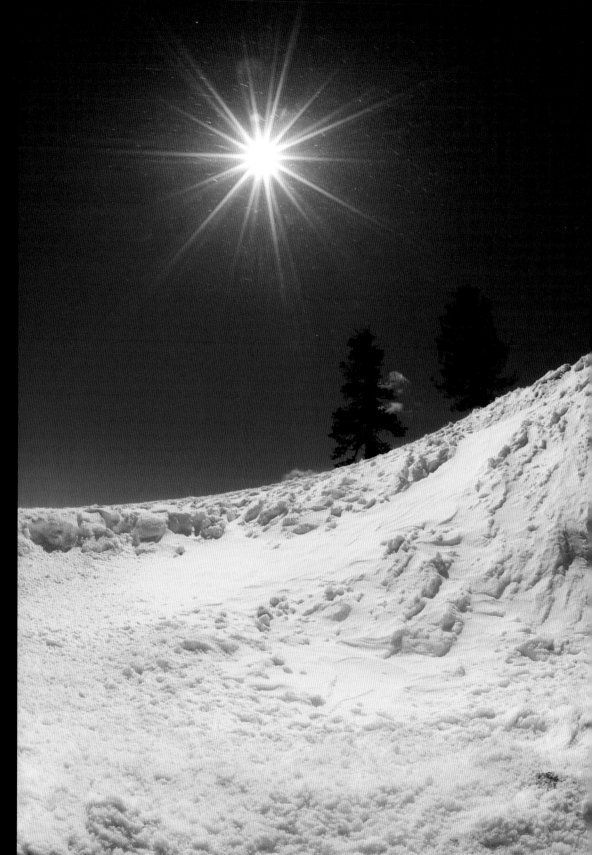

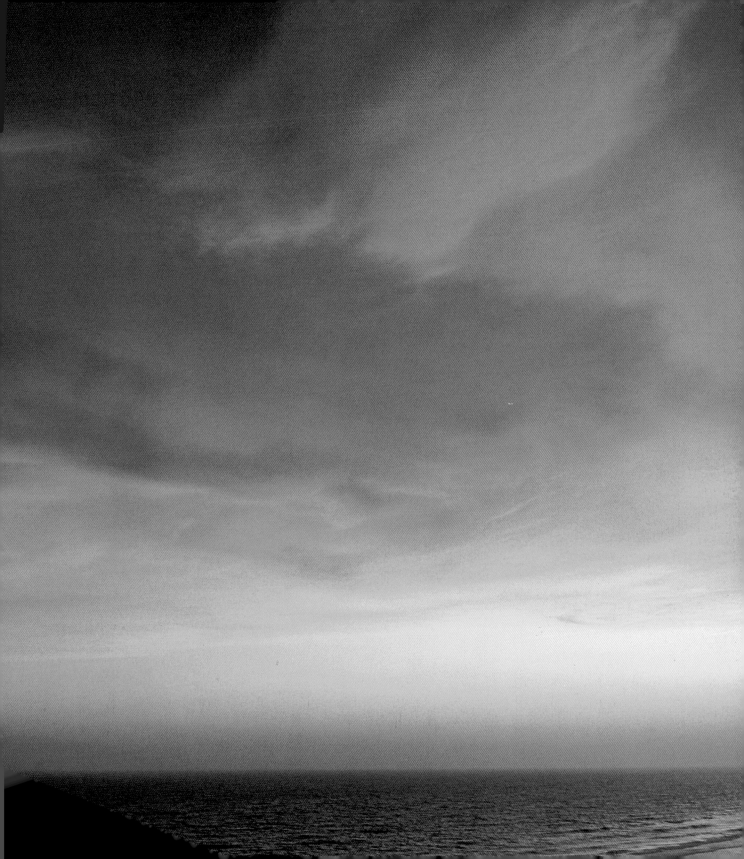

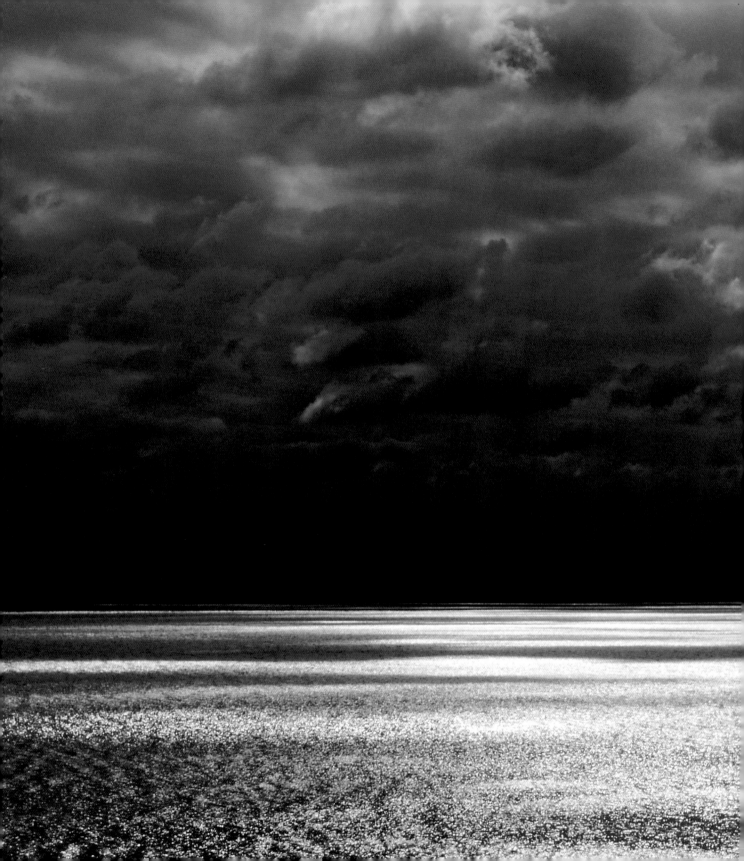

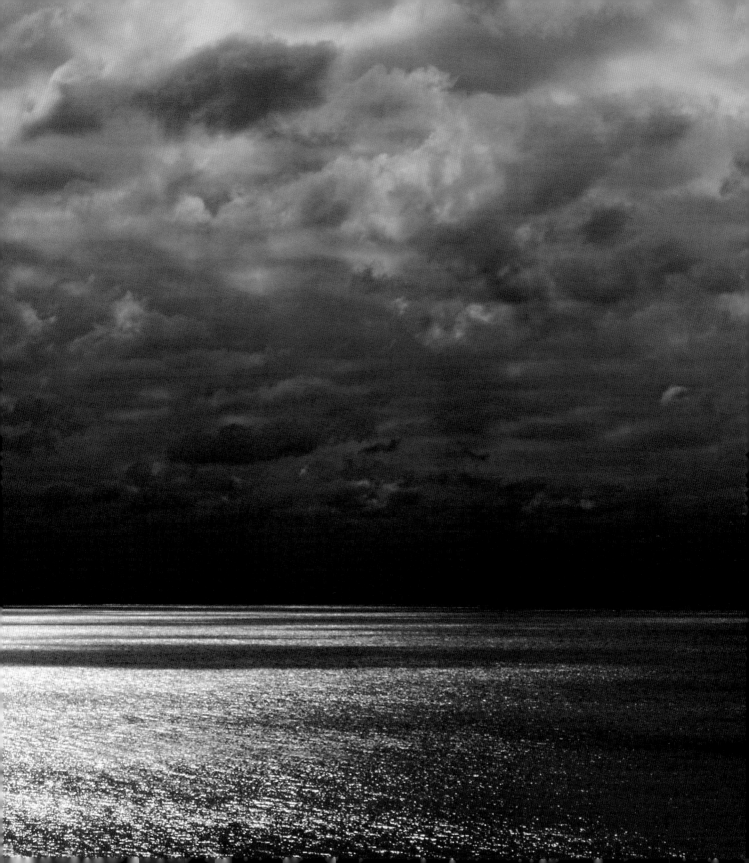

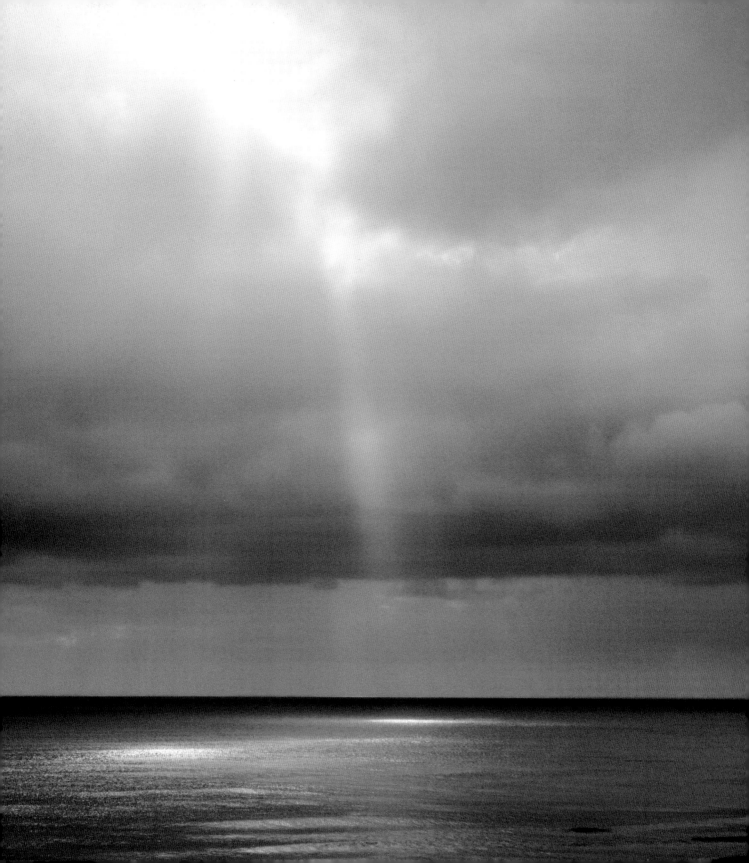

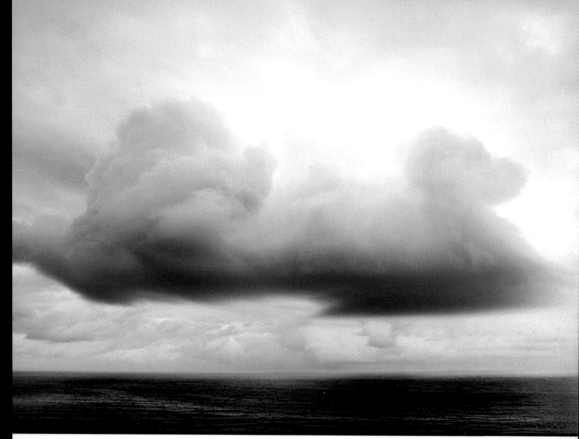

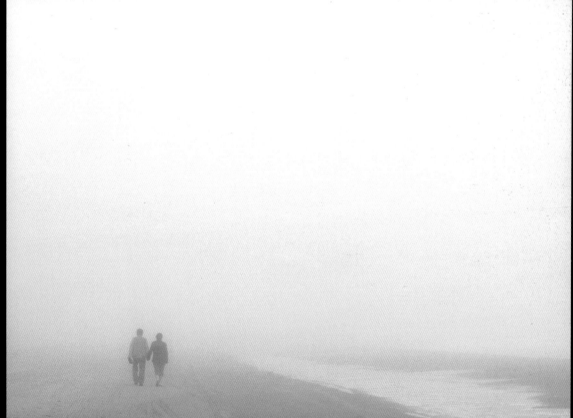

Rays of sunlight spotlight
the Atlantic Ocean during
a passing storm near North
Myrtle Beach, South Carolina,
on January 3, 2006.

Storm clouds loom over
the Atlantic Ocean off the
coast of South Carolina
on December 13, 2006.

Heavy fog consumes the East
Coast near Myrtle Beach,
South Carolina, during a
month of topsy-turvy record
cold-and-hot temperatures
in December 2006.

From winter to spring
in Flint Hills, Kansas,
on March 21, 2006.

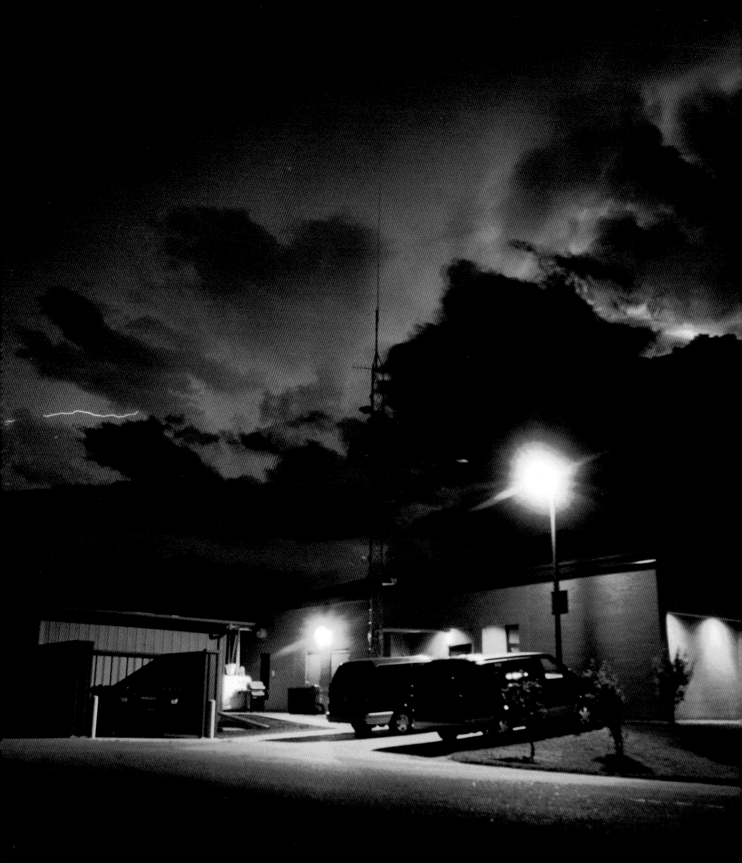

> *In the spring,
> I have counted
> 136 different
> kinds of
> weather inside
> of 24 hours.*
>
> —Mark Twain

spring

Spring is an especially volatile season, yielding nearly every conceivable weather threat, including blizzard, drought, flood, hail, ice, lightning, tornado, tropical storm, subzero wind chill, and wildfire. But for storm chasers, above all else, spring means supercell thunderstorms.

A supercell is a long-lived, frequently severe thunderstorm with a persistently rotating updraft. This type of storm is notorious for producing lightning, large hailstones, and damaging winds. Since it rotates, it can also produce tornadoes.

When I moved from Los Angeles to Wichita in 1992, one of the first things I did was to begin interviewing as many veteran storm chasers and tornado experts as possible: Howard Bluestein, Jon Davies, Robert Davies-Jones, Chuck Doswell, David Hoadley, Warren Faidley, Marty Feely, Roger Jensen, Jim Leonard, Martin Lisius, Tim Marshall, Erik Rasmussen, Jerry Straka, Dr. Josh Wurman, and many others. I even had the privilege of interviewing the father of the tornado "F-Scale," Dr. Tetsuya Theodore Fujita, before he passed away in 1998.

The National Weather Service in Wichita, led by meteorologist Richard Elder, took me under its wing, as did Mike Smith, President of WeatherData, Inc., one of America's earliest and most successful private forecasting companies. Thanks to these generous weathermen, I was learning something new about our climate every day, and by 1993 I was ready to chase on my own.

My first spring season storm chase occurred on March 29, 1993. Coincidentally, it occurred the night of the Academy Awards. I was attending an Oscars party at screenwriter Janice Graham's home in Wichita, when my weather-radio alarm sounded. A tornado watch had been issued, and I was out the door. The resulting storm was loaded with lightning and thunder, but no twister.

On April 24, 1993, a severe tornado struck Catoosa, Oklahoma, just outside of Tulsa. What caught my attention more than anything was the fact that the twister had hit a popular local truck stop. It prompted a flashback to all those long drives my mother and I used to make from Springfield to my Grandma's house in northern Illinois. We'd always make a pit stop to get a cup of coffee and soda pop at the Dixie Truck Stop in Logan County. I loved trucks as a boy.

Two days later, on April 26, I zipped down to Catoosa. I was overwhelmed by the widespread destruction. Overturned semitrucks. Shattered school buses. Toppled buildings. Winds in excess of 150 miles per hour had wrapped steel beams around solid concrete posts as easily as a child wraps licorice around a finger.

But it was a nearby neighborhood that made me silent with horror. The homes were either gone or heavily damaged. One house in particular caught my eye. All that remained was a bathtub, a toilet, and a single wall.

"They survived by gettin' in the tub and coverin' up," a stunned local shared with me.

I raised my camera and pushed the shutter button only once. Standing in silence, my eyes recorded the aftermath. It was tough to accept, but I knew it was important to see both sides of extreme weather.

Later that night, in the comfort of my Wichita apartment, I updated my journal with six words: "Storm chasing has a dark side."

That spring, catastrophic flooding occurred in nine states along the Mississippi and

Magenta-colored lightning erupts over the National Weather Service in Wichita, Kansas.

Missouri rivers. Dubbed the Great Flood of 1993, the event lasted for months, resulting in dozens of deaths and fifteen billion dollars in property damage and crop losses. Eight thousand homes were destroyed. Two thousand barges stranded. More than four hundred counties were declared disaster areas. It was the worst flood in the United States since 1927. I wrote about the event, but did not shoot it. I was still emotionally processing what I had witnessed in Catoosa. I wanted and needed to think about something completely different.

Returning my attention to Hollywood, I wrote *Trouble on 162*. It was an original screenplay about a teenage girl who hijacks her school bus from Wichita to Denver in an effort to reestablish contact with her estranged father. Warner Bros. Pictures purchased the script with Norman Jewison attached to produce.

The income allowed me to purchase new camera equipment and shoot more often. In between meetings with studio executives, I also began planning future expeditions to study global warming and our shifting climate.

In March 1995, friends and I rented a houseboat and spent several days battling hurricane-force winds on Lake Powell in Utah. On the third day of the adventure, we were nearly capsized and forced to make an emergency landing along a sandy shoreline. Suddenly I had been propelled into my favorite childhood sitcom, *Gilligan's Island*.

But unlike the fictional TV show, our island was suffering from drought conditions. Water levels were so low that docking or beaching the boat became extra challenging, even for our experienced skipper. The ground was so severely parched and dry that driving our fluke-style anchor into the ground was impossible.

America's heartland was also beginning to show signs of baking away. A few weeks after houseboating, meteorologist and fellow storm chaser Michael Phelps and I documented a tornado near Garden City, Kansas. As the storm swirled over drought-stricken farmland, the twister became so wrapped up in dust we could no longer see the vortex.

On April 19, 1996, the fierceness of an unusually powerful weather system struck again. This time it was my home state of Illinois that felt the wrath. A single-day record of thirty-six tornadoes hit the Land of Lincoln—more tornadoes than the state normally receives in an entire year. Thirty-one counties sustained damage.

Since it was my home state, I accepted an assignment to photograph the aftermath in Decatur, about thirty miles east of the capital city where I was raised.

Two weeks later the motion picture *Twister* opened in theaters nationwide. It was an instant blockbuster. At first, storm chasers were unsure whether the movie would help or hurt the perception of storm chasing. In my opinion, it helped. From the spring of 1996 forward all I had to say was, "I'm a storm chaser," and people knew what I was referring to. In fact, it soon became a fun way for getting people to discuss not only storm chasing, but also global warming. And just in time.

On April 8, 1997, winter decided to unexpectedly invade spring. A late-season snowstorm dumped several inches of snow on Wichita, prompting many local residents who were out in their yards pruning flowers to raise an eyebrow and ask, "What do you make of all this wild weather?"

I thought long and hard about the question. In the spring of 1999 I posted the following message on my Web site:

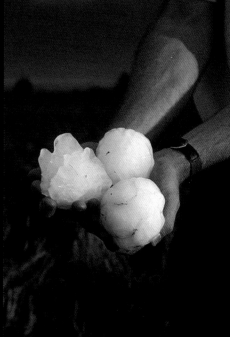

TOP
Winds of an F-3 tornado wrapped this steel beam around concrete posts in Catoosa, Oklahoma, on April 24, 1993.

ABOVE
A storm chaser displays softball-sized hailstones in Meade County, Kansas, on May 31, 1999.

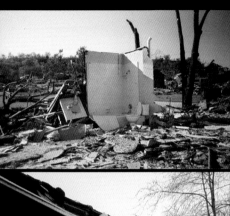

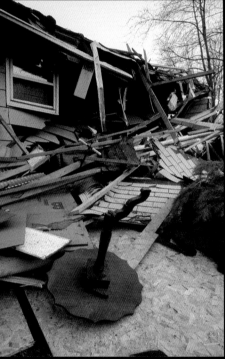

Since the 1980s, I have logged more than a million miles and nearly one hundred natural disasters documenting North America's spectacular and ever-changing weather. During my storm chasing, I have learned at least two very important lessons:

First, severe weather is often inspirational, endowing people with wisdom to put life and priorities into perspective.

Second, severe weather is remorseless with those who do not pay attention.

What I have witnessed has convinced me that America has entered into a period of increased frequency and harshness with respect to all types of storms.

During the spring season of 1997, I watched in amazement as scientists were able to study a tornado close up for the first time using truck-mounted, dual high-resolution Doppler radars. The mission, led by Dr. Joshua Wurman, provided a never-before-seen two-dimensional view of a tornado.

"If we can someday understand how a mesocyclone spawns a tornado, then we might be able to help improve forecasts and warnings," Dr. Wurman told me.

He was going to need all the help he could get on May 3, 1999.

On that day the atmosphere erupted. Close to seventy tornadoes struck Oklahoma and Kansas. It was the largest tornado outbreak in Oklahoma history.

The most significant twister struck the Moore area, a suburb of Oklahoma City. At least thirty-five people lost their lives, making it the deadliest single tornado in thirty years. Nearly eleven thousand homes and businesses were destroyed.

Wurman and his Doppler-on-Wheels team also entered the history books when they measured the tornado's wind speed of 318 miles per hour, the highest ever documented on Earth, and just shy of America's first twister rated F-6.

Entire streets were obliterated. Homes had exploded into the air, leaving only concrete foundations. Cars looked more like washcloths wrung by a giant. Trees left standing had been completely stripped of bark. Shoes had pierced two-by-fours. Golf clubs impaled solid doors. An iron kitchen sink had been wrapped around a tree limb. The aftermath of the Moore F-5 tornado was the most complete and horrific destruction I have ever documented.

While on assignment, I interviewed a woman whose husband had died during the storm. She walked me over to where their house had once stood.

"That's where our porch used to be," she pointed. "He was sitting there, with his feet propped up, having a beer." She began to cry. "I tried to get him to go to the closet, but he said the tornado was gonna miss us."

He was wrong.

On March 10, 2000, more snow fell in the Wichita area. It was a welcome relief to this photographer's eyes following the brutality of the previous year. For me, snow is as peaceful as a tornado is violent. Snowfall temporarily silences an otherwise strident culture.

In April, my attention turned sharply from snow to the tropics. Hurricane prognosticator Dr. William Gray's updated forecast was out for all to read, and his prediction was apocalyptic.

Speaking at the National Hurricane Conference in 2000, Gray told listeners that an analysis of weather patterns over the past one hundred years had convinced him that a bombardment of hurricanes was coming and would likely last through at least 2015. Gray, a professor of meteorology at Colorado State University in Fort Collins, Colorado, said we could expect such hurricanes to cause damage five to ten times worse than ever before in the Gulf and Atlantic coast states. In April, the well-known Hurricane Hunters toured five vulnerable Gulf coast communities to help spread the word.

Max Mayfield, then acting director of NOAA's National Hurricane Center, told everyone, "We can provide the warnings. But the public must prepare appropriately and act as directed by their local officials to avoid the dangers of the next major hurricane."

In the spring of 2001, hurricane-force winds struck Kansas, knocking down trees and overturning semitrucks. It was yet another example of weird weather and a shifting climate.

On April 21, 2001, a bizarre and devastating tornado materialized just after dark. It was bizarre because in the good old days of "normal weather," storms frequently weakened after sunset. But this storm cell detonated with energy and intensified with uncommon speed. The vortex struck so suddenly that the National Weather Service didn't even have enough time to issue a tornado warning. The twister, rated an F-4 with chaotic winds in excess of two hundred miles per hour, minced its way through Hoisington, Kansas, like a shop saw out of control. Five hundred and sixty-nine homes were damaged or destroyed.

Fellow storm chasers and I instantly became an improvised rescue team and rushed to help the wounded. It was the worst destruction I'd photographed since Moore, Oklahoma, in 1999. In some ways, Hoisington was even more distressing. This damage was only minutes old. I could hear the hissing of broken gas lines. The smell of splintered wood, ripped-up soil, and sewage was overpowering. The local man we had been dispensed to locate had been crushed to death beneath a car. He would be the storm's one fatality.

For two days I couldn't sleep. Lessons from a decade of storm chasing kept ricocheting in my head. What could we have done differently? How could we have helped save the man's life? Why didn't he seek shelter? How bad is global warming actually going to get?

Weird tornadoes continued in the spring of 2002. In fact the first of the season for Kansas was downright odd. On April 11, 2002, storm chaser Katherine Bay and I spotted a small debris cloud swirling over an open rural farm field. Above it was clear sky. No rain. No thunder. A neighboring thunderstorm was producing hail, but that was about it.

As we intercepted the vortex just east of Pretty Prairie, Kansas, we watched as a full-fledged tornado finally became perceptible, complete with funnel and condensation. The crest of the vortex was visible through our sunroof, directly above our heads. The view was both rousing and daunting.

Since we were the only storm chasers close by, I immediately called the tornado in to authorities. A Kansas state trooper soon joined us and together we watched as the twister struck a row of trees and continued to grow in size. It had been on the ground and snaking to the southeast, away from us, for nearly thirty minutes.

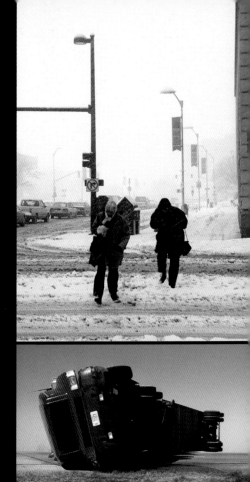

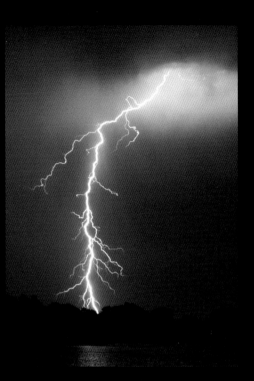

Lightning strikes near a lake in Wichita, Kansas, on May 21, 2006. According to the National Weather Service, death by lightning in America is on the rise.

As the tornado spun over a nearby wheat field, the vortex abruptly vanished. Without any field dirt to create a debris cloud, the twister had become invisible. I stopped the vehicle and climbed out as Katherine focused the crosshairs of the camcorder on my eager eyes.

"There's the funnel, right above us," I reported. "It should be moving off to the south-southeast." I paused, reevaluating the scene. "Oh, my God. You can hear it!" Sure enough, I could hear the sound of rushing water, just shy of being a roar. That didn't matter. The noise, whatever it was, was coming closer, second by second.

"Shit! It's changing its direction, damn it," I said as small pieces of debris unexpectedly began falling from the sky. To our alarm, the twister had changed course by a full 180 degrees and was now chasing us!

"We've got to back up!" I yelled, jumping into the driver's seat. I abruptly yanked my Explorer into reverse and stomped on the accelerator. A few yards away and quickly closing, the twister struck the ditch and an adjacent farm field. The sky exploded into a swirling debris cloud of dirt, mud, barbed wire, and small tree limbs. It was one of the most remarkable sights of nature I had ever witnessed. Time stopped as the brown-colored Liberty Bell–shaped tornado crossed our road, missing the state trooper, Katherine, and me by only five hundred feet.

Katherine and I traded looks of relief and reverence. "Remember this moment, because you may never be this close to a tornado ever again," I said. We each took a deep breath and watched as the spectacular twister finally dissipated, then vanished for good.

During the spring of 2003, the tropics tried to steal the show. Tropical Storm Ana became the first tropical cyclone ever to form in the Atlantic Ocean in the month of April. Thankfully, the storm never made landfall. Now I was really worried. Weird tornadoes, missing snow, record flooding, bizarre-colored sunsets, wearing shorts in Kansas at Christmas, and tropical storms forming around tax time? I no longer found myself asking, "Is global warming real?" Instead I questioned, "What freak storm will global warming influence next?"

The answer came in May.

An unprecedented seven consecutive tornado outbreaks invaded America. From May 3 through May 11, 2003, there were an astonishing 401 twisters in nineteen states. It was the most rampant episode of severe weather in US history.

Among those hardest hit was Pierce City, Missouri, where nearly every building was heavily damaged or ruined. Five people, several of whom had lived in mobile homes, lost their lives. It was the worst tornado aftermath I'd observed since Hoisington. Huge seventy-year-old trees were not only destroyed, they had been ripped from the ground.

In Franklin, Kansas, a high-end F-4 had scoured the ground, literally moving pieces of earth. Cars and trucks had been thrown more than one hundred yards. Homes didn't stand a chance. One of the most memorable images for me was of a child's bicycle which had been brutally twisted around a tree. As in Pierce City, several people lost their lives.

During the spring of 2004, the tornadoes just kept coming. On May 12, research meteorologist Jon Davies, storm chaser Katherine Bay, and I documented a significant

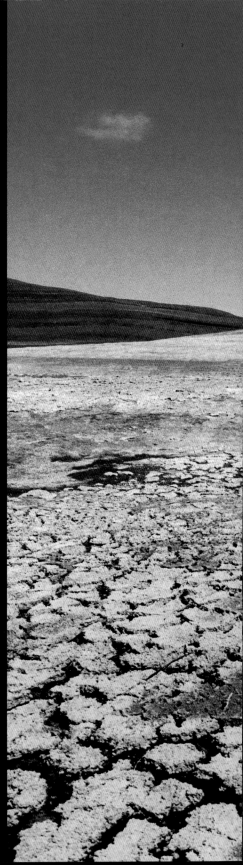

tornado as it struck Attica, Kansas. Unlike the Pretty Prairie tornado event in 2002, this time we intentionally got close. So close that we could actually hear the "waterfall" sound that only someone about to take a direct strike gets to hear. We'd wanted to see, hear, and smell the meteorological beast that had become such a part of our collective lives in recent years.

Coincidentally, *The Day After Tomorrow*, a motion picture addressing global warming and the threat of a future ice age, opened in theaters nationwide two weeks later. Having worked on the movie as a hurricane expedition leader made the week feel even more peculiar. Some sort of synchronicity was occurring again. Movies. Weather. Photography. The only element missing was my hometown of Springfield, Illinois.

Two years later, in spring 2006, everything came full circle when yet another tornado outbreak struck the Midwest. One hundred and five tornadoes were reported. This time my hometown of Springfield took a direct strike. The two separate twisters hit my native land in the blackness of night, causing more than one hundred million dollars in damage.

The Lincoln Home National Historic Site had been spared, but numerous familiar childhood landmarks were now gone.

Paradoxically, I was in Nebraska when the twisters hit, documenting a snowstorm occurring on the backside of the very same storm system. Within a few days I was in Springfield. Captain Jeff Berkler, commander of the Tactical Response Unit for the Sangamon County Sheriff's Office, gave me a tour of the destruction. Jeff and I had grown up together, and it was especially poignant that he escorted me through our childhood neighborhoods, which had been ravaged by the storm.

For this storm chaser, spring frequently reminds me of the importance of humbleness, friendship, and healing. In 2006 spring also proved to me the obvious:

Global warming is real.

The symptoms of global warming were clear in the Lake Powell, Utah, area as early as the spring of 1995.

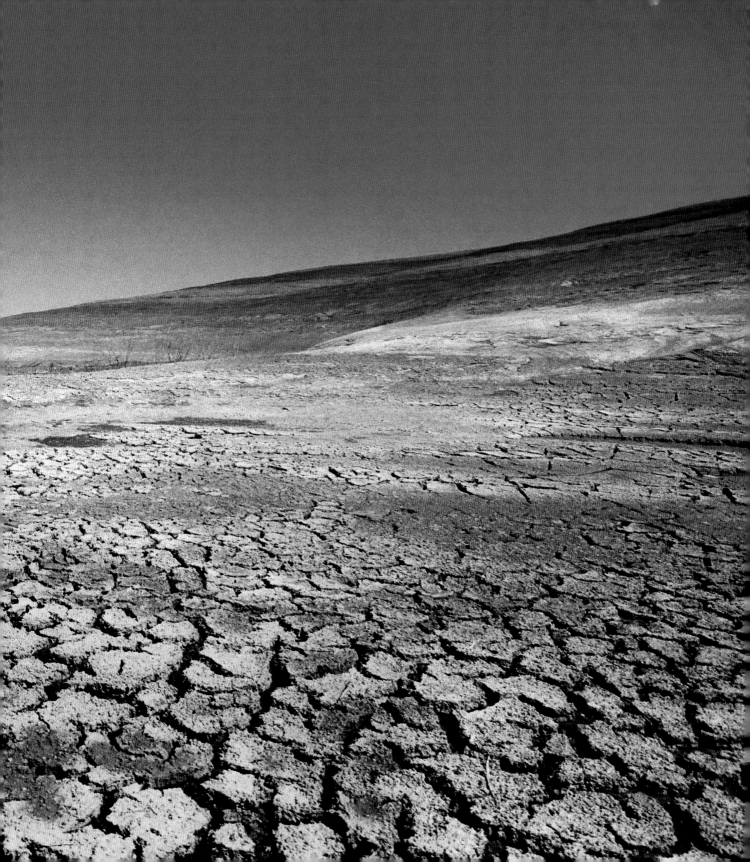

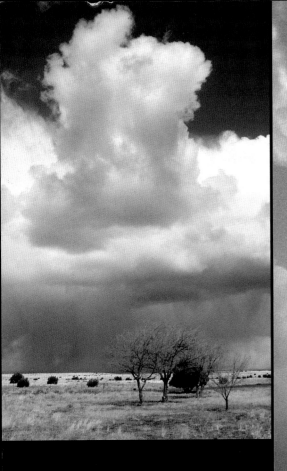

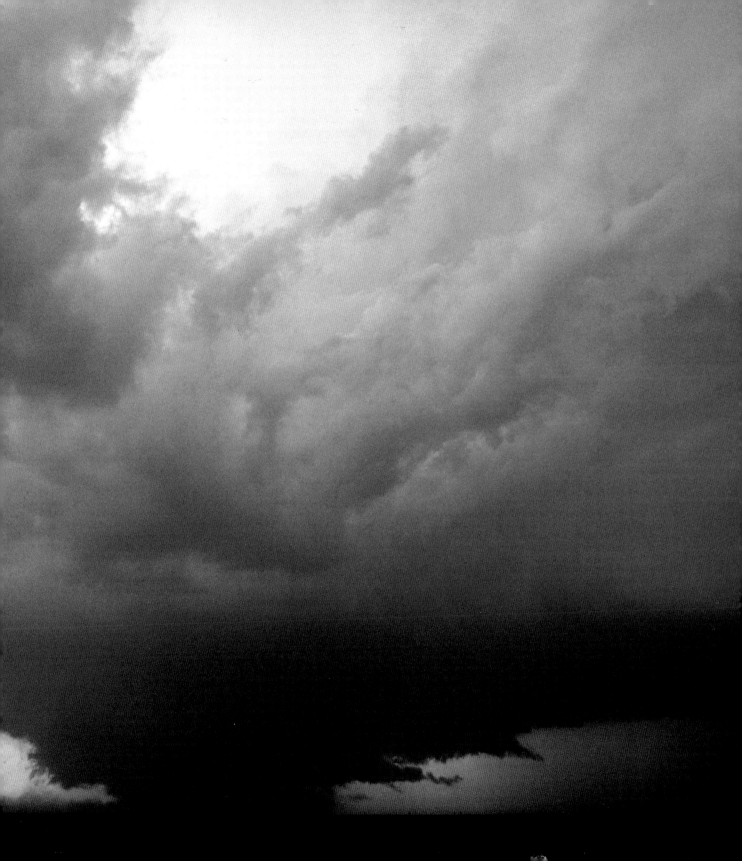

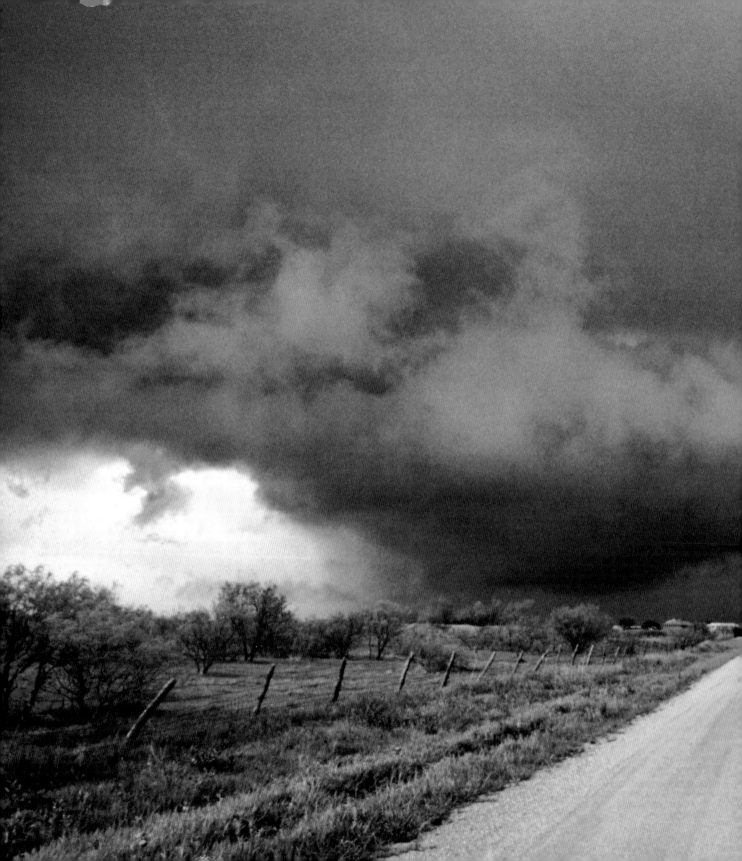

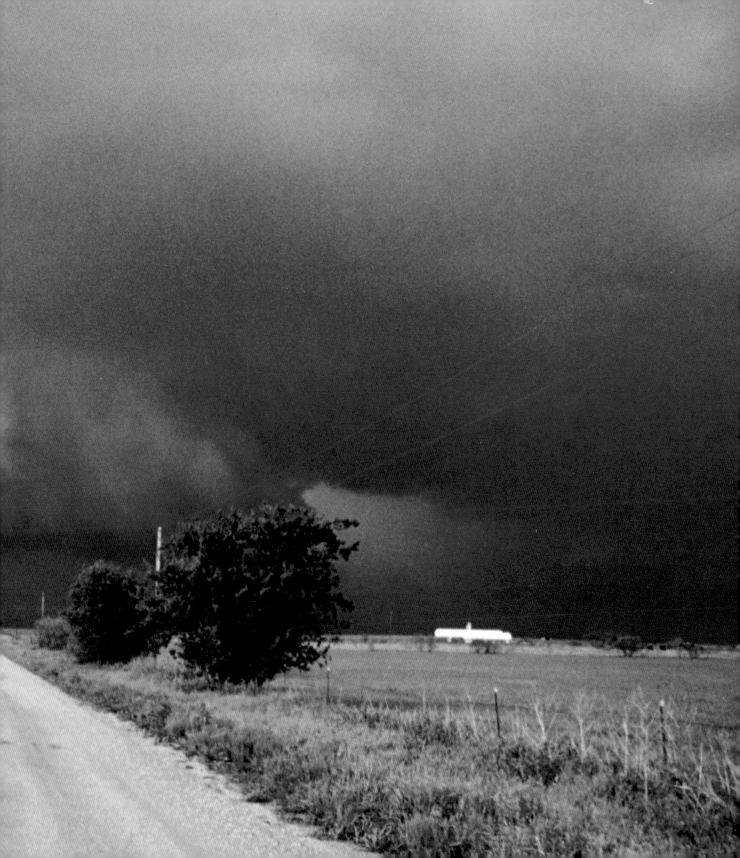

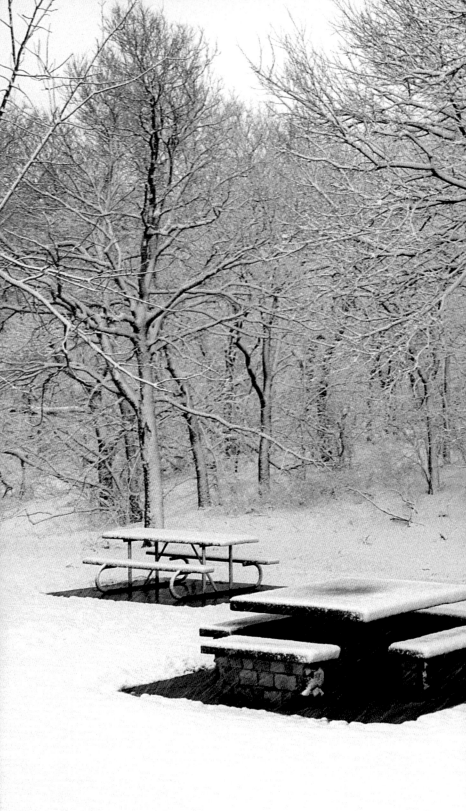

A late season snowstorm,
eighteen days past the start
of spring, envelops a flower in
Wichita, Kansas, on April 8, 1997.

A late winter storm blankets
Arthur B. Sim Memorial Park in
Wichita, Kansas, on April 8, 1997.

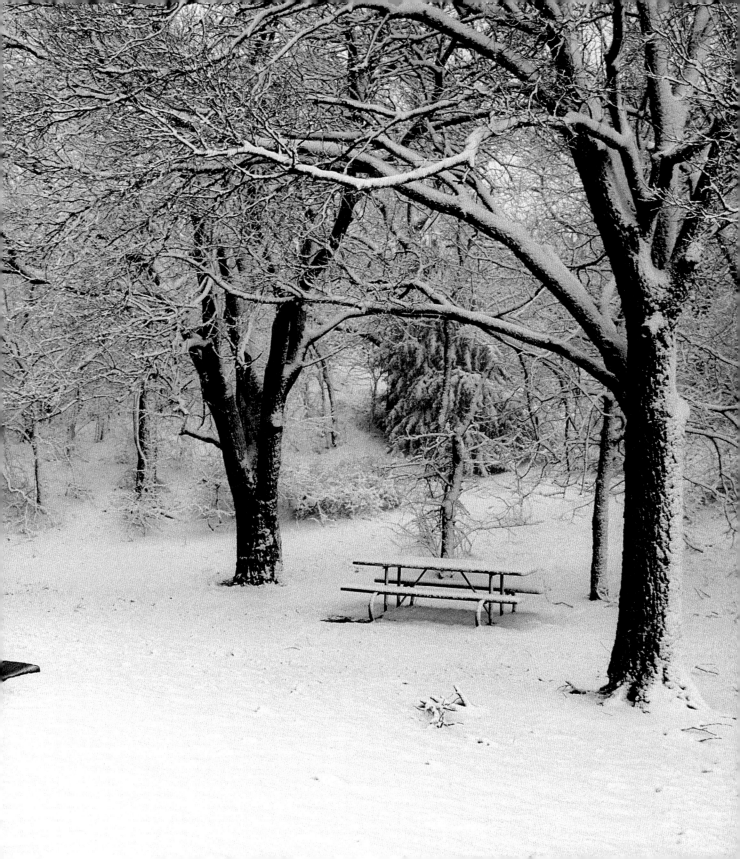

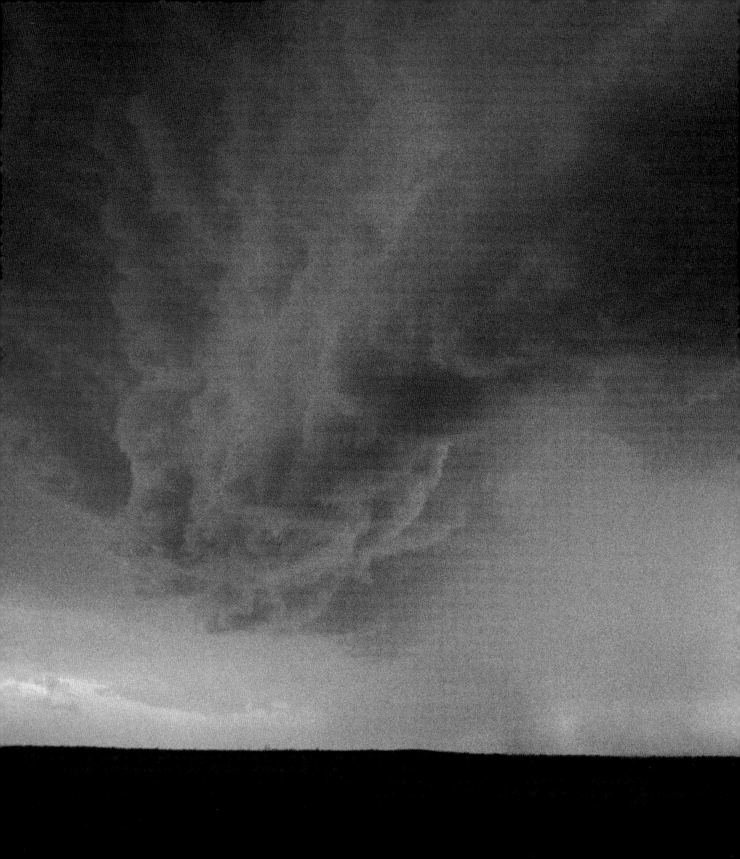

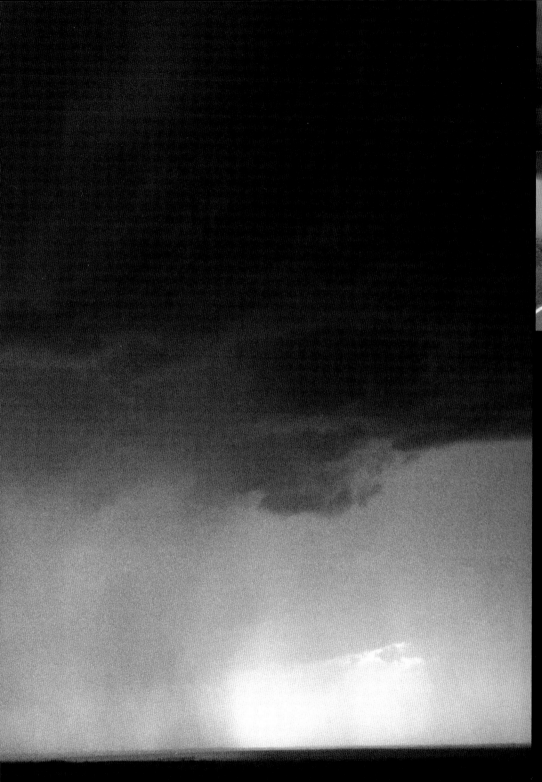

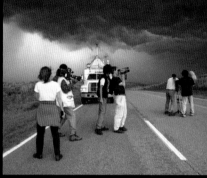

LEFT
A mesocyclone swirls across the sky at sunset in Meade County, Kansas, on April 4, 1997.

TOP
A Doppler-on-Wheels portable weather radar truck scans a severe thunderstorm in Oklahoma on May 23, 1997.

ABOVE
Outflowing winds and precipitation sculpt a ragged shelf cloud over a troupe of storm chasers in western Oklahoma on May 23, 1997.

OVERLEAF
A motorist in a pickup truck attempts to escape the path of a tornadic mesocyclone rotating above central Kansas on May 24, 1998.

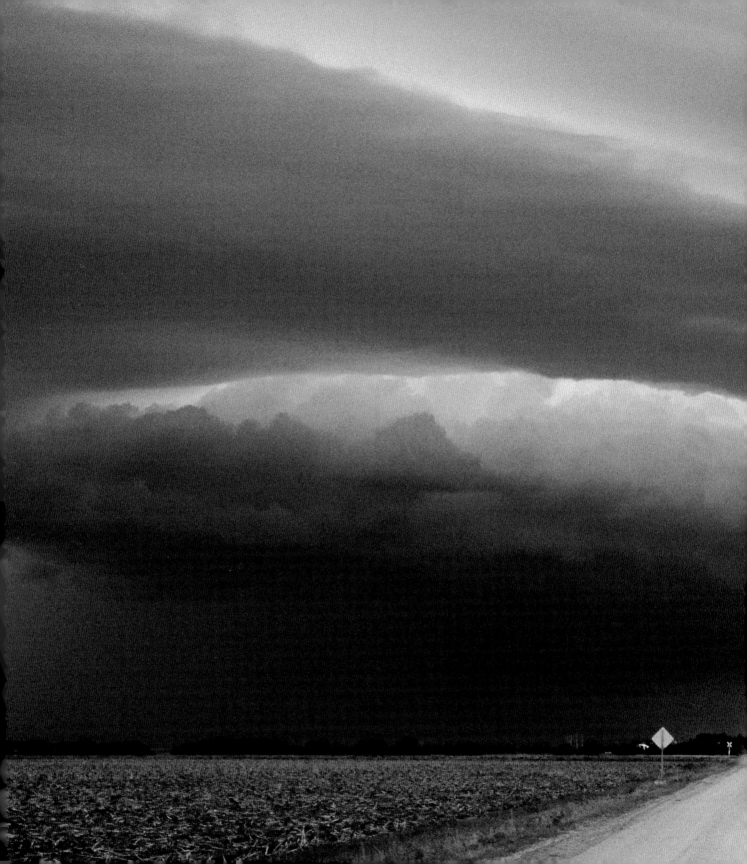

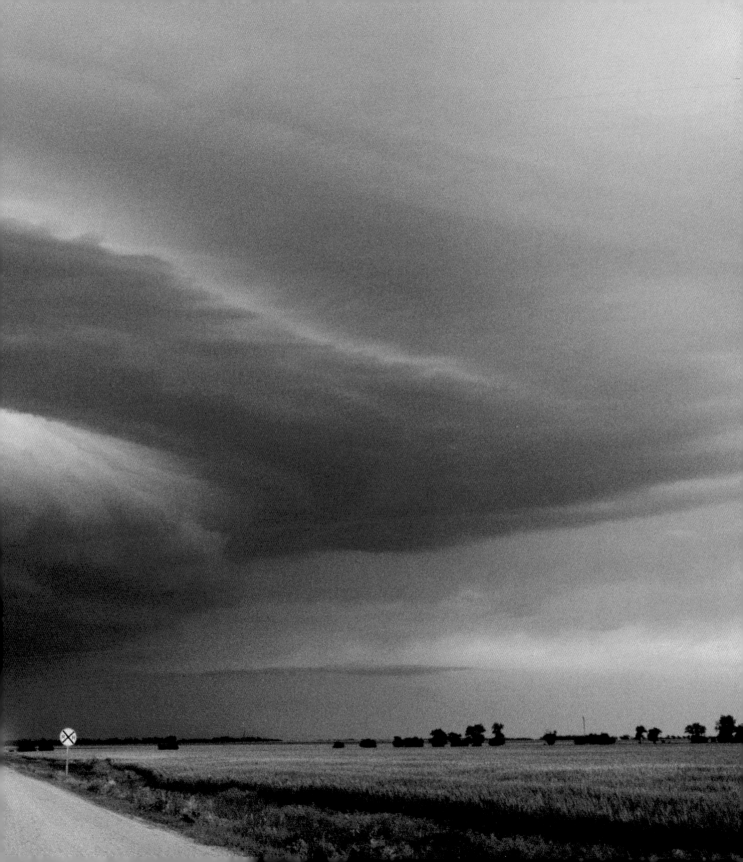

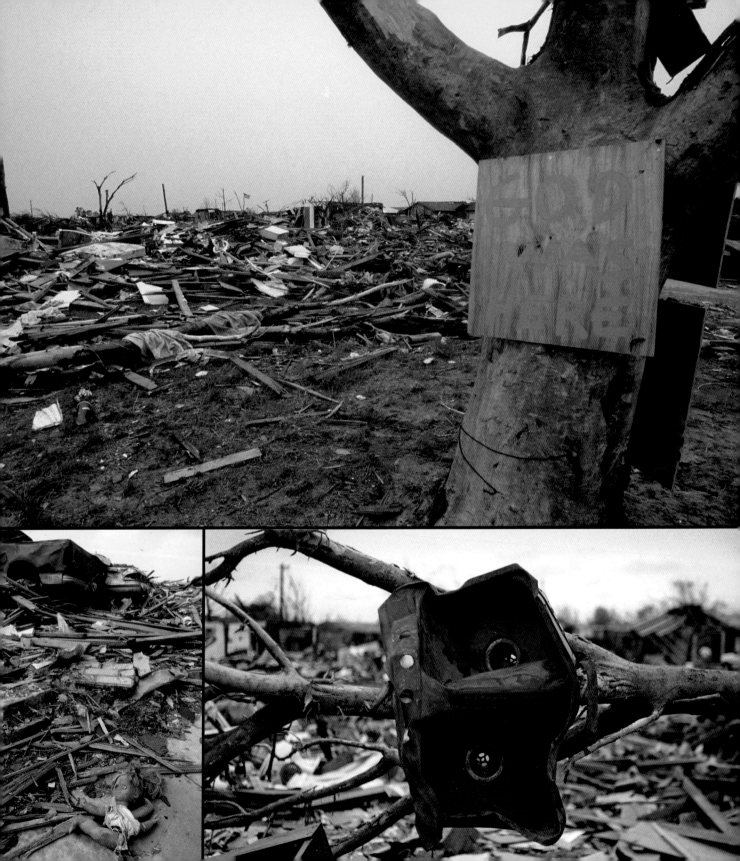

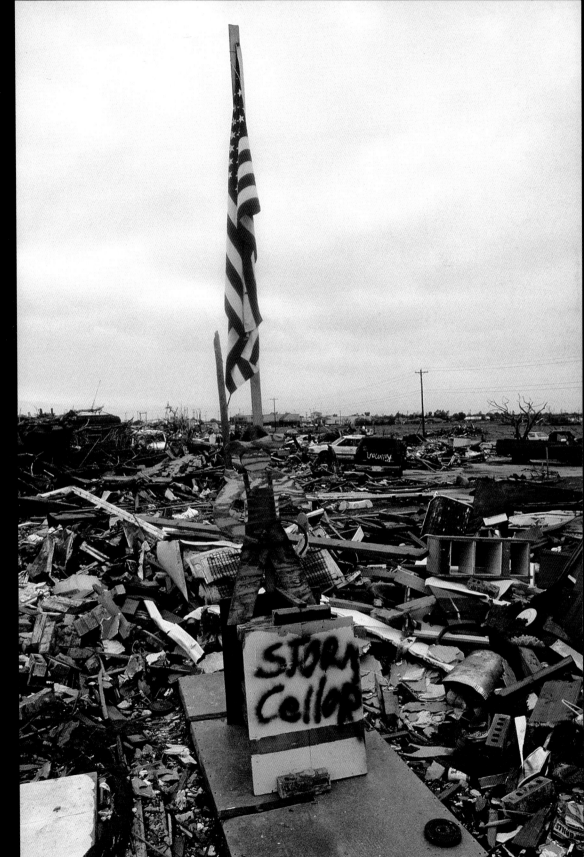

OPPOSITE ABOVE
Victims of disasters frequently create therapeutically made messages following a storm. On May 3, 1999, Moore, Oklahoma, was devastated by an F-5 tornado that struck with record-setting winds in excess of three-hundred miles per hour.

OPPOSITE BELOW LEFT
A child's doll lies in the rubble aftermath of an F-5 tornado in Moore, Oklahoma, on Mother's Day, 1999.

OPPOSITE BELOW RIGHT
An F-5 tornado with winds around three-hundred miles per hour wrapped this steel sink around a tree branch in Moore, Oklahoma, on May 3, 1999.

RIGHT
This storm shelter saved the lives of a Moore, Oklahoma, family during a violent twister on May 3, 1999. It was the first time in recorded history that an F-5 tornado hit the Oklahoma City metro area.

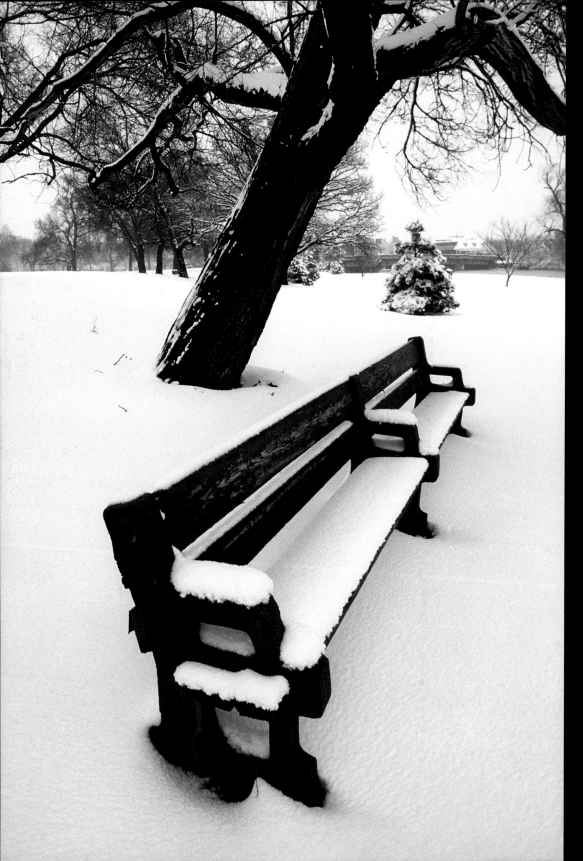

Calm after the storm
in Wichita, Kansas, on
April 8, 1997. The first few
hours following a snowstorm
can be delightfully peaceful
and rejuvenating.

Cumulus clouds form unusually
close to the ground as fog and
marble-size hailstones impact
western Kansas on April 10, 2005.

Windblown snow and frigid
temperatures impact a golf
course in Wichita, Kansas,
on March 2, 2002.

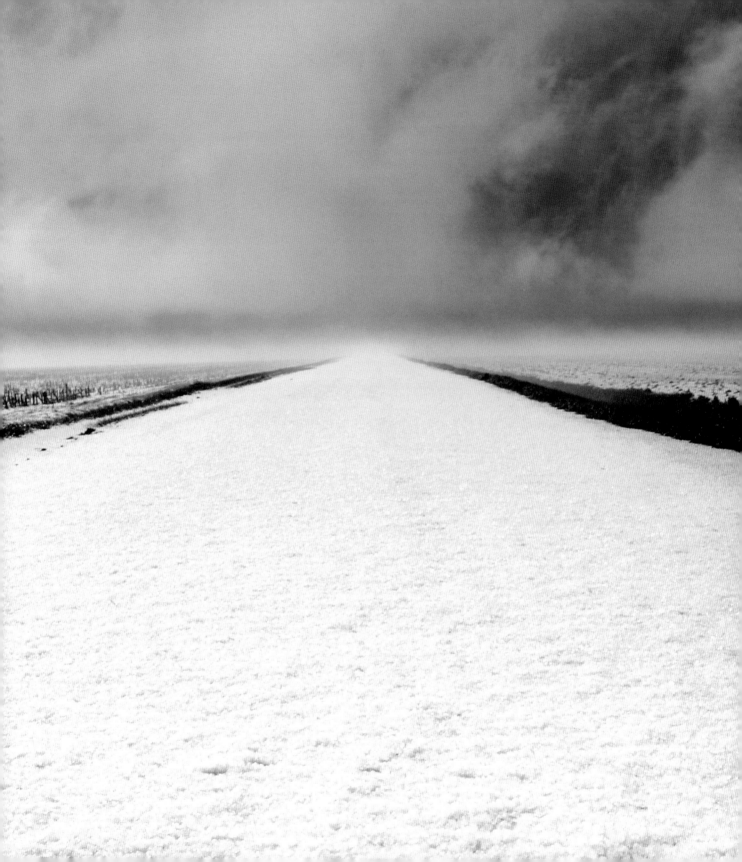

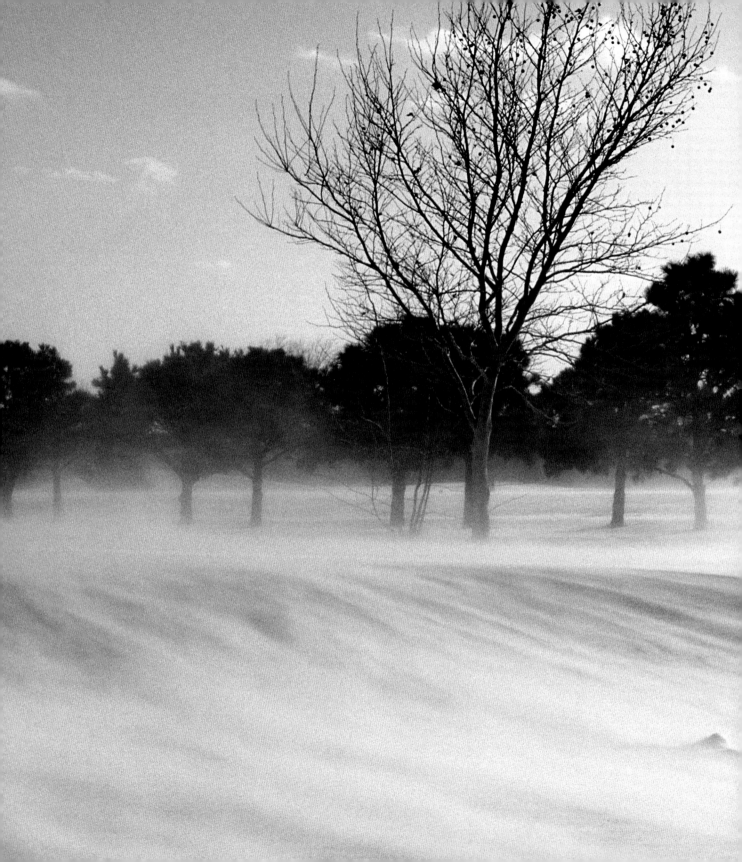

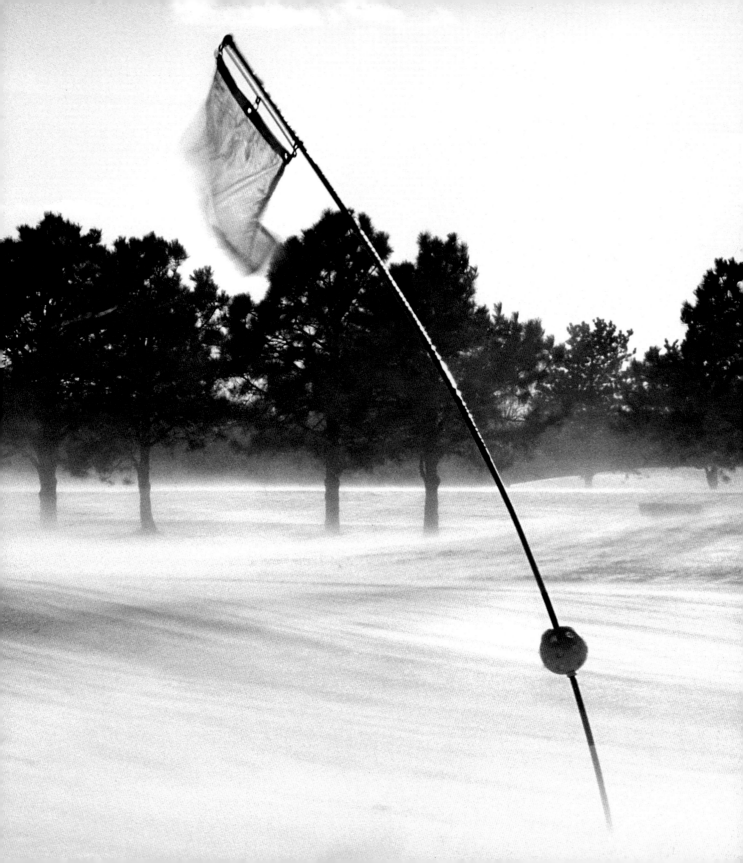

LEFT

Less than an hour after this photo was taken, an F-4 tornado developed from this supercell thunderstorm, striking Hoisington, Kansas, on April 21, 2001.

OVERLEAF LEFT

An unmarked Kansas state trooper throws his car into reverse to escape the path of a tornado near Pretty Prairie, Kansas, on April 11, 2002. It was the first Kansas twister of the season.

OVERLEAF RIGHT

A tornado develops at twilight near Trinidad, Colorado, on May 28, 2001.

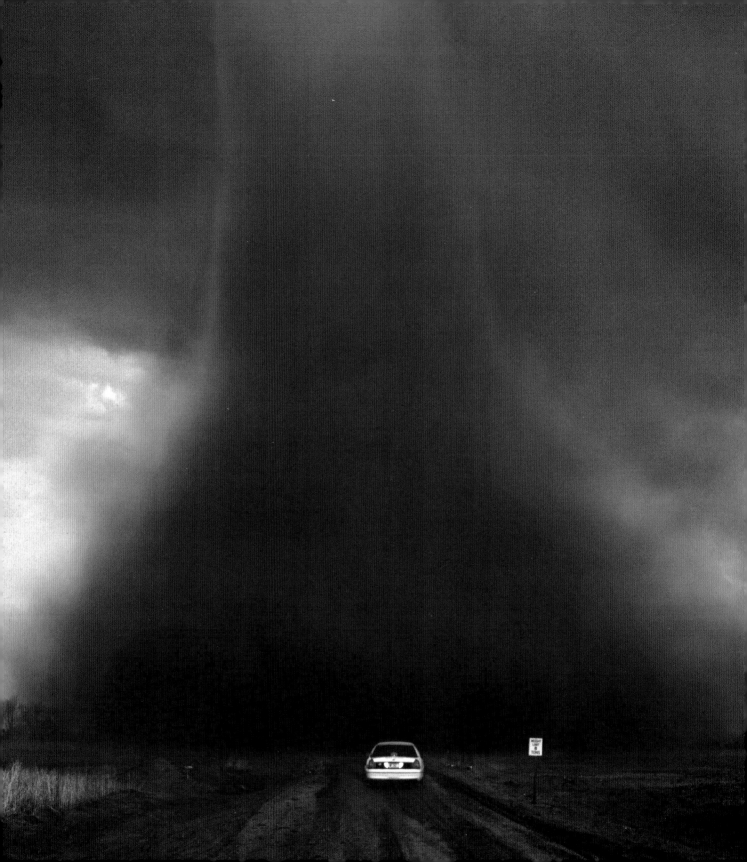

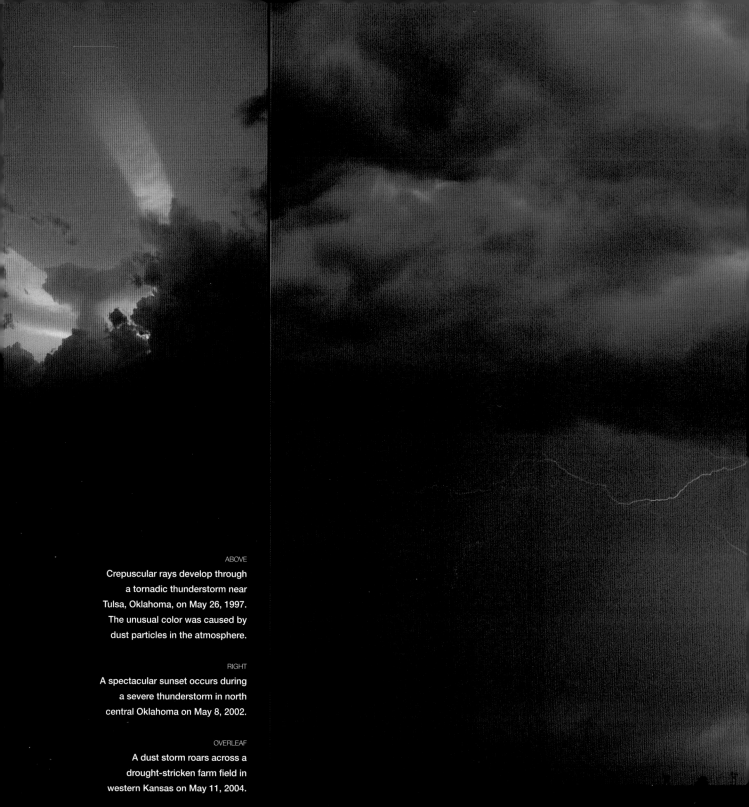

ABOVE
Crepuscular rays develop through
a tornadic thunderstorm near
Tulsa, Oklahoma, on May 26, 1997.
The unusual color was caused by
dust particles in the atmosphere.

RIGHT
A spectacular sunset occurs during
a severe thunderstorm in north
central Oklahoma on May 8, 2002.

OVERLEAF
A dust storm roars across a
drought-stricken farm field in
western Kansas on May 11, 2004.

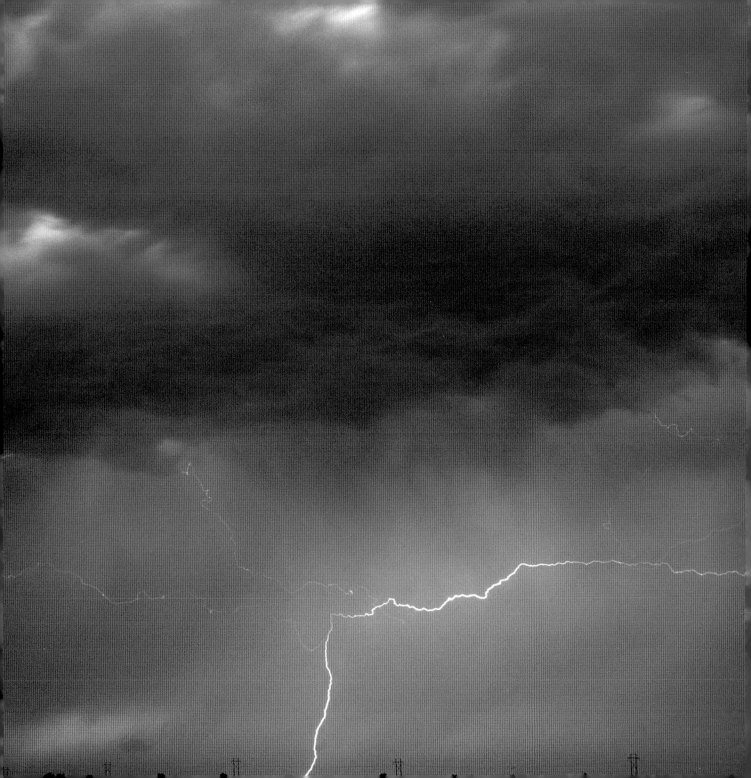

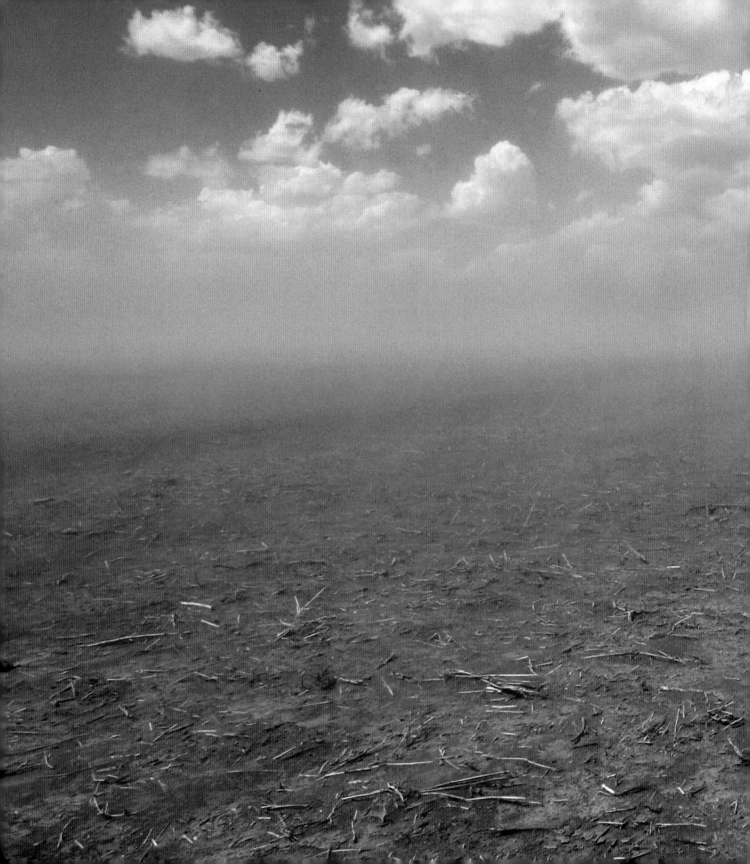

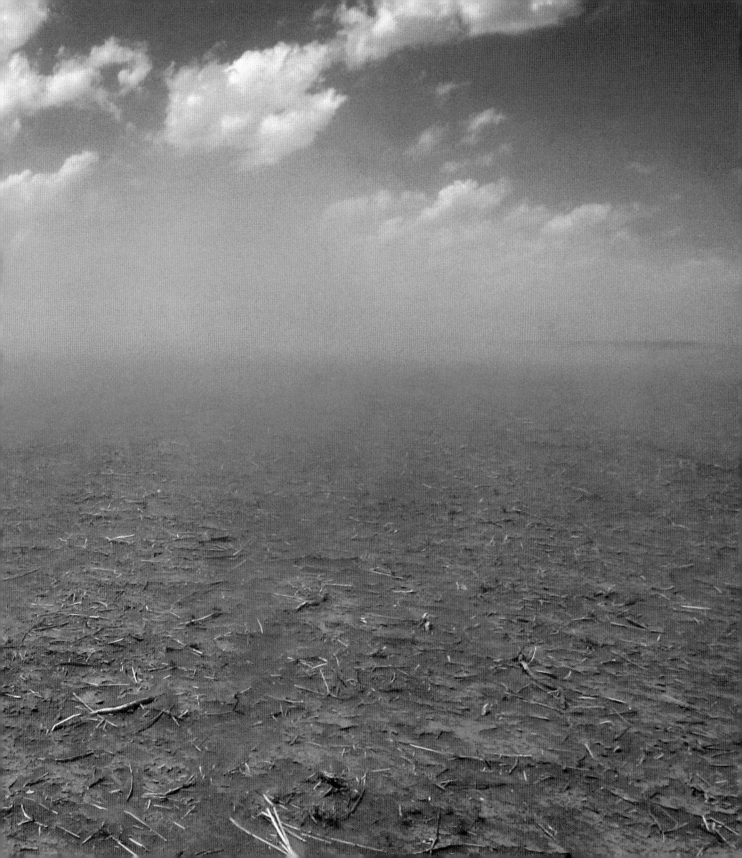

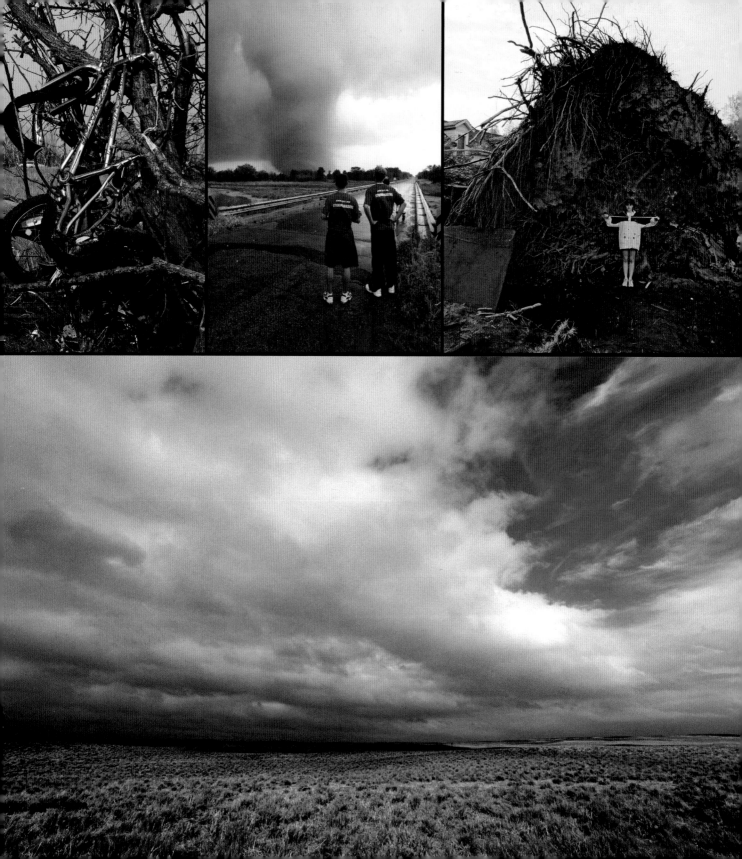

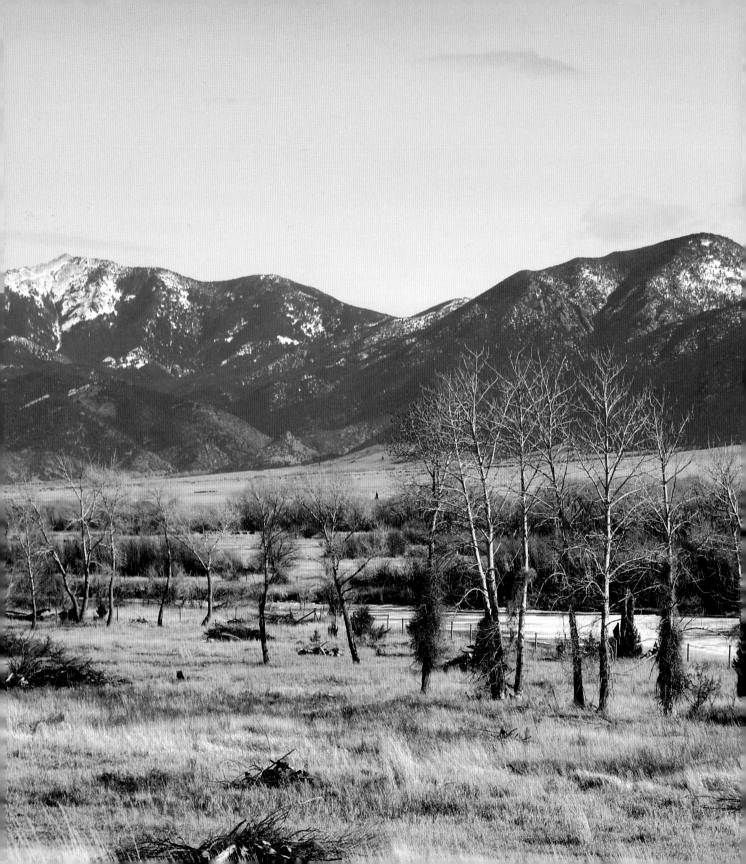

Where's the snow? Record-high
temperatures replaced snowfall
in Montana during the winter of
2005–06. The January through
September period in 2006 was
the warmest ever recorded in
the state.

ABOVE
Drought conditions in eastern
Montana in July 2004.

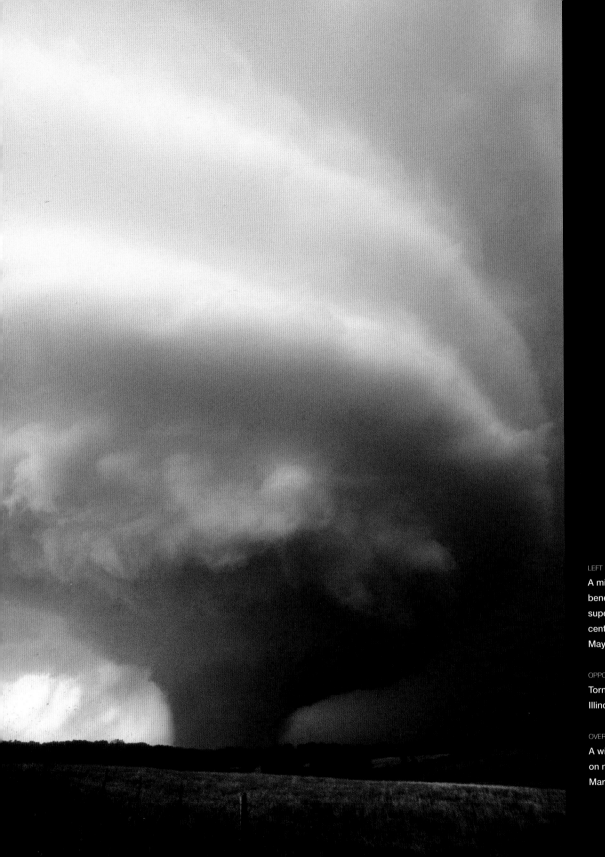

LEFT

A mile-wide tornado strikes
beneath a picturesque striated
supercell thunderstorm in north-
central Kansas on
May 29, 2004.

OPPOSITE

Tornado damage in Springfield,
Illinois, in March 2006.

OVERLEAF

A winter storm bears down
on northwest Wyoming on
March 4, 2006.

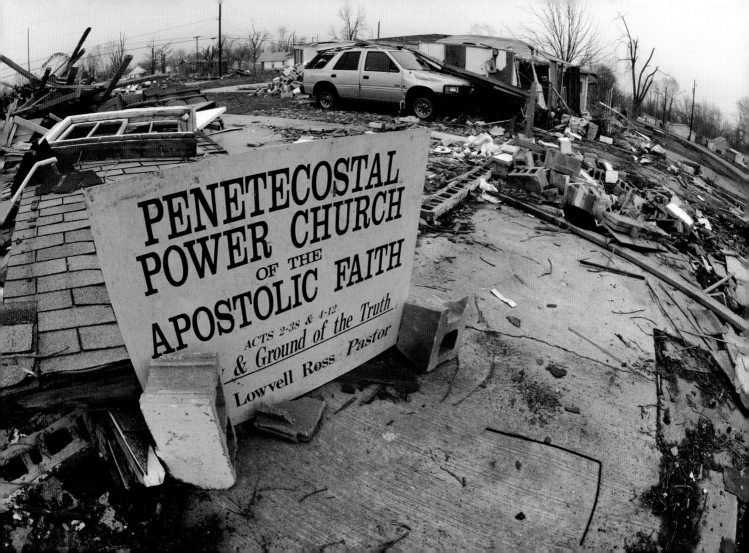

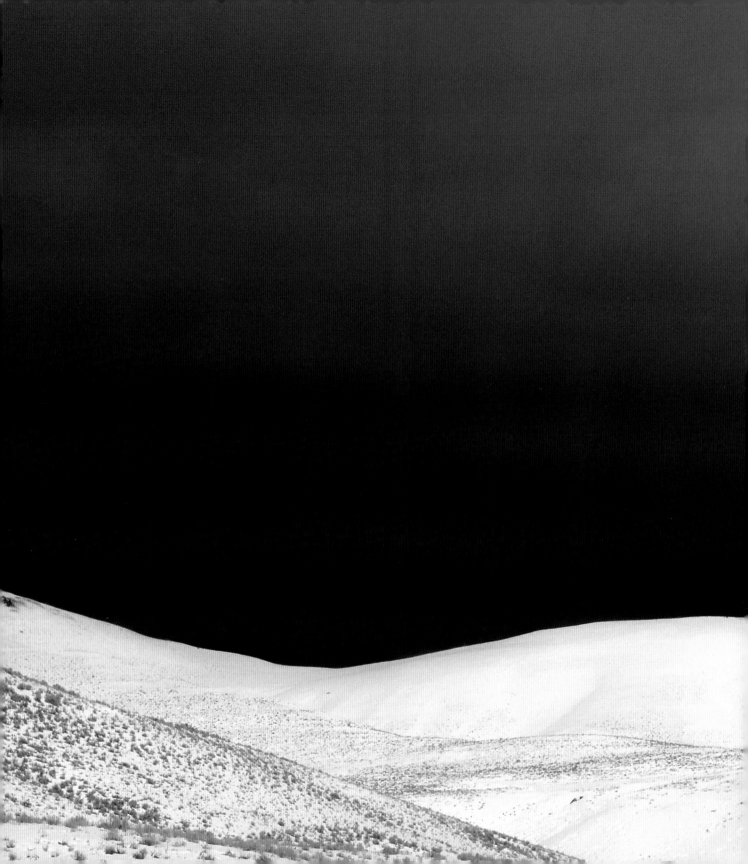

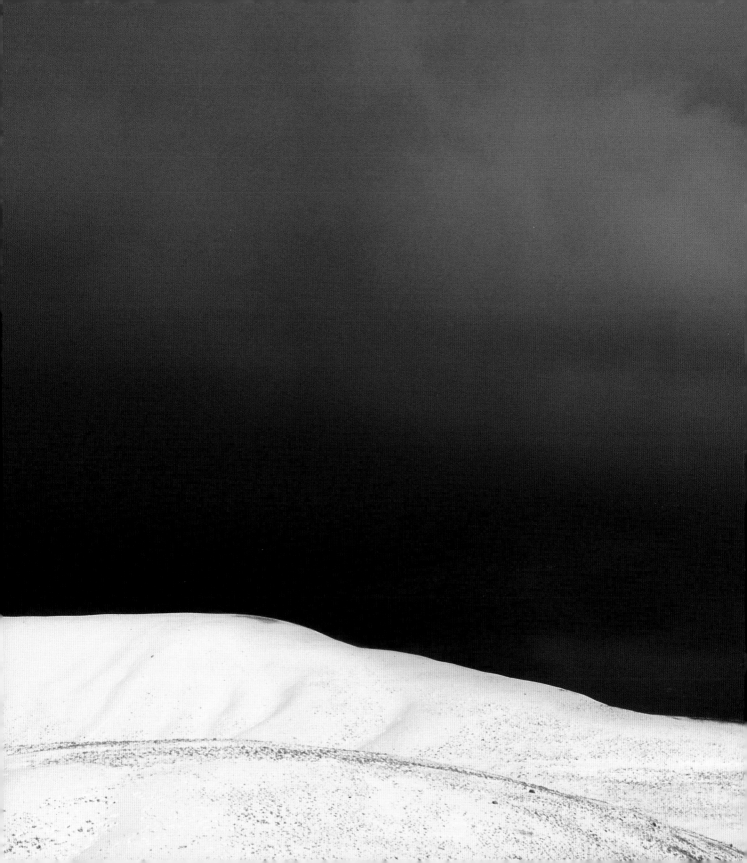

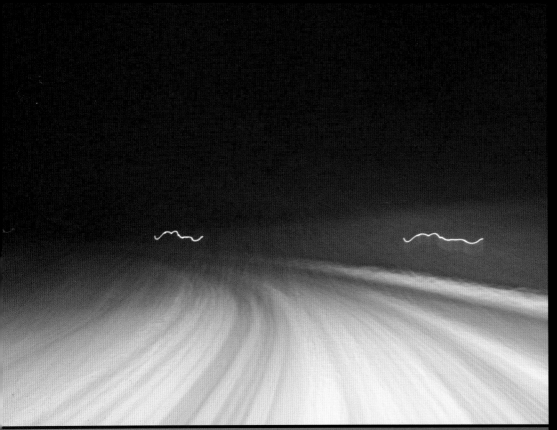

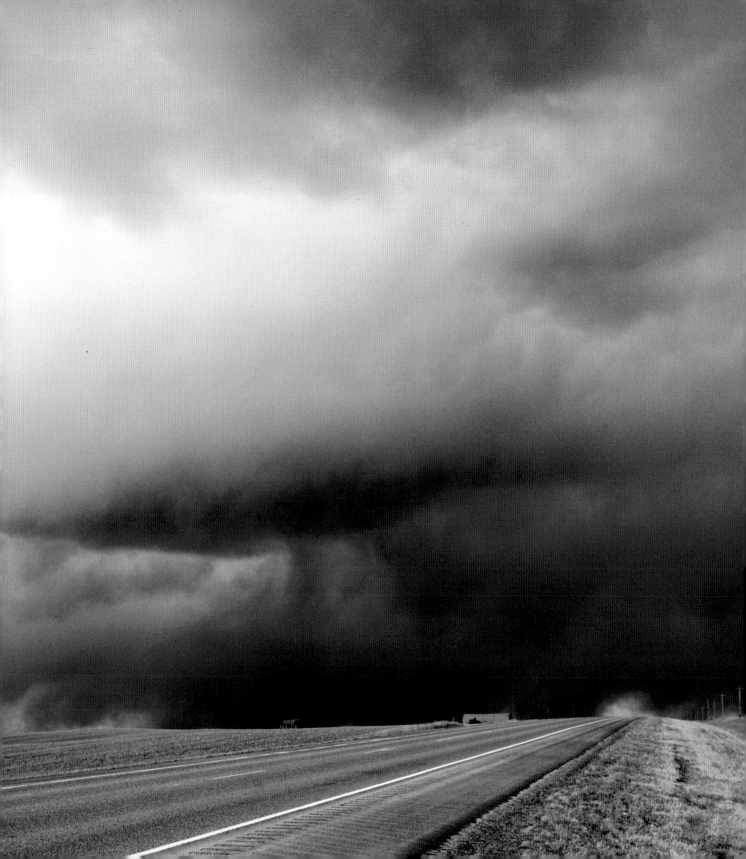

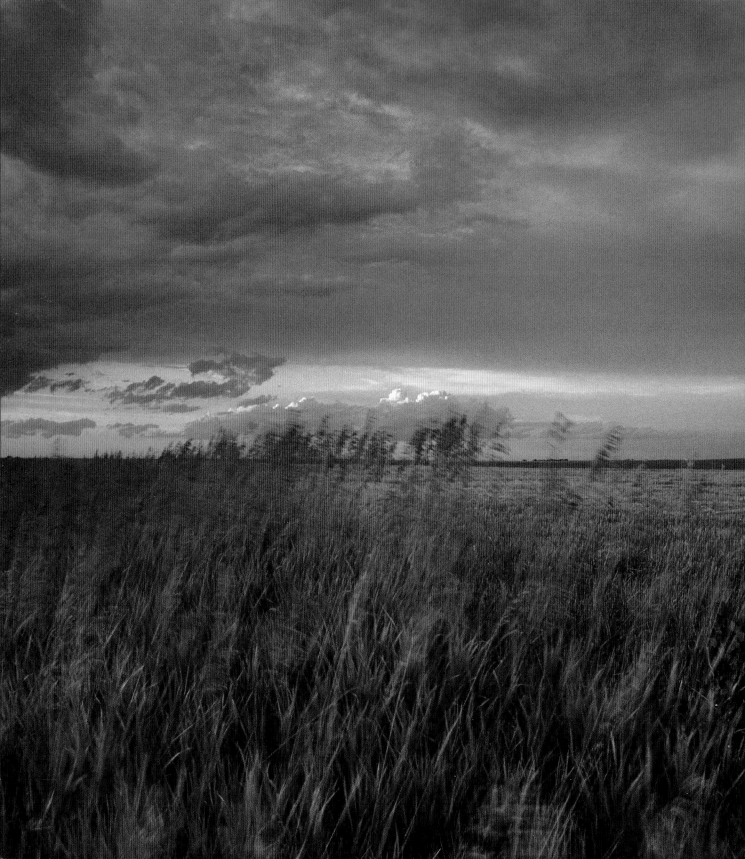

*In all things
of nature
there is something
of the marvelous.*

—Aristotle

Storm clouds paint the
sky over a Kansas wheat
field on July 23, 1995.

For many people, summer represents the end of the school year and time for vacations. To a storm chaser it means photogenic supercells and the official start of the Atlantic hurricane season. The summer months also tend to yield an increase in one of nature's most notorious threats: lightning. I consider cloud-to-ground lightning bolts one of the greatest threats to storm chasers.

Regrettably, the number of people injured or killed in the US by lightning each summer is rising.

"People are ignoring the common warning signs of thunderstorms or failing to get to a safe place when thunderstorms threaten," says John Jensenius, a lightning safety expert at NOAA. During the past fifteen years, I myself have had lightning strike within one hundred yards of me on seven occasions.

Despite the danger of Zeus, I find summer to be one of the best seasons for capturing atmospheric portraits. Storms are slower moving, and the hues of the sky tend to be livelier. Dust in drought-stricken areas is frequently vacuumed up into the sky by a thunderstorm's updraft, or blown outward beneath a downdraft. This can result in glorious sunsets with colors so rich they look as if a celestial hand has tinted the sky.

As an artist, I search for storms that yield rich, striking colors, strong contrasts, graphically interesting shapes, peculiar textures, and well-balanced light. Such a storm occurred on July 25, 1995, in Butler County, Kansas. The warm golden colors of the setting sun, combined with a hint of twilight and a striated shelf cloud on the front edge of the storm, were stunning.

June 5 has frequently been a lucky day for me as a storm chaser, and June 5, 1996, was no exception. Storm chasers Jon Davies, Aaron Blaser, and I intercepted an explosive supercell near Nortonville, Kansas. The large rotating storm resembled a flying saucer about to touch down. As locals descended into cellars, I jockeyed for a good spot to document the picturesque cell. Around us, tornado sirens wailed and thunder shook the land. One of the greatest challenges during that chase, however, wasn't lightning. It was me struggling not to sneeze.

I was suffering from a horrific summer cold. Jon, who was also sick, and I were both heavily medicated. If Aaron hadn't agreed to do all the driving that day, I would have missed the storm.

On June 12, 1997, I photographed a rotating storm at twilight in south central Kansas. Just as I nudged the shutter button, a bolt of lightning struck the ground beneath the updraft. It was an awe-inspiring sight. The slow-moving system unfortunately sparked significant flash flooding in Wichita. My work as a photojournalist abruptly changed to that of a rescuer.

While en route to shoot the flood, I bumped into Jon Davies, who was also documenting the storm. To improve our chances of covering the flash flooding safely, Jon climbed into my Explorer and we promptly joined forces. The safety limit I had set for myself in driving through flooded roads was nineteen inches. That's deep, but I knew from experience that if I drove slowly, my vehicle could take it.

Most drivers go too fast when attempting to cross flooded streets. This was the case with a young woman who had sped through an intersection only to have her engine

stall and her sports car swallowed by water. Waving her arms, she screamed for Jon and me to stop, which we did.

"Please! Please! Take my baby!" she cried, her car now bouncing up and down and beginning to float away. Jon instantly climbed out of our truck and sloshed over to the doomed car where she held out her toddler. I remained inside the Explorer to radio for help. The next thing I knew, the back door was closing. I turned, radio mic still clutched in my hand. Seated in the center of the backseat was a little boy, probably no more than two. We exchanged a look of alarm. He wasn't crying, but I could tell he was afraid.

"We're going to be okay," I said. Then it occurred to me: that's what my mother had said to me in the outer bands of Hurricane Camille nearly thirty years ago.

That night I studied the transparency of the preflooding storm and the lightning bolt I had taken less than an hour before rescuing the young woman and her son. The longer-than-usual exposure, combined with the storm's rotation, gave the after-dark cumulonimbus clouds a surreal brushed look. "It looks like a face," suggested a colleague, who titled the image "Skull & Lightning." It was one of my earliest and most authentic atmospheric portraits. The image left me craving for yet more color.

My seven-year quest to photograph an exceptionally vibrant double rainbow at close range was realized during the summer season of 1998. Ironically, it came while trying to catch up to a tornado-warned supercell in Cowley County, Kansas. Normally, I aim to be in position before convection becomes a full-fledged severe storm, but on this day I had been running behind. Well, actually, I hadn't been running at all. Thanks to an injury suffered weeks before, my left ankle and foot were in a cast.

On June 8, I hobbled out of my Explorer and into a pouring rain, cast and all. With tornado sirens screeching away, I raised my Nikon SLR, adjusted polarization, and snapped away. The cast was ruined and had to be replaced, but the elusive phenomena had been worth the trouble and discomfort. I had found my pot of gold.

A few days later, Jon Davies and I bumped into each other again in a noteworthy thunderstorm. It was June 20 in central Kansas. Conditions were miserable. It was a record-setting 108 degrees, but the horizon at sunset was stunning. Thanks to drought conditions, the atmosphere was full of particles. Striking the impurities at just the optimum angle, the setting sun turned the backside of a line of severe storms into a neon pumpkin-colored tapestry.

The next month, I turned my focus once again toward tropical cyclones. I had documented Category 3 Hurricane Fran the year before, but walked away without any memorable photography. Simply put, hurricanes are generally an ugly subject—socially and photographically; these fiends are frequently mean-spirited and monochromatic. Strong contrast? Nope. Interesting shapes? Hardly. Peculiar textures? Too difficult to observe. Well-balanced lighting? Forget it. After Hurricane Fran, I was determined more than ever to capture a hurricane in an artful style.

On August 26, 1998, nature provided me with a second chance when Hurricane Bonnie, almost a Category 3 cyclone, roared ashore near Wilmington, North Carolina. Although I shot a number of useful editorial and scientific images, once again I failed to capture the tropical cyclone artfully. Shooting a hurricane was like standing in the middle of a warm blizzard.

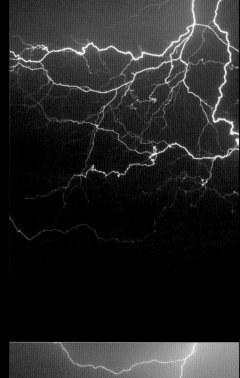

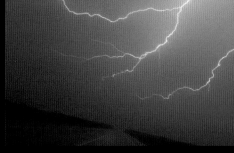

TOP
An electrical storm fires
over Gillette, Wyoming,
on June 15, 2003.

ABOVE
Lightning wriggles across
a highway in north central
Oklahoma on June 16, 2005.

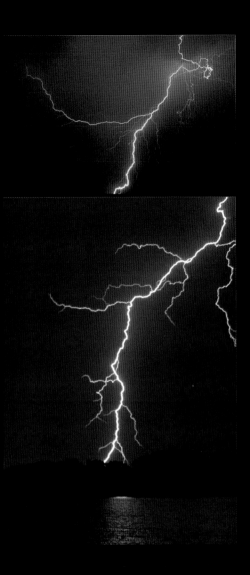

In August of the following year, I photographed menacing drought conditions in southwest Ohio. Record heat had continued, and it showed on the brutally hard land beneath my boots. Many areas looked more like the cracked landscape I had documented in Lake Powell, Utah. Lakes in Ohio were literally disappearing. Popular recreational sites had to be closed because there simply wasn't enough water for boating.

But not even the dearth of rain stopped tornadoes from forming in northwest Kansas on June 29, 2000. Meteorologist Michael Phelps and I had rendezvoused with a scientific research project called STEPS (Severe Thunderstorm Electrification and Precipitation Study). Shortly after the launch of a weather balloon, the mesocyclone we were tracking produced several picturesque tornadoes over rural farmland. It was the best type of storm: no one hurt, very picturesque, and slow moving. The supercell yielded one photo op after another, making it what I like to call "a four-lens day." Any storm chase that ends with me having used four or more different types of photographic lenses, from telephoto zooms to super-wide angles, is an extraordinary storm.

Kansas endured tornado watches several days in a row during the first week of June 2001, including several late-day threats. On June 3, storm chasers Katherine Bay, Tom Ensign, and I intercepted a rare midnight tornadic supercell not far from Wichita. The storm's structure was highlighted by frequent bursts of intracloud lightning, which allowed me to capture its shape, texture, and unique color.

The summers of 2001 and 2002 produced a variety of scenic, if not distinctive thunderstorms, but my longest and most bittersweet storm chase was yet to come.

On May 26, 2003, I lost one of my best friends. Her name was Vivian Armstrong. She was my grandmother, but for eighty-three years she had been more like a surrogate father, a sister, even a mentor. She was an artist and a devoted schoolteacher.

A few days after her funeral, the forecast called for tornadoes in Nebraska, but Katherine Bay and I were still in South Carolina, more than fifteen hundred miles away— and I hadn't flown since the in-flight thunderstorms of 1984.

On Sunday afternoon, June 8, Katherine and I hurriedly packed the Explorer and prepared to chase. We drove and drove and drove. More than fifteen hundred miles and just over twenty-four straight waking hours later, we rendezvoused in central Nebraska with other storm chasers, including Jon Davies.

The updated forecast required us to drive an additional one hundred and twenty miles north. Exhausted, I didn't think Katherine and I could go any farther. But Jon encouraged us. He would take the lead, and other storm chasers would follow to be sure we didn't fall asleep behind the wheel.

Less than two hours later, I watched as the sky dropped one of the most picturesque tornadoes I've ever seen. The white "elephant's trunk" twister shimmered in the late-day glow of sunlight over deserted farmland. Exhausted and weak, I could hardly stand, much less operate a camera. Still, the remarkable against-all-odds moment brought me a smile. It was a four-lens storm.

On June 22, 2003, my attention switched to global warming weirdness again. A supercell thunderstorm near Aurora, Nebraska, dropped hailstones the size of volleyballs. The icy boulders were so big they made craters in the ground. After weeks of scientific

TOP
Lightning bolts cut across a night sky over Kansas on July 20, 2000.

ABOVE
Lightning strikes near a lake and residential area in Wichita, Kansas, on May 21, 2006.

comparison, the National Weather Service determined the hailstones were the largest ever to fall in the US. Yet another "can the weather get any stranger?" record had been broken.

Next, Jon, Katherine, and I headed back up to South Dakota, where we intercepted a supercell the size of Rhode Island. The gargantuan cell produced multiple tornadoes. Just before dark I photographed two twisters on the ground at the very same time. By sunrise, fifty-four tornadoes had been reported throughout the state. It was the largest single outbreak of twisters in South Dakota history.

In 2004, June 5 was lucky for me once again—very lucky. That Saturday called for a chance of thunderstorms in the Wichita area, but nothing special. I had planned to take the day off and was visiting Jon. Around 4:00 P.M. he noticed a small, isolated storm on radar just northwest of Sedgwick County. I was several weeks into test-driving a handheld weather-tracking device called Storm Hawk for WeatherData, Inc. This was an excellent opportunity to do a spontaneous test and have a little fun, so out the door we went.

Using Storm Hawk, we intercepted the cell in less than an hour. At first all we could see was a gray curtain of rain, but then something magical happened. The storm moved ahead of the core of precipitation. We were suddenly observing a highly picturesque, striated, low-precipitation supercell. It was one of the most unusually shaped storms I had ever witnessed in all of my chasing.

Unfortunately, the lighting was flat and little color was present early on. But this storm would soon surprise us. Unlike the majority, which move northeast, this cell was moving due south—and the sky was clear to the west. Jon and I traded a look and smiled. If we could stay with the storm, the sun would eventually set directly behind it. That might give us some color, certainly better lighting.

In the meantime, we shot a few pictures, drove a few miles, stopped again, shot more frames, and gradually made our way south, patrolling the storm. Sunset was less than an hour away and our anticipation was mounting. One more shot, I thought, and then we'll blaze south and get out ahead of the mesocyclone.

I pulled off the rural farm road at a graveled intersection. Suddenly, the ground beneath my front right tire began sinking near the edge of a culvert. I instantly yanked us into reverse and floored it, but it was futile. The rear of the vehicle went up, and the front went down. The side of the road, softened by rain earlier in the week, had collapsed. We were stuck! With the storm continuing to move south, we would be out of position for the sunset. Our chase was over . . . or was it?

"When the solution is simple, God is answering," Albert Einstein once said.

On June 5, 2004, God answered.

From seemingly out of nowhere, two vanloads of meteorology students from my home state of Illinois suddenly pulled up. Paul Sirvatka, a professor of meteorology at the College of DuPage, had recognized our dilemma. Without even asking, more than a dozen young storm chasers piled out of the college vans and surrounded the front of my Explorer.

"All together!" hollered the oldest student. "Three . . . two . . . one . . . lift!" And suddenly, as fast as Jon and I had become stuck—we were free!

As we sped south, the sun began to set. We had less than fifteen minutes, but that's all it took. We pulled over, jumped out, and—while dodging hailstones the size of golf balls—set up our tripods. The view was spectacular. A rare, rain-free, isolated, saucer-

A storm chaser listens to
a weather report while patiently
waiting for storms
to fire in northern Kansas on

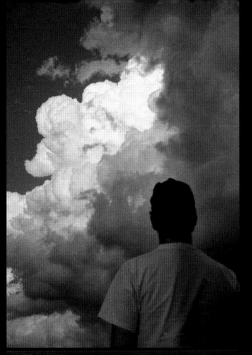

shaped supercell backlit by the setting sun. CLICK. CLICK. On the second squeeze of my shutter, a lone, magenta-colored lightning bolt dropped from the storm. It was what William Least Heat-Moon would have called, "a raw scorch of lightning." It was what I called a blessing.

The image represents everything I love about storm chasing: following a hunch, travel, science, friendship, fellowship, second chances, serendipity, technology, art, and atmospheric magic.

The captured photo is the cover of this book.

One week later, the summer of 2004 became truly surreal.

The forecast for June 12 called for severe thunderstorms, including possible tornadoes, in the Wichita area. In between monitoring hourly conditions and packing our vehicle, I learned that open auditions were being held at a local mall for an upcoming reality show based on none other than my favorite childhood sitcom, *Gilligan's Island*. Actress Dawn Wells, who played Mary Ann, would make a personal appearance.

Since storms weren't expected until late afternoon, I raced over to the mall. After shooting a few stills for Corbis of the auditions, I was introduced to Ms. Wells. She couldn't have been nicer. When Dawn learned I was a real-life storm chaser, she couldn't stop asking questions about tornadoes. Suddenly, my cell phone chirped. It was Jon informing me that a tornado watch had been issued and that we'd better head out.

Understandably, Mary Ann's questions quickly switched from the subject of storm chasing to the subject of getting out of Wichita. I briefed the producers on the developing weather situation and headed off to work.

"Wait!" said Ms. Wells. "We have to take a photo together."

CLICK. We traded business cards and a hug and I was out the door.

Minutes later, Jon and I were on our way to the developing storm. To commemorate my rendezvous with Ms. Wells, Jon played a CD, which happened to feature the *Gilligan's Island* theme song.

"The weather started getting rough, the tiny ship was tossed," went the song. Well, we weren't in a ship, but the weather did start getting rough. Less than two hours after my visit with Dawn Wells, Jon and I documented five tornadoes in south central Kansas. Once again, Hollywood and weather had combined in my increasingly surreal life.

Having nearly overdosed on surrealism and irony, I decided to head up to southern Montana to camp in the wilderness and do further tests with Storm Hawk. Katherine Bay joined me for the two-week sojourn. It was just what the doctor ordered: clean air, full moon, deer, bear, and a couple of harmless t-storms.

While we were picking up supplies in Ashland, thirty miles from our camp, a local Indian woman invited us to attend the Northern Cheyenne Indian annual Fourth of July powwow. We eagerly and happily accepted, but upon arriving, we were faced with two bewildering surprises: 1) We were the only Caucasians present, and 2) dark storm clouds literally followed us into the reservation. The dancing began on schedule, but most eyes were on the sky . . . and us. Rain was clearly moving in, but how much and for how long?

Overhearing a discussion of whether or not to call off the powwow, I scurried back to my truck and fired up Storm Hawk. The Doppler radar image on the device indicated

TOP

Storm chaser Aaron Blaser eyes the sky from Coronado Heights, Kansas, on October 6, 1994.

ABOVE

Research meteorologist Jon Davies (left) and pilot Dan Lane document a severe thunderstorm at sunset during a record-setting 108-degree temperature in central Kansas on June 20, 1998.

hat, despite the menacing look to the clouds, it would be a brief shower. I relayed this information to one of the Indian security officers. Sure enough, it rained for about five minutes, then stopped. The powwow joyously continued and, before I knew it, I was seated next to Chief Spotted Eagle, spiritual leader of the Northern Cheyenne tribe.

"What's it doing now?" he kept asking me, leaning over to look at the handheld radar.

"It's still clear," I offered, reassuringly pointing to the screen.

"Then you should dance," he said.

Katherine and I traded a look, our eyes going wide as half-dollars. Now, I'm no expert on the Northern Cheyenne tribe, but I knew enough about Native American culture to know this was an honor. They wrapped us in a handmade blanket to shield us against the chilly night air, and then Katherine and I moved onto the dance floor. The beating of the drums and my heart increased. It was a remarkable moment of pride, humility, and spiritual growth.

I was going to need that inspiring memory in the days ahead.

During the first fifteen years of my photographic project, I logged 329 "on-the-clock" storm chases. I am happy to report that I have only experienced two honest-to-God "near-death" experiences. Both were during a hurricane. And both were during the month of August.

On August 12, 2004, meteorologist Greg Zamarripa and I rendezvoused in Tampa, Florida, in preparation for documenting the landfall of Hurricane Charley. The National Hurricane Center forecast called for the tropical cyclone to make landfall in the Tampa Bay area as a Category 2 storm.

With the exception of testing the newest version of WeatherData's Storm Hawk, this hurricane mission had almost a business-as-usual feel to it. Between the two of us, Greg and I had documented twelve prior hurricanes. On early Friday morning, I was more concerned about finding a place open for breakfast than worrying about meteorological surprises. But this was Friday the thirteenth.

Research meteorologist Jon Davies soon called. He was monitoring the storm from his weather lab in Wichita, Kansas. Jon suggested we abandon Tampa and head south in the general direction of Punta Gorda. He felt Charley was showing signs of wobbling and might be changing directions.

Greg and I headed south. Our two-part goal was fairly simple: 1) Shoot the effects of Category 2 hurricane winds on coconut palm trees; and 2) if we could safely do so, penetrate the eye of the hurricane and record our position using Storm Hawk.

Less than an hour into our drive, Katherine Bay called to inform us that the hurricane had been upgraded to a Category 3. She was watching radar from our weather lab in Columbia, South Carolina.

As we approached Port Charlotte County, the sky was gray and appeared less threatening than an Oklahoma thunderstorm. Winds were light and it was only sprinkling. But something was wrong. People were dashing to their cars and speeding away. Convenience stores were scrambling to shut their doors. A few local businesses struggled to cover windows with plywood.

My cell rang again. Jon called to tell us Charley was now an extremely dangerous Category 4 storm and headed straight for us. The mood in our vehicle changed abruptly. Neither Greg nor I had ever been in a Category 4 hurricane

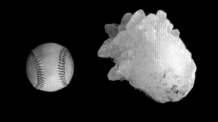

TOP

This volleyball-size hailstone plummeted from the sky in Aurora, Nebraska, on June 22, 2003. The piece of ice measured six-and-a-half inches across and seventeen-and-three-eighths inches in circumference, making it one of the largest hailstones ever recorded in the United States.

ABOVE

Hailstones, nearly three times larger than the size of a baseball, fell from the sky in Aurora, Nebraska, on June 22, 2003.

Greg and I selected a shelter next to what we determined were two well-built brick buildings and marked it on the map. Until winds reached seventy-five miles per hour, we continued to drive around the community and document the approaching hurricane.

I was photographing coconut palm trees from our vehicle in a residential neighborhood when Jon called again. He warned us that we would likely be in the path of the northeast quadrant of the hurricane's eye wall—typically the most vicious segment of a tropical cyclone. Outside the vehicle, winds whipped around at sixty-five miles per hour.

All of a sudden, a gust of one hundred miles per hour wind blasted through the neighborhood, splintering roofs and breaking windows. Our vehicle was hit by flying debris, damaging the driver's door and roof-mounted antennas. In a matter of seconds, another gust, and then another. As the video camera rolled, our voices changed from reasonable calm to—*holy fuck!* Charley was on the verge of becoming a Category 5 hurricane and we were not going to make it back to our original shelter.

In between the torrents of wind, we managed to maneuver our vehicle into the driveway of an abandoned house, beneath a carport. Twenty seconds later, our street became a tempest of flying projectiles. Trees were yanked from the ground. Roofs ripped away from their homes. Greg and I were showered with severed wood, rubber, and glass. We were being hit dead on by the equivalent of a significant twister. The roar was earsplitting, more thunderous than even the jet engine sounds of Camille.

I struggled to keep the video camera raised and functioning. If I'm going to die, I thought, I want colleagues to know what happened.

"We're going to be okay," I reassured myself. But this was no Camille. Charley was an atomic bomb disguised as a hurricane.

As parts of the house began tearing apart, I quickly engineered a videotaped farewell to my mother and friends, a first for even yours truly. A few feet away, Greg was facedown on the concrete. Suddenly, my terror faded, replaced by a sense of tranquillity. I was about to die and that was okay.

A bright, excruciating white light swiftly appeared. I lifted my head and squinted. Behind a thin slice of cirrus clouds, I could see the perfect round shape of the sun. The roar had faded as quickly as if some supernatural DJ had turned down the volume on an atmospheric radio.

Greg and I gradually climbed to our feet and looked straight up into a broad, translucent white cylinder. We were in the eye of Hurricane Charley; the heart of a Category 4 demon. Dead calm. No wind whatsoever. You could have held a feather in the palm of your hand and it wouldn't have quivered.

After hollering for help and banging on doors, we were rescued by Jim McDonald and family. Just as they brought us into their makeshift tornado shelter, the hurricane's southern eye wall struck. The passage of the eye of this incredible storm had lasted no more than four long minutes and fifty seconds.

"I was in the Vietnam War and survived a plane crash, and Hurricane Charley was worse," McDonald told me. "If you guys hadn't found us, you'd be dead."

Greg had a punctured right knee, and I had a sprained left thumb and lump on my head. We were both bruised, scraped, and sullied—but we were alive.

Charley was the first Category 4 hurricane to make landfall in the United States since Hugo in 1989. It was also the most destructive tropical cyclone to impact America since Category 5 Hurricane Andrew in 1992.

Although I was nearly killed in Hurricane Charley, I felt compelled to get right back into the saddle. I wanted another hurricane as soon as possible. I was mystified. I was terrified. I was angry. And I made a pact with myself. If I successfully penetrated the eyes of all other US landfalling hurricanes in 2004, it would be nature's way of saying, "I'll never kill you."

Okay, I admit, I certainly wasn't thinking scientifically, but I was a changed man. No storm had ever stunned me so hauntingly. Besides, how many more hurricanes could possibly make landfall in 2004? One? Maybe two . . . ?

As luck would have it, four more hurricanes made landfall that year.

Before the 2004 season ended, I had penetrated the eyes of all four of the hurricanes: Category 1 Gaston, Category 2 Frances, Category 3 Ivan, and Category 3 Jeanne. Each time, I recorded our position in the eye using Storm Hawk. Though none were as shocking as Hurricane Charley, piercing the eyes of five consecutive hurricanes was an extraordinary lifetime passage for me—personally, scientifically, and photographically. During each and every storm I offered help where I could, providing first aid, storm spotting, and communication relays, frequently passing out water and food to nameless victims.

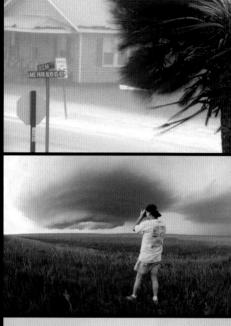

Fourteen hurricanes had passed through my life. However, capturing a fine art image during a hurricane continued to elude me.

According to the National Hurricane Center, the 2004 hurricane season was one of the deadliest and most costly. Three thousand one hundred and thirty-two people had lost their lives, with the storms resulting in at least $42 billion in damage. Ironically, it was the fifth latest start to a hurricane season since 1954. And it was the first time since 1886 that four hurricanes had hit the same state in the same season—Florida.

The summer of 2005 marked the fifteenth year of my photographic project. It was the season when the strange got stranger, and documenting the strangeness got, well, bizarre.

Storm chasers had just come away from May, which produced a record *low* number of tornadoes for Oklahoma. In fact, there weren't *any*. For the first time since official records began in 1950, no twisters were reported in the Sooner State.

On June 8, I suffered a freak accident while shooting during a National Geographic expedition. Mistimed communication with the driver of the chase vehicle resulted in the

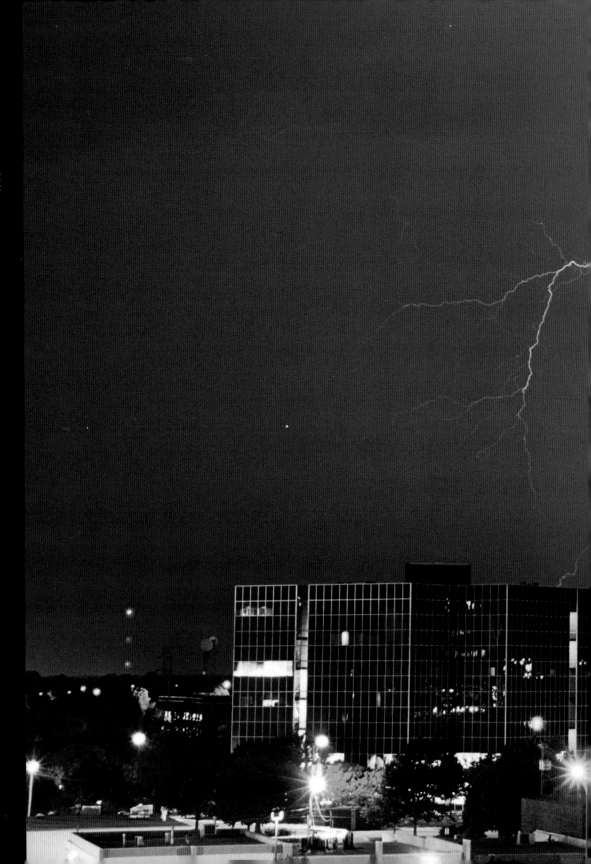

RIGHT

An electrical storm erupts over downtown Wichita, Kansas, on July 20, 2000.

OVERLEAF

A severe thunderstorm with striated shelf clouds strikes Butler County, Kansas, at sunset on July 25, 1995.

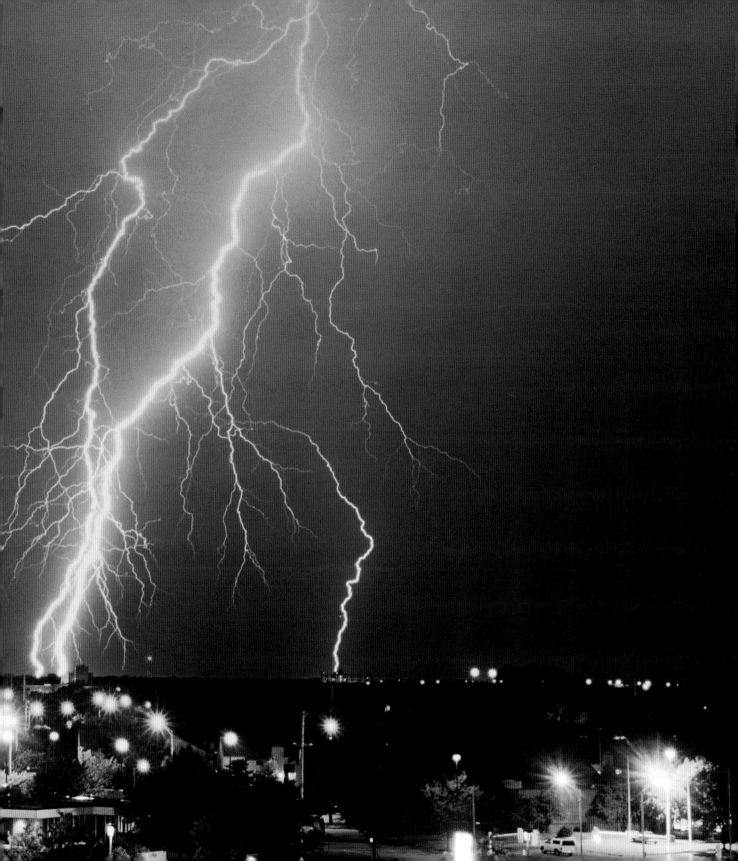

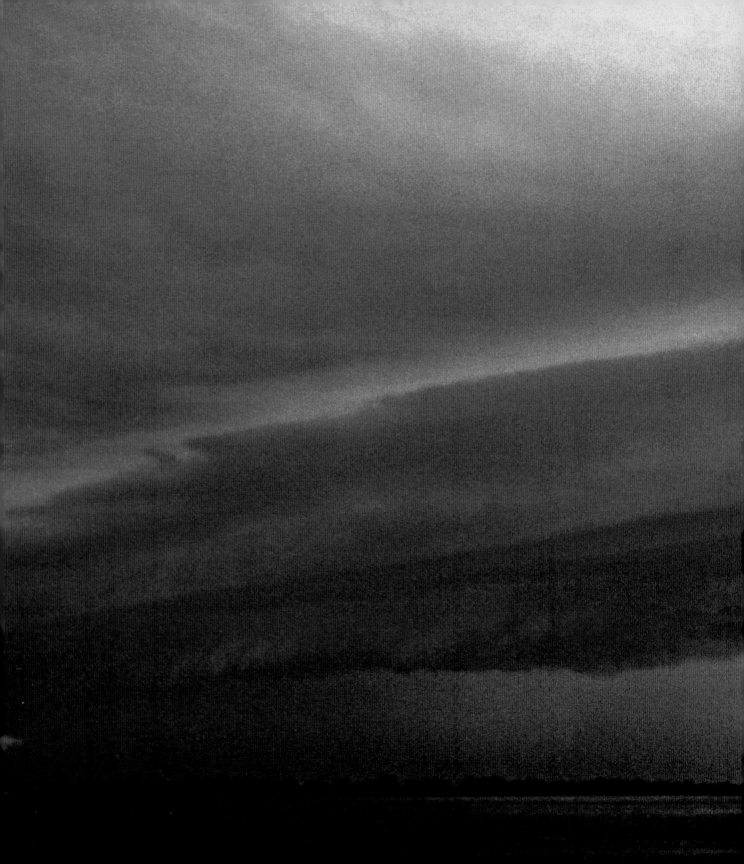

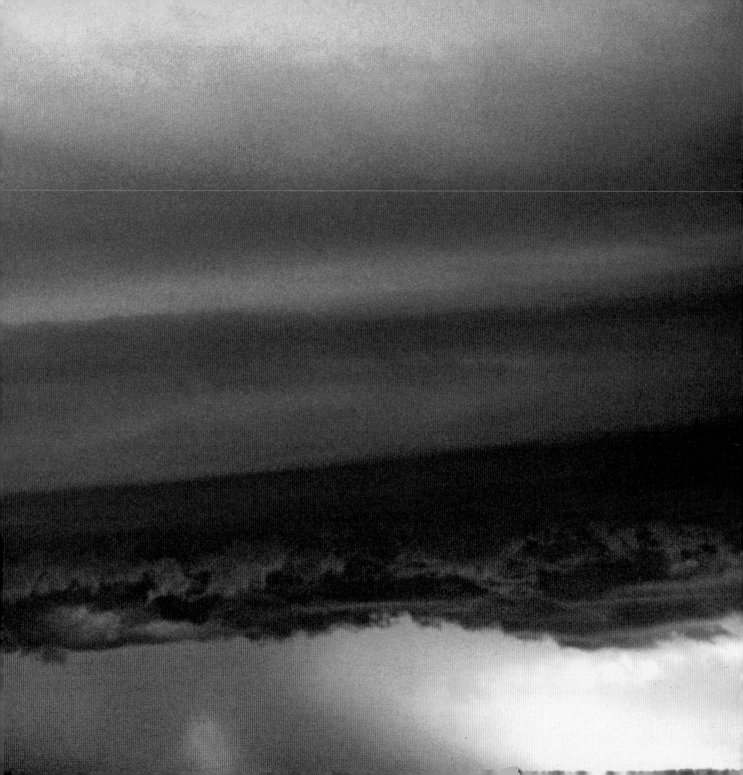

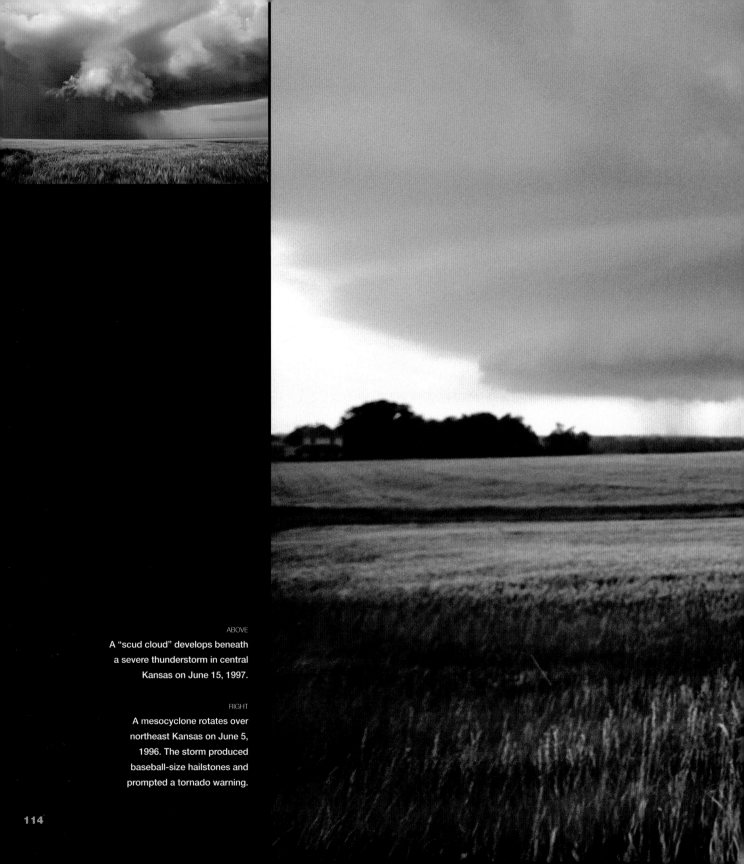

ABOVE

A "scud cloud" develops beneath
a severe thunderstorm in central
Kansas on June 15, 1997.

RIGHT

A mesocyclone rotates over
northeast Kansas on June 5,
1996. The storm produced
baseball-size hailstones and
prompted a tornado warning.

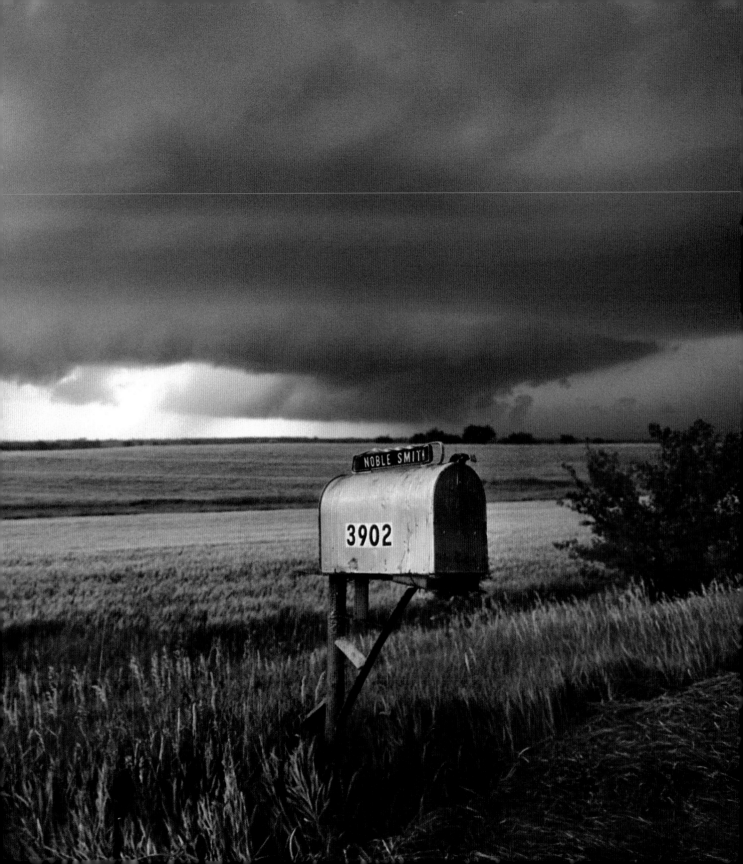

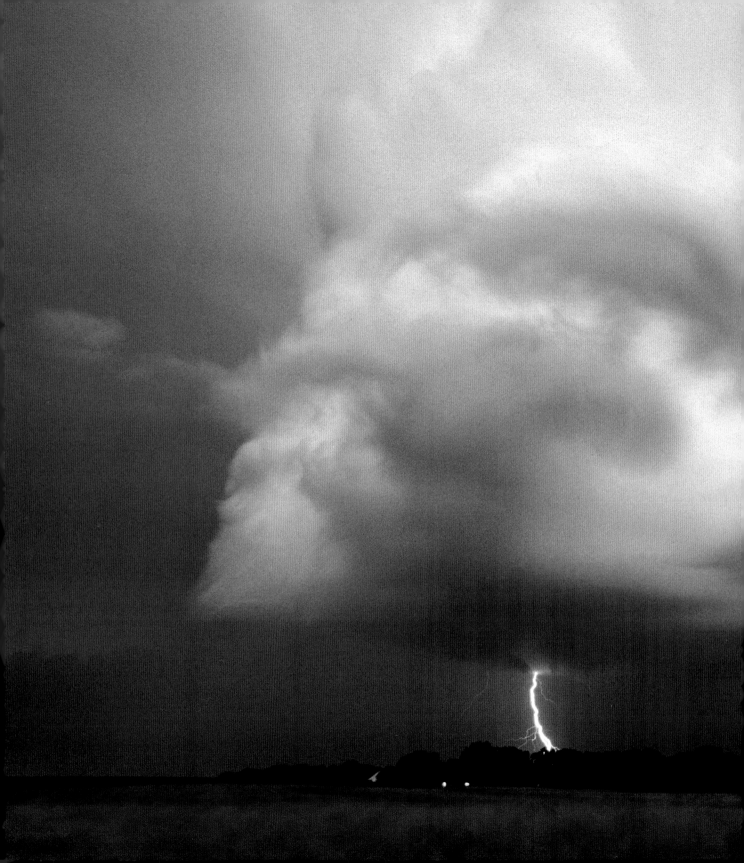

LEFT

Lightning drops beneath a rotating supercell thunderstorm during astronomical twilight in southern Kansas on June 12, 1997.

OVERLEAF

A vibrant double rainbow shimmers on the backside of a tornadic thunderstorm in Cowley County, Kansas, on June 8, 1998.

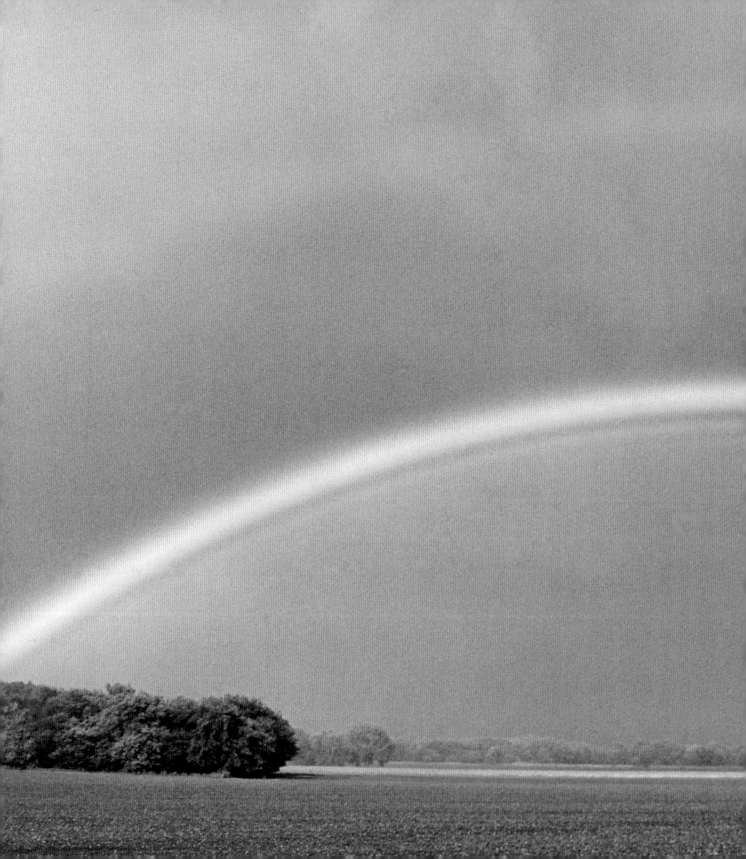

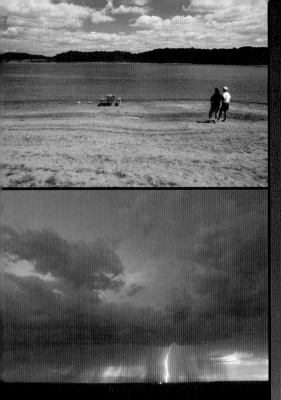

Residents of southwest Ohio
examine severe drought conditions
at a local lake on August 15, 1999.
The recreational area was closed
due to record-low water levels.

ABOVE

Lightning strikes at sunset during
a thunderstorm near Lemmon,
South Dakota, on June 27, 2001.

RIGHT

A severe thunderstorm and lightning
strike over southern Sedgwick
County, Kansas, on July 25, 1998.

OVERLEAF

A severe thunderstorm
develops over Kiowa County,
Kansas, on June 13, 2000.

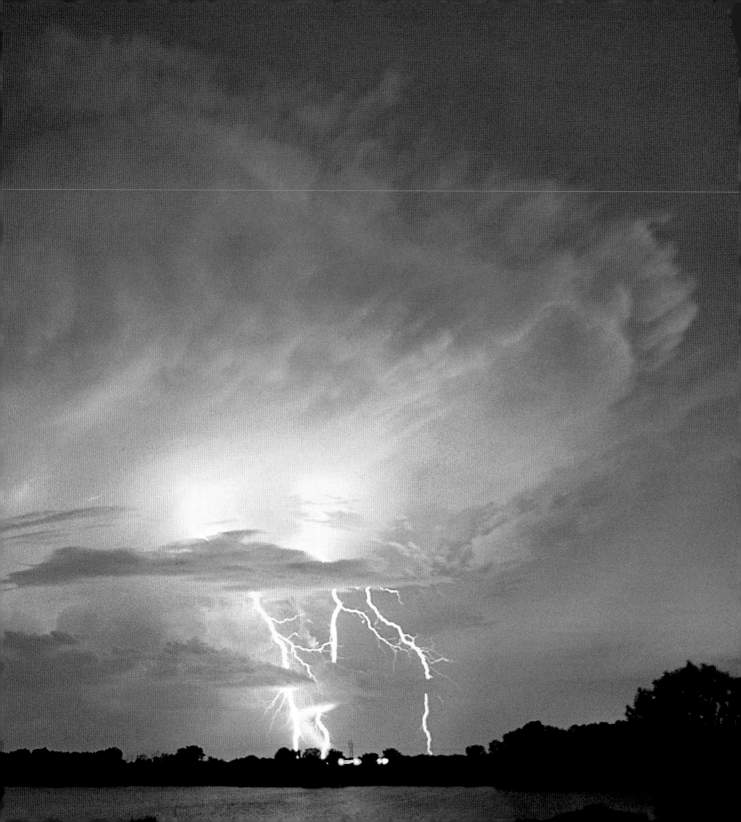

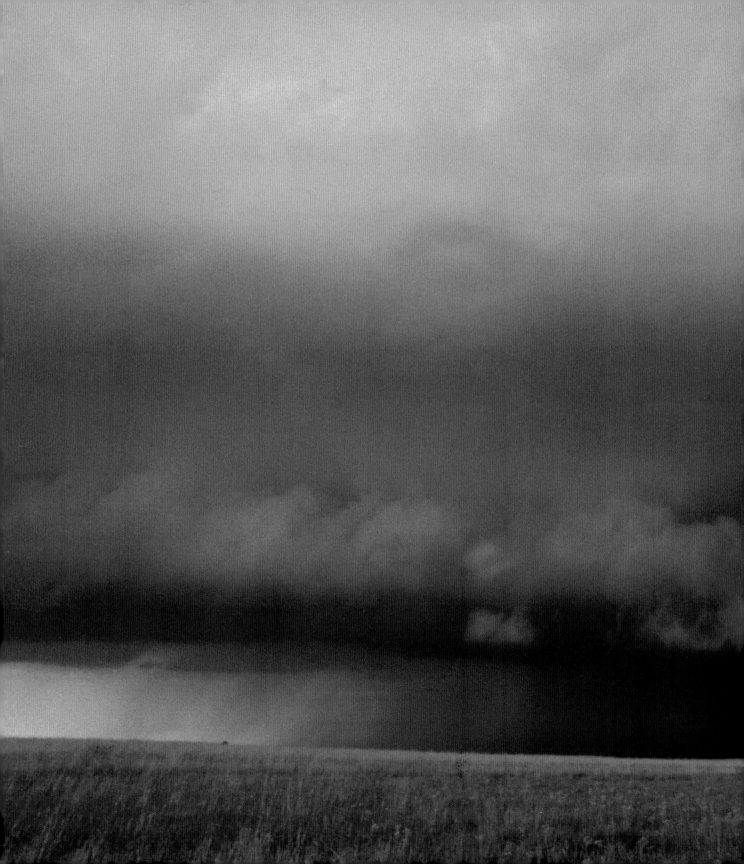

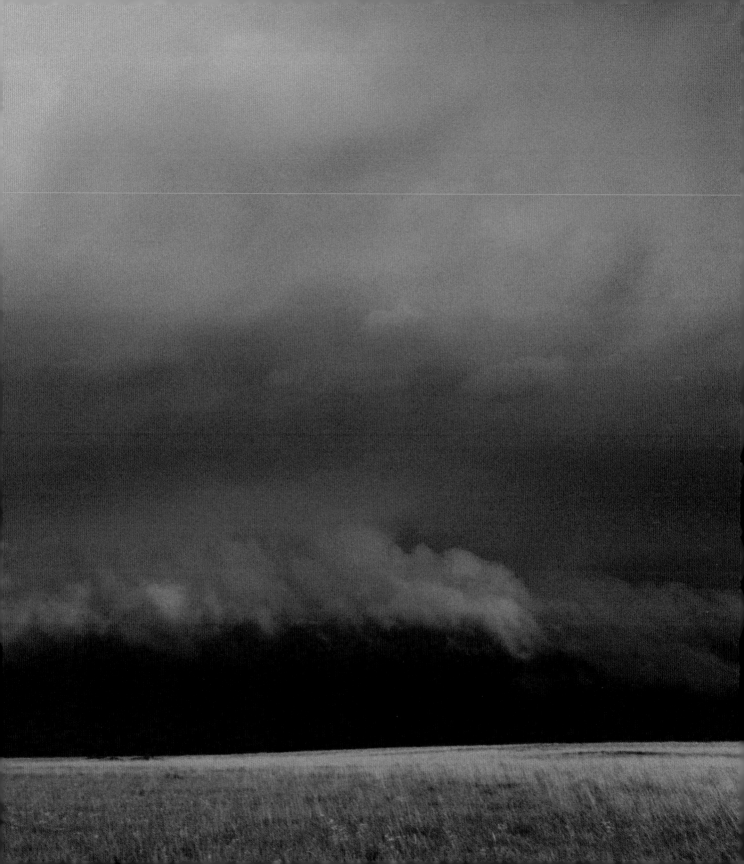

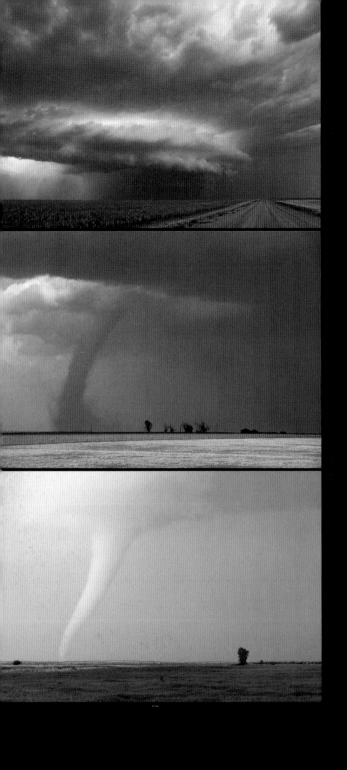

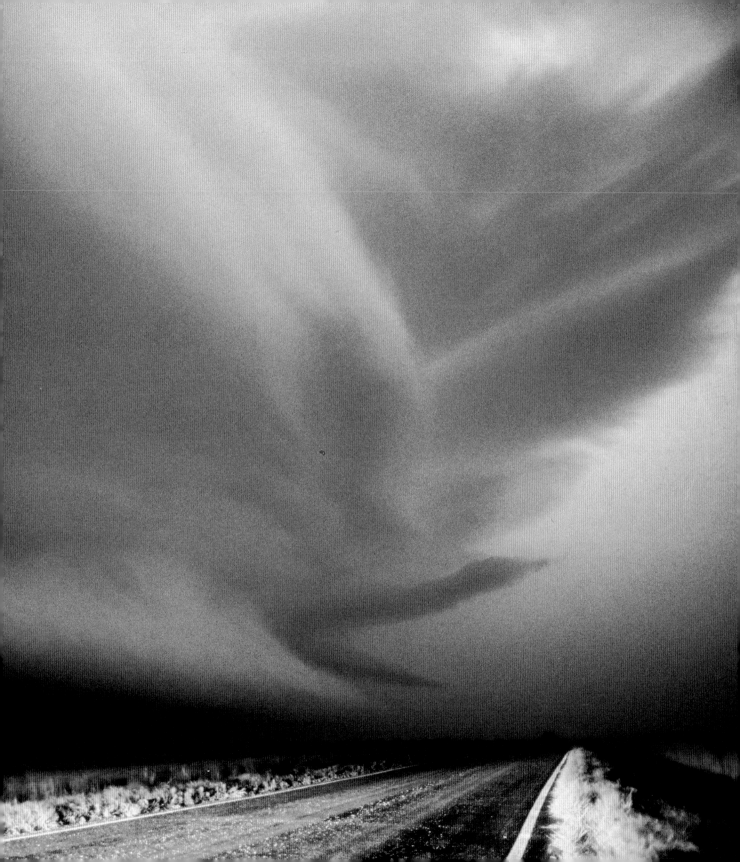

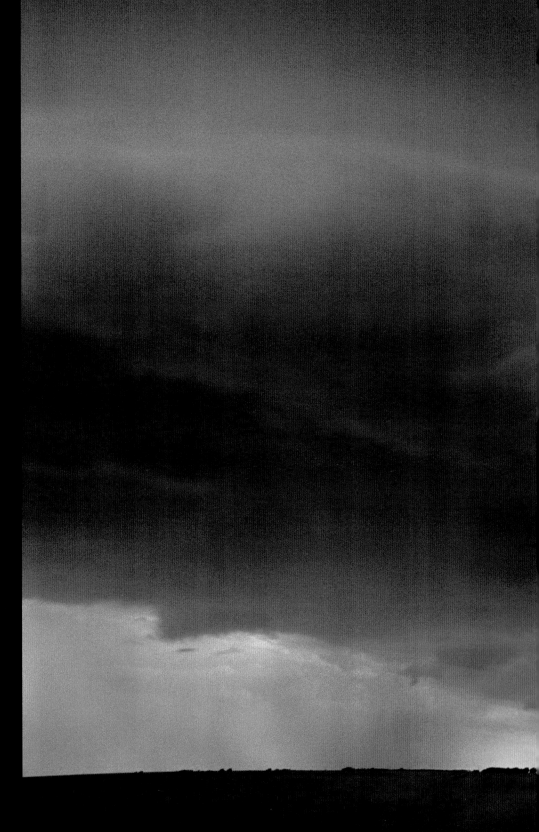

PAGE 124 TOP
A supercell thunderstorm
sweeps across Thomas County,
Kansas, on June 29, 2000.

PAGE 124 CENTER
A tornado swirls across
Cheyenne County, Kansas,
on June 29, 2000.

PAGE 124 BOTTOM
An "elephant's trunk" tornado
spins across northern Nebraska
on June 9, 2003. This photo
was taken less than two
hours after driving 1,614
miles from South Carolina in
an attempt to intercept the
Midwest storm system.

PAGES 124–125
A rare "after dark" image
of a tornadic supercell
threatening central Kansas
on June 3, 2001. Illumination
of the storm is the result of
intracloud lightning bolts.

RIGHT
A lone lightning bolt strikes the
ground beneath an isolated
supercell thunderstorm at
sunset near Medicine Lodge,
Kansas, on June 5, 2004.

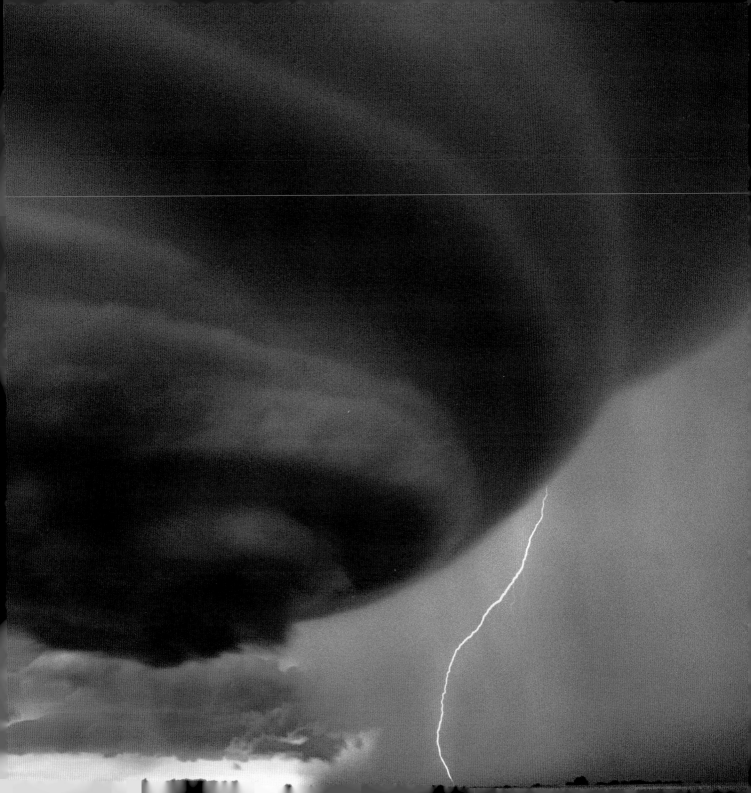

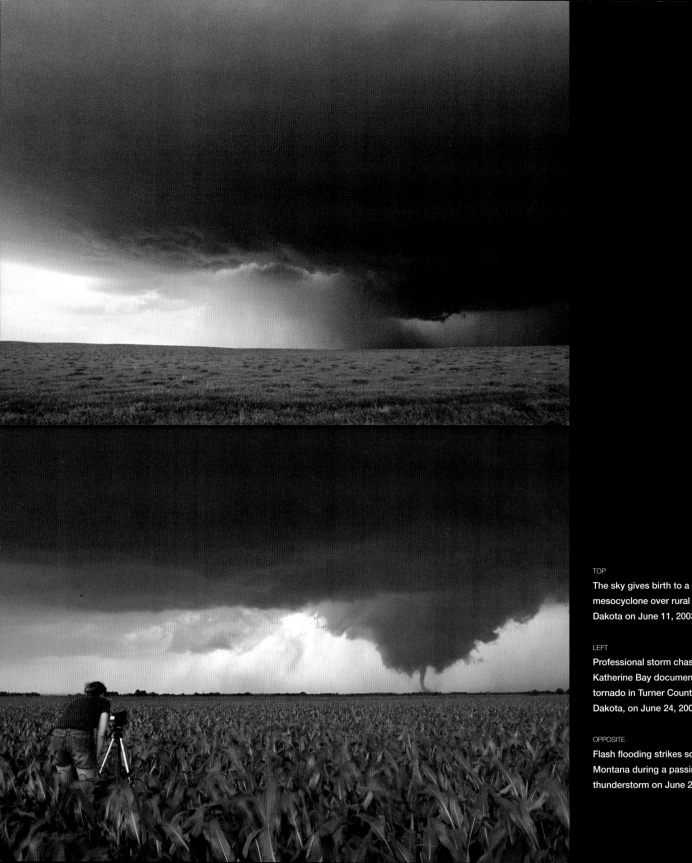

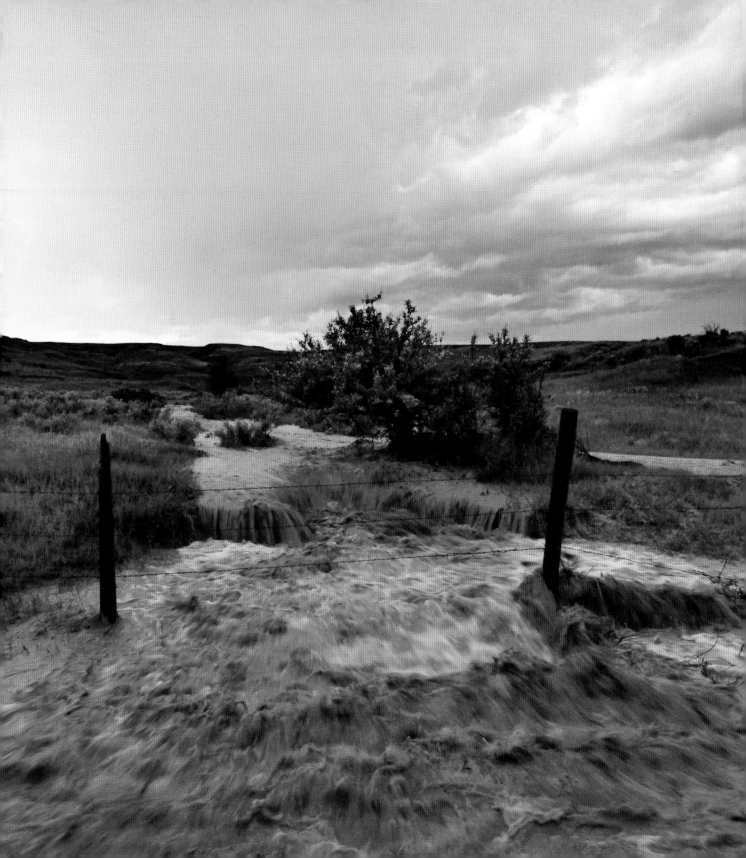

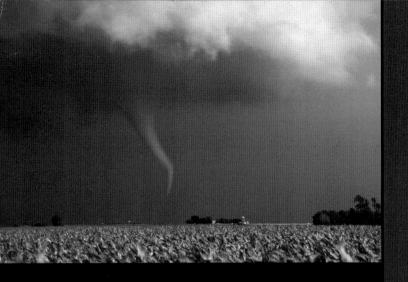

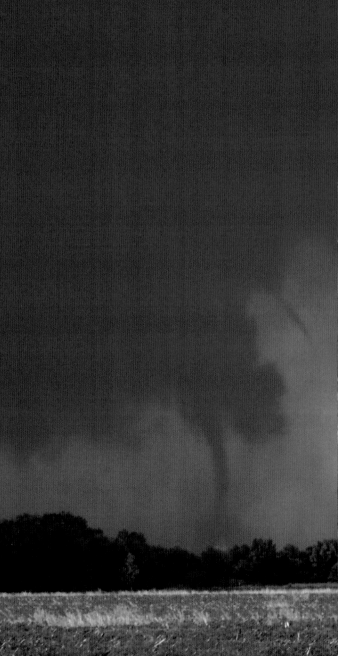

ABOVE

A tornado snakes to the ground
over Turner County, South
Dakota, on June 24, 2003.

RIGHT

Double trouble: Simultaneous
tornadoes threaten Turner
County, South Dakota, on June
24, 2003. It was the largest
single-day outbreak of tornadoes
in South Dakota's history.

OVERLEAF

A low-precipitation supercell
thunderstorm swirls across
farmland near Medicine Lodge,
Kansas, on June 5, 2004.

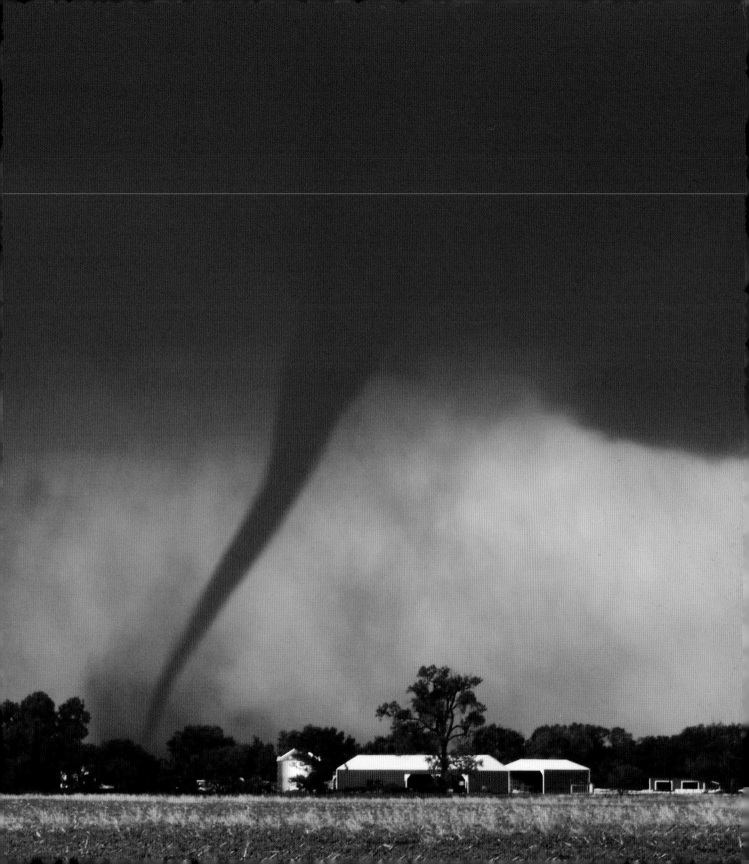

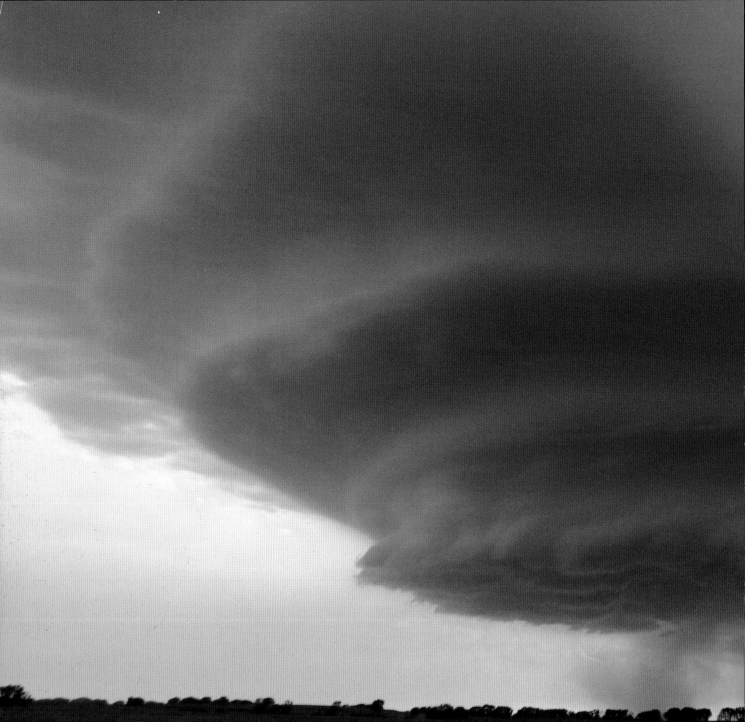

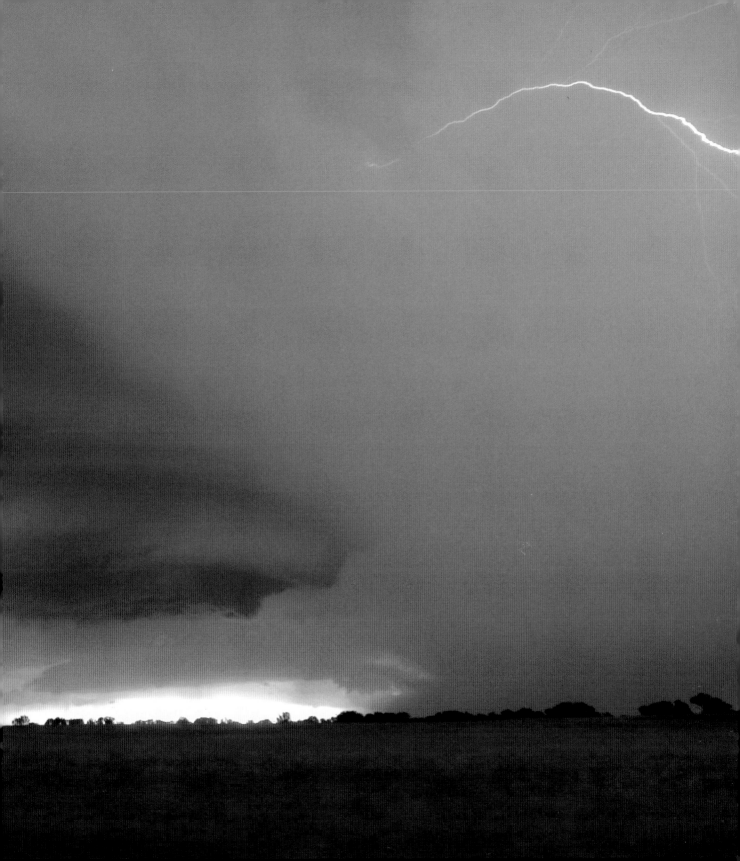

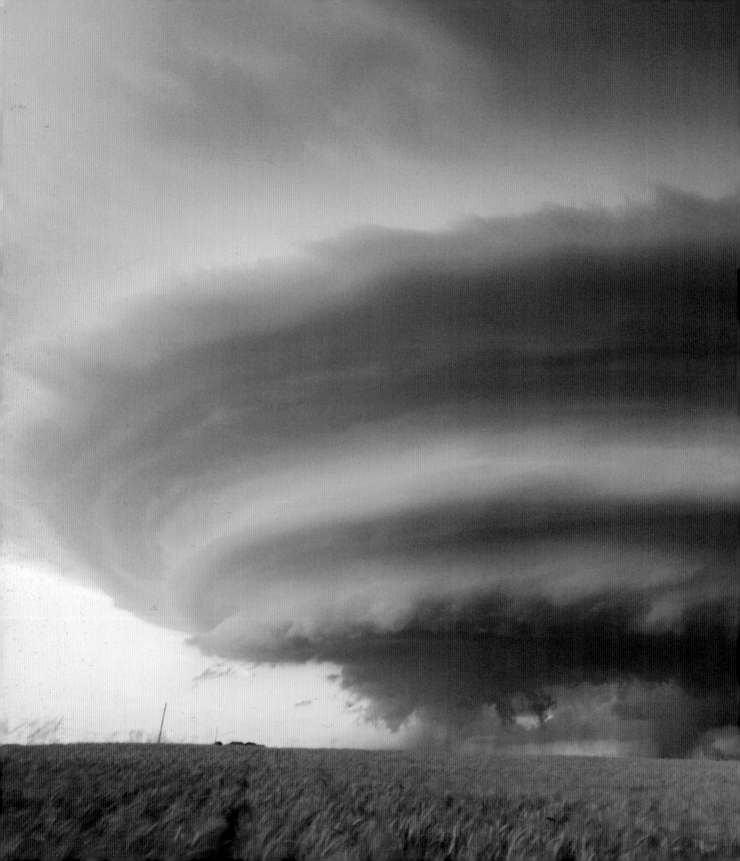

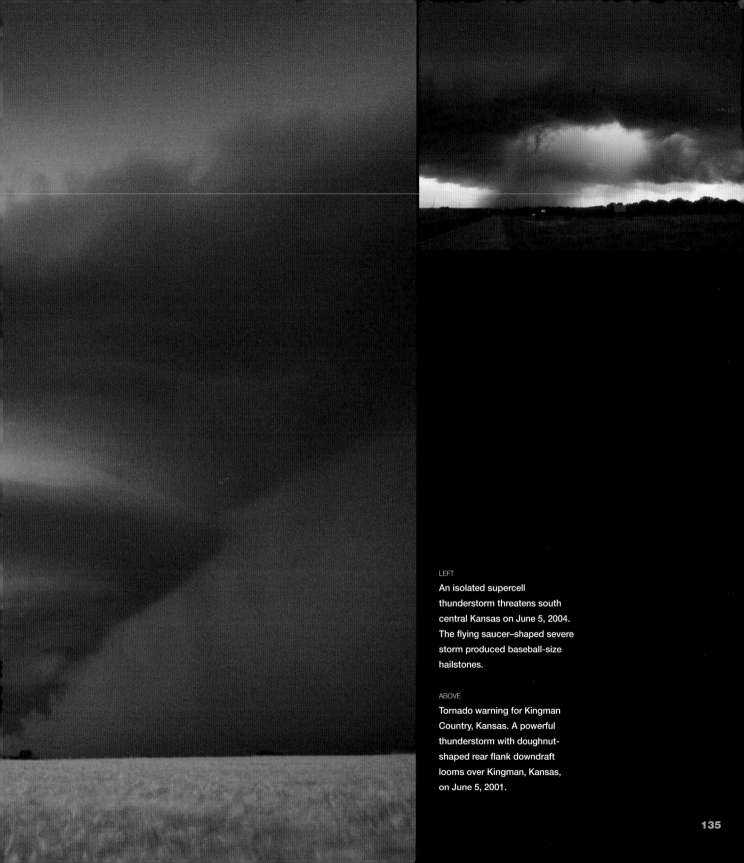

LEFT

An isolated supercell thunderstorm threatens south central Kansas on June 5, 2004. The flying saucer–shaped severe storm produced baseball-size hailstones.

ABOVE

Tornado warning for Kingman Country, Kansas. A powerful thunderstorm with doughnut-shaped rear flank downdraft looms over Kingman, Kansas, on June 5, 2001.

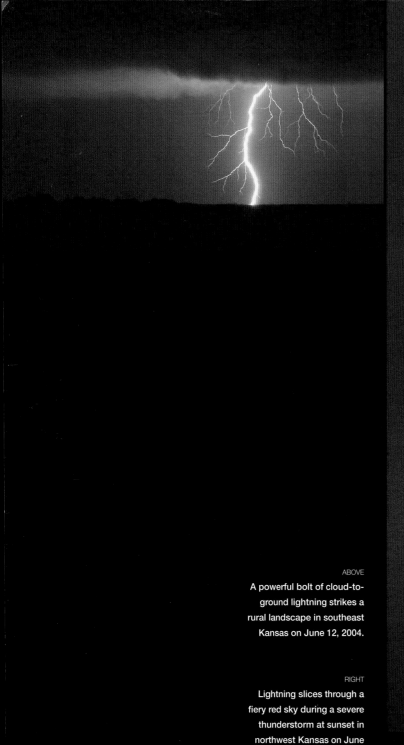

ABOVE

A powerful bolt of cloud-to-
ground lightning strikes a
rural landscape in southeast
Kansas on June 12, 2004.

RIGHT

Lightning slices through a
fiery red sky during a severe
thunderstorm at sunset in
northwest Kansas on June

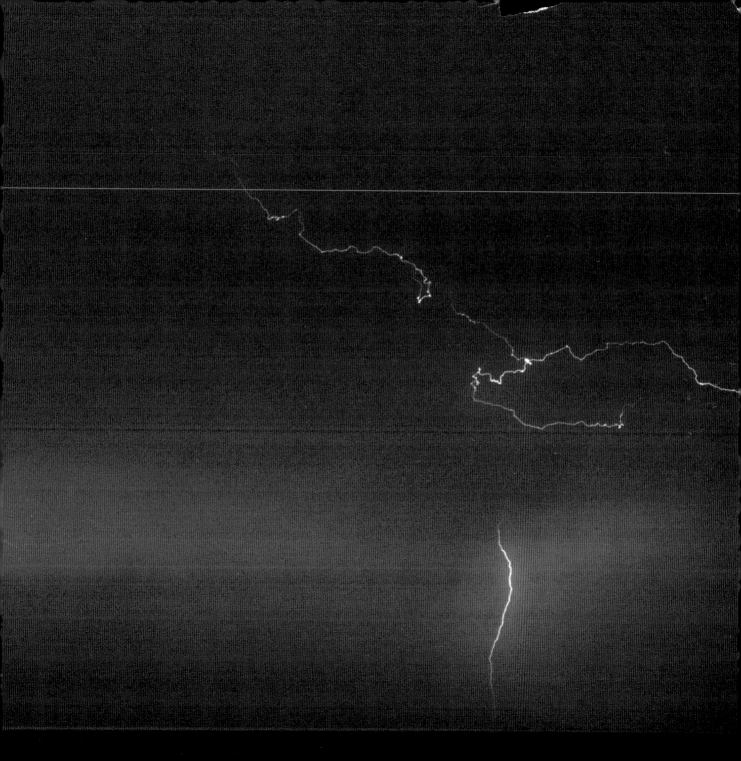

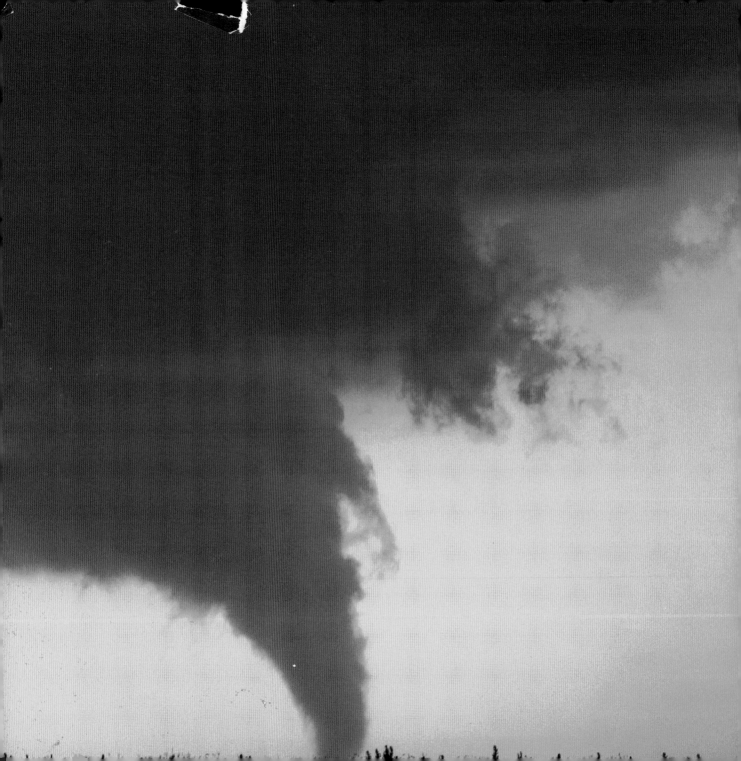

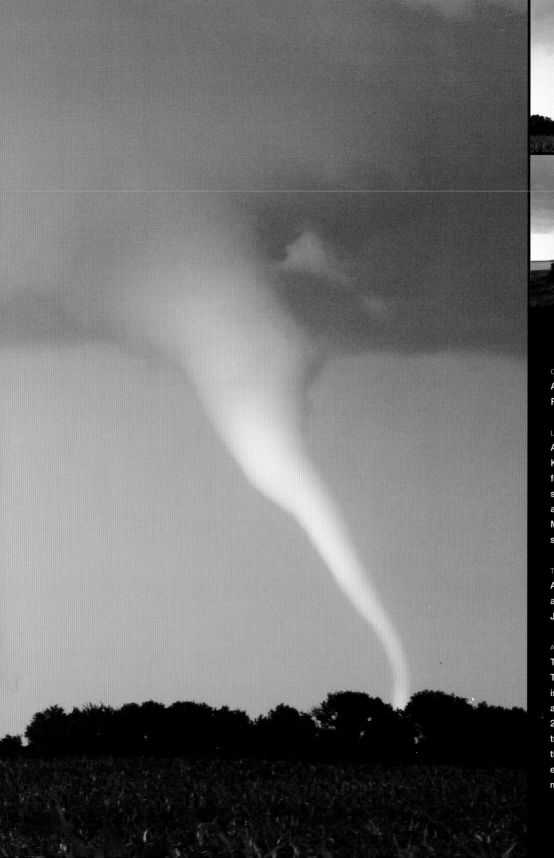

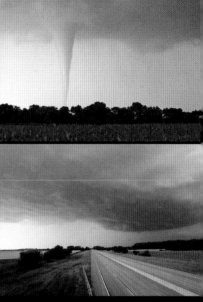

A tornado strikes at sunset near Rock, Kansas, on June 12, 2004.

A tornado threatens Mulvane, Kansas, on June 12, 1994. A few hours before this photo was snapped, I was visiting with actress Dawn Wells, who played Mary Ann on the popular TV series *Gilligan's Island*.

A "stove-pipe" twister moves across Mulvane, Kansas, on June 12, 2004.

This stretch of the Kansas Turnpike just south of Wichita is eerily deserted because of a tornado warning on June 12, 2004. State police stopped traffic in both directions until the threat had passed to the east. The storm produced multiple twisters.

ABOVE

A thunderstorm rumbles
over Custer National Forest
in Powder River County,
Montana, on July 1, 2004. The
scarred trees were blackened
during a preceding wildfire.

RIGHT

Thunderstorms bring
much-needed rain to
southeast Montana on the
Fourth of July 2004.

OVERLEAF

Thunderstorms develop
over southern Montana
on July 3, 2004.

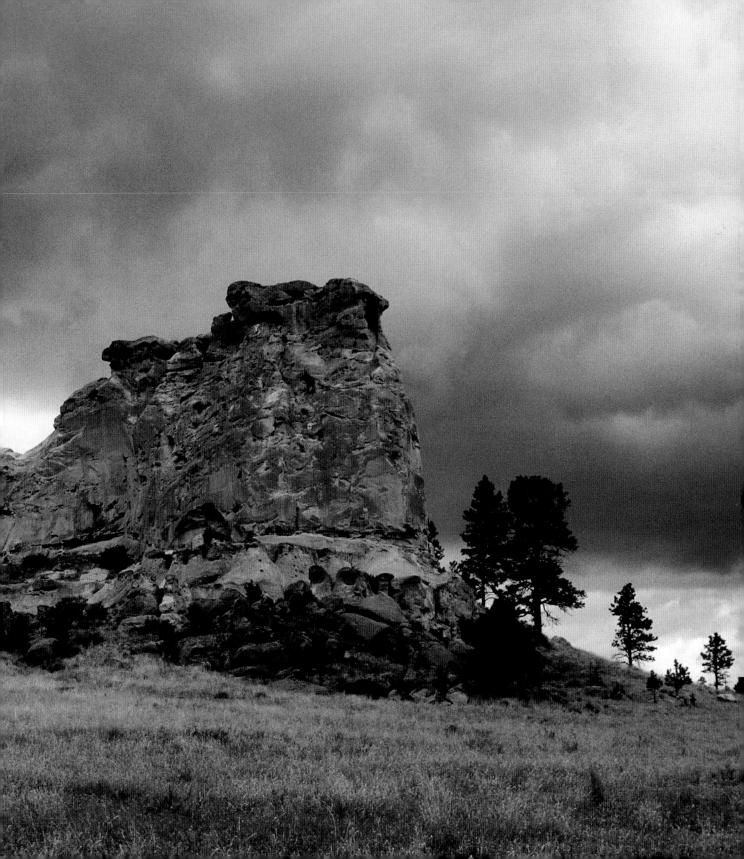

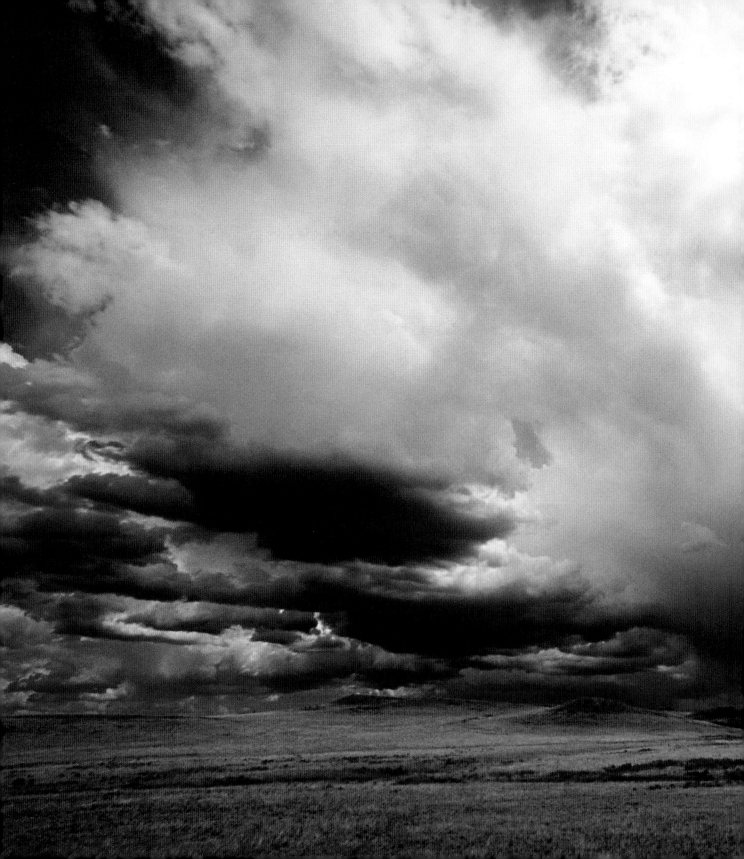

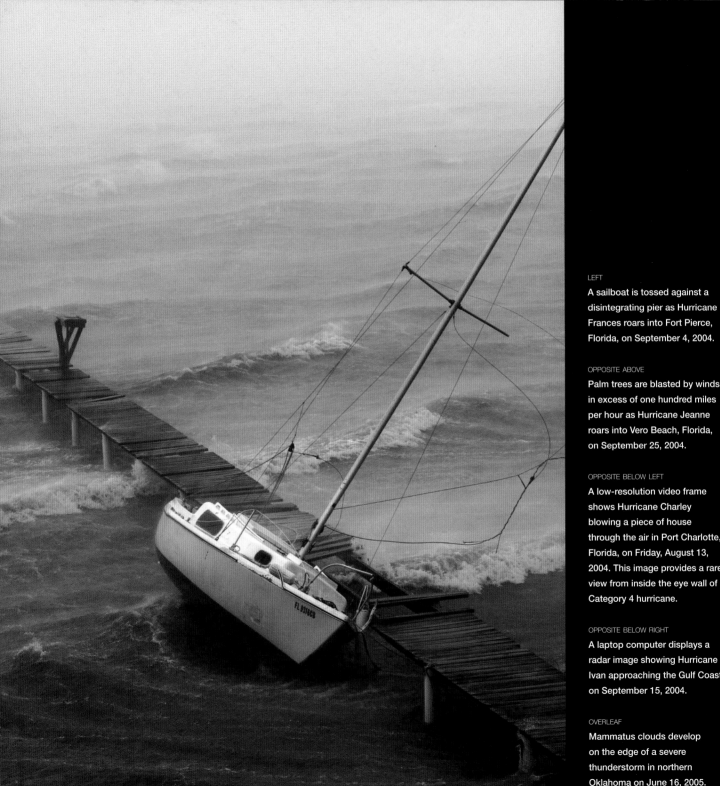

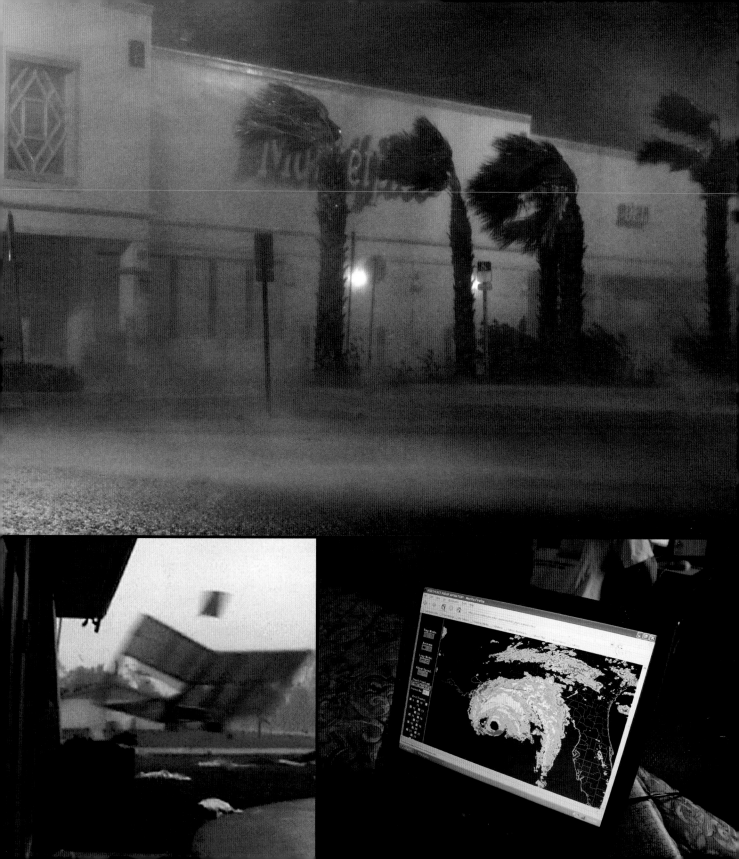

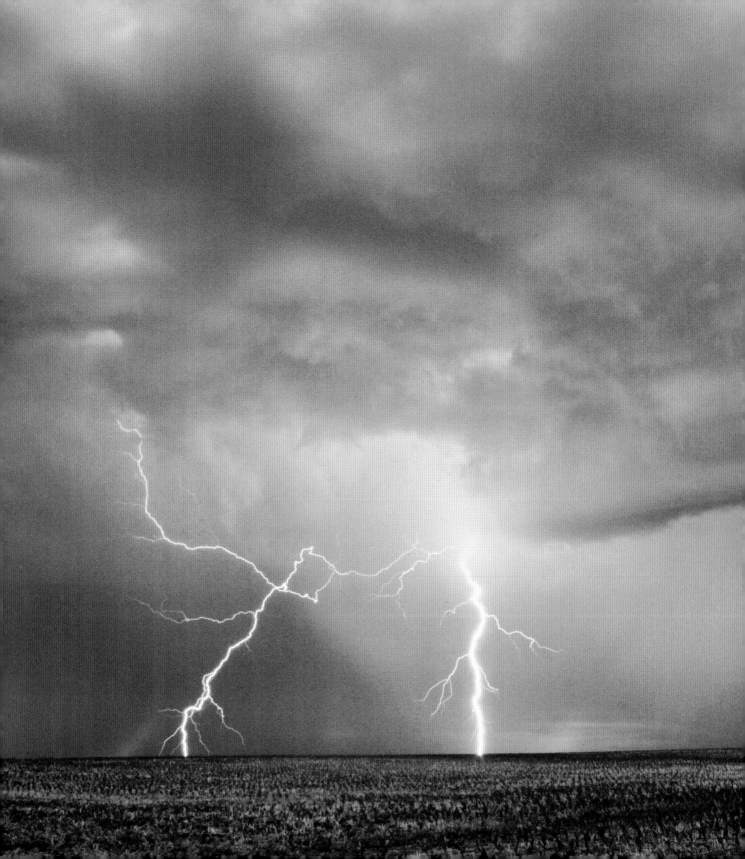

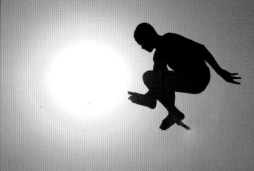

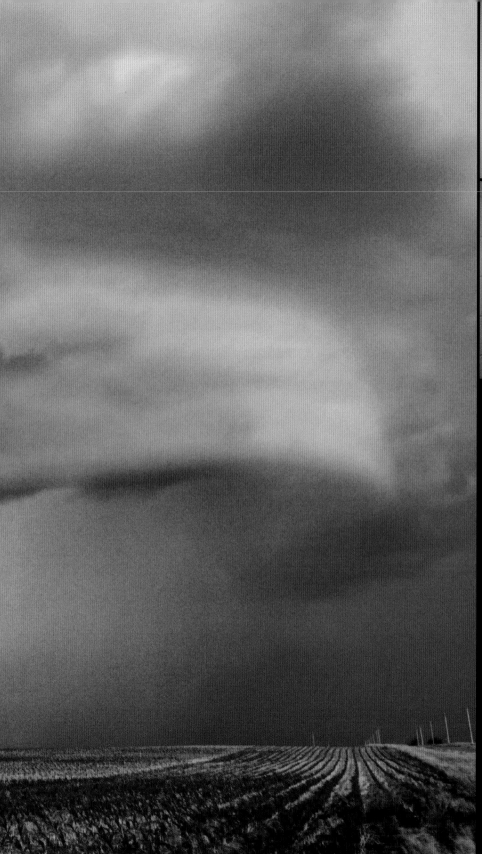

LEFT

Lightning pierces the ground
during a severe thunderstorm
near Alliance, Nebraska,
on June 9, 2006.

TOP

A scorching sun silhouettes
a young man as he launches
from a diving board at a public
swimming pool in Wichita,
Kansas, on July 18, 2006. The
temperature that day in Wichita
soared to a record-setting 109
degrees. 2006 witnessed the
second warmest summer in
United States history.

ABOVE

A woman in North Carolina
displays a severe sunburn on
September 20, 2003. As the
global temperatures rise, so will
sun-related health threats such as
sunburn and heat stroke.

**One touch
of nature
makes the
whole world kin.**

—William Shakespeare

autumn

Kids find a new way to climb
their favorite tree after a
tornado uprooted this large
oak in Wichita, Kansas,
on September 5, 1992.

September 5, 1992, rookie storm chase was far from perfect. Instead of heading out into the wide-open plains of western Kansas and intercepting a storm, this tornado struck less than three hundred yards from my Wichita apartment.

Speeding after the twister in my '85 Chevy Cavalier, I soon realized I'd made a big mistake. Inside, I recorded, "The uhhh . . . the winds are increasing." Just then, I found myself less than fifty yards from my childhood nightmare as it chewed on treetops and power poles. It was spitting out trash, broken limbs, and rocks every which way. Then, as if suddenly driving onto a thin sheet of ice, I lost control of the car. A wind gust well over one hundred miles per hour blew my vehicle sideways and into the concrete curb with a suspension-destroying thud.

"Dear God, please don't let me die," I shouted into my audio recorder.

Every muscle in my body tightened with fear and exhilaration. "I'm attempting to get to shelter in time to take cover!" I blurted into the mic. "I'm going very fast! The tornado's right over me!"

I managed to escape unharmed, but my ego was heavily bruised. In short, I did everything wrong. I was unprepared, late, and got too close. I even forgot my camera (only to discover it later beneath my seat). Hardcore storm chasing was a lot more challenging than I had anticipated.

The next day, I retraced the path of the twister. Damage was mostly limited to broken windows and damaged roofs, but numerous trees had also been uprooted. My favorite shot to come out of my first chase was an image of two kids playing on an uprooted oak tree. It gave completely new meaning to "kids climbing a tree."

Over the next couple of years I spent most of my autumn seasons visiting various counties in the west and writing. I always packed a NOAA weather radio wherever I drove. If a weather warning or watch had been issued, the alarm went off and I loaded the cameras. Storms don't have to be severe to be picturesque. This is especially true during the autumn months. Such was the scenario on September 11, 1994.

I was tucked away in a hotel in Roosevelt, Utah, working on a rewrite of *Trouble on 162* for Warner Bros. Pictures when a line of strong thunderstorms approached Uintah County. I grabbed the cameras and headed out the door. A few miles down the road, I set up my gear. Placing an irrigation wheel in the foreground, I aimed my lens toward the storm. The end result was a peaceful-looking image that possessed rich colors, strong contrast, interesting shapes, pleasing texture, and balanced lighting—my favorite characteristics in a fine art weather photograph.

That November, meteorologist Michael Phelps and I intercepted a potent winter storm in eastern Colorado. Blizzardlike conditions were expected and I wanted to test my new SUV for an upcoming expedition to Alaska. Nature didn't disappoint. The winter storm was verified and we were slammed with high winds and several feet of snow.

In the autumn of 1995 *Popular Science* magazine published a cover story titled, "Hurricane Alert: Killer Storms Are Coming." The article centered on the long-range tropical cyclone predictions of Dr. William Gray, widely regarded as one of the best hurricane prognosticators in the US. The forecast was ominous at best.

"We've gone twenty-five years with relatively little activity," Gray is quoted as

saying: "Inevitably, long stretches of destruction will return. Florida and the East Coast will see hurricane devastation such as they have never experienced before."

When I read this article, I immediately recognized two things. I wanted to write for *Popular Science,* and I wanted to document a hurricane. Sure, my mother and I had inadvertently driven into the outer bands of Camille together in 1969. But the autumn of 1995 left me with an urge to intercept a hurricane as a professional and, if possible, to penetrate the eye.

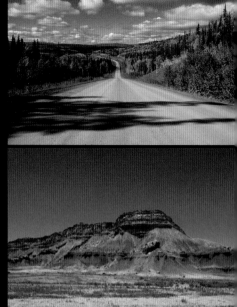

But first there was Alaska. For years I had always wanted to visit this massive state, and in 1994 I organized an expedition. Meteorologist Michael Phelps and I would drive my Explorer from Wichita all the way to the Arctic Circle and back. Our goal was to witness the northern lights in person. We would also spend fifty days documenting any evidence of unusual weather influenced by global warming. I invested in top-of-the-line Arctic gear that would protect me down to minus-forty-degree temperatures. This was, after all, Alaska.

We departed Wichita, Kansas, on August 24, 1995. The journey to the Arctic Circle was just over five thousand miles, and the drive took us ten days. Along our route we were treated to numerous photo ops, from sharp autumn colors to a wide variety of wildlife that included moose and bear.

On September 5, our mutual dream of someday witnessing the aurora borealis in Alaska was realized. The shimmering show began just before midnight local time and continued until sunrise. As the orange glow of sunrise crested the horizon, I captured an image that possessed nearly all of my favorite meteorological art distinctiveness. It was truly a joyous experience.

Now remember, we were also there to identify and record any unusual weather that might support the young, but intensifying, concern over global warming. Well, it didn't take long. Fairbanks either tied or broke several record-high temperatures during our visit. Instead of wearing the Arctic gear I had purchased in the lower forty-eight, I found myself conducting research and photographing more middle-of-the-night aurora in short pants and a T-shirt. It was *that* warm. Ironically, the heaviest snowfall of the month was occurring back in—yep, you guessed it—Kansas. A premature winter storm blasted parts of the Sunflower State, leaving us only to watch it on the Weather Channel in Fairbanks.

On September 5, 1996, storm chasers Jon Davies, Michael Phelps, Joe Wasser, and I intercepted Hurricane Fran, a powerful Category 3 hurricane, as it made a ferocious landfall in North Carolina. At least two dozen people lost their lives. Hundreds of beachfront homes were destroyed or seriously damaged. Four and a half million people were left without power.

Using recently reinforced brick walls at a car wash as a shield, I photographed Hurricane Fran's explosive one hundred and fifteen miles per hour eye wall winds. I watched as structures literally tore apart before my very eyes. The direct hit by the Category 3 hurricane was unlike anything I had seen during the outer band of Camille. But what impressed me the most was the sound of the wind. That fighter jet engine roar seemed to go forever, and it was deafening, even claustrophobic.

When the winds did finally calm, the roar fading into a soft breeze, I knew I was in the eye of my first professional hurricane. The humidity was unpleasantly thick to the

TOP

Autumn in Alaska, just south of the Arctic Circle, September 1995. The day I shot this photo, Category 4 Hurricane Luis was bearing down on the Lesser Antilles in the Atlantic.

ABOVE

Severe drought conditions in the Green River, Utah, area, on October 10, 1995.

point of making it difficult to breathe. It was during this time that Joe and I elected to join a local family inside their home for shelter.

Two weeks later, Jon Davies and I were back in the Midwest photographing tornadoes in Oklahoma. Storm systems seemed to be hitting us faster and with more energy.

With weather anomalies becoming more noticeable, *Popular Science* assigned me to write and shoot a cover story titled, "New Eyes on the Storm," which was published in the autumn of 1997.

On September 12, 1997, Category 5 Hurricane Linda became the most powerful tropical cyclone ever recorded in the eastern Pacific, with sustained winds of 185 miles per hour and gusts over two hundred. Los Angeles–area media fueled public anxieties by suggesting Linda might make landfall in Southern California as a Category 1 hurricane. In 1939 a tropical storm hit Southern California resulting in forty-five deaths. The 1997 scare prompted the National Weather Service in Oxnard to issue this snappish statement:

"Notice to Media: The remains of Hurricane Linda may move over Southern California Monday. Some of the media have been saying that hurricane conditions may affect Southern California. This is not true! . . . If the system does move over Southern California, the primary threat is flash flooding and high surf. Be responsible. Please do not over dramatize this threat. A lot of alarmed people are calling this office."

The menacing hurricane thankfully weakened and had a minimal impact on Southern California.

During the autumn of 1998, people in New Orleans and the state of Louisiana thought their worst weather nightmare might be coming true. On September 26, Category 4 Hurricane Georges was headed toward the Gulf Coast. The National Hurricane Center forecast called for the storm to make landfall in southeast Louisiana as a Category 3 storm. The large hurricane had already impacted five other countries, resulting in at least five hundred deaths.

People trying to evacuate southern Louisiana, New Orleans included, soon found their vehicles stuck in traffic.

"The majority of people evacuated with less than twenty-four hours to go and that's when the horrible traffic occurred," said Dr. Susan Howell, director of the University of New Orleans Survey Research Center in a 1999 interview I conducted for *Scientific American* magazine. "It took people eight hours to drive eighty miles. It was bedlam."

Jon Davies and I departed Wichita late that night and headed for Gulfport, Mississippi, to document the landfall of Georges. We had no traffic at all. Of all the hurricanes I've covered, that's one thing I've never gotten used to—having an abandoned interstate all to myself, while everyone else is driving in the opposite direction. It's very eerie.

During our nine hundred and fifty–mile drive south, we learned on the radio that for the first time in its history, the Superdome was being used as a shelter of last resort for those who could not or did not evacuate.

Georges struck the southern Mississippi coastline around 4:00 A.M. on September 28 as a Category 2 hurricane. We photographed as much as we could in the predawn darkness, and then more after sunrise. Meanwhile, at the Superdome twelve thousand

evacuees had become very restless and impatient. People began looting the building, ripping up seats, and breaking into concession areas. The end result was at least fifty-five thousand dollars in damages; the vandalism had actually done more destruction to the Superdome than the hurricane.

According to Dr. Howell, New Orleans officials were to rethink whether the Superdome should ever be used as a hurricane shelter of last resort again.

As Hurricane Georges made national headlines, the effects of global warming stealthily continued. September 1998 was the warmest ever observed in Glasgow, Montana. Little Rock, Arkansas, reported having its hottest May-through-September period since full records began. By contrast, in early October, Hilo, Hawaii, experienced record-setting *cool* temperatures. Everything appeared meteorologically inverted. Even folks in the Nevada desert, who rarely see rain, watched as new precipitation records were set.

While Jon and I documented Hurricane Georges, autumn temperature records were broken in Kansas as the mercury soared to more than 100 degrees. Schools without air conditioning canceled classes. Instead of having a "snow day," kids called it a "sun day."

By mid-autumn of 1998, I felt compelled to do more than just take pictures. For the first time I felt the need to literally warn family and friends. But I didn't want to scare my family inappropriately, or anyone else for that matter. The National Weather Service statement concerning the media and Hurricane Linda remained fresh in my mind. But I had to do *something*.

Since interest in my photographs had increased over the past couple of years, I decided to do a high-quality, miniature poster—four-color, glossy, and about nine by twelve inches in size. It would feature seven of my images, plus a title at the very top. I would use it to advertise my artwork, while hopefully drawing appropriate attention to the subject matter.

The poster debuted in November 1998 and was an instant hit. The promo piece featured seven eye-catching images of weather-related phenomena and, at the very top, a very simple four-word title:

"Our Climate Is Changing."

Meteorological oddities associated with global warming continued through the autumn of 1999. On August 11, a rare tornado struck downtown Salt Lake City, Utah, with little advance warning. Since many citizens were caught unprepared, more than one hundred people were injured. One man lost his life.

In September Hurricane Floyd formed off the coast of Africa and became one of the largest Category 4 hurricanes ever recorded. Forecasters at the National Hurricane Center struggled to accurately predict Floyd's path and anticipated strength at landfall. Nearly all of the East Coast, from Florida to Massachusetts, was under a hurricane warning at some point as the gargantuan tropical cyclone approached America.

The six-hundred-mile-wide Hurricane Floyd prompted the largest peacetime evacuation ever in the United States, which I documented for *Scientific American* magazine. Dreading casualties, officials in more than sixty counties urged residents to move to higher ground. In response, close to three million Floridians, Georgians, and North and South Carolinians jumped into their vehicles and hit the roads.

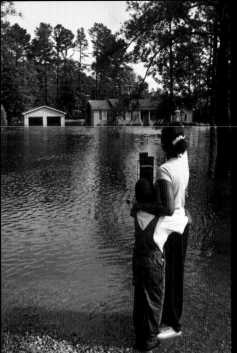

A young brother and sister eye their home from a safe distance after record-setting floodwaters consumed their North Carolina neighborhood during Hurricane Floyd on September 17, 1999.

I joined Dr. Joshua Wurman as he strategically positioned his truck-mounted Doppler radar into the crosshairs of the hurricane. We experienced a direct hit by the now-Category 2 storm at Topsail Beach in North Carolina around 2:00 A.M. on September 16.

But the big story unfolding around Floyd wasn't the hurricane. It was the crippled evacuation effort. With Floyd less than twenty-four hours away, many people were stuck in complete gridlock or had run out of gas while trying to escape. Fortunately, Floyd weakened significantly before making landfall.

"If Floyd hadn't weakened and turned at the last minute, the hurricane would have traveled right up parts of I-16 and I-26," said meteorologist Michael Phelps. "It would have killed a lot of people sitting or sleeping in their cars."

Weeks later, several state officials told me off the record that America's interstate system simply isn't capable of handling large-scale evacuations. The roads were never designed to accommodate so many motorists at one time.

"Look how bad city rush hours have gotten," said one emergency manager. "If people can't go fast or get very far on a day with good weather, why should we believe we can move millions of people during a hurricane?"

In an October phone interview, former Federal Emergency Management Agency director James Lee Witt told me, "We will look at the federal highway system to see what we can do." Witt, a cabinet advisor on natural disasters to former President Clinton, recognized the urgent need to prepare for more storms.

"We have to try to keep communities and individuals from becoming the victims of these storms by being better prepared," Witt said. "What scientists are telling us is that we could be in a very active period for the next ten years because of the way the global atmospheric changes are taking place."

In November 1999 it wasn't the size of a hurricane, but the storm's unusual *direction* that impressed scientists. Nicknamed "Wrong-Way Lenny," the twelfth named storm of the Atlantic hurricane season moved from west to east instead of the dependable path of east to west. It was the first time anyone had witnessed this in the history of Atlantic tropical cyclone records.

On October 8, 2000, I wrote in my journal, "After witnessing record heat last Monday in America's heartland, the news this weekend was history-making COLD! Unofficial report—more than two hundred records were broken (or smashed). The extreme swings continue. In Kansas alone we have gone from record heat—to record cold—to record heat—to record cold in less than fifteen days. The changes are so abrupt that many people are getting sick."

Two weeks later, I was witnessing my first October tornado in Kansas.

Tornadoes made news again the following year when fifty-nine twisters raked through nine US central and southeastern states between October 9 and 13, 2001. That set a modern-day record for the most tornadoes during the first half of any October.

With all of these science fiction–like atmospheric anomalies, I couldn't help but wonder how Jules Verne or H. G. Wells would have reacted. I do know how Hollywood responded. With the success of the movie *Twister* in 1996, it was only a matter of time before another "weather movie" was produced.

The Day After Tomorrow (2004), a movie about a major disruption in Earth's climate,

soon went into preproduction, with Dennis Quaid and Jake Gyllenhaal to star. Roland Emmerich of *Independence Day* fame would produce and direct. The motion picture was to be loosely based on the 1999 book *The Coming Global Superstorm* by Art Bell and Whitley Strieber. Once again, Hollywood and weather were about to rendezvous in my life.

Twentieth Century Fox hired me to serve as a sort of mountain climbing guide for the movie's second unit special effects crew. Only instead of taking them up the side of Kilimanjaro, I was to guide them into as many hurricanes during the 2002 Atlantic tropical season as possible. The three-person crew, led by second unit director Anna Foerster, would shoot footage that would later be incorporated into the movie. Storm chasers Jon Davies and Katherine Bay also joined our expedition. Jon served as our lead forecaster; Katherine handled safety preparedness and logistics.

On September 26, 2002, the team documented Isidore as it made landfall near Gulfport, Mississippi. Once a Category 3 hurricane, Isidore weakened to a tropical storm before battering Harrison County with damaging winds and flood-producing rainfall.

On October 3, we documented Hurricane Lili as it pushed into Lafayette, Louisiana, as a Category 1 tropical cyclone. Lili had been a Category 4 hurricane, but weakened rapidly as it approached the coast. Both storms produced multiple photo ops, giving Hollywood a good taste of bad weather. I was especially proud that our team completed its work safely.

September 2002 set a new record for the most number of tropical cyclones forming in a single September with eight. Now in my eleventh year of chasing storms, I took the 2002 hurricane season as one last red flag that not only were storms becoming more severe, they were also becoming more frequent.

But before I could finish captioning my photos from the 2002 hurricane season, tornadoes were back in the news. An unusually long-lived and widespread outbreak of twisters occurred from November 9–11.

Dubbed by meteorologists as the "Veterans Day Weekend Outbreak," more than seventy tornadoes touched down in seventeen states. I was dispatched to cover one of the hardest-hit areas, Mossy Grove, Tennessee. An F-3 twister had devastated the small mountainside community, destroying nearly everything in its path.

On September 18, 2003, I learned the true definition of storm surge, compliments of Category 2 Hurricane Isabel. Storm chasers Jon Davies, Michael Phelps, Katherine Bay, and I had planned for the landfall of Isabel almost a full week in advance, but nothing prepared me for what I was about to witness and photograph.

Katherine and I were rescuing two local men from rapidly rising floodwaters on North Carolina's State Highway 12 near Hatteras Village. Suddenly, my Explorer was literally picked up and moved off the highway by a surge of ocean water. Although Isabel's one-hundred-mile-per-hour winds had yet to make landfall, the Atlantic Ocean was now over my hood. Miraculously, and to Ford's credit, my engine was still humming.

I tugged the SUV into reverse and wiggled us out of the water. If the engine had stalled, Katherine and I would have been swept out to sea. Less than two hours after our incident, Isabel destroyed a one-thousand-foot section of the highway—the very stretch where my Explorer had been struck.

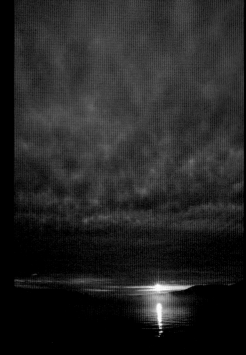

TOP

Fog and cirrostratus clouds form over Greers Ferry Lake, Arkansas, at sunrise on November 17, 1998.

ABOVE

Autumn in South Carolina, November 2001. As I shot this photo, Category 4 Hurricane Michelle was threatening mariners in the western Atlantic.

Our Highway 12 storm surge experience would prove invaluable in preparing for future hurricanes.

On July 28, 2005, hurricanetrack.com editor Mark Sudduth, a veteran professional hurricane chaser, wrote in his blog:

> *We are about to enter what I think is a very dangerous time period for this country . . . With water temps so much above normal in some areas, and the seemingly endless supply of tropical energy, it is only a matter of time now until we see a devastating hurricane change some area forever . . . None of us has control over this kind of power—so it is up to us to be prepared. The most dangerous time of the season lies ahead.*

Five days later, the National Hurricane Center issued an ominous warning of its own. The forecast urged residents along the Gulf and East Coasts to be extra prepared for life-threatening hurricanes.

On August 23, 2005, Tropical Depression 12 formed over the southeastern Bahamas. At 7:00 A.M., August 24, Wednesday morning, it was given a name: Katrina.

Behind the scenes, a flurry of activity erupted among meteorologists, climatologists, oceanographers, and storm chasers. Everyone I spoke with had a "bad feeling" about this one, and around-the-clock surveillance began.

That same day, I e-mailed a rare heads-up warning to all of my media clients, which included the major American television networks and Corbis:

> *Quick note to let you know that for the first time since Hurricane Dennis in July, we're going into major hurricane mode here at Jim Reed Photography. Katrina may strike the southeast coast of Florida as a Category 1, but we're becoming increasingly concerned she may become a major hurricane once in the Gulf.*

The next day it was clear, Katrina was about to strike southeast Florida. To my shock, far too many people appeared to be ignoring the approaching cyclone. How could this be? Considering all the red flags and experience that came with the four hurricanes that devastated the state the year before, why were citizens of Florida turning their backs on nature so disrespectfully?

The tropical storm intensified into a formidable Category 1 hurricane and made a forceful landfall near Miami Beach. As palm trees bent to the ground and horizontal clouds of sand roared across the city, people were literally dancing in the wind, outside and unprotected. Many residents motored about in cars and trucks, honking horns and giving each other the thumbs-up sign. But this was no victory for Floridians. At least six people needlessly lost their lives.

On Friday, August 26, my company issued a release titled, "Storm Chasers Prepare for Hurricane Katrina to Impact Gulf Coast."

In the release I said, "Katrina certainly has the potential to become one of our country's most expensive hurricanes."

> *Hurricanes are God's way of saying, 'Get off my property.'*
>
> —Bill Maher

Hurricane Katrina roars into Gulfport, Mississippi, on August 29, 2005, producing whiteout conditions and a record-setting storm surge. This photo was taken from the fourth floor of a beachfront building.

That night I made arrangements to document the hurricane from the Beachfront Holiday Inn in Gulfport, Mississippi, the same hotel I had successfully used as a base of operations during several previous hurricane chases. The very same hotel where *The Day After Tomorrow* crew and I had stayed for Isidore and Lili. I was familiar with the Gulfport area, and the hotel was built on one of the highest elevations along the coast.

By 1:00 P.M. on Sunday, August 28, Katrina had become a massive meteorological beast. Having uncommonly intensified from a Category 3 to a Category 5 hurricane in less than twelve hours, Katrina's sustained winds were now a mind-boggling 172 miles per hour, with even higher gusts.

That afternoon, I rendezvoused with hurricane videographer Mike Theiss at the hotel. The plan called for us to record Katrina's landfall together. Mike would shoot video; I would shoot stills. Working as a team, we would lower our risk of injury. Between the two of us, we had previously documented thirty hurricanes, including Charley. We had been studying Katrina for nearly a week and we were well prepared. Water for two weeks, food for one. Life vests, helmets, satellite phone, and a Coast Guard rescue kit.

But to our horror, most of the people we encountered that afternoon were *not* prepared. In fact, several people were sitting leisurely on car hoods at the beach.

"Aren't you worried?" I asked a man, who was leaning against his car, drinking a beer.

"Not really," he answered with a defiant calm. "I was here for Camille and it don't get any worse than that."

Camille.

And that's when it suddenly occurred to me—my life had come full circle. Thirty-six years ago, almost to the day, I was seated next to my mother, our car trembling from the outer-band winds of Camille.

I encouraged the man to take shelter, wished him well, and walked away, camera in hand. Minutes later, I found myself photographing an outer band of Katrina as it approached the Mississippi coast. Time was running out.

The National Weather Service issued a special statement warning: "Hurricane Katrina is a most powerful hurricane with unprecedented strength, rivaling the intensity of Hurricane Camille in 1969."

Citizens in Louisiana and Mississippi were told, "Devastating damage is expected. Persons, pets, and livestock exposed to the winds will face certain death if struck."

Mike and I took deep breaths, then reviewed our checklist.

The next morning, less than one hundred yards from the water, Mike and I documented the landfall of Hurricane Katrina's one hundred and twenty mile per hour winds and record-setting storm surge. In my journal I would later write the following entries extracted from video and audio recordings:

6:25 A.M. Storm coming in faster than expected; gusts already approaching 100 m.p.h. Eastbound lane of U.S. Route 90 completely underwater. Blowing debris, including small tree limbs, coming down.

6:45 A.M. Shooting what we can from our violently shaking SUV. Forget

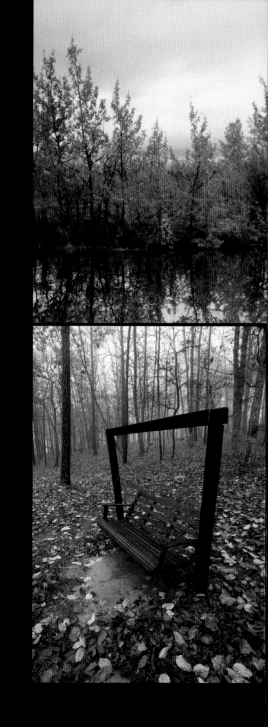

yesterday's reconnaissance work. The street to the parking garage is already impassible with two feet of violently churning water and whiteout conditions. Surge coming in sooner and more powerfully than expected.

7:15 A.M. Hotel's fifty-foot sign just collapsed. Before we could photograph the fallen sign, a large tree limb came crashing down on the back of the SUV, blowing out two windows and producing an explosive concussion. Extremely loud. We're unhurt, but covered in glass, and wind now tunneling through vehicle. Not good.

7:25 A.M. We're back at the hotel, unloading the SUV. There's a woman peeking out from behind a first-floor window. She said her name is Lillie Williams. We urged her to move upstairs, but she's refusing to go.

8:15 A.M. Phone is dead.

8:30 A.M. Noticed carpet along first-floor hallway is wet. Followed water into one of the rooms. Storm surge is slamming up against the window. It resembles a demonic aquarium. The wind-forced surge is literally pushing through the air-conditioning unit. Water is spraying out of the vents and onto the carpet. The atmosphere is contaminated with the pungent taste of salt.

8:32 A.M. Mike is making one last attempt to shoot outside the hotel at the southeast entrance. A six-foot wave and surge just forced him back into the corner, up against the building. He's trapped in the corner of the atrium. Shit. Water rapidly rising. We won't be going out front again anytime soon. It's way too dangerous.

8:40 A.M. Water is now pouring into the hotel lobby, rising quickly. Will move everyone into the third-floor stairwell where we have pre-positioned blankets, mattresses, and emergency supplies. Lillie Williams is going to drown if she stays in her room. A group decision has been made to rescue Ms. Williams. After forcing her door open, United States Navy Petty officers John Gulizia and Michael Latka carry her from the room where her furniture is already floating!

8:58 A.M. Water now waist deep in the lobby. It's as warm as bath water. We almost relax, until submerged debris punches us in the groin. Cars in the parking lot are floating, bobbing up and down. Surge really coming in now. Where is everyone?! Make sure everyone's accounted for! This is it!

A few minutes later, the alarm on the hotel courtesy van suddenly starts to wail and that's when we see it: a ten-to-fifteen-foot wave heading straight for the hotel, swelling almost gently as it approaches. But we know this won't be gentle. Seconds later, the surge turns an abandoned rental car into a two-ton battering ram. The sedan pounds against the front glass doors. Suddenly the glass shatters and the roaring surge carries the car through the lobby, forcing us into the emergency stairwell.

TOP
Autumn colors in the Yukon
Territory, Canada, 1995.

BOTTOM
Autumn in the southeastern
United States, 1997.

9:54 A.M. From inside the stairwell, Mike and I document the rapidly rising water. It's like a scene right out of the movie Titanic, only our water seems almost animalistic. No sooner does it roar into the stairwell, grabbing at our ankles when, all of a sudden, it disappears, retreating outside as if to look for someone else to kill. As we carefully inch our way back down, the surge returns ferociously, nearly knocking us from our feet.

From outside the hotel, we hear homes and buildings being torn apart, trees cracking in half, gas lines hissing like pissed-off pythons.

11:25 A.M. The sky and wind progressively lighten. Hurricane Katrina's eye is just to our west. Within minutes, the flooding recedes to less than a foot of standing water. Hurricane Katrina's storm surge has returned to the sea.

We were still alive.

Hurricane Katrina had pinned us inside the hotel for nearly nine hours. Mike and I had videotaped and photographed the full evolution of a major hurricane's Category 5–size storm surge from close range. The work produced a feeling of pride and triumph until we climbed over mounds of debris and emerged outside.

We were the only building within a one-mile stretch that hadn't been destroyed. The first floor of our hotel had been gutted. Only concrete walls and protruding showerheads remained—but the five-story building was still standing. Surrounding us, homes and businesses had been obliterated. Only concrete slabs remained.

Where forty-year-old trees once stood, we now saw only craters. It was the worst aftermath I'd seen since surveying the F-5 tornado destruction in Moore, Oklahoma, in 1999.

Katrina's surge had lifted, and then dropped huge barrages onto entire apartment complexes and homes. The structures were crushed. Those inside never stood a chance. On Mike's video, screams can be heard in the background.

I will never forget those sounds during the landfall of Hurricane Katrina as long as I live.

It took Mike and me at least twenty-four hours to dig our way out of the neighborhood. While doing so, we stopped to administer first aid, shut off leaking gas lines, pass out bottles of water, and feed those that we could using a Coleman stove.

It was days before I could sleep again, the week a blur of emotions and images: an appearance on NBC's *Today Show*, radio interviews, calls from newspapers, e-mails from old high school friends, flashbacks of injured animals, writing, picture taking, and tragedy in Louisiana.

The TV news footage I saw coming out of New Orleans in the days that followed Katrina broke my heart. The leaders and people living in Louisiana had been warned about a storm like this for years. More recently, Hurricane Cindy had threatened on July 6; Hurricane Dennis had endangered the Gulf Coast on July 10. The National Weather Service reissued the need for urgent preparedness three weeks before Katrina, giving leaders ample time to take steps for protecting the citizens of Louisiana. The mammoth

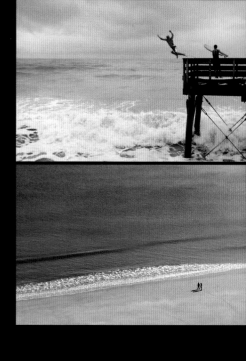

TOP

Don't try this at home. A surfer leaps from a pier into the Atlantic Ocean in an attempt to catch a big wave as Tropical Storm Kyle battered Isle of Palms, South Carolina, on October 11, 2002.

ABOVE

Myrtle Beach, South Carolina, typically one of the most popular tourist destinations in America, was nearly deserted as record cold temperatures moved into the area on October 25, 2006. Four days earlier, the area experienced record heat.

storm itself provided citizens in Louisiana and Mississippi a six-day head start to reach higher ground.

Corbis distributed many of my Katrina images throughout the world, but it's the photograph that ran as a two-page spread in *U.S. News & World Report* that I'm most proud of. Titled "Anatomy of a Disaster: 5 Days That Changed a Nation," it was the photo of Katrina's first outer band approaching Gulfport. I had shot it at astronomical twilight. The sky was a stunning turquoise blue. The image possessed vibrant color, strong contrast, an interesting shape, peculiar texture, and balanced lighting.

For the first time in my career, I had successfully captured a fine art shot of a hurricane. The price was excruciating.

While autumn can yield hurricanes and tornadoes that often cause damage on the ground and loss of life, the season can also be out-and-out extraterrestrial.

Shortly before daybreak on October 28, 2003, computer screens, CRT monitors, and an X-ray imager suddenly hummed to life at the Space Environment Center in Boulder, Colorado. Inside NASA's Space Radiation Analysis Group in Houston, Texas, Mission Control was placed on heightened alert. Electrical grids at New York Power Authority began to strain.

Chris Atkins of Farmington, New York, stopped his car as his four-year-old daughter Bethany pointed out the windshield and asked, "Daddy, why is there fire in the sky?" Above the car, flame-shaped curtains of red light wriggled supernaturally across the sky. Magnificent. Saintly. Hypnotic.

Nineteen hours earlier, an area on the surface of the sun erupted. The result, a solar flare, sent millions of tons of electrically charged particles and gases hurtling toward our planet. It was an unusual space-weather event.

Traveling at five million miles per hour, the coronal mass ejection (CME) torpedoed Earth's magnetic field on October 29, 2003, triggering an extreme geomagnetic storm and aurora borealis.

To the amazement and delight of sky watchers all over the world, auroras began appearing at locations where the mystical occurrence is seldom seen. In Orlando, Florida, the sky turned pinkish red at sunset on October 29.

I photographed the space-weather phenomena from several locations in South Carolina. Suspended over Lake Wateree in Kershaw County, portions of the sky looked almost as if they were bleeding. But it wasn't alarming; it was more like watching the effervescent heart of a napping giant.

Einstein likely would have marveled at this moment. "The most beautiful thing we can experience is the mysterious. It is the source of all true art and science," he once said.

But solar storms can also disrupt radio communications, navigation systems, satellites, and power grids. In 1989 a flare only half as strong as the October 28 eruption caused a widespread power blackout in Quebec.

It's no wonder space-weather forecasters were extra concerned on November 4 when the sun erupted again, this time unleashing the most powerful solar flare ever witnessed in the Industrial Age. Scientists had that *Close Encounters of the Third Kind* look on their faces. They were astounded, then relieved. The flare was nearing the western side of the sun when it erupted. Mercifully, the blast was directed away from Earth.

Storm clouds and record-setting cold didn't stop tourist Teddy Johnson from flying his kite over Myrtle Beach, South Carolina, on October 16, 2006. His emerald-colored kite, backlit by partial sunlight, provided a welcome contrast to an otherwise portentous sky. The night before, the temperature dipped to forty-three degrees, breaking a fifty-six-year-old record.

According to the Space Environment Center, the 2003 geomagnetic storms were some of the most intense solar events ever documented. A rising number of forecasters now believe they have statistical evidence that solar activity and the occurrence of El Niño may be interrelated.

In October 2005 Hurricane Vince formed over cool water, instead of warm; and Hurricane Wilma became the all-time most powerful hurricane ever to form in the Atlantic. November 30 is the National Hurricane Center's official last day of the Atlantic hurricane season, but a trend has developed. A rising number of tropical cyclones have formed in November and December over the past two decades.

In addition to bringing us Hurricane Katrina, the 2005 Atlantic hurricane season witnessed five tropical cyclones form after November 1. There were so many tropical threats in 2005 that the National Hurricane Center literally ran out of names for storms. For the first time in recorded history, it was forced to use the Greek alphabet to name Alpha, Beta, Gamma, Delta, Epsilon, and Zeta. Of the twenty-eight named storms in 2005, a remarkable fifteen became hurricanes. A record four hurricanes made landfall in the United States. The 2005 hurricane season was so incredible that it even set a record for, well . . . setting records.

So it was no surprise when scientists predicted a very active hurricane season for 2006, calling for as many as sixteen named storms.

But the atmosphere threw us a curveball. The season proved only average, with ten tropical cyclones and without a single hurricane striking the US. How could this be?

The National Hurricane Center believes the seasonal activity was lower than expected because of the rapid and surprise revisit by El Niño. The phenomenon, a periodic warming of the ocean waters in the central and eastern Pacific, can influence wind patterns and pressure across the Atlantic basin. El Niño helped to produce higher-than-anticipated wind shear, among other conditions that suppressed hurricane development along the East Coast and the Gulf of Mexico. There was also an unusual amount of desert dust in the air drifting from Africa which helped restrain cloud development out over the Atlantic.

In short, we were lucky—this time. Each year the weather has proven to be more and more unpredictable. Just when we think we might be able to forecast storms, nature surprises us—sometimes quietly, often violently. Only by studying what has come before can we even begin to understand what might lie ahead.

Motorists are warned as a potent
winter storm impacts southern
Colorado on November 19, 1994.

ICY
ROAD

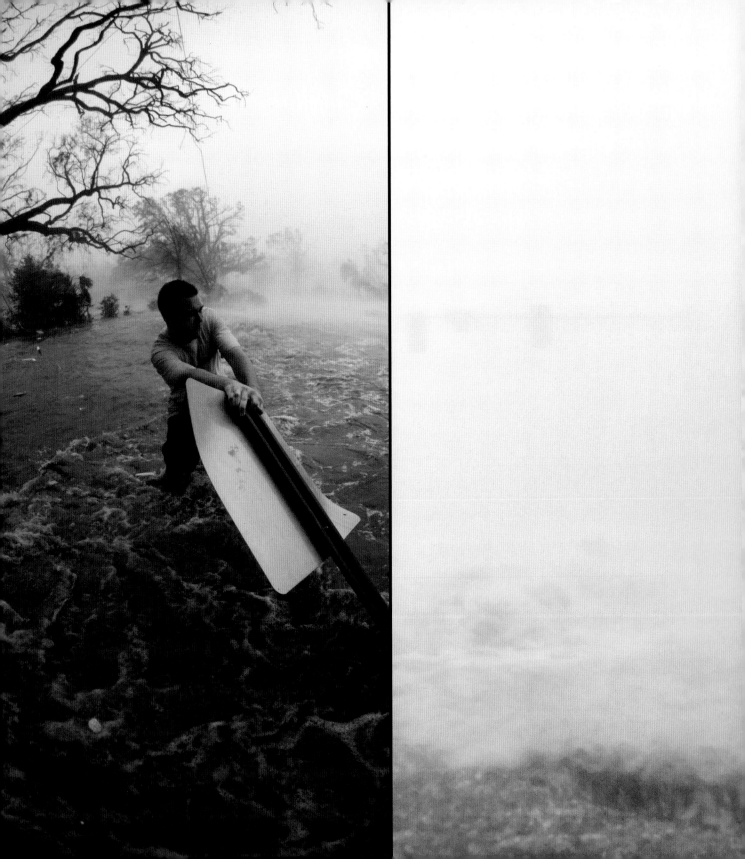

OPPOSITE

Hurricane videographer Mike Theiss clutches a road sign for balance during Hurricane Katrina in Gulfport, Mississippi, on August 29, 2005. Theiss was attempting to reach shelter when a strong gust forced him to stop.

LEFT

Hurricane Katrina's historic storm surge roars across US Route 90 in Gulfport, Mississippi, on August 29, 2005.

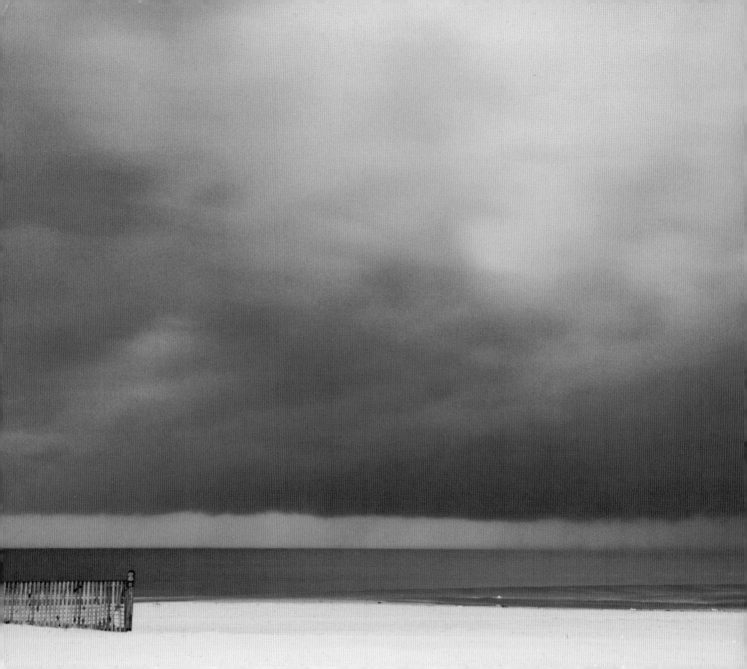

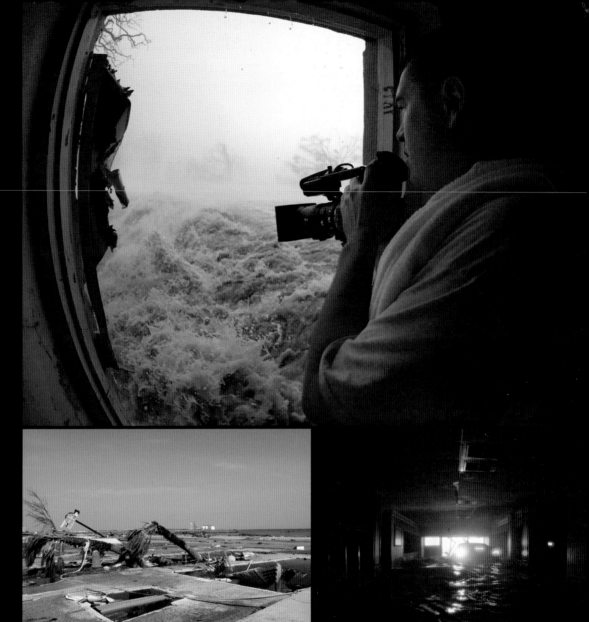

OPPOSITE

Hurricane Katrina nears Gulfport, Mississippi, during astronomical twilight on August 28, 2005.

RIGHT

Professional extreme weather photographer Mike Theiss documents the record-setting storm surge of Hurricane Katrina from the doorway of a hotel in Gulfport, Mississippi, on August 29, 2005.

BELOW LEFT

Hurricane Katrina's record-setting storm surge literally washed away entire hotels along the southern Mississippi coastline on August 29, 2005.

BELOW RIGHT

The monstrous Category 5 record-setting storm surge of Hurricane Katrina pushes a car through the lobby of a beachfront hotel in Gulfport, Mississippi, on August 29, 2005.

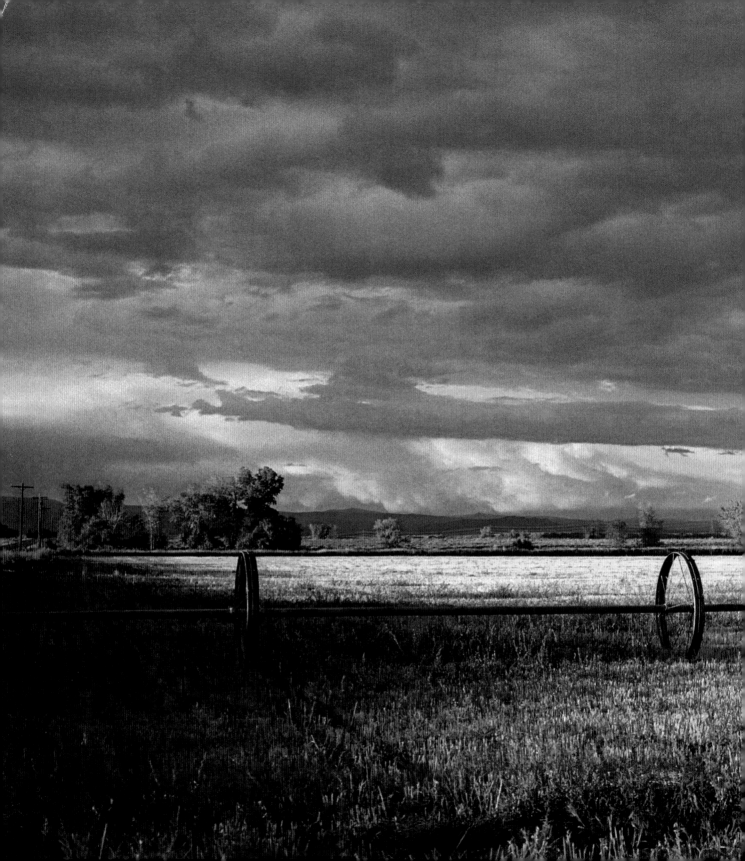

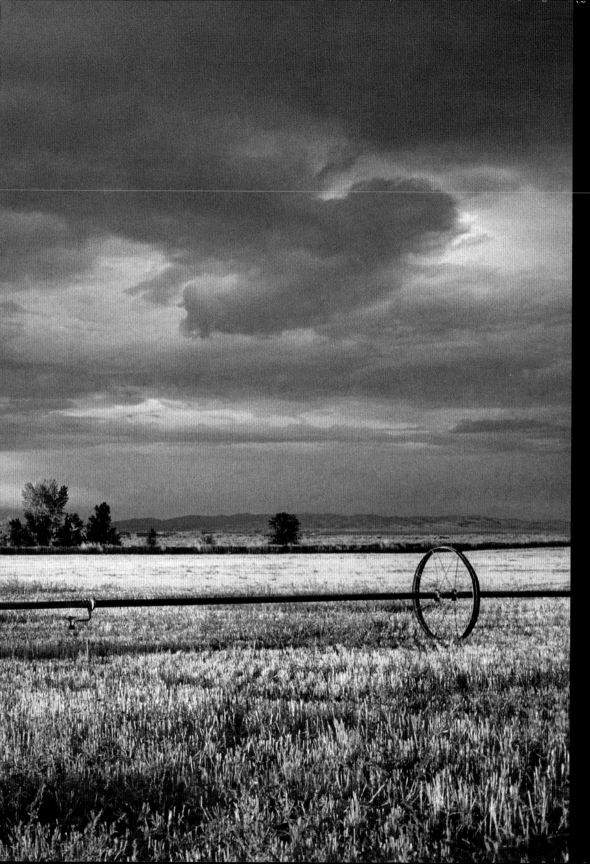

LEFT

Thunderstorms develop near Roosevelt, Utah, on September 11, 1994.

OVERLEAF

A green curtain of aurora brushes the sky at sunrise near the Arctic Circle in Alaska, on September 6, 1995.

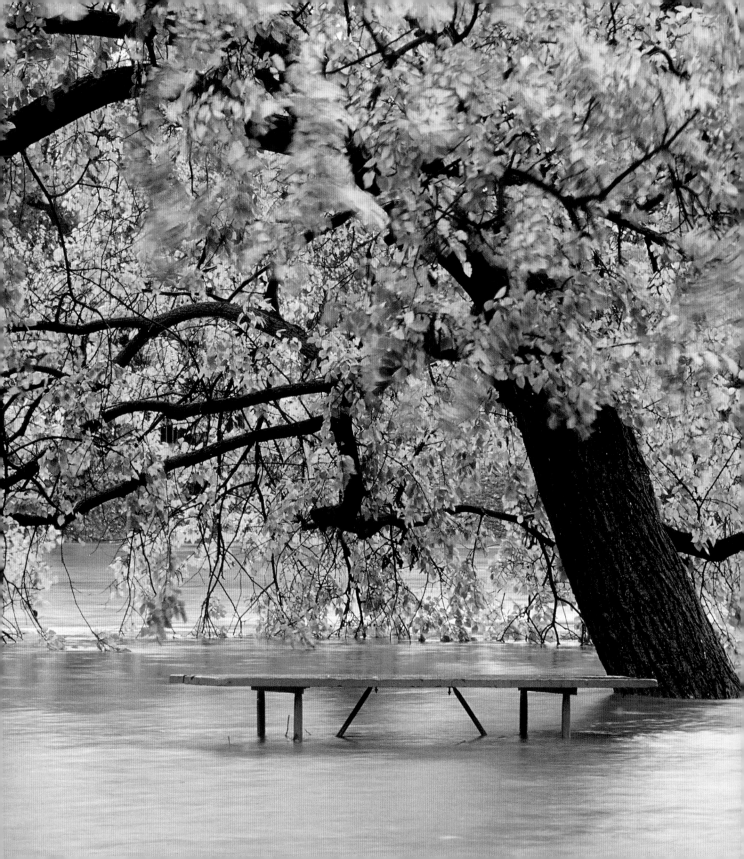

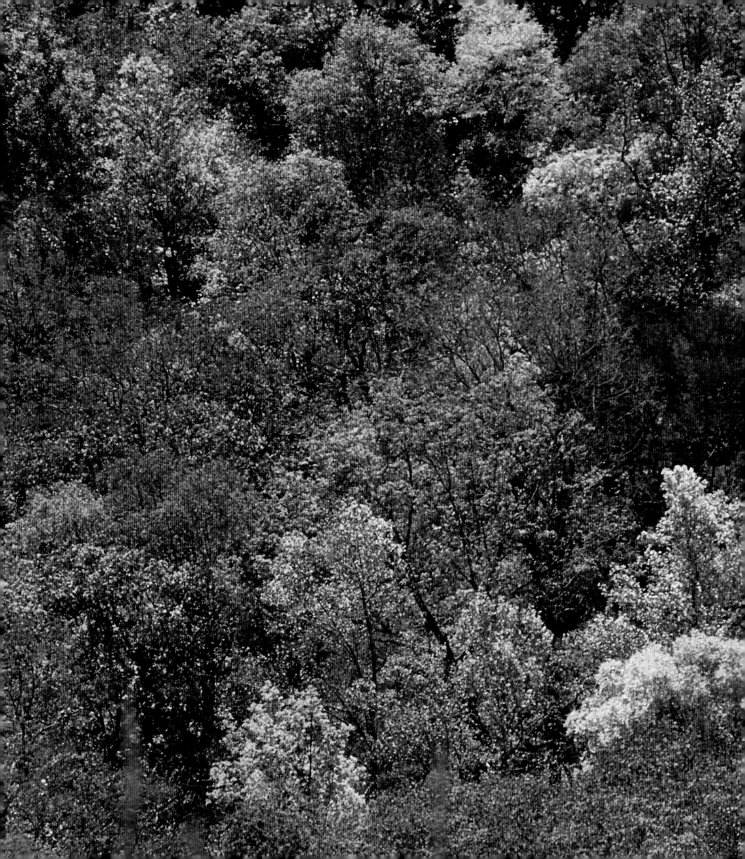

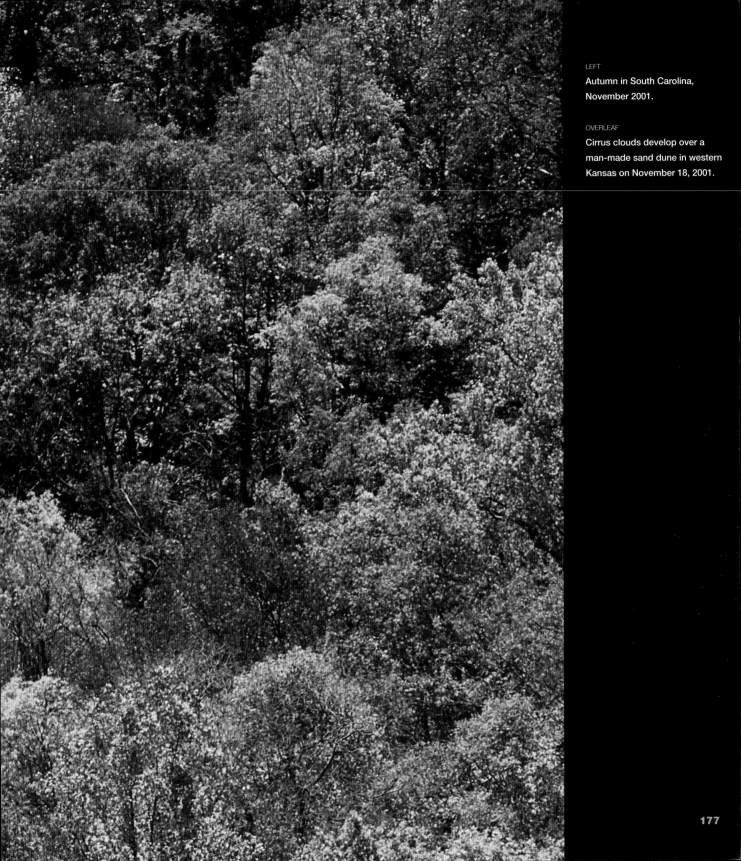

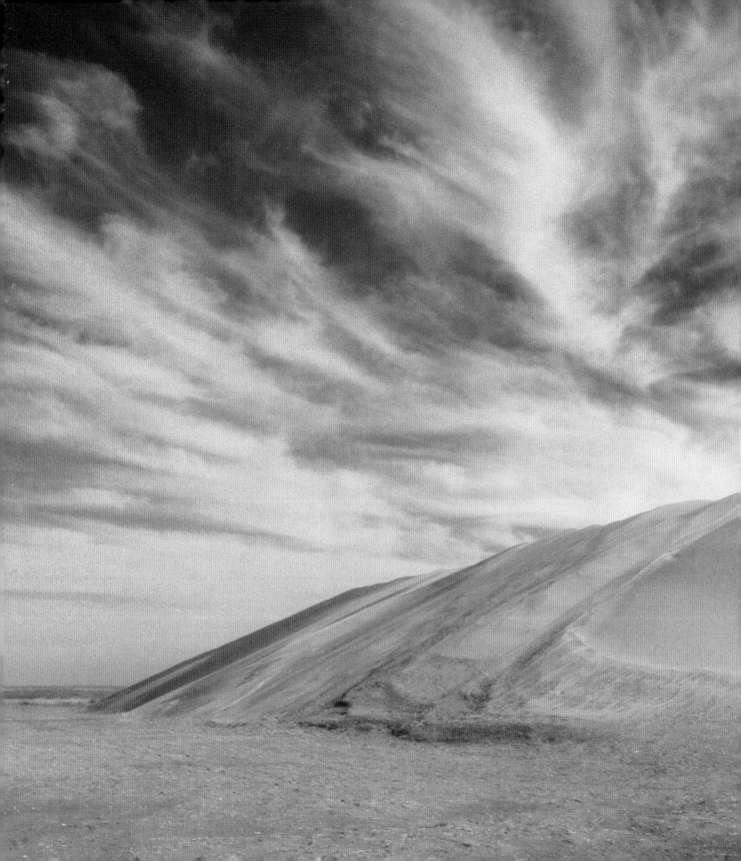

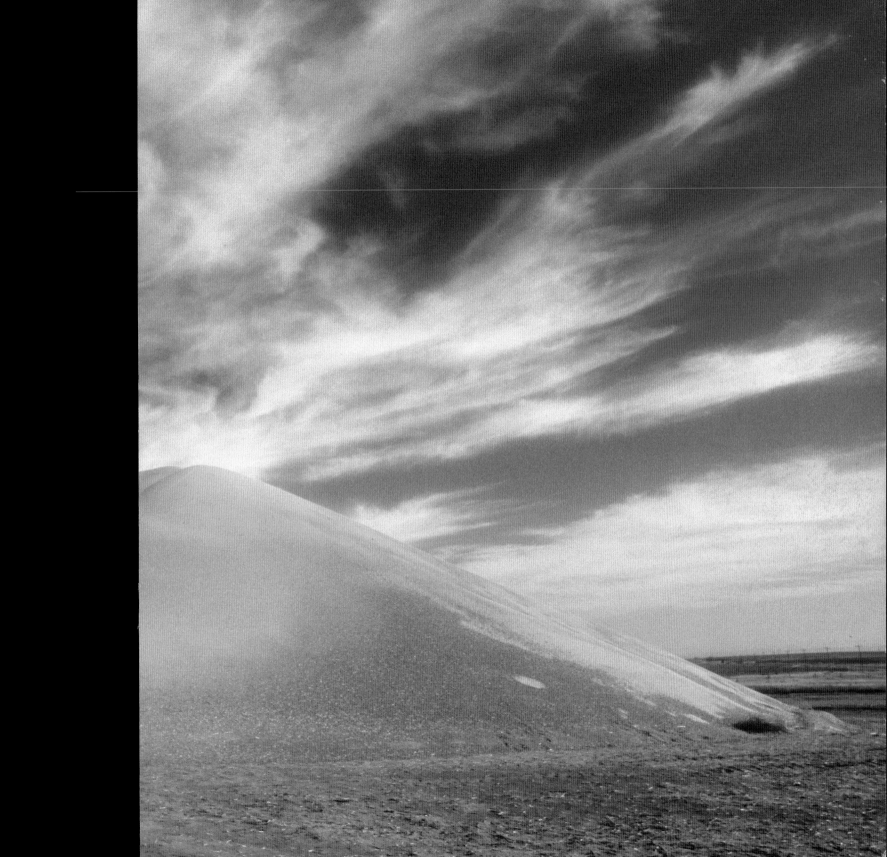

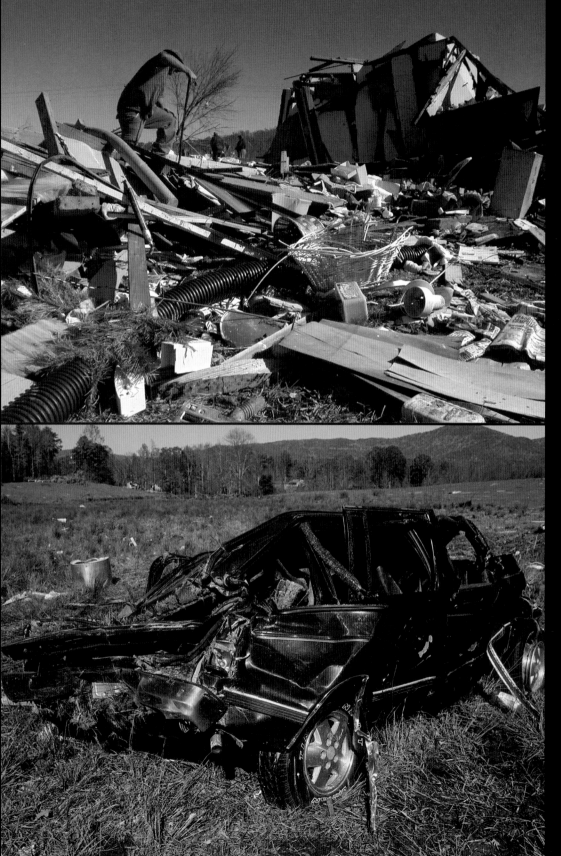

A man trudges across a destroyed home in Mossy Grove, Tennessee, where a powerful twister obliterated the small town on November 10, 2002. An estimated eighty-eight tornadoes ripped through six states during a major severe weather outbreak on November 10–11, 2002. At least thirty-five people lost their lives.

Several members of a family riding in this car were killed when an F-3 twister struck the Mossy Grove, Tennessee, area in November 2002.

A motorist drives in reverse on Highway 12 near Hatteras, North Carolina, to avoid being overtaken by the storm surge of Hurricane Isabel on September 18, 2003. A few hours after this photo was captured, the Category 2 tropical cyclone destroyed a one-thousand-foot section of the highway. The National Hurricane Center considers Isabel to be one of the most significant hurricanes to affect northeast North Carolina and east central Virginia. Sixteen people in seven different states lost their lives due to drowning and lack of proper preparation.

Hurricane Isabel destroyed this one-thousand-foot section of North Carolina's Highway 12 on September 18, 2003.

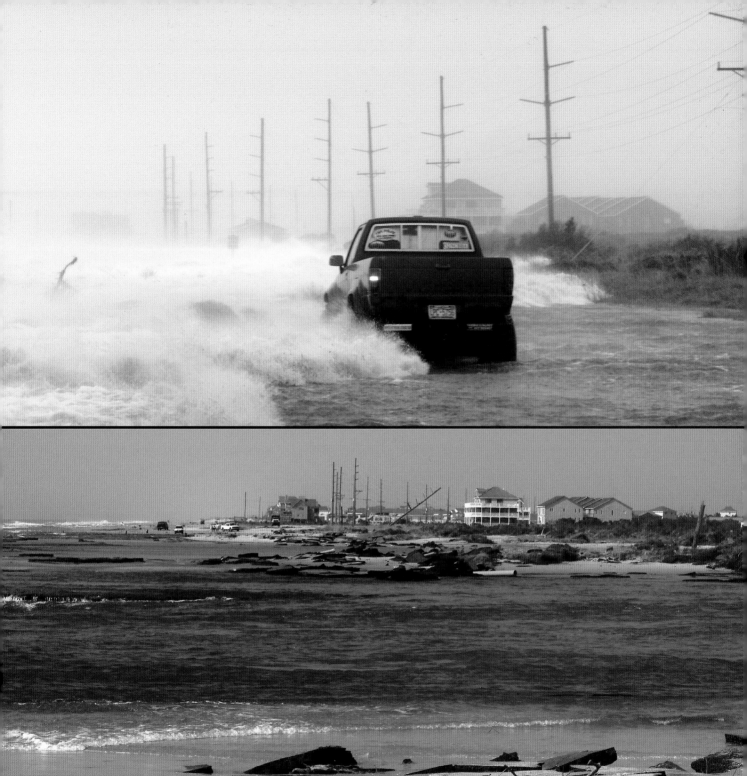

LEFT

A rare episode of bright red aurora occurs over Lake Wateree, South Carolina, during a geomagnetic storm on October 29, 2003.

OVERLEAF LEFT

The week of September 17, 1995, yielded magnificent sunsets and record heat in Fairbanks, Alaska.

OVERLEAF RIGHT

Stark contrasts. As I shot this blazing red sunrise in Myrtle Beach, South Carolina, on October 13, 2006, it was fifty-seven degrees and mild. To my north, in Buffalo, New York, it was thirty-seven degrees with thunderstorms and record snowfall.

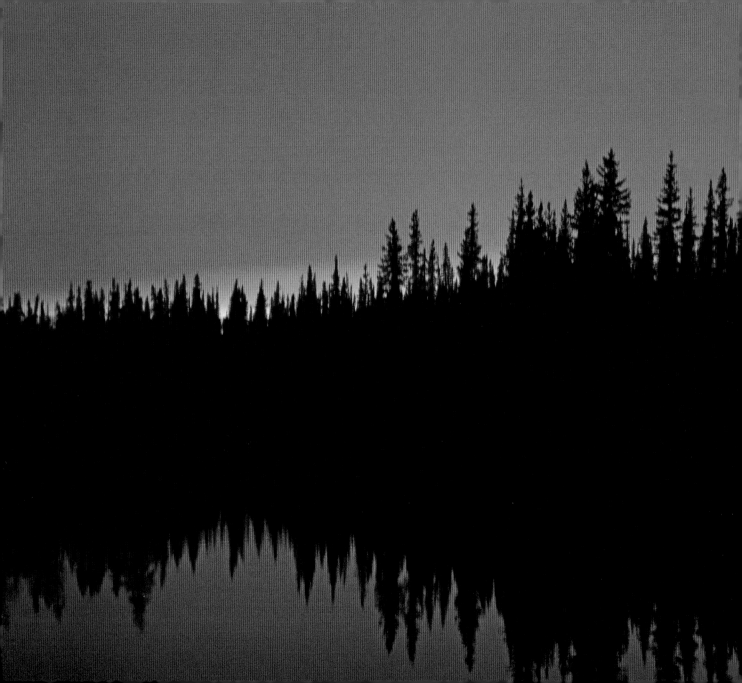

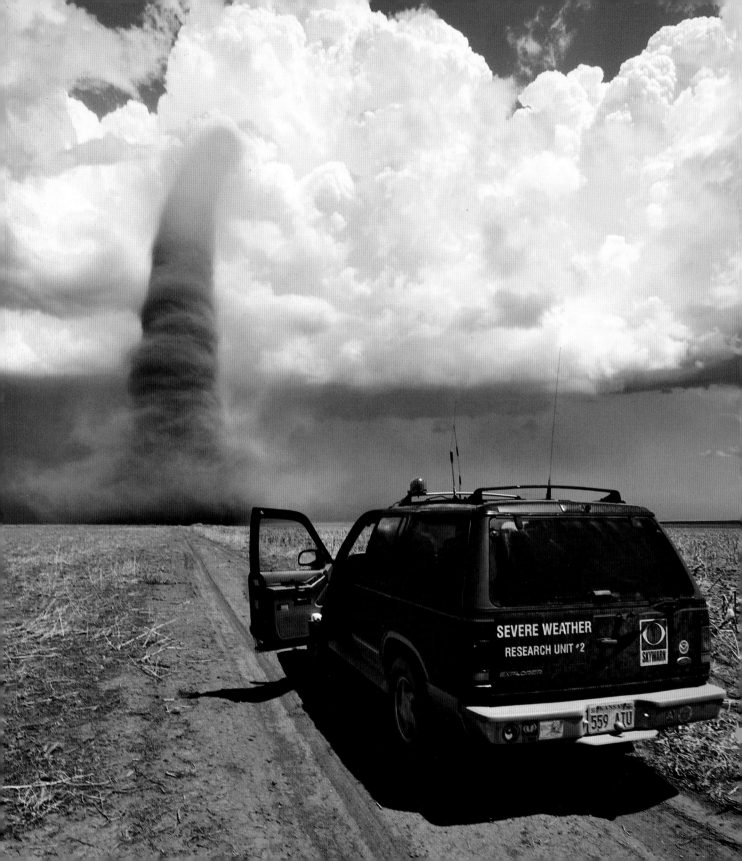

> *Look deep into nature, and then you will understand everything better.*
>
> —Albert Einstein

epilogue

By the end of my seventeenth year of documenting America's changing climate, I have logged 357 storm chases, intercepted seventeen hurricanes, and photographed over sixty tornadoes. I have experienced blizzards, ice storms, droughts, floods—nearly every type of meteorological phenomena. The result of my journey still has me feeling inspired, but now more concerned than ever before.

Debating global warming has its value, but from my experience in the field, I am convinced we must immediately and simultaneously concentrate on *adapting* to our ever-increasing weekly weather challenges. How we *prepare* for our planet's mounting climate hazards is paramount to our survival.

Gone are the days of saying, "We never saw it coming!" and "We didn't have any warning!"

It's time to firmly respect nature, one another, and the writing on the wall:

- Weather hazards have become and will continue to be increasingly harsh.
- Weather hazards are rising in number and will continue to do so.
- Weather hazards have become and will continue to be more abrupt.

Don't believe the writing? Well, let's take a look at what has happened since the hardcover version of *Storm Chaser: A Photographer's Journey* first went to press less than two years ago.

HARSHER STORMS

On May 4, 2007, a massive tornado, almost two miles wide with winds over 200 miles per hour, struck Greensburg, Kansas. The twister, later given an EF-5 rating by the National Weather Service, destroyed nearly the entire town. Although the first EF-5 since the Oklahoma tornado outbreak of May 3, 1999, it would be less than thirteen months before the next. Another monstrous EF-5 slammed into Parkersburg, Iowa on May 25, 2008. As in Greensburg, nearly the whole community was leveled.

Twisters are not only becoming larger, but longer-lived as well. The February 5, 2008, Super Tuesday outbreak produced eighty-seven tornadoes, including the second longest-lived tornado in US history. An EF-4 twister remained on the ground in the state of Arkansas for a shocking 123 miles. This was the longest single tornado track ever recorded in Arkansas. At least fifty-seven people were killed across four states during the outbreak—the deadliest since the National Weather Service began using their state-of-the-art NEXRAD Doppler radar system in 1997.

Tropical cyclones are also becoming harsher—especially in size, duration, and expense. In September 2008, Hurricane Ike became the most massive Atlantic tropical cyclone ever recorded. Ike's hurricane-force winds were measured at 240 miles in diameter with tropical-storm winds at 550 miles in diameter. Ike is also one of the costliest hurricanes in US history, with damages exceeding $20 billion.

In 2008, Hurricane Bertha made history as the longest-lived July Atlantic tropical cyclone ever recorded, lasting eighteen days before weakening. Tropical Storm Fay, August 15–26, 2008, became the first storm in recorded history to make landfall in Florida

Professional storm chasers monitor an approaching tornado in western Kansas on May 8, 2008.

four separate times—striking the Florida Keys, Naples, Melbourne, and Panama City, before eventually dissipating. That's one state, four landfalls.

FREQUENT STORMS

2008 was one of the most active years for severe weather ever recorded, with more than 23,000 individual reports sent to the National Weather Service. By June 30, the Storm Prediction Center in Norman, Oklahoma, had issued 647 severe weather watches, compared to 467 for the same period the year before. Twisters impacted thirty-seven states during more than thirty outbreaks of severe weather.

In Kansas, where I'm currently based, we had to respond to twenty-three straight days of severe weather watches, from May 29–June 20—something I had never experienced. But in 2008, tornadoes also hit areas well outside of Tornado Alley. On July 24, there were twelve reports of tornadoes, one fatal, in New Hampshire. Twisters also struck in Rhode Island and Idaho.

With this rising number of storms comes the rising threat to big cities. On March 14, 2008, downtown Atlanta suffered its first direct hit by a tornado, which resulted in at least one death, multiple injuries, and millions of dollars in damage. More than a hundred flights were cancelled at O'Hare International Airport when at least two tornadoes struck the Chicago area on August 4, 2008. The EF-2 twister that struck Brooklyn, New York, on August 8, 2007, was the strongest tornado to strike New York City ever recorded.

A growing number of cities—including Nashville, Oklahoma City, Fort Worth, Salt Lake City, and Miami— have all been impacted by tornadoes over the past ten years.

As we prepare to go to press with the expanded and revised edition of *Storm Chaser: A Photographer's Journey*, 2008 is well on the way to witnessing the greatest number of tornadoes ever recorded in a single year.

Hurricanes, tropical storms, flooding, wild fires, and lightning-related injuries are also on the rise.

ABRUPT STORMS

As if the rise in number of storms isn't challenging enough, the speed in which they are developing is also increasing. On September 17, 2007, residents living along the east coast of Texas scrambled unexpectedly for safety as Humberto went from an unnamed tropical depression to a Category 1 hurricane in less than twenty-four hours. The intensification rate was one of the highest that has ever been observed. According to the National Hurricane Center, "The rapid formation of a hurricane near the shore has long been a concern emphasized by the NHC in its outreach and preparedness talks. Humberto serves as a rare, important example."

On August 19, 2007, folks living in the Oklahoma City area awoke to the sounds of a tropical storm. But it wasn't a tropical storm. Well, not exactly. The remnants of Tropical Storm Erin had drifted northward from Texas. The remnant low actually intensified over Oklahoma producing an abrupt—and unusual—weather hazard: violent winds and life-threatening flash flooding, stronger than at landfall in Texas.

On January 7, 2008, residents of southeast Wisconsin flooded the local 911 switchboard with calls asking, "Why are the tornado sirens going off?" Callers were urged

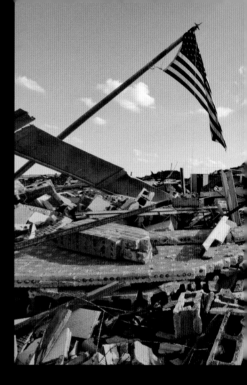

ABOVE
All that remains of the downtown Greensburg, Kansas, United States Post Office is a pile of rubble and an American flag. Much of Greensburg was obliterated by an EF-5 tornado on May 4, 2007.

OPPOSITE
A rolling weather lab called the Tornado Intercept Vehicle (nicknamed TIV-1) emerges from beneath a supercell thunderstorm in western South Dakota on June 6, 2007.

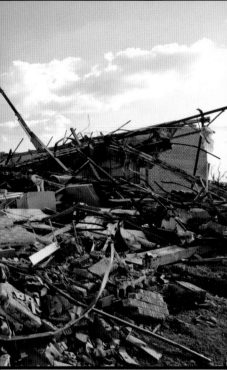

to head for their shelters. Seventy-five tornadoes struck the US that day during an abrupt and rare, winter outbreak. A friend later sent me an image of people dressed in parkas and gloves cleaning up tornado debris, surrounded by snow.

So, how do we adapt and prepare?

Based on my firsthand experiences with hundreds of storms, here are my top five recommendations:

1. Buy and use a NOAA weather radio.
2. Create a game plan.
3. Learn about weather.
4. Avoid driving during adverse conditions.
5. Be vigilant.

WEATHER RADIO

A NOAA all-hazards weather radio is the smoke detector for severe weather. It's small, battery-operated, and a true life and property saver. Any time the National Weather Service issues a watch or warning, a loud alert tone emits from the radio, followed by specific information detailing what you need to know in order to prepare for what's coming. It's that simple.

The radio is available at most major retail stores that sell electronics, sporting goods, or marine accessories. You can also purchase a weather radio online.

GAME PLAN

As weather hazards rise, you must have a personal or family game plan. That means being responsible for your own actions. If you already own and use a weather radio, you're off to a great start! But do you actually have a plan for what to do when severe weather approaches? Where will you go for shelter? What will you do with your pets and animals? How strongly built is your home? Do you have adequate insurance? These are critical questions that must be answered prior to the need arising.

WEATHER SMARTS

It may sound overly simple, but in my experience, the more you understand the weather, the better weather treats you. During your next coffee break, get online and discover the difference between a hurricane and a tornado. What's the difference between a watch and a warning? What time is high tide or astronomical twilight? What's the forecast for your area?

A number of Web sites will even teach you how to become your own forecaster. Consider keeping a journal like I do. How many weather records were broken this week? Who experienced the hottest temperature? The coldest?

DRIVING CONDITIONS

Nearly every week I hear or read about an interstate, highway, or street that had to be closed because of a multi-vehicle pileup or crash that was "caused by the weather." It makes me want to scream.

Weather doesn't "cause" a pileup or a wreck—drivers do. Specifically, drivers who

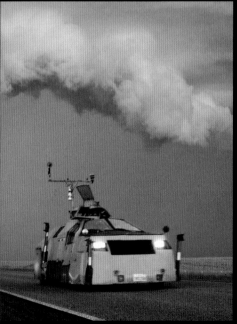

are careless or unsuspecting when traveling during adverse weather conditions. During the 2007–08 winter season dozens of US interstates and highways had to be closed due to hundreds of completely preventable motor vehicle crashes.

On February 10, 2008, there was a sixty-eight-vehicle pileup in Pennsylvania blamed on snow. Sixty-eight vehicles! Again, snow did not "cause" anyone to start his or her engine and drive into the storm. Had these drivers checked the forecast in advance, they would have learned from the National Weather Service: "Driving conditions will be treacherous. Travel is strongly discouraged."

Whether it's snow, smoke, or some other challenge—*it's your responsibility* to understand the hazards.

BE VIGILANT

Monitor the weather in your area on a daily basis. Learn how to check radar, pending watches, and active warnings. If the chance of weather hazards is mentioned in the morning, look for updates throughout the day. Check again before going to bed—and keep your weather radio turned on. Remember, it all starts with taking *personal responsibility*.

Of the top ten most costly catastrophes in the United States, eight are hurricanes, with six having occurred since 2004. Most meteorologists I have interviewed are convinced that America is going to experience future hurricanes that are even larger and more forceful than Katrina and Ike.

In 2008, a new record was set when six tropical cyclones made consecutive landfall in the US: Dolly, Edouard, Fay, Gustav, Hannah, and Ike. That's six storms in a row, each striking the US—something that has never happened before. But despite this increased frequency, recent surveys continue to reveal a frighteningly high percentage of residents in hurricane-vulnerable states still don't take hurricanes seriously. More than 50 percent do not have a family disaster plan.

During Katrina, the world watched as America experienced its worst loss of life from a weather event since the 1920s. How could this occur in a country so advanced? How could this occur in a country so wealthy and strong? How did we allow this to happen, period?

Simple answer: we weren't prepared.

In 1999, social scientist Roger Pielke Jr. said to me during an interview for *Scientific American* magazine, "A lot of times people look to Mother Nature as the cause for our problems, when in fact, it's actually the decisions we make every day that are underlying our vulnerabilities."

I urge you to evaluate your own vulnerabilities and prepare accordingly. That, in and of itself, is a great start to adapting.

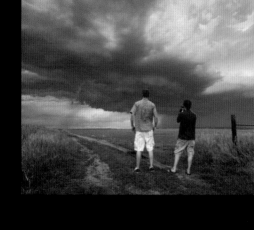

TOP
Storm chasers Joel Taylor (left) and Reed Timmer document a supercell thunderstorm in South Dakota on June 6, 2007.

OPPOSITE
Hurricane Gustav approaches New Orleans, Louisiana, on August 31, 2008. The tropical cyclone made landfall a few hours later as a Category 2 hurricane just west of the city.

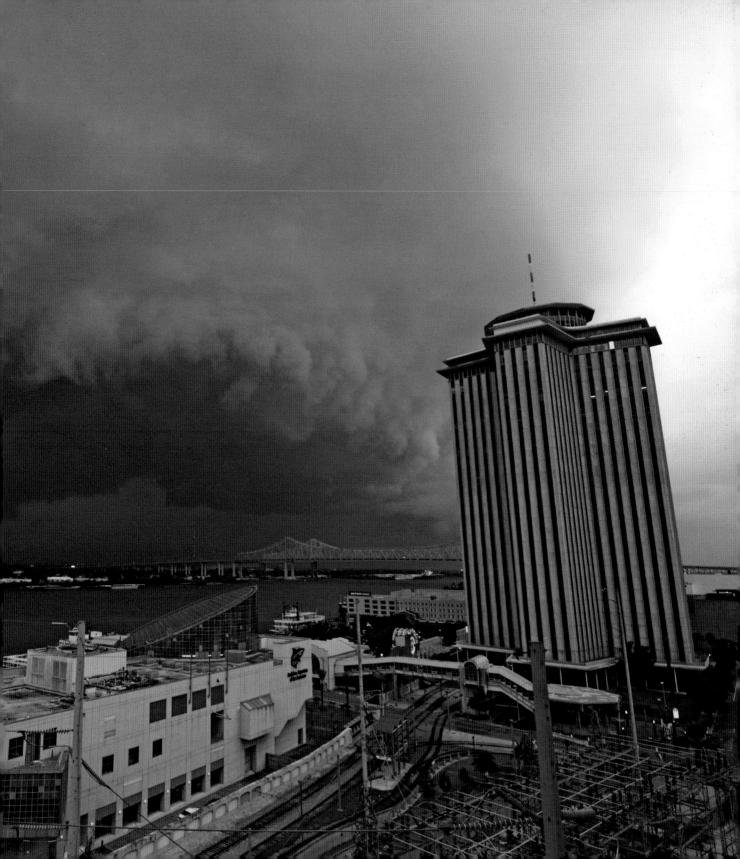

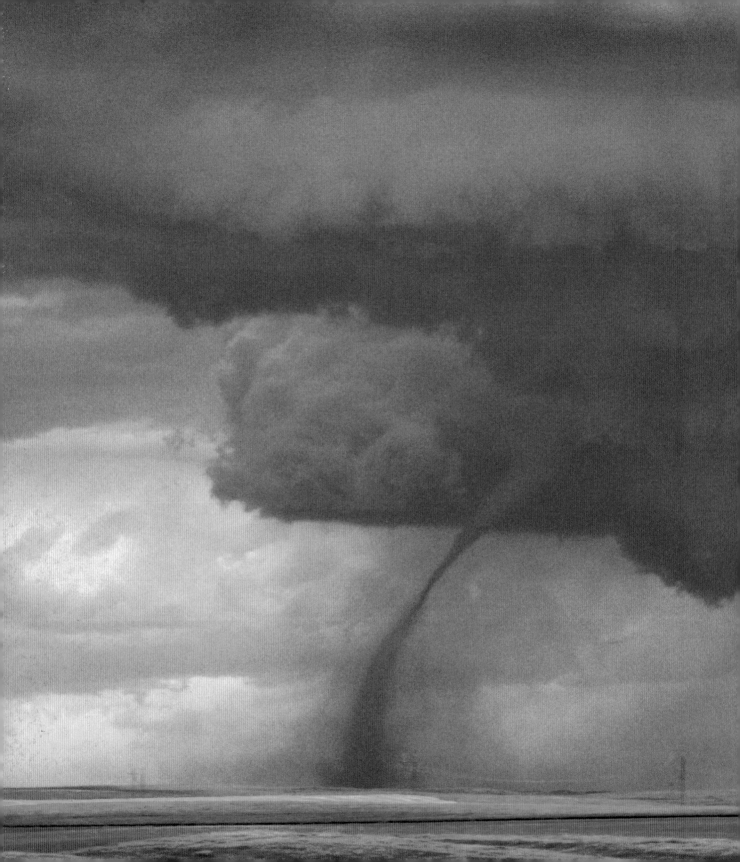

LEFT

A tornado whirls across western
South Dakota on June 6, 2007.

OVERLEAF

A heavy glaze of ice coats trees
in central Kansas following
a powerful winter storm that
struck America's heartland on
December 10–11, 2007. The
winter storm left at least twenty-
four dead and close to a million
residents without electricty.

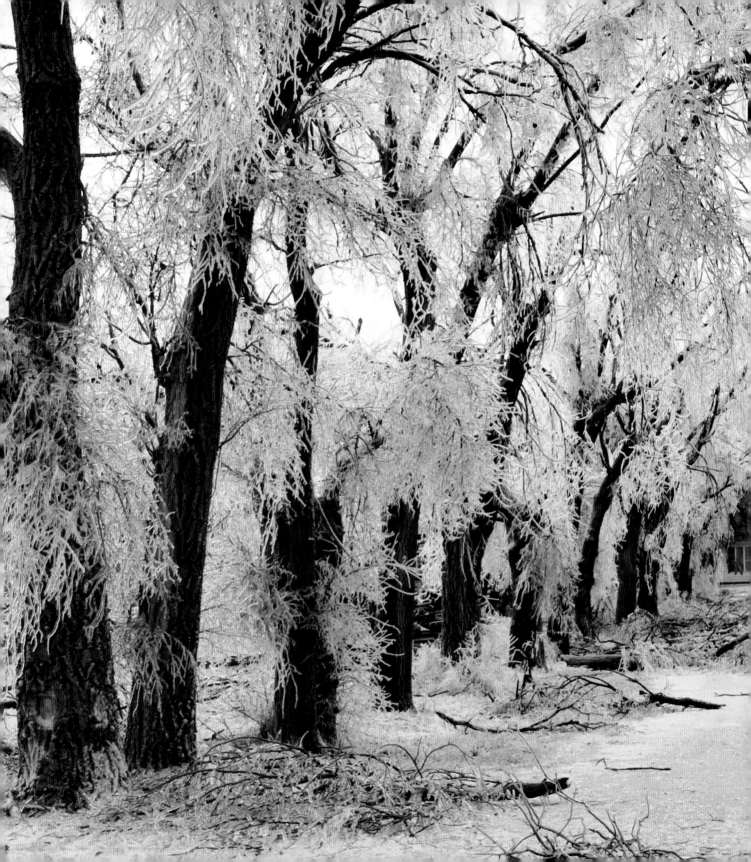

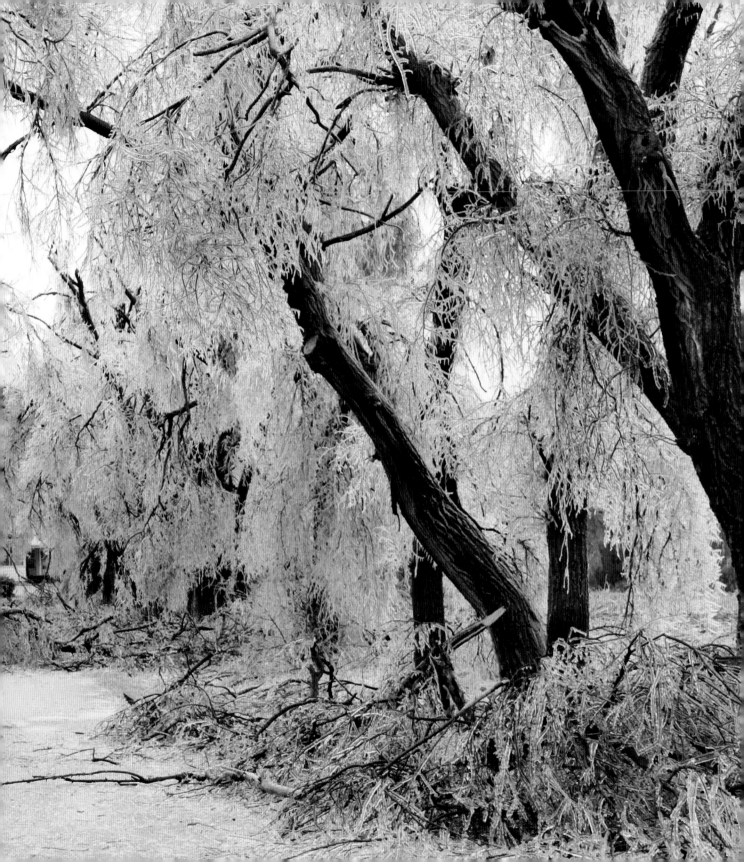

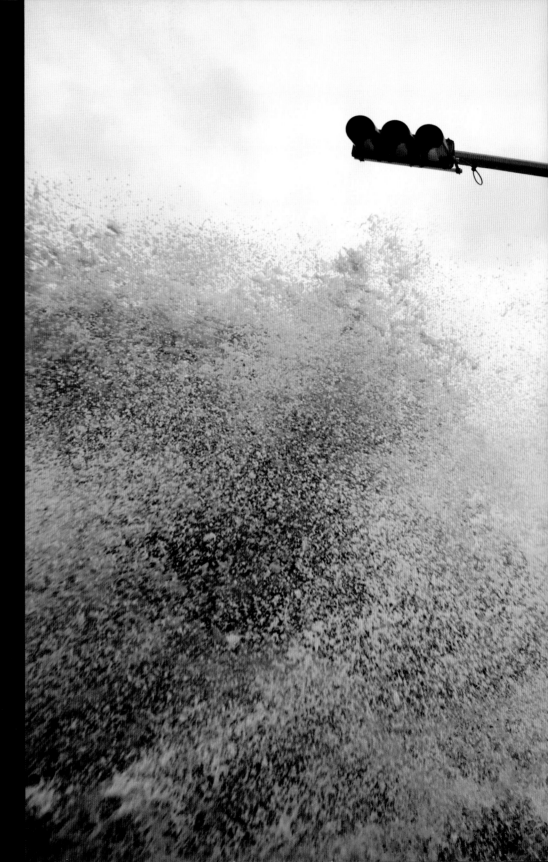

RIGHT

Waves explode over a seawall and into Galveston, Texas, as Hurricane Ike approaches on September 12, 2008. Less than twelve hours after this photo was taken, Hurricane Ike's ferocious storm surge destroyed many homes and businesses along the southeast Texas coast.

OVERLEAF

Storm clouds drift over a field of wildflowers in south central Kansas on April 11, 2008.

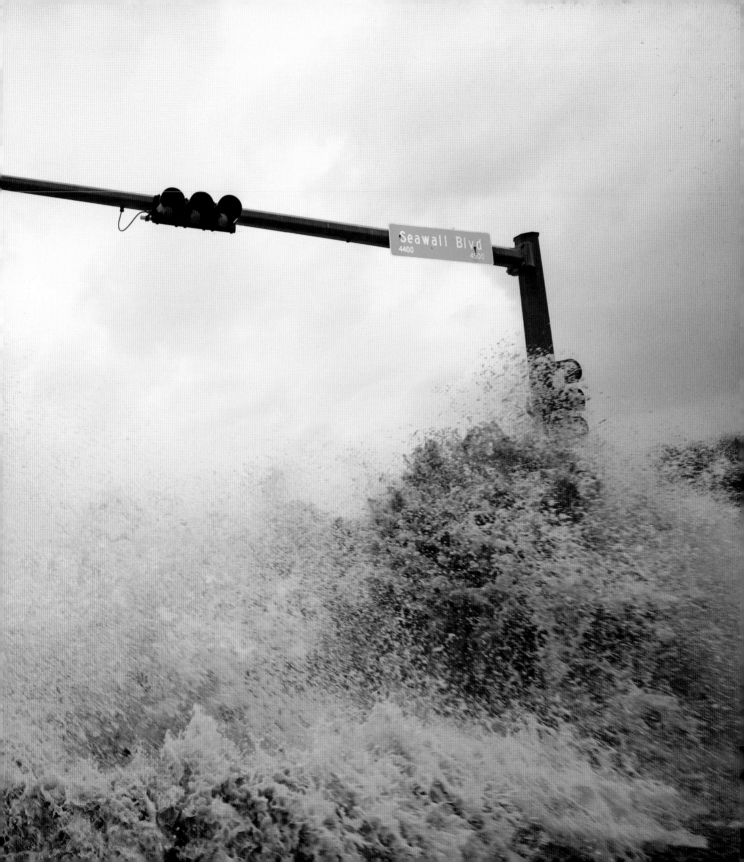

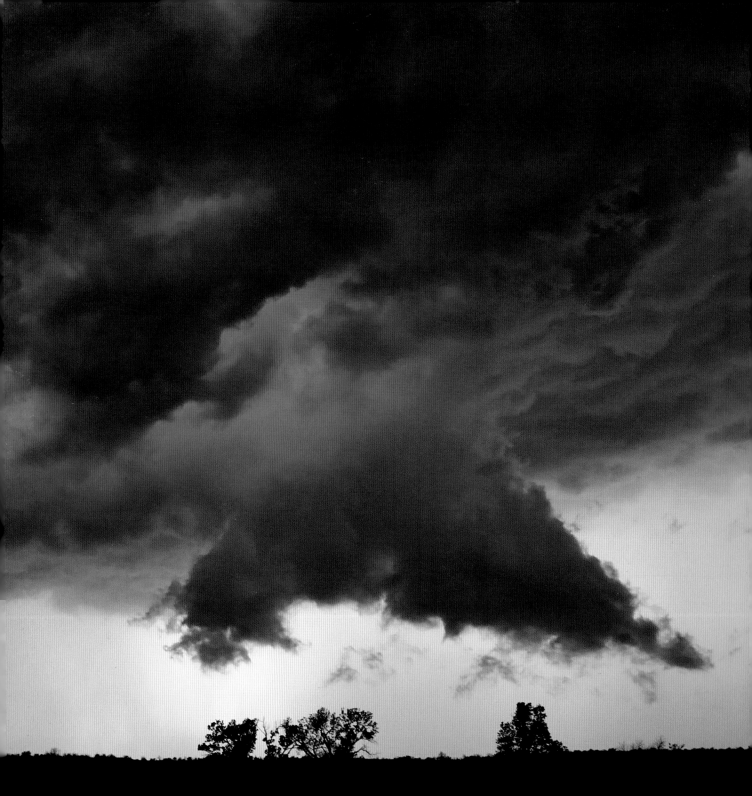

A developing wall cloud takes shape beneath a tornadic thunderstorm near Fredonia, Kansas, on May 1, 2008.

A supercell thunderstorm erupts over west central Kansas on May 8, 2008.

An explosive tornadic supercell threatens Wakeeney, Kansas, on May 22, 2008.

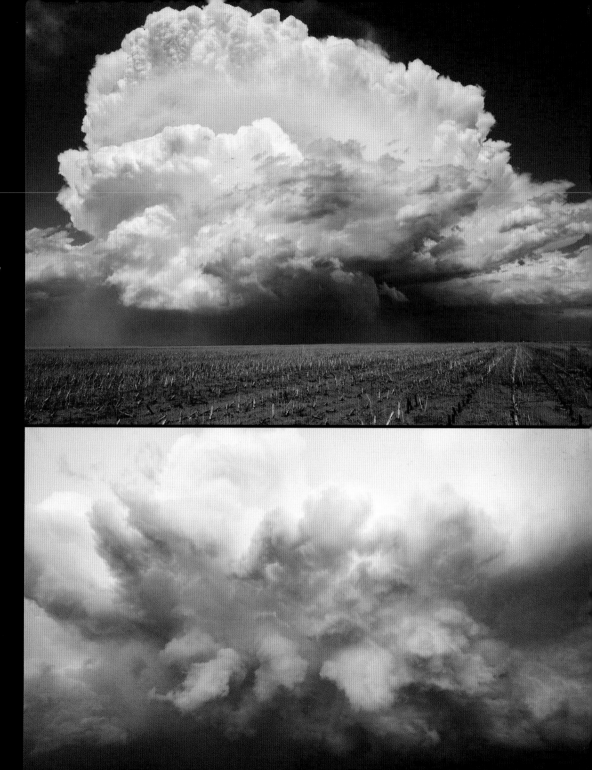

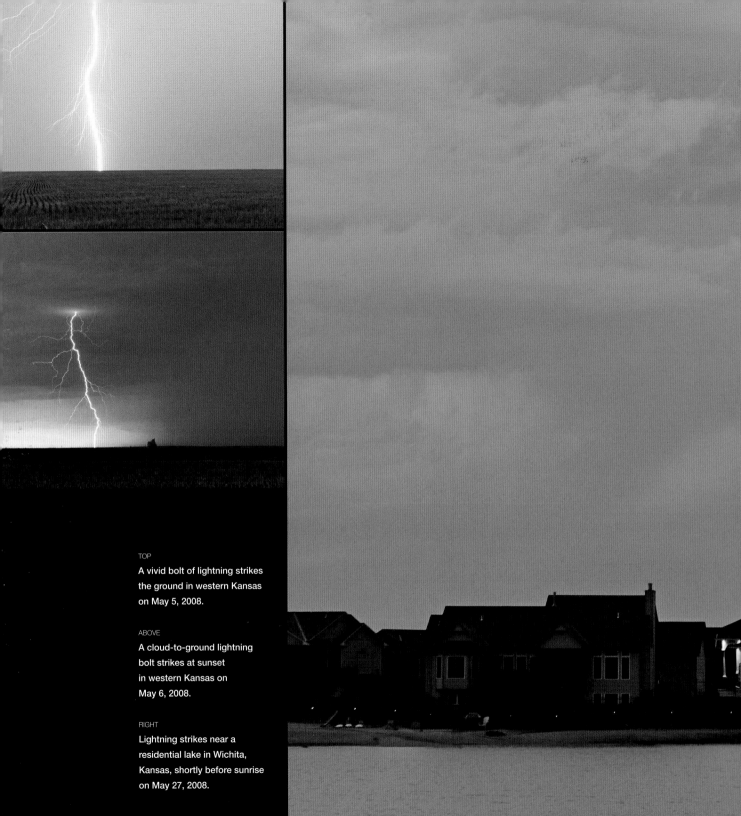

TOP

A vivid bolt of lightning strikes the ground in western Kansas on May 5, 2008.

ABOVE

A cloud-to-ground lightning bolt strikes at sunset in western Kansas on May 6, 2008.

RIGHT

Lightning strikes near a residential lake in Wichita, Kansas, shortly before sunrise on May 27, 2008.

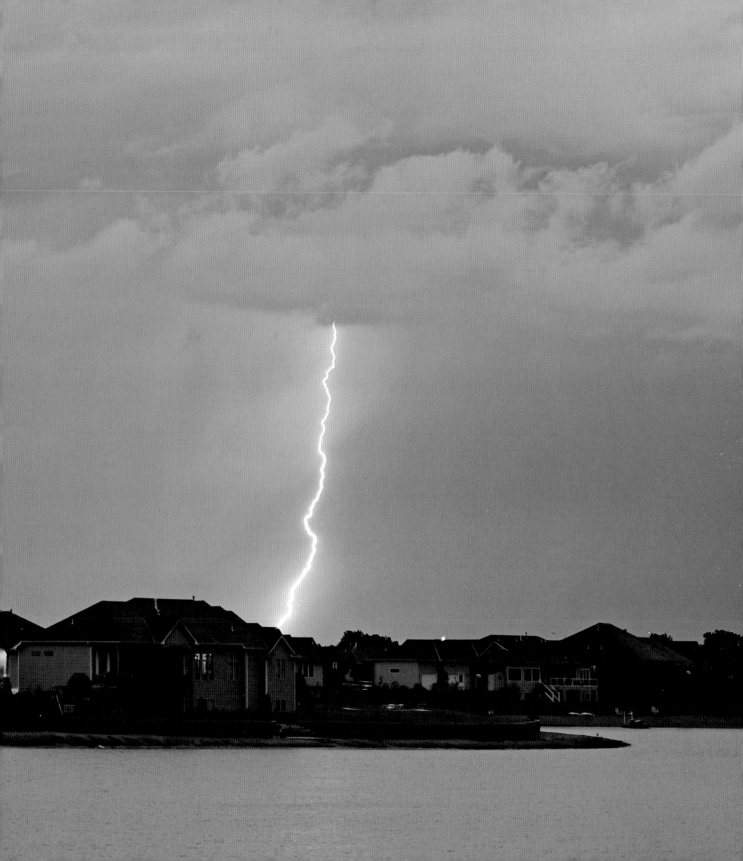

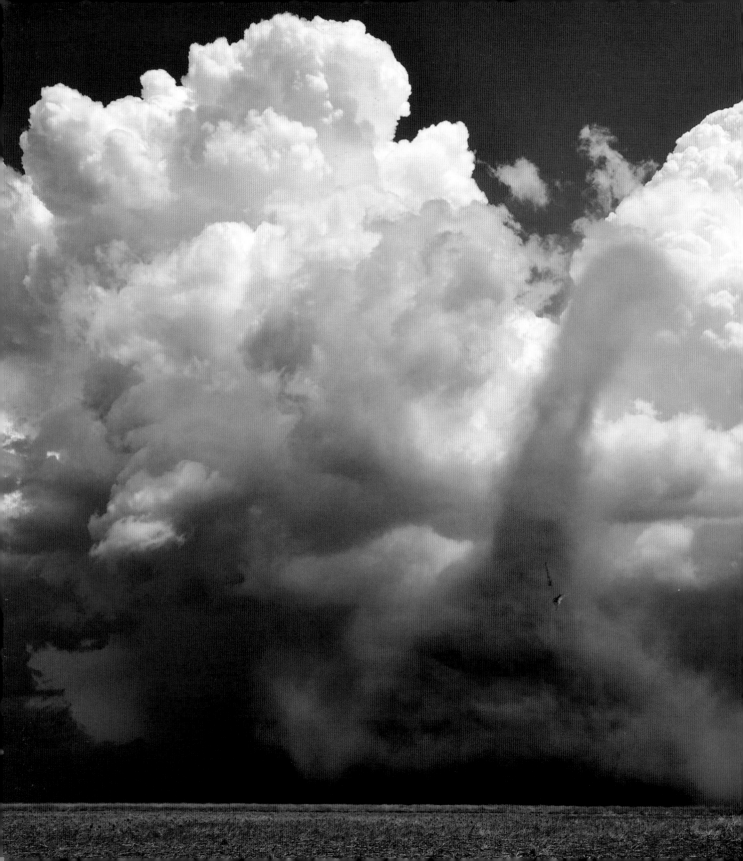

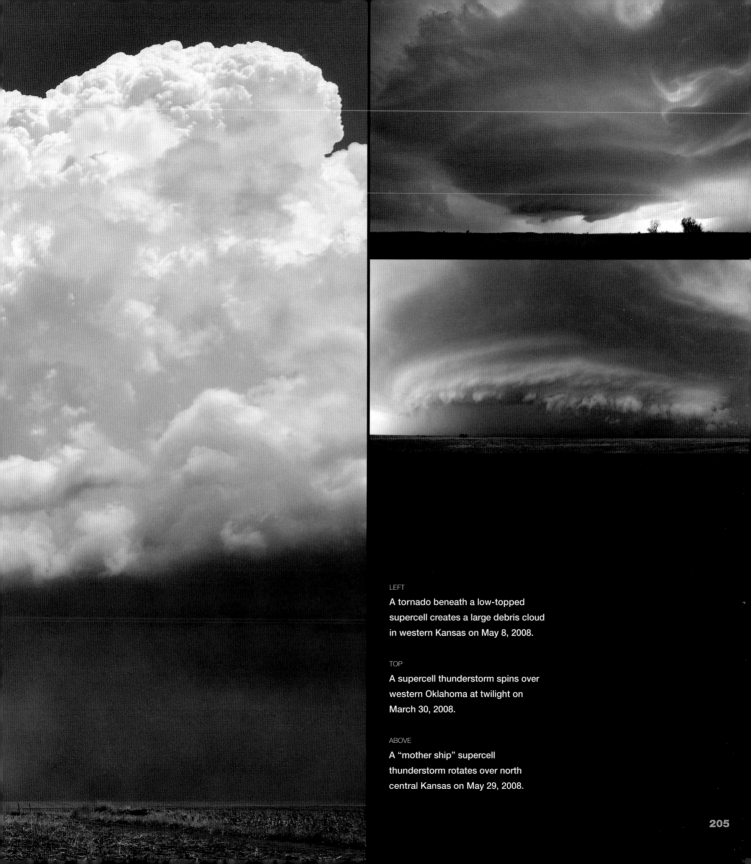

LEFT

A tornado beneath a low-topped supercell creates a large debris cloud in western Kansas on May 8, 2008.

TOP

A supercell thunderstorm spins over western Oklahoma at twilight on March 30, 2008.

ABOVE

A "mother ship" supercell thunderstorm rotates over north central Kansas on May 29, 2008.

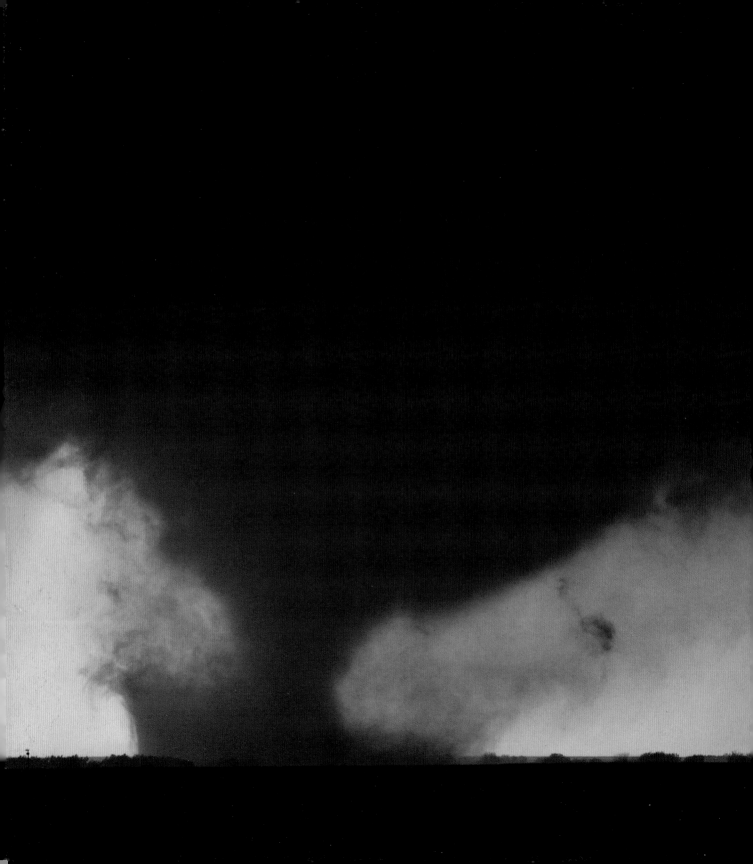

glossary and bibliography

ENHANCED FUJITA TORNADO DAMAGE SCALE (also known as the EF Scale). A tornado rating system designed to replace the Fujita Tornado Damage Scale in an effort to achieve greater accuracy.

FUJITA TORNADO DAMAGE SCALE (also known as the F Scale). A scale of wind-damage intensity in which tornado wind speeds are determined from a survey of the damage caused by the storm.

GLOBAL WARMING. An increase in the average temperature of the Earth's surface.

HURRICANE. A tropical cyclone with winds of seventy-four miles per hour or greater that can produce violent winds, storm surges, torrential rains, and flooding.

MESOCYCLONE. The rotating region of a supercell thunderstorm, typically two to six miles in diameter.

SAFFIR-SIMPSON HURRICANE SCALE. A one through five rating based on a hurricane's present intensity. This scale is used to give an estimate of the potential property damage and flooding expected from a hurricane landfall.

STORM CHASER. One who tracks and intercepts storms.

STORM SURGE. An onshore rush of multiple waves caused primarily by high winds pushing on the ocean's surface, usually during a tropical cyclone.

TIDAL WAVE. An unusually high sea wave or unusual rise of water alongshore due to strong winds or earthquake.

TORNADO. A violently rotating column of air in contact with both a cloud base and the ground.

TROPICAL CYCLONE. An organized deep convection with a closed surface-wind circulation and a well-defined center. Also known as a hurricane, typhoon, and tropical storm.

TSUNAMI. A great sea wave produced especially by submarine earth movement or volcanic eruption.

TWISTER. Same as a tornado (see definition above).

TYPHOON. Same as a hurricane (see definition above).

WEATHER PHOTOGRAPHER. One who practices photography with an emphasis on weather.

WINDCHILL. The apparent temperature felt on exposed skin due to the combination of air temperature and wind speed.

RECOMMENDED WEB SITES

College of DuPage Next Generation Weather Lab (www.weather.cod.edu)

Hurricanetrack.com (www.hurricanetrack.com)

National Center for Atmospheric Research (www.rap.ucar.edu/weather)

National Hurricane Center (www.nhc.noaa.gov)

National Hurricane Survival Initiative (www.hurricanesafety.org)

National Oceanic and Atmospheric Administration (www.noaa.gov)

NOAA Weather Radio (www.weather.gov/nwr)

Silver Lining Tours (www.silverliningtours.com)

Storm Prediction Center (www.spc.noaa.gov)

Storm Ready! (www.stormready.noaa.gov)

Stormtrack (www.stormtrack.org)

Tempest Tours (www.tempesttours.com)

Tornado Project Online, The (www.tornadoproject.com)

Weather Channel, The (www.weather.com)

Weather Underground, The (www.wunderground.com)

World Meteorological Organization (www.wmo.ch)

RECOMMENDED READING

Bell, Art and Whitley Strieber. *The Coming Global Superstorm*. New York: Pocket Star, 2000.

Davies, Jon. *Storm Chasers—On the Trail of Twisters!* Helena, MT: Farcountry Press, 2007.

Reed, Jim and Mike Theiss. *Hurricane Katrina: Through the Eyes of Storm Chasers*. Helena, MT: Farcountry Press, 2005.

RECOMMENDED VIEWING

DiCaprio, Leonardo, *The 11th Hour*, Hollywood, CA: Warner Independent Pictures, 2007

Emmerich, Roland. *The Day After Tomorrow*. London, England: 20th Century Fox, 2004.

Gore, Al. *An Inconvenient Truth*. Hollywood, CA: Paramount Classics, 2006.

Lee, Spike. *When the Levees Broke: A Requiem in Four Acts*, New York: HBO Documentary Films, 2006.

Reggio, Godfrey. *Koyaanisqatsi: Life Out of Balance*. Hollywood, CA: Island Alive and New Cinema, 1983.

index

Washington
BLUE-RIBBON
Fly Fishing Guide

John Shewey

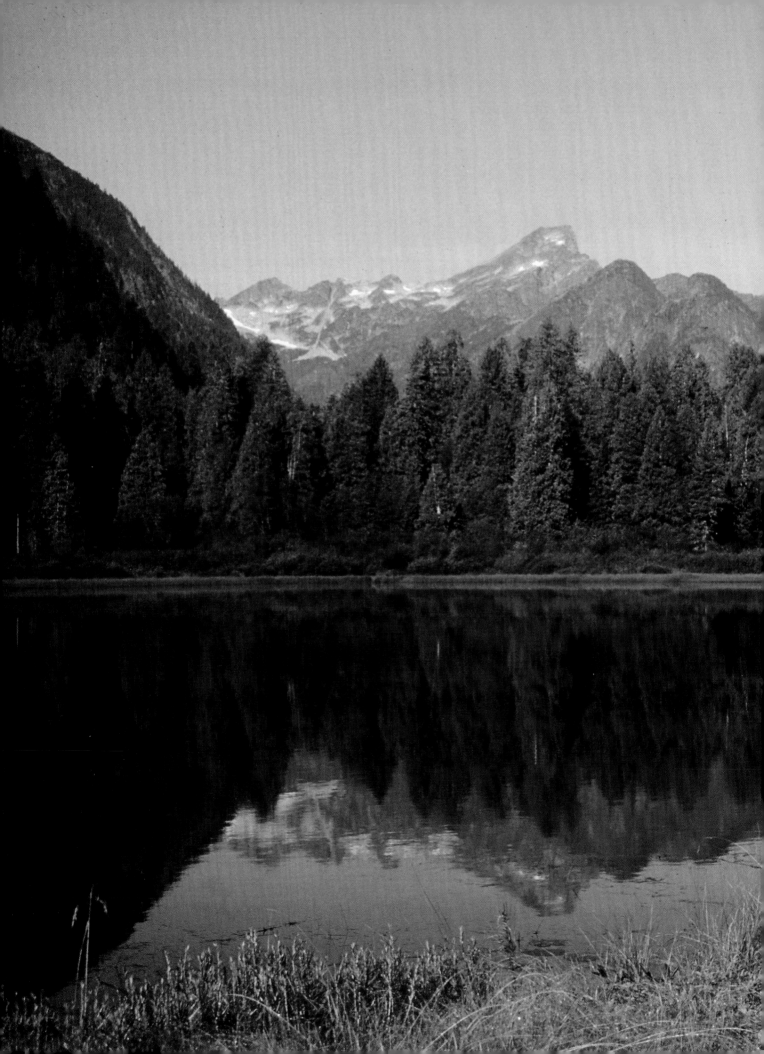

Washington
BLUE-RIBBON
Fly Fishing Guide

John Shewey

Frank Amato
PUBLICATIONS, INC.

ABOUT THE AUTHOR

A writer, author and photographer from Oregon, John Shewey travels extensively throughout the Northwest in pursuit of fly-angling adventures. Summer steelhead and upland gamebirds occupy much of his time during the autumn, but John's angling pursuits lead him annually to destinations ranging from the Pacific surf to the famous Western spring creeks to the the alpine lakes of the West. His steelhead flies have earned national recognition. John has authored numerous magazine articles and his other books include *Mastering the Spring Creeks, Fly Fishing for Summer Steelhead, Northwest Flyfishing: Trout & Beyond, Fly Fishing Pacific Northwest Waters, Alpine Angler,* and *North Umpqua Steelhead Journal.*

ACKNOWLEDGMENTS

This project would not have been possible if not for the assistance of many individuals. My sincere thanks goes to the people of the Washington Department of Fish & Wildlife. Thanks also to my fishing partners, Forrest Maxwell and Tim Blount, who have helped immensely in my "field research" (and loved every minute of it); finally, thanks to DeAnn for putting up with some 100 days of absenteeism during my research trips for this book.

Published in 1999 by:
Frank Amato Publications, Inc.
PO Box 82112 • Portland, Oregon 97282 • (503) 653-8108

Cover photos: John Shewey
Fly Plates: Jim Schollmeyer

All other photographs taken by the author unless otherwise noted.

Book Design: Tony Amato
Production: Staff

Softbound ISBN: 1-57188-134-4 Softbound UPC: 0-66066-00334-8

Printed in Canada

1 3 5 7 9 10 8 6 4 2

TABLE OF CONTENTS

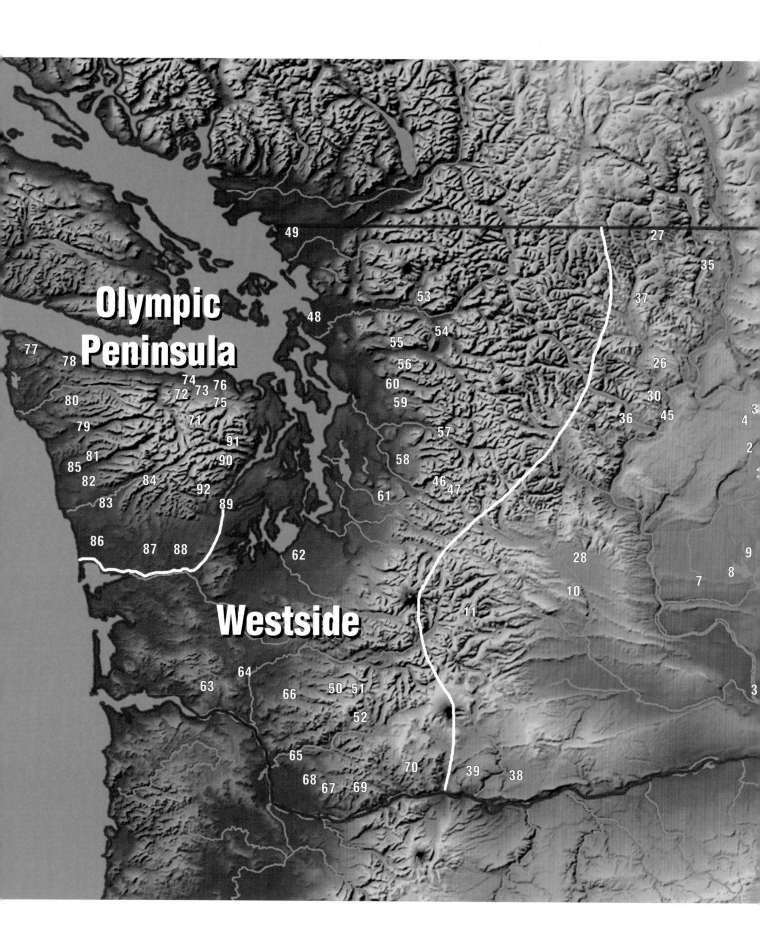

Olympic Peninsula

Westside

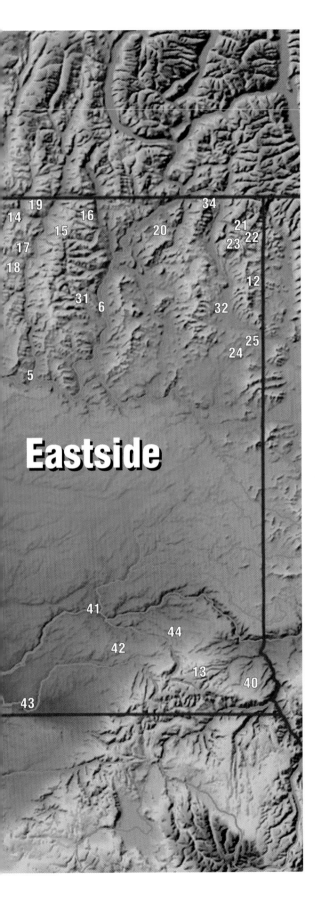

EASTSIDE LAKES

1 Dry Falls Lake
2 Lake Lenore
3 Grimes Lake
4 Jameson Lake
5 Banks Lake
6 Roosevelt Lake
7 Lenice Lake, Nunnally Lake, Merry Lake
8 Quail Lake
9 Seep Lakes and Potholes Reservoir
10 Wenas Lake
11 Leech Lake
12 Browns Lake
13 Big Four Lake
14 Chopaka Lake
15 Ell Lake
16 Bonaparte Lake
17 Aeneas Lake
18 Blue Lake
19 Blue Lake (near Wannacut Lake)
20 Long Lake
21 Starvation Lake
22 Bayley Lake
23 McDowell River
24 Amber Lake
25 Medical Lake
26 Wapato Lake
27 The Pasayton Wilderness

EASTSIDE TROUT STREAMS

28 Yakima River
29 Rocky Ford Creek
30 Entiat River
31 San Poil River
32 Colville River
33 Rocky Ford Creek
34 Kettle River
35 Chewack River

EASTSIDE STEELHEAD STREAMS

36 Wenatchee River
37 Methow River
38 Klickitat River
39 White Salmon River
40 Grand Ronde River
41 Snake River
42 Touchet River
43 Walla Walla River
44 Tucannon River
45 Entiat River

WESTSIDE LAKES & TROUT STREAMS

46 Rattlesnake Lake
47 The Forks of the Snoqualmie
48 Pass Lake
49 Squalicum Lake
50 Coldwater Lake
51 Castle Lake
52 Merrill Lake

WESTSIDE STEELHEAD STREAMS

53 Skagit River
54 Sauk River
55 North Fork Stillaguamish River
56 South Fork Stillaguamish River
57 Skykomish River
58 Snoqualmie
59 Tolt River
60 Pilchuck River
61 Green River
62 Nisqually River
63 Elochoman River
64 Cowlitz River
65 Kalama Rivers
66 South Fork Toutle River
67 East Fork Lewis River
68 North Fork Lewis River
69 Washougal River
70 Wind River

OLYMPIC PENINSULA RIVERS & LAKES

71 Elwha River, Upper
72 Aldwell Lake
73 Elwha River, Middle
74 Elwha River, Lower
75 Dungeness River, Upper
76 Dungeness River
77 Hoko River
78 Sol Duc River
79 Bogachiel River
80 Calawah River
81 Hoh River
82 Queets River
83 Quinault River, Lower
84 Quinault River, Upper
85 Clearwater River
86 Humptulips River
87 Wishkah River
88 Wynoochee River
89 Skokomish River and Hoodsport
90 Duckabush River
91 Dosewallips River
92 Prices Lake

MAP 7

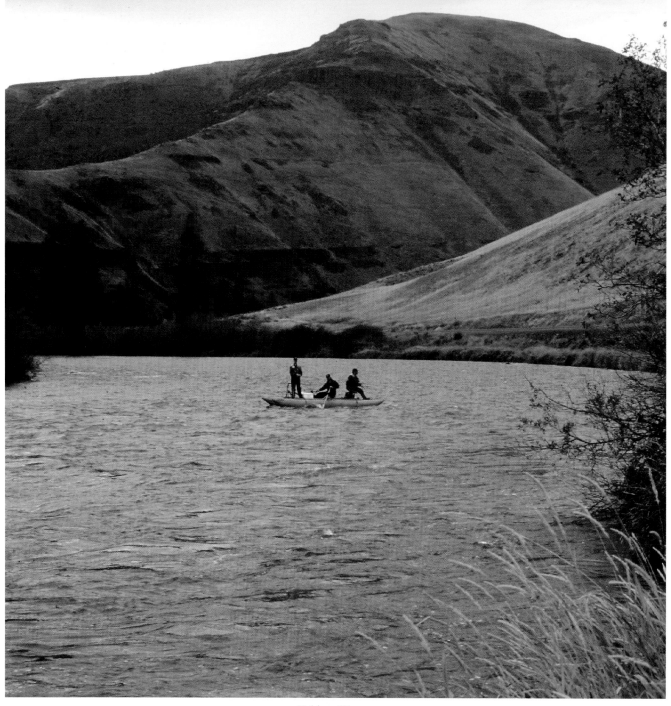

Yakima River.

INTRODUCTION

In writing this guide book, I had to consider many potential consequences. Chief among these is the fact that by virtue of writing about specific destinations I would likely make somebody mad. After all, none of us likes to see our "pet" waters written up in either book or magazine form. My answer to that was simply to focus on the most significant waters—those waters of most interest to fly-anglers. In the case of small waters in out-of-the-way places, I decided in many cases to offer enough comment to get you started in the right direction. For other such waters, I have said little or nothing: Anyone with a desire to explore new places can locate a tiny mountain stream or remote alpine lake on a Forest Service map, lace up the hiking boots, and embark on a voyage of discovery.

I have not visited every destination listed in this book. I have been to most of them. Those places to which I have not personally ventured, however, received the same thorough research as those places with which I am familiar. My goal, above all else, was to write an accurate and useful guide to the many great fly-fishing waters in Washington. Within this guide, I hope you will find information that will help you discover Washington from a fly-angler's perspective. Writing this book was a great experience for me as I visited waters I have always wanted to fish and re-acquainted myself with old stomping grounds, rekindling fond memories of great days afield.

Eastern Washington's greatest claim to fly-fishing fame is its myriad productive lakes that produce fast-growing trout. Scattered across the entire region, from Chopaka Lake high in the Okanogan country, to the scrub-land seepage lakes along the Columbia, the stillwater fisheries of eastern Washington offer the opportunity to angle for trout that frequently span 16 to 20 inches.

What's more, many of these lakes occupy remarkable landscapes, perhaps none more so than Dry Falls Lake and Lake Lenore, whose shores yield to precipitous basalt rims. The wind blows hard and often across the lakes of the Washington plains. But the morning calm expresses the desert beauty with stunning sunrises and the setting sun of evening paints the rimrocks in vivid shades of red and crimson; the sage-covered hills in pastel purple.

Many of the best lakes are set aside as fly-only or Selective Fishery waters. Indeed, these regulations are responsible for creating such great fisheries. Fly-anglers flock to the lakes, especially in the spring, but even the crowds of an April weekend hardly affect the quality of the fishing—though in places you may have to watch your backcast to avoid hitting a fellow float-tuber.

If you are new to the lake country of eastern Washington, a few words of wisdom for your travels: Be sure to carry plenty of drinking water and perhaps an extra gas can. If you plan on building a campfire, bring your own wood and check on the fire regulations at specific locales. Large towns are few and far between, but many eastern Washington communities welcome travelers: A few first-rate restaurants (at least by my standards) and plenty of friendly, clean accommodations are available for the asking in destinations like Othello, Ephrata, Tonasket, Oroville, and Omak among many others.

Eastern Washington includes a lot of different landscapes, not just the sagebrush plains and scenic coulees many people associate with the dry side of the mountains. In fact, the northern tier of the east side features forested mountains while the desert plains of the southeast yield in many places to vast expanses of grain, and in the valleys to rich vineyards increasingly renowned for superb wines. Yakima, Spokane, and the Tri-Cities are, of course, the largest cities east of the Cascades, and all offer fly-angling shops as do the foothill towns of Wenatchee and Ellensburg.

Dry Falls Lake (Grant County)

Named for the stunning basalt cliffs encircling much of the lake, Dry Falls is the remnant seepage of once-massive waterfalls of the mighty Columbia River's pre-historic path. This stark and beautiful desert setting is one of the attractions of fishing this popular selective-fishery lake, which is nestled in the northern corner of Sun Lakes State Park just a few miles south of Coulee City.

The other attraction is the trout, for Dry Falls Lake grows them well. Rainbows and browns inhabit this fertile 99-acre lake with average fish

Large Dry Falls Lake trout.

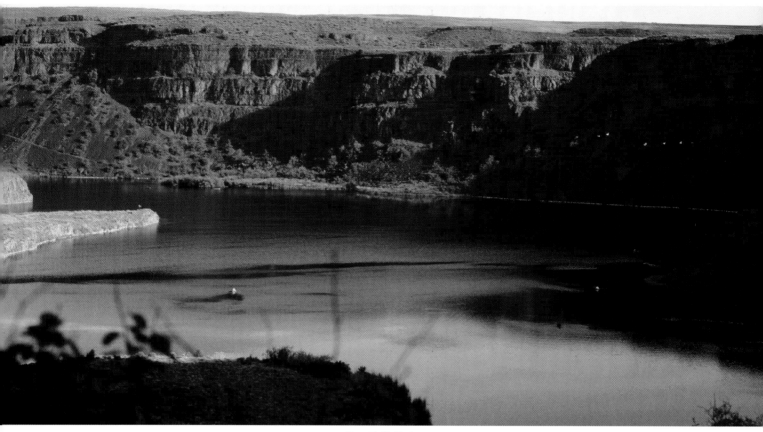

Dry Falls Lake.

running 14 to 16 inches and quite a few stretching to 20 or more inches. The occasional fortunate angler will hook a torpedo brown trout of six or seven pounds.

Most of the lake is less than 25 feet deep and extensive weedy shallows dominate except in the deep basin lying just off the ancient cliffs that form the north shore. The entire south side of the lake, including a long, narrow channel that reaches out like a finger is comprised of densely vegetated, super-rich shallows. Perhaps the most enjoyable fishing on the lake takes place in these shallows and along the shallow edges elsewhere where trout cruise along looking for food. In these areas, anglers can sight-fish for big trout spring and fall, especially during calm mornings and evenings.

The heat of mid- to late summer drives the fish off the shallows during most of the day, but anglers who venture out at dawn and dusk can find big trout cruising lanes in the weed beds. Summer fishing can also prove productive in the lake's deep north side: Fish a leech pattern or other large fly near the bottom on a sinking line. The first good *Callibaetis* and Chironomid hatches also offer some shallow-water fishing along the lake margins, although any slight breeze ripples the water and makes sight-fishing impossible.

Spring on Dry Falls means Chironomids. The "midge" rises can be spectacular at times, but they can also be frustrating. The trout typically key on pupae rising toward the surface. Sparsely dressed black, dark gray, or crimson pupa patterns, tied on size 14 to 16 hooks and fished sub-surface with a combination of short twitches and dead-drifting, produce strikes most of the time. Use a 12- to 18-foot leader with a long tippet of 5X or even 6X material. You can employ a Griffith's Gnat as a strike indicator, attaching this dropper two to six feet above the pupa pattern.

Some Washington lake anglers make a practice of "bobber fishing" during the midge hatch by using a large Corkie or similar float attached to the leader above one or more pupa patterns. The whole works is pitched overboard and then allowed to drift with the wind. While I can't argue the effectiveness of this method I will contend that, except when

the trout grabs hold, it leaves a lot to be desired in terms of action. I like to cast a fly line and I like the way a fish smacks a fly being actively retrieved. Hence the bobber method isn't for me. Try it for yourself, though, and perhaps you will find that the inherent effectiveness of this method outweighs its tedium.

When Dry Falls trout are feeding greedily on the Chironomids during a heavy spring emergence you are not likely to hook a trout on anything but a like imitation. If you see lots of dimpling trout, fish a pupa pattern in the surface film or just below the surface. A combination of the two often works wonders: Fish a suspender midge or a buzzer on the dropper and a lightly dressed pupa on the tip just a few inches below.

If adult Chironomids abound but you don't see dimpling trout in any numbers, you can safely assume the trout are feeding on midge pupae above the weed beds. In this case, fish a pupa pattern below an indicator or below a Griffith's Gnat or buzzer as described above. Unless a heavy Chironomid emergence brings lots of trout to the surface, I prefer to search out those fish cruising along the shallow edges, where one can try to intercept them with a damsel or *Callibaetis* mayfly nymph. Even when midges dominate on Dry Falls, you can generally find a few trout cruising the edges and sampling other foods.

The *Callibaetis* hatch on Dry Falls, while not as heavy and predictable as that on some of eastern Washington's other lakes, nonetheless offers good fishing at times during late spring and early summer. The mayflies emerge throughout the lake, even in surprisingly deep water, where the duns often find themselves adrift for quite some time. On several occasions I've encountered sparse but fishable *Callibaetis* hatches during September.

The damsel population is enormous, with the hatch peaking between late May and late June depending on spring weather patterns. Use 15- to 18-foot leaders and fish nymphs on a slow retrieve near weed beds and shoreline reeds. Effective patterns are numerous, though I've come to rely on just a few dressings for most of my damsel fishing. These include the Strip Damsel and Diving Damsel. If you encounter a good Dry Falls

damsel hatch on a windy day, watch the edges along the reed stands. Sometimes the trout will rise for adult damsels, making for some explosive dry-fly action.

Dragonfly nymphs are abundant as well and like the damsel nymphs, their color will match that of the weeds where they live. This is a great lake for fishing Floating Dragonfly nymphs. The trick works like this: Using a high-density 10-foot sink-tip line and a 12- to 15-foot leader, cast the Floating Dragon over weed beds in six to 20 feet of water. Allow the line to sink while the Floating Dragon floats on top. After the line sinks to the bottom, pull the fly under water with a sharp jerk on the line. Now make four to six quick six-inch pulls on the line and then pause. Repeat until you reach the end of the line. This technique causes the fly to swim down rather than up, mimicking the efforts of a dislodged dragonfly nymph to swim back to the cover of the weed beds.

Dry Falls Lake is thick with the other typical lake inhabitants—water beetles, scuds, boatmen, leeches, and snails. Water boatman and water beetle imitations can be especially effective late in the evening during late spring and early summer and again during the fall.

Autumn brings an end to the typically hot eastern Washington summer and spurs Dry Falls trout into a renewed feeding binge during which just about any attractor-type lake fly will take its share of fish. Perennial favorites include olive or peacock Carey Specials, Woolly Buggers, and any number of leech patterns, all of which will produce right up to the season closure (end of November) or ice-up, whichever arrives first.

Dry Falls Lake is the perfect float-tube water. It features an irregular shoreline that swings up against the cliffs and then wraps around a long peninsula jutting into the lake from the southwest. Just off this peninsula lies a rocky island. The lake is just large enough that even on crowded days one can find a corner or cove far enough away from other folks. And indeed the lake gets crowded. Dry Falls is a favorite for fly-angling clubs during the spring.

As the season wears on, however, the crowds tend to ease a bit. Hot summer weather puts a damper on daytime fishing as the trout seek refuge in the depths, but morning and evening can be productive even at the height of July and August. With autumn comes cool weather and fewer people than spring.

To reach Dry Falls Lake from the south, follow I-90 into Grant County and then, if you're arriving from the west, take Hwy. 283 northbound or if you're arriving from the east take Hwy. 17 north out of Moses Lake. Both highways converge just north of Ephrata in the little town of Soap Lake. From here, drive north on 17 past Lake Lenore and past Blue Lake before turning right into Sun Lakes State Park. Drive down through the park, past the public campground, and then turn left on a signed road. Follow the signs from here for about three miles to reach the lake. The last half of the road is gravel and can get rough in places.

Camping is not allowed at Dry Falls Lake, so you may want to stake out a spot at the raccoon-infested campground at the state park. If you're so inclined, an early morning hike through the desert landscape northeast of the lake is worth the time. Deer trails comb the area, though you can seek your own route just as easily. Desert birds, including falcons, owls, chukars, wrens, and countless others are abundant, as are lizards and snakes, including rattlers. Springtime wildflower blooms can be spectacular.

Park Lake, the north third of which lies within Sun Lakes State Park, is worth checking out if Dry Falls gets too crowded. It too holds rainbows and browns and though they won't typically get as big as those in Dry Falls, they can provide for a fun evening. Deep Lake, out

on the east edge of the park, can offer good fishing for average rainbows. Meadow Creek, which connects Deep Lake and Park Lake, holds small trout as well. Warmwater enthusiasts can ferret out some crappie, bass, and sunfish opportunities in the area.

Lake Lenore (Grant County)

Its trout fishing aside, Lake Lenore is a rather awesome piece of real estate, filling a spectacular desert coulee whose sides are formed of sheer rock escarpments. The narrow lake occupies five miles of Lower Grand Coulee and covers about 1,500 acres.

The trout are impressive as well, as much for their size as for their ability to withstand alkaline waters and extremes in temperature. These are Lahontan cutthroat trout, natives of Nevada that have been successfully introduced in Lake Lenore. In fact they thrive here, reaching lengths close to 30 inches with four- and five-pound specimens quite common. These cutthroat were introduced during the late 1970s and have since survived remarkably well in Lake Lenore—a body of water that otherwise could not support trout due to its alkaline waters. These days, six- to 10-pound Lahontans are fairly common.

They are beautiful trout, ranging from silvery-green to olive-orange in cast with large spots and deep orange slashes adorning their huge jaws. They don't jump like a rainbow, but they are determined fighters and a cutthroat of five or six pounds comes to the net begrudgingly.

During spring, when the fish go through the motions of spawning, many of them ascend a small stream on the lake's east bank where a fenced holding pool allows close-up observation. At this time they are colored most brilliantly and you can watch as some very large trout vie for positioning along the gravel bottom.

Perhaps a better way to get a close-up view of a big Lake Lenore trout is to find yourself attached to one by way of fly rod. They are generally pretty easy to figure out: Leech patterns and streamers work most all the time and Chironomid patterns can be deadly throughout the season. Unless they are keying on Chironomids, the Lahontans are not too particular in their preferences so you can't often go wrong with

Lake Lenore.

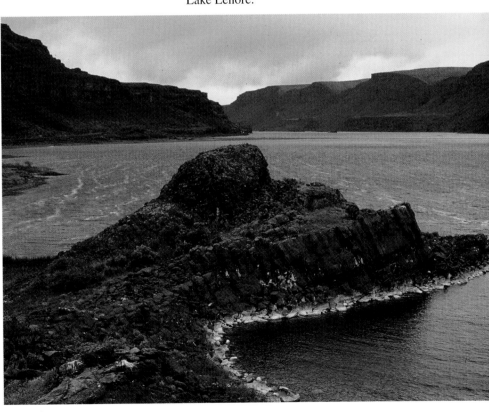

Spawning cutts on Lake Lenore.

attractor flies. Some of my own favorites include black/green Woolly Buggers, pink or orange Kokanee Candys, and Carey Specials in peacock or bright red. Myriad other patterns produce equally well.

Float tubes and other watercraft are popular on Lenore, but shoreline anglers, wading the extensive shallows, catch plenty of fish, too. In fact Lenore averages less than 20 feet in depth and large portions of the lake, especially on the south end, are quite shallow with extensive weed growth. Trout thrive in these shallows, especially during spring and fall when fishing is best.

In fact, the southeast shoreline is my favorite area throughout the year, but I also like to fish the slightly deeper water along the northeast shoreline. Both the north and south ends of the lake feature gravel-bottom coves where the cutthroat gather during the spring spawning season. Successful spawning does not occur, but many of the trout color up and go through the motions, staging over the gravel in shallow water. Many of these fish will be quite dark during the March through May spawning season, and counted amongst the anglers pursuing them are plenty of snaggers.

I suppose one could argue that with no successful reproduction actually taking place, the trout might as well be fair game for anglers. Certainly many feeding trout cruise the spawning beds and the spawners themselves occasionally take time out to feed. Still, myself and many other anglers share a steadfast aversion to fishing over spawning beds. If you do fish these popular areas on Lake Lenore, use small flies and a slow retrieve to avoid snagging fish and avoid the urge to cast to the fish cruising at your feet as these fish are generally more interested in spawning than in eating.

Anglers willing to explore the rest of this sprawling lake—not just the ever-popular north and south ends—will find lots of bright eager trout in both spring and fall. Spring is the busiest season on Lenore, but I would argue that fall offers the better fishing and certainly smaller crowds. Autumn brings cooler weather to the Grand Coulee country, jolting the cutthroat out of their summer lethargy. The lake is open until the end of November.

The wind that is so much a part of life in the Coulee country of eastern Washington can quite suddenly whip Lake Lenore into a white-capped froth. Be careful about wandering too far from shore in a float tube or you may face the unpleasant reality of a long paddle against a 20 mile-per-hour wind. A big rock island about two-thirds the way down the lake offers some shelter for floaters and several shallow coves around the lake can provide at least partial refuge from the wind.

Lake Lenore's entire east bank is easily accessible because Hwy. 17 runs its length. A good boat ramp is located about mid-point on the east shore at the public fishing access (camping is allowed here, but there are no facilities other than the ramp and the outhouses). Another launch is located near the inlet creek a mile or so north at the access site shared by the WDFW's fish trap. Rough launches are located at several other locations.

To reach Lenore from the south, follow I-90 to either Moses Lake (if you're coming from the east) or to the Hwy. 283 exit just north of George (if you're coming from the west). Follow Hwy. 17 or 283 north to Ephrata and continue north through Soap Lake and on up to Lenore. Highway 2 from Cashmere or Hwy. 28 from Wenatchee will get you there from the west.

Lake Lenore opens for catch-and-release fishing on March 1 and a one-fish limit goes into effect on June 1. The lake remains open until the end of November. Selective-fishery regulations are in effect throughout the season, except that electric motors are allowed.

Lake Lenore offers little in the way of amenities, but Sun Lakes State Park, located just a few miles north along Hwy. 17 features a big camp-ground with hook-ups. Motel space is plentiful in the nearby towns of Soap lake and Ephrata. The nearest fly shop is in Wenatchee an hour or so to the southwest.

Grimes Lake (Douglas County)

The fertile waters of Grimes Lake, much like its neighbor to the south-east, Lake Lenore, are highly alkaline and thus unable to support most trout. Lahontan cutthroat, however, thrive in such places. These remarkable fish, native to the Lahontan Basin in Nevada, are supremely adapted to alkaline desert waters and for that reason have been successfully introduced into Grimes Lake.

Their adaptation to such environs stem from the geologic history of the Great Basin, where once-gigantic Lake Lahontan eventually dried up with the changing climate, leaving comparatively sump-like remains in the form of Walker and Pyramid lakes. The latter has developed into a popular and productive fly-rod fishery for the world's largest cutthroat trout and is the historic source for the hatchery stocks of Lahontan cutts now used in Washington and other states.

Grimes Lake is one such place where the Lahontans now thrive. Grimes and nearby Jameson Lake both occupy the head of Moses Coulee in Douglas County, about 15 miles due west of massive Banks Lake and about five miles south of the community of Mansfield. Access is from Mansfield, where you turn south on Mansfield Road (sign points the way to Jameson Lake) and drive eight miles to a signed left-hand turn to

Grimes Lake. The road leads down to the lake's south end.

Mansfield itself sits a long ways from anything: From the Seattle area, follow I-90 or Hwy. 2 east. Hwy. 2 crosses the Columbia at Wenatchee, then continues north and then east. Turn north on State Route 172 about 35 miles past Rocky Reach Dam. I-90 makes good time in getting to the Columbia at Vantage. Cross the river and continue northeast until you reach the State Route 283 turnoff leading to Ephrata. Continue north to Soap Lake and follow Hwy. 17 north past Lake Lenore and up to Dry Falls Dam at Banks Lake. Turn left at the gas station (Dry Falls Junction) go about a half mile and then turn right (north) on Hwy. 17, which you will follow 14 miles to its intersection with State Route 172. Turn left and drive another 13 miles to Mansfield.

A small boat is a good idea if you wish to reach the north half of this 175-acre lake. Only electric motors are allowed. You can carry a float tube up either shoreline and in fact can at times enjoy fast action by wading and working the shallows, especially in the morning and evening.

Grimes Lake cutthroat average a healthy 16 to 18 inches with plenty of 20-inch fish available and a few real bruisers to boot. Like Lahontans anywhere, they are generally easy to catch assuming you fish early in the season, which on Grimes spans only from June 1 through August 31. Grimes is surrounded by private property and as such its public access is a product of agreements between the landowner and the WDFW—hence the short season.

Attractor-type patterns usually produce as well as anything. These include Woolly Buggers and leech patterns, Carey Specials, Kokanee Candys, Marabou Searchers, and numerous others. Chironomid pupae, damsel nymphs, water beetles, scuds, and other aquatic trout foods abound, so like imitations are appropriate. At times, the trout will key on Chironomids.

The narrowest part of Grimes Lake—which rests below precipitous basalt rims—drops off quickly to depths of about 60 feet. Fish the near-shore drop-offs here and fish the extensive shallows on the north and south ends of this elongated lake. Hot summer weather during July and August compresses the fishing to morning and evening so many anglers fish the lake in June, just after the opener.

Banks Lake (Grant County)

More than 30 miles long and spanning some 30,000 acres, Banks Lake occupies eastern Washington's massive Grand Coulee, where the reservoir is contained by Dry Falls Dam. Banks Lake is increasingly famed for its largemouth bass fishery and professional anglers hold annual tournaments here. Walleye and smallmouth bass, along with crappie, yellow perch, and rainbow trout and carp comprise additional offerings in this fertile reservoir.

While Banks Lake is no secret to the serious bass and walleye angler, it remains quite overlooked by the fly-fishing community. In fact, fly-anglers can find fast action on a variety of species, especially smallmouth bass along rocky shorelines and large rainbow trout near inlets and along drop-offs adjacent to shallow, fertile bays. Smallmouth up to several pounds are fairly common and average rainbows span a fat 14 to 20 inches.

Size alone makes Banks somewhat intimidating to the fly-angler, so the best strategy is to pick out one small section of water and fish the area as if it were a lake unto itself. Access is good along the east side of this lengthy reservoir because State Route 155 follows the shoreline from Dry Falls Dam on the south end all the way to Electric City on the north end. Along the way are numerous access areas, some formal, others undeveloped. Despite the reservoir's size, a small boat or even a float tube is all you need to fish the near-shore margins. Such small craft have an added advantage in that they can be launched just about anywhere.

Timing the best fishing on Banks Lake varies according to species: Largemouth bass action peaks from May through September; smallmouth action from April through September. Trout fishing is best during the spring and again during fall, all the way to ice-up. Crappie fishing peaks during May and June and continues through the summer if you can locate the schools.

To reach Banks Lake, follow Highway 2 from the east or west to Dry Falls Dam. State Route 155 turns north off Hwy. 2 about two miles east of Coulee City on the east end of the dam. From the south, you can follow I-90 to SR 283 and then follow SR 283 to SR 17. This is the same route that takes you to Rocky Ford Creek, Lake Lenore and Dry Falls Lake. Follow SR 17 north past Soap Lake and Lake Lenore and past the

Jameson Lake (Douglas County)

Located just south of Grimes Lake in Moses Coulee, 500-acre Jameson Lake is a popular destination for the meat-hunting crowds but nonetheless offers good fly-fishing for rainbows that run from 10 to 18 inches, sometimes bigger. Trout grow quickly in Jameson's fertile waters and are harvested nearly as quickly. Still good float-tube fishing is available for hard-fighting, deep-bodied fish—especially in the fall when the crowds disperse and the spring-planted trout have gained several inches.

The north half of the lake is characterized by extensive weedy shallows—perfect water for early and late-season fly-angling. Jameson Lake Resort is situated at the northeast end of the lake and you can launch there for a nominal fee. A public ramp at the south end receives lots of boat traffic throughout most of the season and another resort (Jack's) is found here as well.

Jameson Lake is closed for two months each summer, from July 4 to October 1. A heavy algae bloom invades the lake at this time. The first half of the split season, from the last Saturday in April until July 4, is most popular and thus quite busy. October is ideal and good fishing continues right up until the last day of the month.

Guide Mike Huffer with a typical fly-caught carp on Banks Lake. Jeff Edvalds photo.

A desert wind howls across Lenice Lake.

turn-off to Sun Lakes State Park. At the top of the grade you arrive at the dam. Turn right to reach Coulee City and Hwy. 155.

Roosevelt Lake (Ferry, Stevens, Lincoln Counties)

Franklin D. Roosevelt Lake is Washington's largest impoundment, stretching for some 150 miles from the British Columbia border all the way to Grand Coulee Dam. Covering almost 80,000 acres, Roosevelt Lake offers virtually every kind of freshwater fish found in Washington. For fly-anglers, the attractions are large rainbow trout and abundant smallmouth bass.

Forget about the lake as a whole and pick out likely habitat for whichever species you decide to pursue. The smallmouth bass inhabit the rocky shorelines while rainbows thrive near stream inlets. Fall is probably the best time for the trout fishing, while smallmouth bass action lasts from late spring through mid-autumn. You can fish from the shore in many places, but a float tube is perfectly suited to the many small coves and inlets. Highway 25 follows the east bank along the upper half of the lake. Highway 21, Highway 174, and a number of secondary roads access the lower end of the lake. To familiarize yourself with the area, consult *DeLorme's Washington Atlas and Gazetteer.*

Lenice Lake, Nunnally Lake, and Merry Lake (Grant County)

These three Selective Fishery lakes are located in what has to be one of the most insane wind-tunnels in the Washington desert. All "seepage lakes," these fertile fisheries were created during the 1960s when major irrigation projects on the Columbia River Basin forced changes in underground water levels and flows.

The three lakes are arranged in a chain along Crab Creek, all within the confines of the 20,000-acre Crab Creek Wildlife Area. The entire region lies on a long bench, slightly above the Columbia River to the west and dominated on the south by the east-west oriented Saddle Mountains and by the likewise-oriented Frenchman Hills some 10 miles to the north. The result of this geography is one giant wind tunnel and

when the wind gets serious in this country—which is fairly often—you'd better be prepared to batten down the hatches

Despite the incessant wind, these three lakes are well worth exploring because they harbor healthy populations of big, strong rainbows. Sixteen- to 20-plus-inch rainbows are the norm and brown trout to several pounds are available as well. All three lakes are rich in all the usual trout foods: Scuds, damsels, dragons, *Callibaetis* mayflies, leeches, water beetles and boatmen, and Chironomids. The Chironomids, or midges, comprise a significant part of the trout's year-round diet and pupa imitations can be highly productive when other patterns produce only occasional strikes.

Late spring and early summer brings impressive hatches of midges, damsels, and *Callibaetis* mayflies. During the occasional still day, these hatches can create excellent surface action. Otherwise, expect to fish wet flies. Autumn brings uncrowded conditions and excellent fishing—and often a break from the wind. Hot summer weather curtails the daytime fishing, but adventurous anglers can still venture out at night and fish big black leech patterns. Fish these on a sinking line via float tube and hold on.

All three lakes fish about the same, so figure out one and you've got all three pretty well wired. The rainbows in these lakes are tough customers that seem to hold a serious aversion to being hooked in the mouth. They typically respond with reel-screaming runs and by diving headlong into the weed beds. If you land a four-pounder, you'll likely be landing a pound of weeds to boot.

To reach the three lakes, follow I-90 east or Hwy. 26 west to Hwy. 243. Hwy. 26 and I-90 meet on the Columbia River's east bank across from the town of Vantage. Hwy. 243 turns south off Hwy. 26 about a mile south of the I-90/26 interchange. Follow 243 south some seven miles to the little town of Beverly and then turn left on Beverly-Crab Creek Road. Follow this road about five miles to the large Lenice Lake parking area on your left. The walk in follows an easy trail through the sagebrush. A float tube or small boat is a good idea since shoreline fishing is more or less limited to the south bank because of the extensive reed beds growing elsewhere on the lake. Lenice spans about 95 acres.

Nunnally, the westernmost lake in the chain, is really two lakes. Its west arm (120 acres) and east arm (80 acres) are separated by a narrow channel. The east arm is usually referred to as "Bobby Lake." Both arms

are long and narrow, covering a total length of more than two miles. The parking area for the west arm is about two miles up Beverly-Crab Creek Road. Look for the fishing access sign and turn to the left. The walk in covers an easy three-eighths of a mile. Bobby Lake is best accessed from the next parking area, about a mile further down the road.

Merry Lake, the middle lake in the chain and probably the least pressured, spans about 40 acres. The parking area and trail head are located about a mile east of the Bobby Lake (East Arm of Nunnally) parking area. You can't miss it if you look for a carnage of junked cars and other rubbish surrounding a small gravel parking lot on the left side of the road. The walk in covers about a half mile.

Like Lenice, Nunnally and Merry lakes offer only limited shoreline fishing because of the extensive reed growth and in some places a bottom of soft ooze. If you don't have watercraft, don the waders and explore the near-shore margins. However, you will find it well worth the effort to haul in a float tube or other craft. All three lakes are under Selective Fishery rules (barbless artificial flies/lures and no motors) and all three are open March 1 through the end of October. Don't leave any valuables in your car.

A fat rainbow caught and released in a desert lake. Jeff Edvalds photo.

Quail Lake (Adams County)

Quail Lake is a quiet little rainbow trout fishery located adjacent to Seep Lakes Wildlife Area north of Othello (on the Columbia National Wildlife Refuge). Its fly-only, catch-and-release regulations assure that Quail Lake escapes the meat-hunting pressure common to many of the Seep Lakes and at the same time creates a thriving fishery for big trout. Periodically exploding populations of sunfish or other rough fish adversely affect the rainbow fishery, but most of the time anglers can count on a healthy abundance of 12- to 20-inch rainbows in this fertile lake.

Among Quail Lake's attractions is an early season *Callibaetis* hatch, a late-spring damsel emergence, heavy Chironomid action, and an abundance of water beetles and boatmen along with just about every other stillwater trout food. Spring and fall offer the best fishing; summer brings sweltering heat to the scrublands and a heavy algae bloom to Quail Lake.

You can catch fish from shore at Quail, but a float tube offers a distinct advantage most of the time. Shoal areas on the south and north ends of this slender, elongated 12-acre lake offer a chance to cast to cruising trout

Quail Lake.

in four to eight feet of water. During slow periods, fish the deep hole at the lake's center, working a leech, dragonfly nymph, Carey Special or some other attractor-type pattern.

Quail Lake requires a short hike of a little less than half a mile over flat terrain. The parking lot sits above the south end of Herman Lake and from there you walk east and then north to Quail Lake's south arm. To get there, follow Hwy. 26 to Othello and then follow First Avenue into downtown. Turn left at the Fir Street intersection and then turn right on Broadway. Follow this road past the canneries (Broadway becomes McManamon Road), out of town to the north, and about five miles to the entrance to Seep Lakes Wildlife Area. Follow the gravel road a mile to the signed turn-off for Quail and Herman lakes.

Seep Lakes and Potholes Reservoir (Grant County)

During the spring and fall, anglers from all over Washington converge on the state's popular and productive eastside trout lakes. Given the quality of fisheries like Lake Lenore, Lenice Lake, Dry Falls Reservoir, and Chopaka Lake, it is little wonder that the region's exceptional warmwater lakes remain largely underutilized by the fly-angling community.

Chief among these myriad warmwater fisheries are Potholes Reservoir and the Seep Lakes just to the south. Potholes itself spans some 25,000 acres while the Seep Lakes below, some four dozen in number, range from ponds of a few acres to strings of interconnected lakes covering more than 100 acres. Largemouth and smallmouth bass, crappie, bluegill, pumpkinseed, perch, and planted rainbow trout abound.

Of the many Seep Lakes, only Quail Lake attracts a fly-angling crowd because its rainbow trout, protected by fly-fishing-only, catch-and-release regulations, reach 20 inches or a little more. Even though hatchery-reared rainbows are present, most of the lakes are dominated by warmwater fish.

Potholes Reservoir, meanwhile, provides ideal habitat for numerous fish species. Trollers take huge rainbows, walleye specialists converge on

Rows of midge pupae lined up in a fly box ready for spring. Jeff Edvalds photo.

the lake for double-digit trophies, and hardware anglers cast all kinds of contraptions for bass and crappie. Among all of this is plenty of opportunity for fly-anglers.

By July, when water levels drop, largemouth bass provide explosive action on poppers in the "sand dunes" area at the north end of the reservoir. This expansive region is characterized by countless sand islands surrounded by a maze of interconnecting channels. During the low-water period of late summer, some 500 to 550 islands will be exposed. The best access is by boat. Anglers can launch at the Blyth Access on the west side of the dam or the Williams Access on the east end. These are free launches. For a $4 fee, boaters can launch at Potholes State Park, just north of the Blyth Access or at nearby Mar-Don Resort. A run of two to four miles northeast reaches the "dunes," where dense willows, brushpiles, channels, coves, and lots of shallow water offer ideal largemouth habitat.

Beaver huts provide some of the best bass cover in the dunes so fish these places thoroughly with poppers, Dahlberg Divers, and rabbit-strip leech patterns. Use a seven- to nine-weight rod capable of throwing heavy bass bugs and capable of yanking bass of several pounds out of heavy cover. Also look for islands with points that drop off into deeper water, providing perfect feeding areas for bass.

Average largemouth bass range from half a pound to three pounds with an occasional five- to six-pound fish around to fuel anticipation. The state park is located just west of O'Sullivan Dam where a marked turnoff leads north to the lake shore. Walk-in anglers can approach from the north just west of the town of Moses Lake and hike into the dunes from Job Corp Dike. Myriad trails lead to the ponds and channels on the south side of the dike. You can carry a float tube in to reach areas not fishable by foot. If you prefer to hire a guide to fish the dunes, call Stump Jumper Guide Service at 509/349-8004.

Smallmouth bass inhabit Potholes Reservoir as well and often grow to respectable sizes. Float-tubers can put in at the parking area about midway across O'Sullivan Dam and fish the rock piles and the face of the dam. Streamer patterns always work and small poppers and diving bugs can bring explosive boils at the surface. Skip Davis, the only fly-fishing guide on the reservoir, recommends Mylar Minnows and other such bait-fish patterns. He also recommends that boaters fish the cliffs along the south shoreline of Lind Coulee, a long arm extending east from the southeast corner of the reservoir.

Immediately southeast of Potholes Reservoir, the 50-odd "seep lakes" lie scattered over about 50 square miles of sand, sagebrush, rimrock, lava, and rolling, scrub-covered hills. The entire region offers excellent public access because the lakes fall within the confines of Seep Lakes Wildlife Area and adjacent Columbia National Wildlife Refuge.

Conditions change from year to year in these lakes, meaning that the hot crappie lake one year might not produce as well the next. At any given time, several of the lakes will be candidates for rehabilitation by the Department of Wildlife, which fights a seemingly endless battle against carp and other rough fish. Regardless, try Long Lake, Shiner Lake, and Soda Lake for sunfish (bluegill and pumpkinseed) and Soda Lake, second largest of the seep lakes, for crappie. Shiner Lake usually offers good crappie fishing as well. Good bets for largemouth bass include Janet Lake, Crescent Lake, Shiner Lake, and Hutchinson Lake.

Several different season frameworks are in place on the numerous seep lakes so be sure to check the current synopsis. The lakes in the Pillar-Wigeon lakes group are open only during the months of March and September, with the latter being the decidedly better bet for warmwater species.

Given the number of lakes involved, fly-anglers willing to do a little exploring can find good fishing for bass, sunfish, and crappie in areas largely undisturbed by other anglers. A number of lakes offer walk-in access only and this alone eliminates most of the pressure. A good map of

the seep lakes is available from Mar-Don Resort, located on the west side of O'Sullivan Dam (509/765-5061).

The drive from Seattle to Potholes Reservoir covers about 170 miles. Follow I-90 all the way to Hwy. 17 just east of Moses Lake. Take 17 south a little more than one mile and then turn right on Road M SE. Drive south seven miles and turn west (right) on Hwy. 262. Follow Hwy. 262 about four miles to O'Sullivan Dam. Mar-Don Resort on the west end of the dam offers lodging, supplies and services. Several roads lead south into the seep lakes. Pick up a map at Mar-Don Resort or just turn south at the signs and wander your way through the maze of lakes, channels, and access roads.

From the southeast, you can enter the Seep Lakes Wildlife Area a few miles northwest of Othello, where McManamon Road leaves the northwest side of town and heads a few miles to a well-marked entrance.

Late summer offers some brutal conditions in this part of the eastern Washington desert. As if daytime high temperatures between 90 and 100 degrees weren't enough, throw in afternoon winds strong enough to pummel the fences with fast-moving tumbleweeds and you've got an environment not particularly hospitable a lot of the time. However, during the morning and evening, when fishing is at its best, temperatures remain mild and the wind stays down. Throw in a three-pound large-mouth smashing a surface popper and you have a great combination.

Wenas Lake (Yakima County)

If you possess the patience to drag big streamers around, maybe for hours on end, you may stumble into a trophy-sized brown trout in 60-acre Wenas Lake located in the foothills northwest of Yakima. Wenas lacks in fertile aquatic weed growth, largely due to widely fluctuating water levels. However, an abundance of shiners keep the brown trout well-fed and the WDFW plants rainbows. Browns to 13 pounds have been taken by gear anglers.

No special rules apply to Wenas Lake, except that only two brown trout may be kept. Thus bait and hardware anglers predominate. Fly-anglers may want to wait until late fall—October and November—before hauling a boat or float tube up to Wenas.

Leech Lake.

The public access area is situated on the lake's northwest side and from there you will be looking out over a broad expanse of relatively shallow water (up to 15 feet deep depending on location and water level). Early and late in the day, the browns cruise the shallows looking for shiners. The southeast extension of the lake offers deeper water and a steeper shoreline as you approach the pool behind the dam. Here too the browns cruise the drop-offs looking for baitfish.

Easiest access to Wenas Lake is from Selah. Depart I-84 at the Hwy. 823 exit at Selah, then follow 823 north through town, where the highway eventually becomes North Wenas Road. Follow the road up Wenas Creek Valley to the lake. Total distance from the freeway is something like 20 miles.

Leech Lake (Yakima County)

Covering 41 scenic acres near the summit of the Cascades east of White Pass, Leech Lake offers good fishing for brook trout up to 16 or more inches, though smaller fish predominate. Leech Lake is restricted to fly-angling-only and is a great place for a small boat or float tube (no motors). Though the lake is open year round, the ice doesn't melt until late May or early June. The fishing picks up immediately and lasts through the summer and all the way up until the lake freezes in mid- to late fall.

Speckled-wing dun mayflies (*Callibaetis*) hatch during the summer, as do Chironomids and caddis. Terrestrials—mostly ants and beetles—provide forage for the fish as well, especially on windy days. During non-hatch periods, any number of wet flies produce, from Woolly Buggers and streamers to small Zug Bugs and Carey Specials.

A campground and launch are located at the lake, which is easily reached by heading west from Yakima or east from I-5 on Highway 12. Leech Lake lies immediately east of White Pass, essentially atop the Cascades' crest.

Browns Lake (Pend Oreille County)

Fairly popular with Spokane-area anglers, Browns Lake is situated in the Colville National Forest east of the Pend Oreille River and about seven miles due west of the Idaho state line. Browns Lake fluctuates rather wildly in water level, but provides fair to good float-tube action when water levels are stable. The lake is stocked with cutthroat which run eight to 18 inches, sometimes a little larger, but with smaller trout being the most abundant. To reach Browns Lake, follow Highway 2 north out of Spokane, then turn north on State Route 211. After about 15 miles, SR 211 intersects Hwy. 20 near the community of Usk. Just north of the junction, turn east and cross the Pend Oreille on Kings Lake Road. Follow this road northeast about seven miles to the turn-off for Browns Lake (FR 5030) and continue up to the lake where you will find a boat launch and public campground.

Big Four Lake (Columbia County)

A man-made pond in the Blue Mountains, Big Four Lake lies beside the Tucannon River in the Umatilla National Forest of southeastern Washington. Floating devices are prohibited, so fly-anglers work from the shore, including from the prime real estate along a narrow little peninsula that juts about halfway into this four-acre lake. The bottom is wadeable in many places, so bring your

waders. Big Four is restricted to fly-fishing only, with a season running from the first of March through October.

Despite its small size, Big Four produces some large rainbows—namely because WDFW plants the lake with brood stock. Trout spanning 12 to 20 inches are typical and they grow quickly on a rich and diverse diet, which includes *Callibaetis* mayflies (speckled wing duns) that hatch during the summer.

Getting to Big Four is a little tricky—a fact that doesn't deter many folks judging by the lake's popularity during the spring and summer. Anglers who can fish mid-week sometimes have the lake all to themselves.

To find Big Four, follow Hwy. 20 to the Marengo Road turnoff (SR 126) about five miles west of Pomeroy. Follow this road several miles down into the Tucannon River canyon and then turn east (left) onto Tucannon Road. Follow Tucannon Road about 16 miles up to the rough parking area for Big Four Lake (unmarked last time I was there). From there you must ford the Tucannon and walk to the lake. A steel cable stretched across the river aids in wading the stream.

Chopaka Lake (Okanogan County)

Mention Chopaka Lake to anglers in the know and they start to drool and twitch uncontrollably as memories of *Callibaetis* mayfly hatches dance through their heads.

Between mid-May and June, fly-anglers from all over Washington descend on this 150-acre lake to fish over one the state's top *Callibaetis* or "speckled-wing dun" mayfly hatches. Rainbows, some more than 20 inches and most 14 or longer, cruise the shallows gulping down duns and emergers during the midday hatch.

By early to mid-June in most years, the damsel hatch gets under way as well, allowing for some serious combat fishing in the reed stands along the lake's western shoreline: Cut your tippet back to about 3X, tie on an adult damsel pattern, cast straight into the tangle of reeds, and hold on. You may not land many of them, but rainbows feeding on adult damsels make for some of Chopaka's most exciting fishing.

The damsel nymphs, of course, are heavily preyed upon by the trout. Fish the nymphs on a long leader with a slow retrieve in shallow water. When the damsel nymphs begin to move, park your tube or boat against the reed stands in a place that allows you to cast parallel to the reeds. Throw a long cast along the edge of the reeds and fish a slow, deliberate retrieve. Midges hatch throughout the year and the early season hatch of large midges (Chironomids) can produce some excellent fishing on both

pupae and adults. Scuds and water beetles, as well as leeches, are available all year long to the trout, which grow quickly in this shallow, fertile lake.

The west end of the lake is quite deep and drops off rather suddenly. When the main lake gets crowded or when a mean wind blows from the west, try sneaking off to the deep end and fishing a leech or streamer on a sinking line. A few years ago I stumbled into some great shoreline *Callibaetis* action on the deep end of the lake and had it all to myself.

Located in Okanogon County, above the scenic Sinlahekin Valley, Chopaka occupies a narrow canyon and stretches a mile and a half from end to end. The entire south half of the lake is shallow while the less-heavily fished north half slopes off to depths of as much as 60 feet while still providing excellent near-shore fishing.

Spring and early summer is a popular time on Chopaka. Fly-angling clubs from western Washington schedule regular (and well-attended) outings to this lake during May and June. During cool summers, July and August offer decent fishing, leading up to the fall fishing, which may be the best thing going for those trying to escape the crowds: Unbeknownst to anglers who visit Chopaka only in the spring, the lake's *Callibaetis* hatches occur into September.

The most direct of the three routes into the Sinlahekin Valley is from the town of Tonasket on Hwy. 97. At the marked intersection in Tonasket, turn west, crossing the Okanogon River, and then turn north on the Loomis-Oroville Rd, which follows the west bank of the river for several miles before swinging west past Whitestone Lake (a decent large-mouth bass lake) and Spectacle Lake (small rainbows). About 19 miles from Tonasket, the road finds the little village of Loomis. Some supplies, along with the latest Chopaka report, are available at the store in Loomis.

Follow the road north out of Loomis for about two miles and then turn left on Toats Coulee Road, which will take you across the narrow Sinlahekin Valley. Wingshooters will drool at the abundant quail and pheasant occupying the private lands of the valley.

Across the valley, the road swings to the south. Cross a cattle guard and then take the first right—a gravel road that hairpins back to the north and then climbs precipitously for two miles. Watch your odometer when you make the turn onto this gravel road and when you reach the five-mile mark, look for the next poorly marked Y-intersection. Veer right and descend a couple miles to the campground on Chopaka's west shore.

Another access to the Sinlahekin Valley loops northwest out of Oroville, passing near the Canadian border along the Similkameen River and then curving south through the tiny town of Nighthawk and

Anglers await the *Callibaetis* hatch on Chopaka Lake.

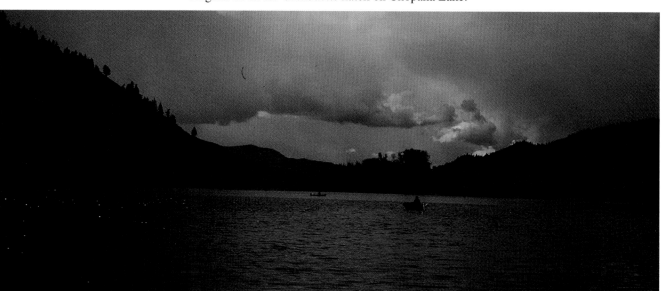

Chopaka Lake rainbows grow quickly on a rich diet of aquatic organisms.

along the east shore of 2,000-acre Palmer Lake (bass, rainbows, crappie, kokanee, etc.).

The third approach follows the Sinlahekin Road through the Sinlahekin Wildlife Area. About five miles north of the little town of Riverside, turn left off Hwy. 97 on Pine Creek Rd. Travel by pavement past Fish Lake and then swing north on Sinlahekin Road, which turns to gravel. The 20-odd miles to Loomis takes you past Blue Lake (rainbows to about 18 inches) and past two brook trout lakes (Ford and Conners). An early morning or evening drive up the scenic valley offers a chance to see lots of game, including deer, pheasant, waterfowl, elk, and perhaps even sheep.

Incidentally, a group of small lakes to the south of Pine Creek Road and west of Hwy. 97 offer fishing for a variety of species, including Lahontan cutthroats in Horseshoe Lake.

Despite the typical crowds, Chopaka is a worthwhile venture for fly-anglers seeking still-water dry-fly fishing for big rainbows. If possible, go mid-week; otherwise, don't expect to have the place to yourself. The lake holds plenty of trout, though, and the hatches generally bring them to the top. Overall, Chopaka is one of the state's best stillwater destinations.

Ell Lake (Okanogan County)

A glacial kettle lake in the Okanogan highlands 19 miles east of Tonasket, Ell Lake provides good fishing for rainbows up to 20 inches; most will run 12 to 16 inches. About 21 acres in size, Ell Lake is shallow and fertile—the perfect float-tuber's lake. An aerator, installed by WDFW, provides oxygen for trout both summer and winter, allowing the fish to carry over and reach three and four years of age.

Chironomid and *Callibaetis* hatches provide good surface action on still days during spring and summer; damsels abound, as do scuds and water beetles. Look for some intensely challenging fishing along the shore line, where large trout cruise and rise for midges or mayflies.

Ell Lake is one of three kettle lakes situated in close proximity along Aeneus Valley Road. The other two, Long Lake and Round Lake, offer

good fishing as well, but are not managed as selective fisheries, hence the average size of the fish is smaller.

To find Ell Lake, follow Hwy. 20 east out of Tonasket and into the foothills for 13 miles. Turn right onto Aeneas Valley Road. Drive 6.5 miles to Ell Lake (you will pass Long Lake and Round Lake). A small campground overlooks the lake and a boat ramp enters the small cove at the lake's south shore. Float-tubers can put in just about anywhere. You can enjoy small-stream fishing in the Okanogan National Forest near here—consult a good topo map and do some exploring.

Bonaparte Lake (Okanogan County)

Bonaparte Lake's general regulations allow anglers to kill five fish per day and on crowded weekends during the summer you're likely to see plenty

Ell Lake.

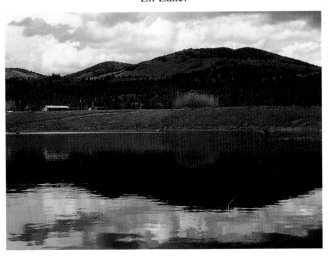

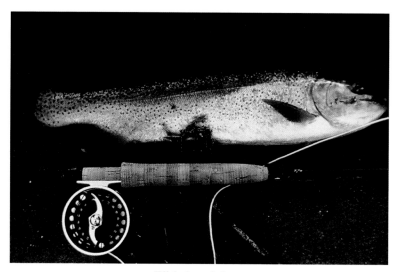

Ell Lake rainbow.

of gear anglers doing just that. However, during the fall, when Bonaparte's brook trout color up prior to the spawning season, fly-anglers can have the lake virtually to themselves. Combine the autumn solitude with an opportunity to find 14- to 20-inch brook trout and rainbows and Bonaparte becomes a decidedly pleasant fishery.

The big brook trout are by no means abundant, but their size and beauty make the effort worthwhile. The stocked rainbows grow to 20 inches or so and the lake also hosts a population of mackinaw, which feed on the lake's kokanee. Immediately after ice-out in April and again during late fall, mackinaw cruise the shallows and those willing to put in the time fishing large streamers might hook a Mack of four to 15 pounds.

Bonaparte is located about 20 miles east of Tonasket. Follow Highway 20 east from town for about 18 miles to the signed road to Bonaparte Lake; turn left and head six miles up to the lake, where a campground occupies the south shore of this 160-acre lake. Lost Lake, located north of Bonaparte Lake, offers good fishing for brook trout. Lost Lake covers about 50 acres and is off-limits to gas motors.

Aeneas Lake (Okanogan County)

No offense meant to those who habitually fish Aeneas Lake, but I find the place somewhat less than scenic, especially when I can fish other nearby northeast Washington lakes that occupy prettier places. Nonetheless, Aeneas makes for an easy morning or evening's fishing if you find yourself in the Tonasket area and its healthy rainbows grow fat on a diet rich in scuds. Ten- to 16-inch trout are typical in this 30-acre lake. Recent years have witnessed a drop in productivity because of an increasingly dense population of sculpins, which compete for food with the planted trout. Rehab was scheduled for the fall of 1997, so prospects should improve thereafter.

To reach Aeneas Lake—which is fly-fishing-only—follow Hwy. 97 to Tonasket and turn west at the main intersection (look for the Loomis/Nighthawk Recreation Area sign). Drive across the river and turn left (Loomis-Oroville Road). Drive another half mile and turn right on Pine Creek Road, which will hang a hard left as you approach the lake. Rough camping is available, as is an easy launch site.

Blue Lake (Okanogan County; Sinlahekin Creek Drainage)

Located alongside the road through the scenic Sinlahekin Valley, Blue Lake offers fair to good angling for rainbows that run 10 to 18 inches. The lake was last rehabilitated in the fall of 1996, so fishing should steadily improve on this scenic 160-acre fishery. Selective Fishery regs are in effect, except that electric motors are allowed. A good gravel launch is

available and multiple rough float-tube launches can be found around the lake.

Blue Lake (Okanogan County; near Wannacut Lake)

Restricted to artificial lures and flies, Blue Lake sits amidst sparsely timbered hills above the town of Oroville in extreme northern Okanogan County. The lake is stocked with Lahontan cutthroat which can withstand the alkaline waters. They average 12 to 16 inches, with quite a few to 18 or 20 inches and larger. Blue Lake covers about 100 acres and reaches depths of about 100 feet. The cutthroat prefer the shallow margins and the lake is easily fished by float tube or small boat (a wide gravel camping area offers easy access for launching small craft). You can cast from shore as well, but be wary of wading, especially when the water level is down because the mud is deep and gooey.

Don't expect a scenic gem when you climb the hill and find Blue Lake, for its shores are grazed heavily by cattle and local kids, fishermen and deer hunters leave plenty of litter at the small rough camping/parking area. Nonetheless, the fishing can be quite productive and you won't find many other people most days.

From Oroville, turn west from Highway 97 at the sign pointing the way to Wannacut Lake. Proceed about a mile, then turn right at the next sign for Wannacut Lake and continue about a mile-and-a-half to the next signed turn-off announcing Wannacut and Blue lakes (Blue Lake Road). Follow this road a little over two miles to Blue Lake.

Long Lake (Ferry County)

Another of the nice float-tube lakes of northeastern Washington, Long Lake offers good fishing for cutthroat trout that are stocked regularly by WDFW. The cutts are planted as fingerlings and they grow fast in the lake's fertile waters. Typical trout span eight to 12 inches with 14- to 18-inch specimens being reasonably common most years. Long Lake spans an elongated 25 acres and features a deep hole in its middle. The edges of the hole often produce good fishing as do the shallow shoal areas on both ends of the lake. *Callibaetis* mayflies hatch with regularity; scuds, damsels, snails, Chironomids, water beetles, and leeches abound. The damsel hatch gets underway during June.

Long Lake is located in western Ferry County, south of the town of Republic, in the Colville National Forest. Follow State Route 21 south out of Republic for six and a half miles, then turn west on Scatter Creek Road (FR 53). At about six miles, watch for Spur 400 and a sign announcing Long and Fish lakes. Turn south here and continue a mile to Long Lake. Nearby Swan Lake offers pan-sized brookies and rainbows while Ferry Lake to the north of Long Lake offers planted rainbows which are subject to winterkill.

Starvation Lake (Stevens County)

When water levels cooperate, this is a great little 29-acre float-tube lake where planted rainbows reach 14 inches or so and where catch-and-release regulations take over after a month-long catch-and-keep season ends on May 31. *Callibaetis* mayflies, Chironomids, and terrestrials provide good surface action around the reeds and lily pads. Starvation Lake is located just off Highway 20 about 10 miles east of Colville. Watch for a signed gravel road that turns south off the highway and drive about a mile to the public access area.

Bayley Lake (Stevens County)

Despite widely fluctuating water levels, Bayley Lake offers fair to good fly-rod action during the spring and fall. A catch-and-keep season lasts for two months (currently one trout of 14-inch minimum length) and then it's catch-and-release afterward with the lake closing on October 31;

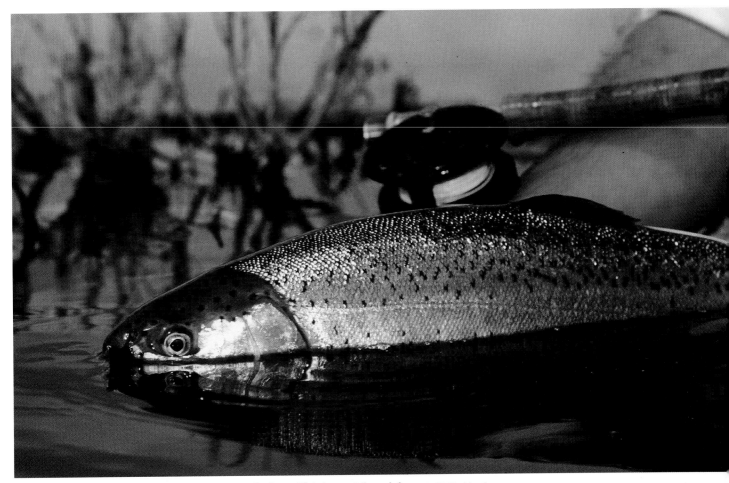

A close-up of a beautiful desert lake rainbow. Jeff Edvalds photo.

through the entire season Bayley Lake remains fly-fishing-only. This is good float-tube water where rainbows and brook trout average 10 to 16 inches with some larger. During the spring of a high-water year, Bayley expands to more than 50 acres. In contrast, autumn of a low-water year might shrink the lake to a scant 15 or 20 acres. To access Bayley, follow Hwy. 20 east out of Colville for about nine miles until you reach Kitt-Narcisse Road (watch for a sign announcing "Little Pend Oreille Wildlife Area"). Turn south and proceed about three miles (stay right at the fork in the road about a mile and a half from Hwy. 20) to a T-intersection at Bear Creek Road, where you will turn left . Follow this road for four and a half miles to a right turn on a dirt access road that leads to the lake. Along the way, you will pass Potter's Pond, which is planted with brook trout and rainbows

McDowell Lake (Stevens County)

A nice little walk-in, fly-fishing-only lake, McDowell spans 47 acres and offers fair to good action on planted rainbows, brown trout, and brook trout, with rainbows predominating. A few 'bows will reach 18 inches or more. Summer algae blooms effectively suspend the fishing, so visit McDowell Lake within a month or so of its opener in late April or during autumn, when good fishing continues up until the lake closes at the end of October. Be sure to carry a float tube over the quarter-mile walk to the lake. To get to the lake, follow Hwy. 20 east out of Colville some nine miles to a right-hand turn on Kitt-Narcisse Road (watch for the sign announcing "Little Pend Oreille Wildlife Area"). After a mile and a half, turn left on Narcisse Creek Road and drive about four miles until you cross the Little Pend Oreille River. The parking area is on your right and the trail leads past the steel gate.

Amber Lake "Calvert Lake" (Spokane County)

This popular Spokane-area lake offers fair to good fishing for rainbows and cutthroat in a scenic semi-desert environ. Modest basalt escarpments rise from the lake shore, which is shaded here and there with ponderosa pines. The lake covers 117 acres but is long and slender, giving the impression of a much more intimate fishery where float-tubers can enjoy a pleasant autumn day.

Amber is governed by Selective Fishery regulations, but electric motors are allowed. A limit of two fish over 14 inches is allowed from opening day on the last Saturday in April until September 30. Thereafter comes the prize: Between October 1 and November 30, Amber Lake is open only to catch-and-release angling and has thus become a popular place for Spokane-area fly-anglers. May is the best month during the early part of the season, offering a good *Callibaetis* hatch along with Chironomid action.

To reach Amber Lake from Spokane, follow I-90 to the State Route 904 Exit at Tyler, about 20 miles southwest of Spokane. Exit the freeway and head into Tyler; turn south on "B" Street, which becomes Pine Spring Road. Follow this road eight miles south to its intersection with Harris Road and turn left, continuing on Pine Spring Road another two and a half miles to the signed turn-off for Amber Lake. You can also reach Amber from Cheney by following Mullinix Road about 10 miles southwest to the right turn at Pine Spring Road. From the west, you can exit at Tyler or back at Sprague and follow the old highway a couple miles east to a right turn at Martin Road. Follow Martin Road 11 miles to Mulinex Road, turn left and drive six miles north to Pine Spring Road.

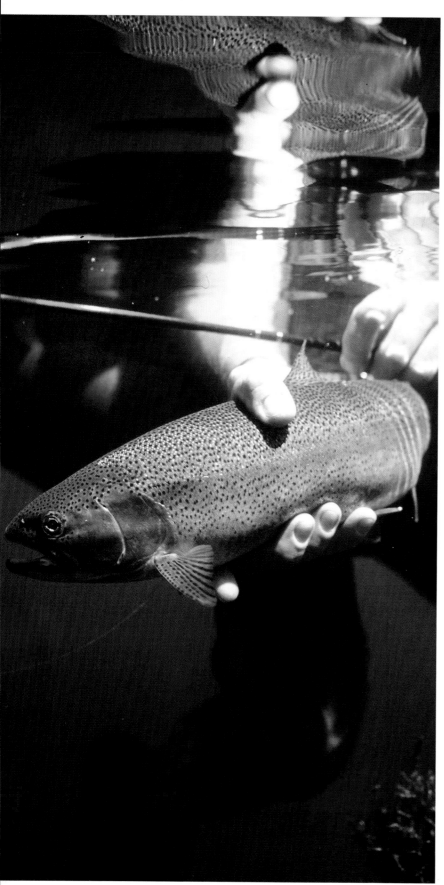

An underwater shot of a rainbow from a float-tube on a desert lake. Jeff Edvalds photo.

Medical Lake (Spokane County)

Practically an urban fishery, Medical Lake borders the community of the same name and is located only 20 minutes from Spokane. The attraction here is quality fishing for brown trout with the lake being managed under Selective Fishery regulations. The fish grow fast in Medical's fertile waters, which were once marketed as having healing power for all sorts of ailments, hence the lake's name.

Brown trout of 14 to 16 inches are typical, but fish exceeding 20 inches are the real prize even though they are not numerous. They feed on a rich mixture of aquatic organisms, including abundant scuds and other fish species. Streamer and leech patterns, fished at dawn or dusk, produce the trophy-sized browns for those fly-anglers who seek them out. Occasionally you will connect with a fair-sized largemouth bass.

Medical Lake is shaped like a big bathtub with its north and south ends wrapping slightly to the west. The middle of the lake is quite deep so the best fishing generally occurs towards either end. Be sure to pack both a floating and sinking line. If midges or mayflies bring trout to the surface you will enjoy some dry-fly action, otherwise you need to fish wet flies, nymphs, and streamers at depths of eight to 20 feet.

All told, Medical Lake covers about 150 acres so you can find plenty of elbow room even on a crowded weekend. The best fishing is during April, May, and September.

A quick, easy drive from Spokane, Medical Lake lies just north of the freeway about six miles down State Route 902. The Medical Lake Exit lies just west of Spokane, a mile or so past the airport. If you are coming from the west, you can take the Salnave Road Exit (the other end of Hwy. 902) and head northwest then due north to the lake (turn left at Fancher Road, then take a right). From 902 on the east, continue into the town of Medical Lake and follow 902 (Salnave Road) around a left (south) turn that will take you to the signed turn-in on the right, which leads to the public launch area.

Wapato Lake (Chelan County)

The Washington Department of Fish & Wildlife calls Wapato Lake the best spring trout fishing opportunity in Chelan County, which generally translates to lots of pressure on the lake's population of 10- to 20-inch rainbows (most in the 12- to 16-inch range). However, Wapato goes to catch-and-release, Selective-Fishery regulations after August 1, creating good fall fishing for fly-anglers who would prefer to avoid the meat-hunting crowds of spring. Wapato covers 186 acres and is located a few miles northwest of Chelan. Follow State Route 150 out of town for about five miles and turn right on Swartout Road and after two miles turn right on Wapato Lake Road.

The Pasayton Wilderness

Extending from the Canadian border to the Methow River Drainage, and from the west slope of the high Cascades east to the Chewack River country, the Pasayton Wilderness covers about half a million acres and offers hike-in access to many miles of mountain streams and dozens upon dozens of fishable alpine lakes. Check with the Okanogan National Forest for trail conditions and for suggestions on routes or destinations. The Forest Service also sells some good topo maps of the area, including one specifically for the Pasayton Wilderness. For fishing information check with the WDFW, whose biologists can provide you with stocking information on the wilderness lakes.

EASTSIDE TROUT STREAMS

For all the state's riches in salmon and steelhead rivers, Washington is decidedly sparse in blue-ribbon trout streams. What Washington may lack in sheer quantity of trout streams, however, it makes up for in great quality—in large measure because of one river, the Yakima. The Yakima offers everything one would expect from a blue-ribbon trout stream: large, wild fish, great hatches, splendid scenery, and catch-and-release regulations.

Indeed, the Yakima is the state's flagship trout stream. It is not, however, the only great stream in the state, nor the only one in eastern Washington. Nearly the Yakima's equal in terms of fame and popularity is Rocky Ford Creek, the productive little spring-fed creek that feeds Moses Lake from the north. Here anglers get a taste of the kind of water and the brand of fly-angling typical of the West's great spring creeks, such as Silver Creek in Idaho or Hat Creek in California.

In addition to the Yakima and Rocky Ford Creek, eastern Washington offers a variety of lesser-known streams that in some cases provide exceptional fly-angling for wild trout. Included among these are many creeks and small rivers that drain the east slope of the Cascades, many of which are ideally suited to anglers looking for out-of-the-way waters where a pair of hiking boots proves more valuable than a pair of waders.

Yakima River

The Yakima River is without question the state's premier wild-trout stream. Nearly 70 miles of this popular river are managed for wild trout, with catch-and-release, Selective Fishery regulations in effect year round. The Yakima's wild rainbows make up most of the catch and fish up to 20 inches long are not uncommon; 12- to 16-inch rainbows are abundant. Cutthroat inhabit the river in limited numbers, along with a scant handful of brook trout and bull trout.

The Yakima holds to a rather odd schedule each year: During summer, the water runs high and off-color because of the irrigation demands of regional agriculture. By September, when the irrigation season is over, the spillways upriver are corked for the winter, causing a dramatic decline in river flows and creating the season's best fishing opportunities.

Luckily, the Yakima is open all year. The water remains low until spring, when releases are made to coincide with snowmelt in the Cascades and when the irrigation season gets under way. Winter and early spring fishing can be good, especially during mild weather. Despite the high water, summer fishing is typically very productive and popular, especially when the river's impressive caddis and stonefly hatches erupt. At high water, the idea is to toss dry flies tight against the bank, where many of the trout reside.

The hatches on the Yakima can be spectacular both in density and duration. The hatch chart to follow details the basic schedule of events. Some of the season's best fishing comes with the golden stonefly hatch, which begins around early March and continues through spring. The hatch begins in the "canyon section" first, often peaking between mid-March and mid-April. On the "upper river" (the river between Ellensburg and Cle Elum), where the water warms later, the stonefly hatch can last into June.

Baetis mayflies (blue-winged olives) hatch during spring, typically during the warm part of the afternoon, and March brown mayflies (*Rhithrogena*) can appear between mid-March and May 30, depending on water conditions, weather patterns, and location. A strong March brown hatch, when you encounter one, is a memorable affair.

Caddis gain significance by May, with the Mother's Day caddis hatch being among the most reliable and anticipated of the bunch. These are *Brachycentrus* caddis, whose significance continues well into the summer. Numerous other caddis appear during May and June, lasting throughout the summer. Also during May, the yellow sallies (little yellow stoneflies) appear, primarily above Ellensburg, but sporadically just about anywhere else. Pale morning duns begin to emerge during late May with hatches continuing into early July.

By mid-July, when the heat of summer sets in, hopper fishing begins on the Yakima, providing some of the season's most exciting and productive dry-fly angling. Evenings bring caddis activity—both hatches and ovipositing flights—featuring several genera at once, among them the tiny "micro-caddis." On hot days, the caddis activity occurs mostly at and after dark. Anglers willing to roll out of the sack before dawn can find great early morning caddis fishing along grassy banks and in back eddies.

Yakima River.

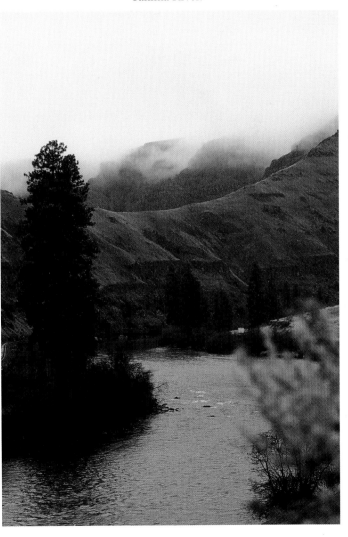

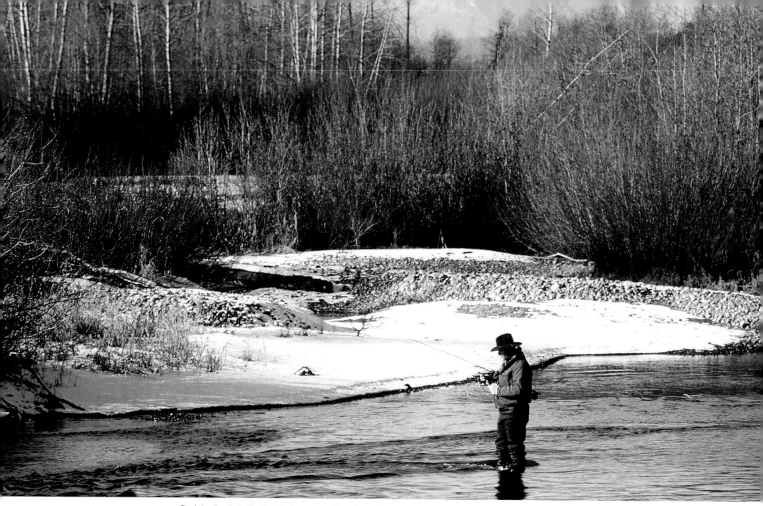

Guide Jack Mitchell changes flies in winter in the Yakima River. Jeff Edvalds photo.

September and October are the best months on the Yakima, combining good hatches with the season's best water conditions, not to mention the changing of the leaves into their fall regalia. *Baetis* mayflies join caddis as the primary hatching insects, but localized hatches of brown willow flies and October caddis can provide explosive action. The *Baetis* hatches can last well into autumn and a strong hatch of pale evening duns (*Heptagenia*) often joins the blue-winged olive emergence between September 25 and October 20 or so. The trout show a decided preference for the larger *Heptagenia*, even though these elegant mayflies may be outnumbered 50 to one by the small *Baetis* duns. Late fall and winter offer few dry-fly opportunities save the occasional Chironomid (midge) hatch that causes short-lived surface feeding, but nymphs and streamers can be productive.

In short, the Yakima is both the best trout stream in Washington and one of the best year-round trout fisheries in the Northwest. With some 70 miles of prime water, the Yakima has earned regional and even national prominence as a blue-ribbon trout stream whose offerings rival the great waters of the other Western states.

Statistics compiled by WDFW show that rainbow trout comprise more than 90 percent of the Yakima's trout population (97.4 percent from Cle Elum to Ellensburg; 94.6 percent in the canyon). Cutthroat run a very distant second and scant populations of hybrids, browns, brook trout, and bull trout comprise the remaining population. In the upper section, Cle Elum to Ellensburg, WDFW samples indicate a population density of about 477 rainbows and 10 cutthroat per river mile. In the canyon, densities average about 424 rainbows per mile. The upper river has a few more trout per mile but those in the canyon waters grow substantially faster. A four-year-old rainbow in the upper river averages 12.5 inches; in the canyon stretch, a four-year-old spans 14.6 inches.

Incidentally, the number of trout in the Yakima hardly compares to the number of whitefish, which is estimated at around 2000 per mile. Should an angler drift nymphs through the right pocket, he or she may hook dozens of whitefish without moving more than a few steps.

Just north of the town of Yakima, the river flows from a scenic desert canyon where steep, grassy slopes and sheer rock escarpments are reflected in the river's fertile waters. This 20-mile-long "canyon section," from Roza Dam upstream to the outskirts of Ellensburg, is the most popular reach on the river and includes lots of good road access and float access. Old Hwy. 821, the "Canyon Road," follows the river through its massive canyon. Between mid-autumn and mid-spring, bighorn sheep can be observed grazing the steep hillsides just above the river, usually along the west bank.

To reach the canyon from the north, follow I-90 to the Canyon Road Exit (Exit 109) at Ellensburg and then follow Canyon Road (Hwy. 821) about four miles to the head of Yakima Canyon. The first access site and put-in at the top of the canyon is off Ringer Road, less than a mile north of the canyon entrance. As you drive south on 821, Ringer Road will turn off to the right, cross the railroad tracks, and lead about a quarter mile to the Ringer Access Site, where you will find a boat ramp, outhouses, ample parking, and some foot access to some good water. Camping is not allowed here.

Just south of the canyon entrance, Wilson Creek flows under the road and into the river. Wilson Creek drains the sediment-laden ditches and creeks of the farmland southeast of Ellensburg and thus typically runs a muddy brown color. Its impact on the river is dramatic and obvious: During fall, when the water drops, the river flows clear at Ringer and points upstream only to be stained with a tint of brown the entire length of the canyon.

The popular bighorn launch site, located a short distance into the canyon below Ringer, was closed off by the landowner for several years; as of this writing, however, an agreement between the property owner and the Kittatas County Field & Stream Club, along with Washington Department of Fish & Wildlife allows for continued public use of this convenient site. A short distance below, at Milepost 20, an increasingly popular rough launch is located on a wide bend. This launch is sufficient for any kind of craft that can be carried to the water by hand (judging by the tracks, a few folks are now backing trailers down this steep, rough launch, which must be some trick considering the proximity of the highway).

Some six miles further downstream lies Umtanum Recreation Site, which offers a good launch along with ample room for rough camping. Just upstream from the rec area is a foot bridge that crosses the river. Anglers willing to walk can access the west bank above and below Umtanum. About two miles below Umtanum is a private launch and campground called River View. The owners operate Red's Fly Shop as well, so anglers can stock up on flies and tackle or simply stop in to check on the fishing. Shuttles and raft rentals are available here as well.

Below River View, the Yakima swings away from the highway around a tremendous sheer rock escarpment before curving back toward the road. Some private land limits access to the bank for a mile or so and then you reach Squaw Creek Rec Site some 12 miles south of the canyon entrance. Three miles downstream of Squaw Creek is the popular take-out called the Slab. The last take-out is about a mile beyond the Slab at the Roza Rec Site just upstream of Roza Dam.

Upstream (northwest) from Ellensburg, Highway 10 roughly parallels the north bank, offering access to much of the 25-mile stretch up to Cle Elum. This section from Cle Elum down to Ellensburg is generally referred to as the upper river. Above Cle Elum, the Yakima is difficult to access as it parallels I-90 through much private property up to the end of the catch-and-release water at Easton Dam.

The upper river runs clean and clear during the fall as it lies above the silting influence of Wilson Creek. Some of this stretch is difficult to access from shore (more or less impossible to access in a few sections) so floaters have an advantage. The main put-ins are at the Washington Department of Wildlife access in East Cle Elum and a short distance down river at the public access site near the junction of Hwy. 10 and Hwy. 970, just upstream of the confluence with Teanaway River. During summer, rafters can drop a boat in the Teanaway and float the few yards down to the Yakima, but the public access site just upstream is easier.

Another possibility is the rough launch at Swauk Creek on Hwy. 10 about seven miles downstream from the Hwy. 970 junction. Swauk Creek is not marked—look for two cement bridges, one after another. Immediately west of these bridges, a steep gravel spur dives off the highway toward the river, ending at the railroad tracks. You'll have to carry a boat over the tracks and down to the rough gravel launch site.

Another rough launch is located on the left bank just below the railroad bridge off Thorp Highway, which turns southeast off Hwy. 10 about 12 miles east of the Hwy. 10/Hwy. 970 junction. Hug the left bank as you pass under the bridge, and just as the big pool there starts to shallow look for the take-out just beyond a screen of overhanging trees. Thorp Highway (Thorp Road) leads down to Dudley Bridge (sometimes called Thorp Bridge). At the northwest side of the bridge, Dudley Road turns to the south off Thorp Road and leads a quarter mile down to the railroad bridge. A small gravel pullout offers scant parking and the launch is a steep gravel affair. (The area around Dudley Bridge is all posted with No Trespassing signs.)

Below Dudley Bridge, the Yakima flows some four miles down to the diversion dam, before which boats must exit the river. For a fee, boaters can use the private take-out owned by River Raft Rentals. This take-out is on the left as you proceed downriver. Another take-out is located on the north bank (left) just above the diversion dam. The river below the diversion dam can be floated from Gladmar Park some four and a half miles down to Upper River Bridge, the take-out being located at the KOA Campground just above the bridge on the left side. Check with the KOA Campground office for permission to use the take-out.

Highway access for walking/wading anglers is good along Hwy. 10 between the diversion dam and Cle Elum, although private property does limit access to substantial sections. In places the river runs just below the highway; in other reaches, anglers must scramble down long, steep embankments to reach the water (beware the poison ivy). In either case, some very good water is available along the highway, including the sections that are accessible from the launch/take-out sites. One of the

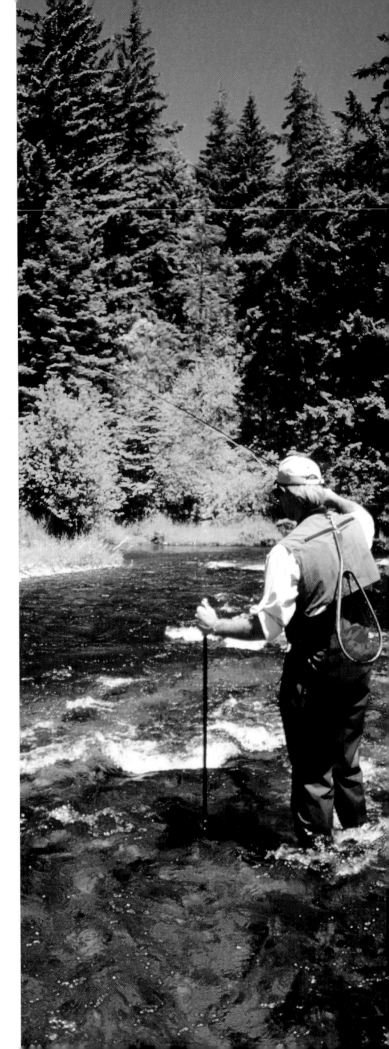

Angler Jay Robeson fishes a run
on the upper Yakima River. Jeff Edvalds photo.

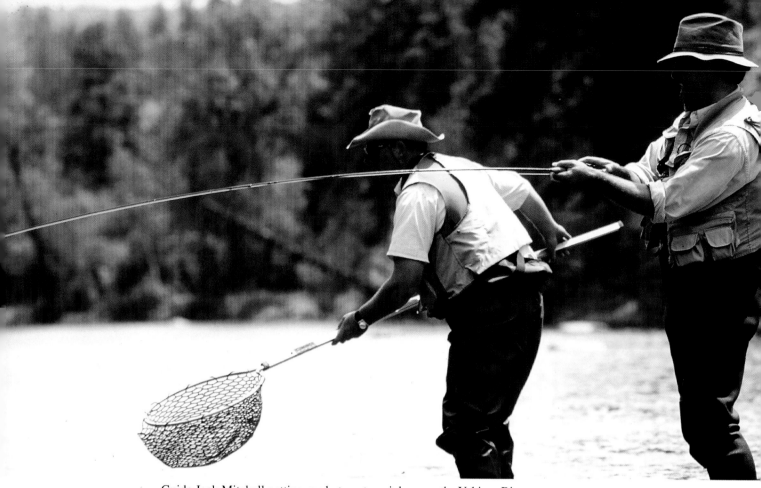

Guide Jack Mitchell getting ready to net a rainbow on the Yakima River. Jeff Edvalds photo

largest Yakima fish I've ever hooked came to a hopper pattern directly under the Thorp Railroad Bridge.

On the upper river's south bank, an old railroad grade parallels the Yakima for many miles, in places offering excellent access to stretches not readily reachable from Hwy. 10. The rails and ties have long since been removed from the old grade, which is now under state ownership as Iron Horse State Park. This is a great trail for walking and mountain biking, yet few anglers take advantage of the opportunity to fish the south bank from the trail.

The best upstream access points for Iron Horse State Park and its John Wayne Trail are located along Lower Peoh Point Road a short distance east of Cle Elum. To reach Lower Peoh Point Road from Cle Elum, take the South Cle Elum exit off I-90. From the east you can also exit at Horlick Road and follow Thorp Prairie Road east to Lower Peoh Point Road or to Watson Cutoff Road, which ends at Lower Peoh Point Road. Lower Peoh Point Road crosses under I-90 and just east of the interstate John Wayne Trail parallels Lower Peoh Point Road for two miles. Along the road are two accesses to the trail (look for the small signs on the north side of the road announcing Iron Horse State Park). The eastern-most trail access is closest to the river as you will be walking or riding east to get to the water.

The best downstream access to John Wayne Trail lies along Taneum Road, which turns west off Thorp Highway about two miles southeast of Dudley Bridge. After turning onto Taneum Road, just watch for the trail and Iron Horse Park signs on the north side of the road about a quarter mile west of Thorp Highway. The Horlick Road Exit off I-90 accesses Taneum Road from the west. Exit the freeway onto Thorp Prairie Road and head east about five miles to Taneum Road.

Between Taneum Road and Lower Peoh Point Road, walking and mountain biking anglers can access most of the best water between Cle Elum and Dudley Bridge—and frequently you'll be the only non-boat angler on that side of the river.

Camping is a little tough to come by along the upper river between Cle Elum and Ellensburg. A private campground is located along Hwy. 970 east of Cle Elum. Other area campgrounds are located in Taneum Canyon west of I-90 and south of Cle Elum and at Lake Easton State Park along I-90.

Yakima River Hatches and Flies

Certain freestone rivers in the West are changing, or rather their trout are changing in response to abundant fishing pressure: No longer can you simply throw a Royal Wulff at every rise and expect to fool lots of big trout. The Yakima is among the best examples of this. Quite simply we are educating lots of the larger trout through a combination of catch-and-release and lots of fishing pressure. Apparently, even with a brain the size of a pea, a trout need only make the mistake of grabbing a fly so many times before it becomes suspicious of oversized offerings drifting above.

Fly-anglers who are adapting their technique and patterns to coincide with this change in trout behavior consistently have the best days on the Yakima and on other streams that have gone through the same thing. Such anglers have switched to spring creek-style patterns to fish the major hatches: X Caddis and Spent-Wing Caddis; Sparkle Duns and Floating Nymphs. Elk Hair Caddis, Humpies, and Royal Wulffs still take lots of trout, but when the chips are down during a heavy hatch, the big trout that have seen lots of stuff and been hooked a few too many times will feed with great care—and it takes finesse, accuracy, and sparse flies to catch these trout consistently, especially by September and October.

So when you visit the Yakima be prepared to fish easy tactics as well as more complicated techniques: A hopper splatted six inches from a steep bank may draw explosive rises all day, but when the evening caddis hatch begins, you may find that an Elk Hair Caddis and an up-and-across cast fools only the small fish. Switch to a downwing pattern or an X Caddis, make a downstream slack-line cast and likely you'll find the big rainbows less suspicious.

Meanwhile, those proficient in the use of streamers (weighted Muddlers, Woolly Buggers, and sculpin patterns) can hook some very large trout in the Yakima, and nymph anglers generally do quite well.

Water conditions, following the whims of seasonal weather patterns and irrigation needs, vary tremendously on the Yakima from year to year, making precise timing of the hatches difficult, if not impossible, to predict. The following chart gives a seasonal framework for the hatches. Don't expect most hatches to last for the entire duration of time indicated below. Rather, look for the indicated hatches to fall somewhere within the time span indicated. The beginning and peak periods of any given hatch on the Yakima might vary by as much as two weeks or more from one year to the next.

MAYFLIES	TIME	PATTERNS
Blue-winged Olive (*Baetis*)	March-Nov.	Size 18-20 Baetis Compara-Dun, olive CDC Emergent Dun, olive
Mostly duns, but some heavy little brown quill spinner falls during September		CDC Floating Nymph, olive size 20 Red Quill Hackle Spinner
Western March Brown (*Rhithrogena morrisoni*)	Mar. 20-May 30	Size 12-14 Sparkle Dun, tan Compara-Dun, tan
Pale Morning Dun (*Ephemerella infrequens*)	May 15-July 15	Size 14-18 Sparkle Dun, pale yellow-green Compara-Dun, pale yellow-green
Good hatches and good but localized spinner falls		CDC Emergent Dun, pale yellow-olive CDC Emergent Dun, pale yellow-olive CDC Floating Nymph, pale yellow-olive Shewey's Emergent Cripple, pale olive-yellow
Green Drake (*Drunella grandis*) Sporadic and localized	May 15-June 25	Size 10 Lawson Green Drake Paradrake
Mahogany Dun (*Paraleptophlebia sp.*) Sporadic and localized	May 10-June 15	Size 16 Sparkle Dun, mahogany brown Compara-Dun, mahogany brown Shewey's Emergent Cripple, mahogany brown CDC Emergent Dun, mahogany brown
Tiny Western Olive (*Baetis*)	Aug. 30-Nov. 15	Size 22 CDC Floating Nymph, light green CDC Emergent Dun, light green
Pale Evening Dun (*Heptagenia sp.*) Localized, but important and reliable	Sept. 20-Oct. 25	Size 14 CDC Emergent Dun, yellow, Sparkle Dun, yellow Compara-Dun, yellow Shewey's Emergent Cripple, yellow

CADDISFLIES	TIME	PATTERNS
Mother's Day Caddis (*Grannom*) (*Brachycentrus americanus*) Most important during May	Apr. 20-July 10	Size 14-16 X Caddis, olive-gray Elk Hair Caddis, olive-gray Spent Partridge Caddis
Spotted Sedge (*Hydropsyche sp.*)	May 15-Aug. 15/Sept.	Size 14-16 X Caddis, olive-tan Spent Partridge Caddis, olive-tan Elk Hair Caddis, olive-tan
Little Western Weedy Water Sedge (*Amiocentrus aspilus*)	May-June	Size 18 X Caddis, green CDC X Caddis Spent Partridge Caddis, green
Tan Sedge	May-July; Sept.	Size 16 Tan Elk Hair Caddis Tan X Caddis Size 16-18 CDC Caddis
Micro Caddis	June-Sept.	Size 20-22 Antron Caddis Pupa Size 20 CDC Caddis
Little Black Caddis	June-July	Size 18 Black Spent Caddis Size 18-20 Black CDC Caddis
October Caddis (*dicosmoecus*) Mostly upper river	Sept. 5-Oct. 30	Size 6-8 Shewey's October Caddis Maxwell's Jughead, orange

STONEFLIES	TIME	PATTERNS
Golden Stonefly (*Calineuria californica*) Sporadic, localized hatches during June	Mar. 1-May 30	Size 6-8 Maxwell's Jughead Stimulator Yellow
Little Yellow Stone (Yellow Sally) (*Isoperla sp.*)	May 20-July 30	Size 12-14 Quigley Yellow Sally Size 10-12 Maxwell's Jughead, yellow
Brown Willow Fly (Trout Fly) (Acroneuria sp.)	September	Size 6-8 Maxwell's Jughead, tan Stimulator, tan or brown

MISCELLANEOUS	TIME	PATTERNS
Hoppers	July-Oct. 15	
Ants, Beetles	June-Sept.	
Midges (Chironomids)	All year, but more significant during winter	

Rocky Ford rainbow.

Rocky Ford Creek

Fly rods in hand, a man and woman were just walking back from the creek and over to one of the three cars now occupying the lot. Having just arrived, I fetched a heavy shirt to fend off the spring chill and sauntered on over for a visit.

"How's fishing?" I offered.

Simultaneously, their eyes sparkled like kids waking up on Christmas morning. "My wife just released a 30-inch trout," the man exclaimed, the magnitude of the fish and the encounter still being savored by both anglers.

As they relived the action for me, I began to notice the increasingly frequent riseforms in a slick glide upstream. Gentle dimples on the surface came more and more frequently until I could stand no more. A fourth angler had joined our little circle and I suggested that someone put the sneak on those rising trout.

The first two folks were content just to reflect on their afternoon; the newcomer had yet to string a rod, so by default the task was left to me. I grabbed a rod from my truck and lead our little troop upstream to get a better look at those rising trout.

Sparkling afternoon reflections made the glare so bad that I couldn't hope to see the size 22 midge emerger I was fishing. I tried casting and then pulling tight on the line until the fly skated on the surface. Then I would lower the rod tip and hope for a drag-free drift. But the swirling currents would have none of it, so I opted for simply throwing the leader into a heap and then lifting the rod tip on any riseform that seemed close to where I guessed the fly was located.

I probably made 20 casts before I timed one right and set the hook on the right rise-form. Size 22 hooks don't stand up well to fat 20-inch rainbows and we parted company in short order; a classic LDR (long-distance release). My suspicions were confirmed when I retrieved the fly only to find the hook bend mostly straightened.

This was classic spring-creek fishing on Washington's classic spring creek: Rocky Ford Creek flows about seven miles through a narrow coulee in the eastern Washington plains, surrendering its waters to the northern extremity of Moses Lake in Grant County.

Average Rocky Ford rainbows span 14 to 20 inches and fish exceeding 20 inches are common most years. These trout grow fast and fat on a diet rich in scuds, snails, mayflies, Chironomids, and other foods.

Along the seven-mile course below its natal springs, Rocky Ford Creek features two public-access areas: A one-mile reach at the top end and a three-mile length above the confluence with Moses Lake. A few miles south of Ephrata, Hwy. 17/282 crosses the creek and provides access to the lower three miles. To reach the upper access site, turn north on Hwy. 17 (towards Soap Lake) about a mile north of the creek. Drive about three and a half miles and turn right at the public access signs ("C" Road). Follow this gravel road about two miles down to the parking area. You can hike downstream from there.

At its top end, the creek feeds a private hatchery before flowing through a short modified channel and into a long, slow flat that is more like a big pond than a creek. The trout at the top end, near the parking lot, see a lot of people. These fish don't spook wildly nor easily, but instead just keep right on feeding even though they know you are standing on the banks above.

Despite the somewhat artificial feel of the place, I do on occasion enjoy this section of creek immediately below the hatchery. It's like practicing for Idaho's Silver Creek. Once you walk down a ways, or when you fish the lower access area, you leave behind that artificial feeling. In the lower public reach, the creek glides quietly along over shallow gravel and sand, meandering through a narrow coulee rich in reeds and grasses. Herons, bitterns, rails, waterfowl, and many other birds are common.

During summer, weeds grow in dense green matts, in places

Rocky Ford. Dec Hogan photo.

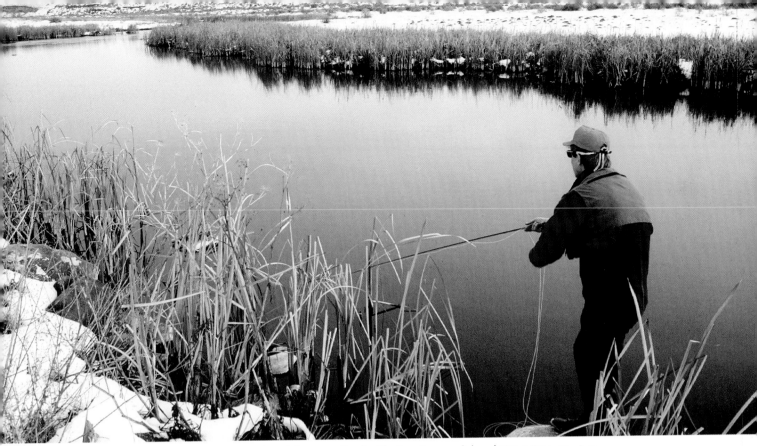

Jay Robeson fishing for rainbows on Rocky Ford spring creek in winter. Jeff Edvalds photo.

crowding the water out of the streambed and into the surrounding meadows. This seasonal flooding makes parts of the creek difficult to approach. You may need waders to get to the creek, but the streambed itself is off limits to wading.

Rocky Ford offers consistent hatches of Chironomids (midges), blue-winged olive mayflies (*Baetis*), and pale morning dun mayflies (*Ephemerella*). Other hatches occur on a less consistent and/or more localized basis, including Tricos, speckled-wing duns (*Callibaetis*), and mahogany duns (*Paraleptophlebia*). The midge hatch is probably the most important single hatch if only because it occurs practically all year. Tiny Griffith's Gnats and floating emerger patterns will fool fish.

During non-hatch periods, try scud patterns (size 14-20), Pheasant Tail Nymphs (size 14-20) or other small nymphs and wet flies. Or fish streamers, such as Woolly Buggers and Bunny Leeches. When fishing over hatches or with small nymphs, you want a leader of 12 to 18 feet with a 6X tippet (sometimes 7X). Streamer fishing requires shorter, heavier leaders.

Rocky Ford Creek is open year round and while crowds are common from Memorial Day to Labor Day, the off-season offers many days when you won't see but one or two other anglers. The lower public reach is less crowded, but probably has fewer fish. I typically opt for fewer people and head for the reach below Hwy. 17.

For most Washington anglers, Rocky Ford is easy to access via I-90. From the east, exit the freeway at Moses Lake and head north on Hwy. 17. From the west, follow I-90 to Hwy. 283, follow 283 to Ephrata, turn right on Hwy. 282 and drive about six miles to the lower access area or turn north on 17 to reach the upper access. For up-to-date reports, contact the Blue Dun Fly Shop in Wenatchee or Gary's Fly Shop in Yakima.

Hatch-matching Patterns For Rocky Ford Creek

Many of the patterns listed for the Yakima River will prove valuable on Rocky Ford Creek. In addition Rocky Ford offers a few hatches that are absent or insignificant on the Yakima. Among these are the *Callibaetis* and Trico mayflies. When Rocky Ford's trout respond to these hatches, anglers can experience classic spring-creek dry-fly action. My favorite patterns are listed at right.

Trico Hackle Spinner

Hook: Dry fly, size 18-22
Tails: Micro Fibetts
Abdomen: White thread
Thorax: Black dubbing (e.g. black mole fur)
Wings: White hackle wound over front half of hook and then c ounter-wound with the dubbing; hackle is then clipped flush below and V-clipped above

Callibaetis CDC Dun

Hook: Dry fly, size 14-16
Tail: Micro Fibetts
Body: Fine olive-tan dubbing
Wing: Gray or tan CDC with a few teal flank fibers on the outer edges

Two yellowlegs standing
along a spring creek. Jeff Edvalds photo.

Entiat River (Chelan County)

The Entiat is a nice, medium-sized, canyon-bound stream that flows in a southeasterly direction between the Entiat and Chelan mountains, eventually reaching the Columbia River some 10 miles upstream from Rocky Reach Dam. Trout fishing can be fair to good and the river is governed by Selective Fishery regulations all the way up to the campground at Fox Creek. Try the upper river and its walk-in tributaries for small natives that love to pounce on dry flies during late summer and early autumn. Access is from Entiat River Road which turns west off the west-side U.S. 97 Alternate at the little town of Entiat, north of Wenatchee. Campgrounds are located along the upper river.

San Poil River (Ferry County)

A worthwhile fishery if you're in the neighborhood, the attractive San Poil River offers fair to good fishing in its public access reach from the 19-mile Creek Bridge down to the northern edge of the Colville Reservation. My limited experience here occurred during September and I found six-to 12-inch rainbows eager to pounce on hopper patterns so long as I worked the more out-of-the-way pockets, riffles, ands runs. Rumor suggests some large trout are available and I don't doubt it based on the available cover.

The reservation reach of the San Poil is open during specified seasons set by the tribes. You will need a permit. I've never explored these waters, but I suspect they might offer some good fishing. Curt Vail of Washington Dept. of Fish & Wildlife recommends the lower river on the reservation.

Colville River (Stevens County)

The Colville River is the type of stream best suited to anglers willing to knock on doors and drive back roads in the farmland of Colville Valley. If you're willing to do both you can find brown trout to several pounds and rainbows up to 14 or more inches. Neither species is abundant, but the river is lightly fished along much of its length owing to a preponderance of private farm lands.

July through September is prime time for hopper fishing but the Colville is open year round, so low water during late fall and mid- to late winter offers ideal conditions for streamer fishing. Try a large Marabou Muddler or sculpin pattern fished on a sink-tip line. The upper river, above the little town of Valley, is governed by Selective Fishery rules. Rainbows predominate here while the browns become more numerous as you move downstream.

The Colville River runs northwesterly and is followed for most of its length by Hwy. 395, which arrives from Spokane to the south. About five miles south of Chewelah, State Route 231 departs 395 and heads southwest to the town of Valley and the river's upper reaches.

Kettle River (Ferry/Stevens County)

One of the state's underappreciated trout streams, the productive and scenic Kettle River flows south out of Canada and forms the border of Ferry and Stevens counties. The Kettle is managed to protect its native rainbow trout, so a two-fish limit is in effect until winter when the trout spawn. From November 1 through the end of March, the river is catch-and-release only with Selective Fishery regulations.

The native rainbow stocks are supplemented with hatchery stocks, but the planted trout are all bred from wild Kettle River broodstock. Mountain whitefish abound and the river contains a few wild brown trout and a few wild brook trout. The rainbows average 10 inches or so, but fish up to 20 inches are available in this low-gradient freestone river.

Caddis and stonefly hatches dominate throughout spring, summer, and fall, including seasonal emergences of golden and giant stoneflies. Blue-winged olives and other mayflies make regular but localized appearances. During most years, hopper fishing can be very productive between July and September.

U.S. Highway 395 follows the Kettle River for its entire 30-odd-mile run through northeastern Washington. To get there, follow I-90 to Spokane and head north on 395. Alternate and longer routes include Hwy. 20 over the North Cascades, through Okanogan County to Omak, north to Tonasket, east to Republic, and then on to Hwy. 395 across the Columbia from Kettle Falls.

Chewack River (Okanogan County)

The Chewack flows north to south, mostly through the Okanogan National Forest, before joining the Methow River at the town of Winthrop. This attractive little river offers fair to good fishing for small rainbows. Its upper reaches, which extend deep into the Pasayton Wilderness, feature beautiful, trout-filled pocket water along with intimate, gin-clear pools. Midsummer through mid-autumn offers the best opportunity. From Winthrop, turn north on Forest Primary Route 51 (Chewack Road) or Forest Road 5010 (Eastside Chewack Road), both of which follow the river north. Several campgrounds are located on the river and along Eightmile Creek, an important tributary that also offers fair trout fishing.

Rocky Ford.

EASTSIDE STEELHEAD STREAMS

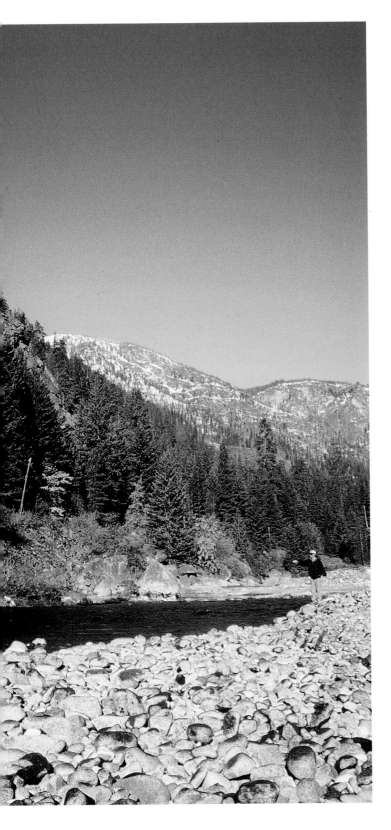

Steelhead populations on the east side of the Cascades are entirely dependent upon the Columbia River, the lifeline that connects all of the eastern Washington drainages to the Pacific Ocean. In recent decades, many of the once-prolific runs of native eastside steelhead have all but disappeared—sad testimony to the affects of habitat loss, water use, and impaired fish passage. Hatchery-produced runs have supplanted the natives in many rivers. Still, several rivers that once supported sizable runs now barely qualify as steelhead streams.

Despite the increasingly depleted runs of natives, the hatchery steelhead still enable several popular and productive fisheries, including those on the Wenatchee, Klickitat, and Grand Ronde, the latter stream being the most popular and often the most productive of the eastside rivers, at least for fly-anglers.

When fly-angling's popularity exploded during the 1980s, the Grand Ronde and Wenatchee hosted dramatically larger crowds each autumn. Yet the fly-angling history of the eastside steelhead streams dates back many years. Legendary Northwest anglers like Ralph Wahl, Enos Bradner, and Walt Johnson fished the eastside streams during the 1950s and thereafter. Likewise, they cast flies to abundant steelhead on the Columbia itself, namely near the mouths of the Methow and Entiat rivers, prior to the construction of Wells Dam. Walt Johnson's beautiful Red Shrimp Spey was inspired by the simple red fly used by one of the local anglers, Ray Olson, who lived in Chelan.

These days, even though the runs of native fish are severely depressed and hatchery fish account for most of the action, the eastside rivers remain remarkable in their rugged, scenic beauty. Moreover, they peak during the best and most beautiful time of year, from September through November. Owing to ideal water temperatures during most of the fall, the eastside rivers are perfectly suited to floating lines; their steelhead often respond to skated dry flies.

Wenatchee River

The beautiful Wenatchee River flows east out of the Cascades, leaving its rugged, scenic mountain canyon at the quaint little tourist town of Leavenworth before winding its way through the fertile apple orchard country on its way down to the Columbia. Along most of its length, the Wenatchee offers an abundance of the kind of water that makes veteran steelhead fly-fishers drool while continually swerving out of the way of oncoming traffic as they pay too much attention to the elegant river below and not enough attention to their driving. I know because I'm guilty of scaring the hell out of my passengers a few times, not to mention the other drivers on the highway.

The Wenatchee is a fall fishery. Its steelhead face a long and arduous journey up the dam-infested Columbia before reaching their home river, so most don't arrive until late in the season. By October, when the fishery peaks, lots of people are busy hunting and working and sending the kids off to school. The river is anything but crowded by mid-month.

Most of the fishing pressure occurs in the 20-odd-mile stretch from the mouth of the river at Wenatchee up to Leavenworth. Access in this reach is good for wading anglers who are willing to explore the numerous residential and rural side roads along and near the river, knocking on doors where necessary. A good boat ramp at the town of Cashmere gives drifting anglers the ability to float the lower river, stopping at any water that catches their fancy.

Wenatchee River.
Following page: Grand Ronde River. Dec Hogan Photo.

Wild steelhead must be released in the Wenatchee and they are in the minority. Most steelhead are hatchery fish and the few thousand of these that make their way back to the river have survived a gauntlet of turbans, dams, predators, and lousy water conditions in the Columbia—a gauntlet that has eaten up nearly 350,000 of their compatriots that are planted as smolts each year.

The Wenatchee offers countless classic runs, pools, and tailouts where dry-line tactics—even skated dry flies—tempt steelhead from five to 12 pounds or more. So long as the weather holds and the water remains reasonably warm, the Wenatchee offers good prospects for those who swing skated dry flies such as Bombers and Grease Liners. Favorite wet flies include typical Northwest classics such as the Skunk, Green-Butt Skunk, and Purple Peril.

The town of Wenatchee offers everything you might need, including Bill Martz' Blue Dun Fly Shop. The towns of Cashmere and Leavenworth offer all services and you stand a reasonable chance of hooking a steelhead within the city limits of either community. Camping is available at Tumwater and Swiftwater campgrounds along Hwy. 2 upstream from Leavenworth.

Methow River

A quietly productive steelhead stream, the Methow River flows for many miles through the Methow Valley along Hwy. 20 and Hwy. 153, finally surrendering its waters to the Columbia at the tiny town of Pateros, north of Chelan. Along its journey out of the North Cascades, the Methow passes through the gaudy tourist town of Winthrop where it is joined by the Chewack River and the gateway town of Twisp, where the Twisp River contributes its flow. With the addition of these and other tributaries, the Methow River forms a rather substantial presence as it approaches the lower valley.

Peak catches occur during September and October. On occasion, August fishing can be good as well. As with the other upper Columbia tributaries, the Methow River's timing can be gauged by watching fish passage numbers for the dams on the upper Columbia. During low-water winters, anglers will continue to take Methow steelhead during December, January, February, and March.

To reach the Methow from the Seattle area, follow Highway 20 up the Skagit River, over the North Cascades and down to the valley, or follow Highway 2 through Leavenworth to Hwy. 97 and then up past Chelan. From points east or south, consult a road map for the easiest of numerous routes to the Methow Valley.

Klickitat River

Draining the east slope of Mt. Adams, the Klickitat River is a unique and productive steelhead stream that enters the Columbia River at the little town of Lyle a few miles northwest of The Dalles, Oregon. During the good old days of the early 1980s, the Klickitat yielded several thousand fish each summer. During the 1990s the average was about 1,000 fish per season, the vast majority of these being of hatchery origin.

The river's unique nature is a direct consequence of its headwaters being located on Mt. Adams' expansive flanks: During warm summer days, glacial melt from the mountain discolors the river by late morning or early afternoon. Assuming the nights remain cold at high elevations above, the Klickitat regains some clarity during the dark hours, allowing for productive morning fishing before again turning glacial green later in the day. This is the typical pattern between July and September, right up until daytime temperatures on the mountain take a decidedly downward turn for the autumn.

By October, (sometimes as early as mid- to late September) the river typically runs quite clear and is fishable all day. And, although the Klickitat rarely makes Washington's Top 10 List among summer steelhead streams, it does yield more than a thousand fish per season, with mid-July through mid-October being the most productive time.

What's more, this scenic river is easily accessible as it is paralleled by

Left: Klickitat River.

state route 142 for most of its first 19 miles. Then it winds through Klickitat Wildlife Area for 10 miles before approaching Goldendale Road, which parallels the river for the remaining few miles up to the Yakima Indian Reservation Boundary. For the most part, the reach of the river flowing through the wildlife area is limited to boat and foot traffic. About halfway through this section lies Soda Springs Campground, reached via Soda Springs Road which turns south off Goldendale Road about five miles northwest of Hwy. 142. A nice day's drift takes you from the put-in upstream at Leidl Campground down to Soda Springs, a distance of about eight miles.

Likewise, you can launch at Soda Springs and float down to the public ramp in the town of Klickitat some 10 miles below. If you float downstream from Klickitat, make sure to exit the river before you reach Klickitat Canyon. Not far above the mouth of the river, the Klickitat Canyon or "gorge" prevents any fishing access as the river is funneled through sheer rock walls on both sides. The best view of this spectacular chasm is from the bridge on Fisher Hill Road a mile and a half upriver from Hwy. 14.

Above the gorge, the Klickitat becomes a classic steelhead river, largely comprised of cobblestone runs and broad tailouts. The winter flood of 1996 devastated the river's course, re-arranging some pools and runs into entirely new configurations, not to mention destroying parts of the highway and ravaging homes and properties along the water. Nonetheless, the river's readable, fly-rod-friendly nature remains.

To reach the Klickitat, follow Hwy. 14 along the Columbia River to the town of Lyle (about 10 miles east of White Salmon), then turn north on State Route 142 to follow the river upstream. After about 18 miles, the highway departs the river, which swings away to the northwest.

White Salmon River (Klickitat/Skamania Counties)

One of the top summer steelhead streams in the Columbia Gorge, the White Salmon offers an abundance of nice fly water. During most years, steelhead harvest from the White Salmon exceeds 1,500 fish and often reaches several thousand. However, the harvest figures for this river can be mis-leading because most of the fish are taken by boaters who work the mouth of the river, using plugs, spoons, and baits.

Nonetheless, plenty of hatchery-origin steelhead ascend the White Salmon and hold in the river's many pools and runs. The best months are August and September, but the fishing often holds up deep into autumn. Classic dry-line methods—even skated dry flies—are ideally suited to this swift river.

State Route 141 follows the river north from the Columbia up to the little town of Trout Lake. To reach the White Salmon follow Hwy. 14 from east from Vancouver or west from the dry side of the state. The river's mouth meets the Columbia about a mile west of the town of Bingen. State Route 141 departs Bingen and heads through White Salmon on its way up to the accessible reaches of the White Salmon River. The town of Hood River, Oregon, lies across the Columbia. Services are available in White Salmon and Bingen and across the river at Hood River, which includes the Gorge Fly Shop. The Hood River Bridge over the Columbia requires a toll on the Oregon side (75 cents).

The nearby Little White Salmon River is a popular destination for hardware anglers who seek salmon and steelhead that run into sprawling Drano Lake at the river's mouth. Some steelhead do ascend the river, however, so fly-anglers might explore the river above the mouth during August and September, especially after a good freshet. Forest Service roads follow the river north. Consult a map of the Gifford Pinchot National Forest.

Grand Ronde River

Perhaps the most popular fly-rod steelhead stream in eastern Washington, the Grand Ronde flows more-or-less northeasterly for more than 200 miles from its source in the Blue Mountains of Oregon, through the Grand Ronde Valley, into its canyon at Elgin and Troy, and then into

Washington before it joins the Snake River downstream from Hells Canyon, seven miles north of the Oregon state line.

Steelhead anglers converge on the river in October and the fishing continues through December. In fact, although these are summer-run steelhead, fishing often continues right through the winter, at least when water conditions allow. Cold water between December and March forces fly-anglers to fish tactics suited to typical winter steelhead angling, but the fishing can be productive. Still, the October-November season is best for those who prefer floating lines and mild weather.

The fishery extends up to the legal deadline at Meadow Creek in Oregon, about half way between La Grand and Ukiah, but the river above Elgin is not particularly of interest to most of the river's serious steelhead anglers.

The Washington section of the river begins almost 10 river miles upstream from the Hwy. 129 Bridge and stretches more than 20 miles downstream from there to the Snake River. The mouth of the Grand Ronde is a popular place with hardware anglers while the river a short distance upstream offers lots of good fly water. Joseph Creek Road follows the river for several miles up to the county bridge, providing good access to the lower Grand Ronde.

Additional drive-in access is available upstream from the highway bridge. Just follow Hwy. 129 to the river's north bank, then turn upstream (west) on Grand Ronde Road, which follows the river up to Troy, Oregon. This reach features easy access to numerous picturesque steelhead runs.

From the highway bridge down to the county bridge, some 20 miles of the Grand Ronde is left to floaters. The put-in for this reach is at the Hwy. 129 bridge (or you can launch upriver at Troy) and the take-out is at the county bridge at Joseph Creek or down at the mouth, which is accessible via Snake River Road from Clarkston, Washington. Plan several days for this trip if you want to fish more than a sampling of pools.

Hatchery steelhead make up a majority of the catch, with four- to eight-pound fish being typical. Each year, however, a few large steelhead—12 to 18 pounds—fall to Grand Ronde fly-anglers; some of these big fish are strays from the Clearwater River to the northeast. Numerous traditional steelhead flies are put to good use on the Grand Ronde and those who arrive before winter sets in can expect to rise fish to skated dry flies. Once the water temperature plummets into the low 40s, start thinking about winter tactics. A sinking or sink-tip line will help keep a swinging fly deep or you can opt for a weighted fly, such as a Comet tied in purple, black, or orange.

Snake River

Fly-anglers who brave the sprawling Snake River can intercept both A- and B-run steelhead headed for the Clearwater, Grande Ronde, Salmon, and other tributaries. The easiest water lies upstream (south) of Clarkston and is paralleled closely by Snake River Road all the way to the Grand Ronde's mouth. You can drive along the road, pick a nice riffle or run, and park above the river. Then just walk down and fish your water. Be careful of the wading, however, as some treacherous areas can take you by surprise.

Steelhead arrive by August, but the fishing picks up around mid-September most years and lasts through the fall. Sometimes warm water temperatures early in the fall make early morning and evening the most productive times to fish the Snake River. If you own a jet sled, you can explore many productive runs that are difficult or impossible to fish from for bank anglers. Launch at Clarkston, Asotin, or at the mouth of the Grand Ronde. Be sure to scout the river ahead or go with someone who knows the water. A Washington or Idaho license allows you to fish both sides of the river, assuming you are in the water. Barbless hooks are required on the border waters.

Touchet River

A lengthy tributary to the Walla Walla River in southeastern Washington, the diminutive Touchet offers a chance at late summer-run steelhead that ascend the river from late October through December. During some

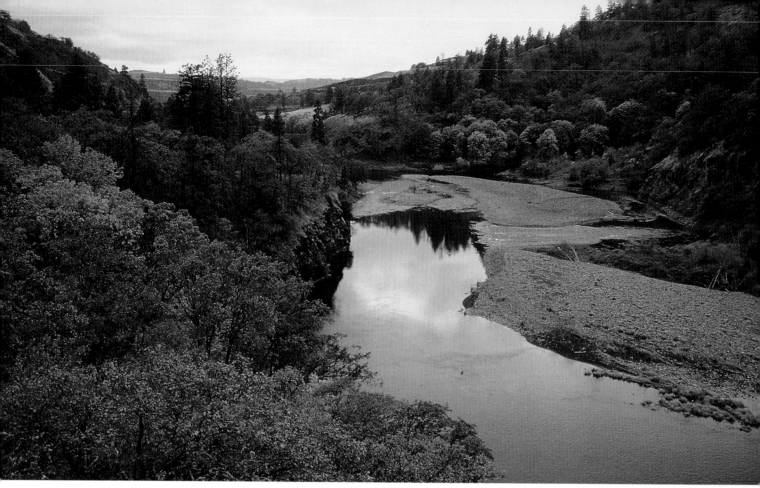

The Klickitat River offers miles of classic steelhead water.

years, the fishing will improve during mid-spring when water temperatures are on the rise. As of this writing, the Touchet is open to steelhead angling from the mouth up to the confluence of the North and South forks just above Dayton and the entire stream is managed to protect the remaining wild steelhead, which must be released.

Access is good below Dayton, where State Route 12 and then State Route 124 follow the river for quite a few miles. From the mouth of the river at the town of Touchet (west of Walla Walla) Touchet North Road follows the river for about 15 miles. Along its entire length, the Touchet flows through lots of private property, so if you are in doubt about access, knock on a door for permission.

To reach the upper half of the steelhead section, follow Highway 12 east from the Tri-Cities and across the Snake River. Turn north at Hwy. 124 and follow 124 northwest through the vineyard country for about 25 miles until you reach the river. From there, Hwy. 124 follows the Touchet up to Waitsburg and then Hwy. 12 continues along the river from Waitsburg to Dayton. The lower 15 miles of the Touchet are accessible from Hwy. 12 about 25 miles from Pasco: Follow the highway east out of town, heading toward Wallula and Walla Walla. Cross the river just west of the little town of Touchet and Touchet North Road turns off to the left a short distance further.

Walla Walla River

Like its tributary the Touchet, the Walla Walla River offers some late fall, winter and spring fishing for summer steelhead. Most of the river flows through private agricultural lands so be sure to seek permission if you have any doubts. The Walla Walla reaches the Columbia at Wallula Junction, west of the town of Walla Walla and south of Tri-Cities. In recent years, the Walla Walla has yielded between 400 and 900 steelhead each season.

Tucannon River

Quite remote as Washington steelhead streams go, the Tucannon flows northwesterly from its sources in the Blue Mountains north of the Oregon border, where Garfield County cuts a narrow swath between Columbia County on the west and Asotin County on the east. After exiting the Blues this small river cuts across the wheat country between the communities of Dayton and Pomeroy, passes through the tiny town of Starbuck and then yields to the Snake River eight miles downstream from Lower Goose Dam.

Having said all that, it might come as a disappointment that the Tucannon's steelhead offerings are limited. The river yields a few hundred fish each year, mostly to trollers and plunkers working the mouth. Nonetheless, fly-anglers can do some damage, mostly on the lower river. Creative types might consider float-tubing the mouth of the river, especially in the narrows below the river's first riffles. Troll or cast and retrieve with a standard steelhead pattern or with a small streamer. The best time is in mid- to late fall.

Exploring the river upstream of the mouth often requires that you seek permission from land-owners, despite the fact that the highway follows alongside many reaches of the river. To reach the Lower Tucannon from the west, follow I-90 to Vantage, cross the Columbia and turn south on Hwy. 26 and follow 26 past Hwy. 395 to Washtucna. Turn south on State Route 260, drive six miles to SR261 and turn left. Follow SR 261 to the Snake River and across the bridge. Then drive a few more miles to the river. From the north or south, take Hwy. 395 to Hwy. 26; from Clarkston/Lewiston, follow Hwy. 12 past Pomeroy to Delaney and turn right on SR 261.

Entiat River

Historically a good summer-steelhead stream, the pretty Entiat River still offers some very limited action on hatchery returns during the fall but its wild run has dwindled to near extinction. As such, all wild steelhead must be released. After its lengthy run from the mountains to the northwest, the Entiat reaches the Columbia at Entiat Lake about 10 miles upstream from Rocky Reach Dam. Entiat River Road follows the river for many miles. Several campgrounds and several photogenic falls are located along the upper reaches of the river.

WESTSIDE
LAKES & TROUT STREAMS

Western Washington has always been better known for its myriad salmon and steelhead streams than for its trout waters, but hidden amidst the many productive anadromous-fish rivers are a handful of fine streams and lakes where restrictive regulations promote good fishing for rainbow, cutthroat, and brown trout. Even anglers who live in or near the Northwest's biggest metropolis can find quality trout fishing within an hour or so of Seattle on streams such as the forks of the Snoqualmie and stillwaters like Rattlesnake Lake and ever-popular Pass Lake.

To the south, several productive lakes surround Mount St. Helens, some of which were created by the eruption itself. Throughout the region, the west slope of the Cascade Mountains affords ample opportunity to explore small, plunge-pool creeks that rush through forested canyons on their precipitous journeys down to the broad valleys through which flow the big steelhead and salmon rivers.

In addition, the Cascade Range offers some of the Northwest's most unheralded but productive hike-in lake fishing. All told, the designated wilderness areas of the Cascade Range in Washington encompass more than a million acres. Add two national parks (Mt. Rainier and North Cascades) and fly-anglers can choose from literally hundreds of high lakes where a pair of hiking boots offers the only access. Brook trout abound in these wilderness lakes, including some surprisingly large fish where ideal conditions exist. Rainbows and cutthroat inhabit other lakes and a few of the waters offer golden trout.

Just to get an idea of the countless options for hike-in fishing, check out some of the maps available from the Forest Service. Some of the best include "Pacific Crest National Scenic Trail," "Goat Rocks Wilderness," "Pasayton Wilderness," "Gifford Pinchot National Forest," "Mt. Baker/Snoqualmie National Forest" and several others available from regional offices.

Rattlesnake Lake

A short drive from the community of Issaqua, Rattlesnake Lake offers easy-access quality fishing for Seattle-area residents. This scenic lake varies quite a lot in size, depending on time of year. Winter rains may swell the lake to 120 acres, but by autumn it may shrink to a fraction of that size.

Rattlesnake is a clear-water lake surrounded by forested ridges, including Rattlesnake Mountain, which rises precipitously from the lake's northwest shore. The fare here includes planted rainbow and cutthroat trout. The fish are stocked each year and big ones run 14 to 16 inches. Because many are planted as fingerlings, they are generally in good shape. Stillwater flies of all varieties will take fish, with most of the action coming by way of sinking lines and wet flies. A *Callibaetis* mayfly hatch occurs during the summer, as do sparse caddis emergences. Chironomids hatch throughout the year.

Float-tube anglers will enjoy this lake and generally outfish shoreline anglers, at least when the lake is full. The shoal areas, most of which are studded with drowned timber and stumps, are more accessible for float-tubers at high water. Launch sites are plentiful, the favorite being the narrow gravel beaches adjacent to the road on the south end of the lake. From here it is a short paddle out to structure-filled waters where rainbows abound. A rough boat launch and a large parking area are located adjacent to the road on the north end of the lake as well.

To reach Rattlesnake Lake, follow I-90 past North Bend and take Exit 32 (436th Avenue SE). Turn south and head up the hill on Cedar Falls Road some three miles to the lake.

The Forks of the Snoqualmie

East of Seattle, near the town of North Bend, the three forks of the Snoqualmie join to form the main river, which then plunges over Snoqualmie Falls and becomes the meandering steelhead stream popular with plunkers (but with lots of good fly water). The forks themselves offer fine fishing for trout within an hour's drive of the Seattle-metro area. Small wild cutthroat, rainbows, and hybrids thereof inhabit the South, Middle, and North forks in good numbers and thus create great opportunity for anglers wishing to get away from the city for a day of pocket-water action.

The South Fork is most accessible because it flows alongside I-90. Despite the immediate proximity of the metro area's major trans-Cascades route, fishing remains excellent on the South Fork because few people stop to sample the river's pleasures. Easy access awaits at a variety of locations: Twin Falls State Park just east of North Bend and at Ollalie State Park (Exit 38) as well as the campgrounds (Tinkham and Denny Creek) further upstream. Essentially all of the freeway exits offer access to this scenic stream whose clear waters pour through boulder-strewn pockets at one locale only to sprawl out over cobblestone pools around the next bend. The stunning little native trout average less than 10 inches; a foot-long specimen is a trophy. What they lack in size they gain 'in spirit and the lovely stream they inhabit offers quiet solitude in many places despite its proximity to the freeway.

During the summer, opt for lightweight waders or skip the waders altogether and wear a pair of cleated wading boots with your shorts or pants. A four- or five-weight rod and a selection of basic attractor-style dry flies completes your outfit for the South Fork, which in many places offers unfettered backcasting room.

The Middle Fork of the Snoqualmie carries more flow than the South and North forks and in many places is easy to fish owing to a lack

Float tubers fish Rattlesnake Lake.

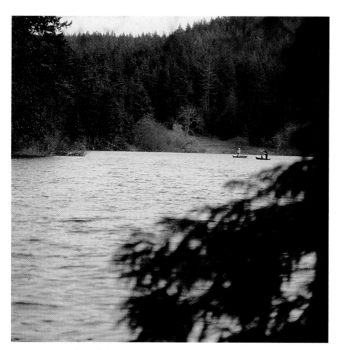

Small boats are perfect on Pass Lake.

of dense riparian shrubbery. The Middle Fork attracts quite a bit of attention during the summer, but fly-anglers can escape to the upper watershed or wait until autumn brings color to the leaves and an end to the traffic on the gravel access road.

Easiest access to the Middle Fork is from I-90. Turn north off the freeway just east of North Bend at Exit 34. Turn left on 468th SE then turn right on Lake Dorothy Road (Middle Fork Road). The road follows most of the river's length, but deteriorates as you reach the uppermost waters. Good fishing can be found throughout the entire length. The river heads in the Alpine Lakes Wilderness and its upper four miles are accessible by trail.

Catch-and-release regulations protect the Middle Fork's wild cutthroat and rainbows, which average seven to 10 inches in the upper reaches. In the lower few miles of the river they can reach 16 inches. The Middle Fork's tributaries offer good fishing for small trout along with exceptional solitude. Two of the best are the Pratt and Taylor rivers. The Pratt River Valley is thus-far devoid of roads and you must wade across the Middle Fork and then hike into the valley to sample the Platt's treasures. A series of high lakes attract light fishing pressure atop the valley. The Taylor River, meanwhile, joins the Middle Fork from the north and is accessed by Taylor River Road.

The lightly fished North Fork Snoqualmie is reached by North Fork County Road leading north out of North Bend and onto Weyerhauser property. The upper two-thirds of the stream are most accessible and the road also provides access to several productive mountain lakes, including Hancock (usually open to auto traffic) and several hike-in lakes.

Several miles above its confluence with the Middle Fork, the North Fork flows through precipitous Black Canyon, a stretch of lightly fished river where deep plunge pools and boulder-strewn pockets offer cutthroat and rainbows that can reach surprising size. The upper river offers some brook trout along with the cutthroat.

Pass Lake

A longtime favorite of northern Washington fly-anglers, 100-acre Pass Lake offers everything one could hope for in a close-to-home stillwater fishery. Misty mornings cloaked in the shifting fogs rolling in off Puget Sound and the evergreen bows reaching through the ghostly white, defy the proximity of a major highway that leads passers by to famed Deception Pass.

The misty mornings of spring frequently yield to beautiful sunny days during summer, when anglers from as far away as Seattle can leave after work and still make Pass lake in time to fish away the long evening hours of June and July. Autumn brings color to the scattered maples, highlighting them vividly against a background of deep green spruce, fir, hemlock, and cedar.

The setting alone makes Pass Lake worth your time, yet this easy-to-reach fishery offers fair to good fishing for brown trout and rainbows, both of which can reach 20 inches or more. Trout of 12 to 16 inches are plentiful thanks to fly-fishing-only rules and thanks in large measure to the efforts of local fly-angling clubs in fighting to maintain the regulations now in place. Cutthroat are available as well and the Department of Wildlife has stocked Atlantic salmon in years past, but these are uncommon.

Pass Lake offers dry-fly action during spring and summer with its hatches of Chironomids and speckled-wing duns, neither of which amounts to an explosive emergence. Although I have fished the lake but a handful of times, I was fortunate one June afternoon to be in the right place at the right time: For whatever reason a multitude of black ants invaded the northwest shoreline and the trout went nuts. During May and June, try Damsel Nymphs in the shallow margins on the lake's east shoreline.

Leech patterns, streamer patterns, and large attractor flies such as the Carey Special produce consistently throughout the year, especially during winter. During the peak of summer, fishing often holds up reasonably well, especially if you concentrate on the deeper areas in the narrows just east of the boat ramp and along the highway side of the lake about halfway down the shoreline. These same places produce some nice catches during the winter for anglers who troll or cast streamers on sinking lines.

Bank fishing is limited so bring a boat or float tube. Motors are not allowed, so drift boats and prams are popular. The launch is located on the west end of the lake just off the highway. Follow I-5 to the Hwy. 20 Exit just north of Mt. Vernon and then head west toward Anacortes. When you reach the junction at Fidalgo Bay, follow Hwy. 20 going south to Deception Pass. After a couple miles you will pass sprawling Lake Campbell on your right. Continue another four miles to Pass Lake. A

The South Fork Snoqualmie offers easy access trout fishing.

mile past the lake you will find Deception Pass and its towering bridge, a must-see sight if you are in the area.

Squalicum Lake

A fertile, popular, 33-acre lake located a few miles northeast of Bellingham, Squalicum offers easy-access, year-round float-tube action for cutthroat and brown trout that average eight to 12 inches, and reach 20 inches on occasion. The lake is limited to fly-fishing-only, so fishing holds up well year in and year out and is sustained by annual stockings by WDFW.

Aquatic trout foods are plentiful in this weedy lake, with all the usual suspects providing ample forage, including scuds, Chironomids, damsels, water beetles, dragons, mayflies, caddis, snails, and leeches. Any number of attractor patterns and imitative flies will work.

To reach Squalicum Lake, which requires a short, easy hike, take I-5 to Bellingham and turn northeast on the Mt. Baker Highway (Hwy. 542). The parking area lies on the right, six miles from the freeway at the east end of a two-mile-long straightaway, just before the highway turns to the northeast. If you see Squalicum Lake Road, you've gone too far. The walk in covers perhaps a quarter mile and you will want to carry in a float tube.

Coldwater Lake

The violent eruption of Mt. St. Helens so changed the landscape in the mountain's shadow that pre-eruption maps are completely useless these days. Among the many changes wrought by the volcanic devastation was the creation of a number of new lakes, most formed when mud and debris flows formed natural dams in steep creek drainages. Such was the case with 750-acre Coldwater Lake.

Coldwater was first stocked with rainbow trout in the late 1980s and these fish are now self-sustaining. Fourteen- to 20-inch trout are typical and rainbows approaching 26 inches have been reported since the lake opened to public access in 1993. Native cutthroat—survivors of the eruption—inhabit the lake as well. Both species benefit from selective fisheries regulations and a one-fish limit with a 16-inch minimum size.

Coldwater is located inside the Mount St. Helens National Volcanic Monument off State Route 504. Fishing Coldwater Lake requires the purchase of a U.S. Forest Service user's pass—$8 per day or $24 per season as of this writing. Contact the USFS's Mount St. Helens headquarters at 360/274-2131. A boat ramp is located at the lake, which is open all year, although snow can block access during winter. Only electric motors are allowed. Highway 504 heads east from Interstate 5 at Castle Rock, north of Kelso.

Streamer patterns, including Woolly Buggers and Carey Specials, account for lots of fish, as do various leech patterns and Chironomid patterns. *Callibaetis* mayflies occur during the summer and black flying ants are quite common from July through September. Coldwater is fairly deep so bring along both a floating and a fast-sinking line.

Castle Lake

Castle Lake, covering more than 200 acres, was formed when mud flows from the Mt. St. Helens eruption dammed Castle Creek. Castle Lake offers good-sized wild rainbows, with occasional reports of 10-pound fish.

Rows of bead-heads in a fly box. Jeff Edvalds photo.

Selective Fishery regulations allow the harvest of only one trout with a 16-inch minimum length. Pressure is light because a day spent fishing Castle Lake is something of a project from beginning to end. First, anglers must follow about 20 miles of rough logging roads and then must make a rather difficult hike down a steep hillside to get to the lake. Access to the parking area is via Weyerhaeuser Forest Road 3000. Washington Department of Fish & Wildlife suggests that anglers obtain a copy of the St. Helens West Hunting Map, published by the Washington Forest Protection Association.

Merrill Lake (Cowlitz County)

Another of the Mt. Saint Helens-area lakes, Merrill survived the big 1980 blast in good shape as its location southwest of the mountain kept it mostly out of harm's way. Among Merrill Lake's attractions is a good hatch of Hexagenia limbata, or giant yellow mayflies, that peaks during the latter half of July and lasts well into August.

The giant yellow mayfly, which fly-anglers call a "Hex," requires highly specific habitat. The inch-plus-long nymphs are burrowers and thus require mud soft enough for tunneling, but not so soft that it collapses. These needs are met on Merrill's north-side shallows, where hatches generally begin around dusk and typically stir the lake's trout into a feeding frenzy. The duns, about two inches in length including their long tails, are greedily devoured by trout, bats, and birds; the nymphs, swimming quickly to the surface are heavily preyed upon by planted brown trout along with a few naturally reproducing rainbows, cutthroat, and brook trout. The browns run 12 to 16 inches, sometimes considerably larger.

Merrill is restricted to fly-fishing only. The lake spans about 350 acres at full pool, but underground seepage causes significant fluctuations in water level. The severe 1996-97 winter caused several slides that damaged the DNR campground and boat launch; check to make sure repairs have been completed. As of this writing, access is by walking past the closed gate on Forest Road 81, which normally takes you to the signed turn-off down to the DNR access area. Merrill Lake is open all year, but snow can block access. The best fishing occurs during the spring, summer, and fall.

To reach Merrill Lake, follow Interstate 5 to Woodland and exit on Highway 503 (Lewis River Road). Follow SR 503 east toward Cougar for about 28 miles and watch for the Merrill Lake sign at FR 81, opposite Yale Lake and about a mile west of Cougar.

WESTSIDE STEELHEAD STREAMS

Steelhead and fly rods are synonymous in western Washington, largely due to the pioneering efforts of individuals like Ralph Wahl, Enos Bradner, Ken McCleod, Walt Johnson, Wes Drain, and others. These men, now legends in steelhead fly-angling lore, were the first to explore with a fly many of the steelhead waters of northwest Washington and in doing so they exerted a critical and lasting influence on steelhead fly-fishing as an art and sport.

During the first half of the 20th Century, when steelhead fly-angling was growing through its infancy, wild fish returned to the great rivers in staggering abundance. But far-reaching changes in the habitat wrought by rampant logging and exponential growth of building on and clearing of the land resulted in dramatic declines in wild fish. Hatcheries sought to supplement dwindling wild runs of steelhead and do so to this day on many Northwest rivers. Suffice it to say, though, that the early generations of steelhead fly-anglers had a lot more fish to pursue and a lot less people pursuing them.

Considering the explosive population growth of northwest Washington, it comes as something of a wonder that many productive rivers continue to offer top-rate steelhead fly-angling opportunities. These opportunities are due in large measure to the tradition of conservation and hard-fought stewardship of the watersheds—traditions that were also started by the foresightful fly-anglers who evolved our sport into what we know today.

Skagit River

A giant of a river in many ways, the Skagit has rapidly become a destination fishery for fly-anglers seeking big native winter steelhead.

Many anglers from outside the immediate area, myself included, simply plan a week or so each winter or spring for the Skagit and then wait and hope for the water to drop and clear. When it does, the Skagit ranks as one of the great winter steelhead rivers and one on which cobblestone/gravel runs beg a classic Spey-style fly or marabou fly and where a 20-pound native might be forthcoming for the dedicated fly rodder.

The Skagit, during the winter months, becomes a magical river and no less spectacular is the valley through which this mighty stream flows. A typical February or March offers enough sunny weather to allow anglers to enjoy a stunning view of the snowcapped crags of the North Cascades from which the Skagit emanates. Bald eagles over-winter in the Skagit Valley, usually in robust numbers.

A huge impoundment—Ross Lake—backs up the river behind a series of three dams: Ross Dam, Diablo Dam, and Gorge Dam. Below Gorge Dam begins the Upper Skagit, which is followed closely by U.S. 20, the North Cascades Highway. At the village of Marblemount, some 20 miles below Gorge Dam, the Cascade River joins the Skagit from the east. Between Marblemount and Rockport, a stretch of about 10 miles, road and walk-in access remains good.

Across the river from Rockport, the Sauk River joins the Skagit from the south. Being dam-controlled, the Skagit might flow clear all the way to Rockport, only to have the Sauk's sediment-laden gray-green flows discolor the river below Rockport. A free-flowing stream, the Sauk rises and falls rapidly with the whims of the weather. Heavy rains or warm weather in the mountains of the Sauk drainage make the river un-fishable and in turn often discolors the Skagit below the confluence.

Skagit River. Dec Hogan photo.

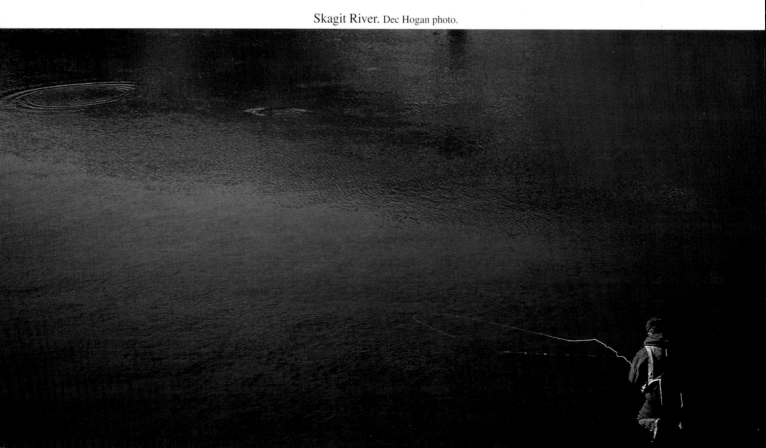

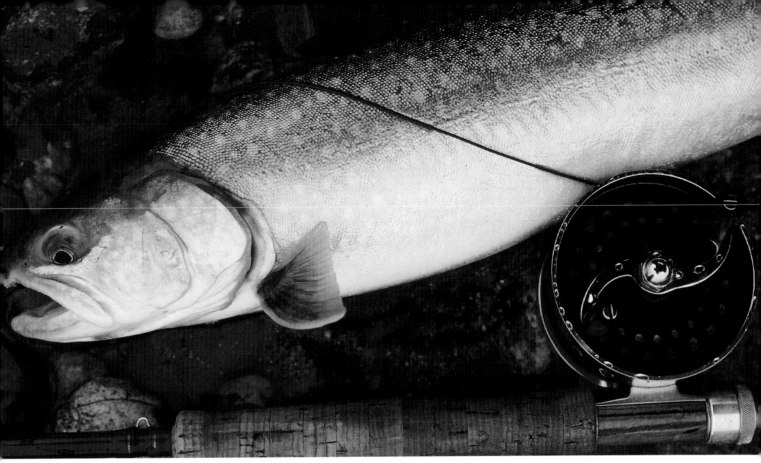

Large Dolly Varden inhabit the Skagit River.

Anglers should keep this scenario in mind when they visit the Skagit, for many is the day that the water color varies dramatically below and above the mouth of the Sauk.

Downstream from Rockport, bank access is restricted by private lands along the river bank. Drift-boat anglers have the upper hand. Numerous launches are located along the river, including the popular launch at Howard Miller Steelhead Park in Rockport, just above the mouth of the Sauk. Two additional ramps, one on each side of the river, are located at the fishing access sites between Rockport and the town of Concrete 12 miles downstream; additional ramps are located at Concrete, between Concrete and Hamilton, at Hamilton and at Sedro Woolley.

Those interested in drifting the river might consider hiring a guide for the first float. Some of the state's best steelhead fly-fishing guides work on this river between January and March. Check with the area fly shops.

The upper river is floatable as well, with a popular and easy section being the 10-mile stretch from Marblemount Bridge down to Howard Miller Steelhead Park in Rockport. As this float will take you through the prime bald eagle areas on the river, be sure to note the restrictions on launch times and access areas (discussed later). Shorter drifts allow for more fishing time: You can put in at Sutter Creek and float about three miles down to Rockport.

In decades past, the Skagit literally produced tens of thousands of steelhead each season. Like most rivers, however, the massive runs of the past are gone now. Hatchery plants accounted for a lot of fish during the years of huge catches, but the big natives of late winter attract the fly-angling crowd. In recent years, the Skagit has produced from six or eight hundred to around 2,000 winter fish each season and a few hundred summer steelhead as well.

In addition, the river hosts a popular and productive run of chum salmon during the fall, with peak fishing during November. Pink salmon (humpies) arrive during odd-numbered years and have become an increasingly popular fishery for fly-anglers, mostly in the lower river. The first surge of pinks generally comes in early or mid-August; a call to one of the tackle shops on the river will keep you up to date on the progress of the run.

Sea-run cutthroat still spawn in the Skagit system and during the fall can provide fair to good fishing in the lower river. Dolly Varden inhabit the river in good numbers, so don't be surprised if you hook a few of these beauties while fishing for steelhead. Many of the Dollies run 18 to 24 inches. As of this writing, Dollies can be kept from this river. Fly-anglers are likely to release the Dollies and based on the plight of native char throughout the Northwest, perhaps gear-anglers should be encouraged to release these colorful fish as well.

Highway 20 runs through the Skagit Valley on the north side of the river from Mt. Vernon. South Skagit Highway follows the south side of the river up to the Sauk River. Both roads, along with numerous local routes, provide bank access to the lower river.

Incidentally, anglers should be aware of rules aimed at protecting the bald eagles wintering along the river. On any given day between December and early February, as many as 450 eagles reside along the Skagit, many of them between Rockport and Marblemount. Part of this reach is set aside in the 1,500-acre Skagit River Bald Eagle Natural Area (SRBENA). Within the SRBENA, the entire south bank of the river is closed to anglers and boats, as are all the islands and a couple of posted gravel bars on the north bank. Additionally, launch restrictions are in

A fly angler works through a run on the Sauk River.

effect at two ramps: At Marblemount, launches are prohibited before 10 a.m. and at Rocky Creek before noon.

Jet sleds are a common sight on the Skagit and like anywhere else, a minority of their operators don't really give a damn about wading anglers. Most steer clear of a fly-angler working through a run. If you launch a sled, be aware of the possibility of overnight water releases from the dam. The water might drop a foot or more during the course of the day, leaving gravel bars exposed where none had been visible in the morning when you launched.

A good map of the Skagit and Sauk rivers is available from the Forest Service. Stop in at the district office on Hwy. 20 in Sedro Woolley and ask to purchase a copy of the map titled "Skagit Wild & Scenic River System."

Sauk River (Skagit/Snohomish County)

A major tributary of the Skagit, the Sauk is a fine steelhead stream in its own right, which explains its popularity with fly-anglers. During March and April, the river is catch-and-release only (check current regulations), so fly-anglers sometimes outnumber gear anglers when the big native fish arrive.

The Sauk is a free-flowing river and as such is subject to wild fluctuations caused by glacial melt, snowmelt, and rainfall. This makes the Sauk a great river for local anglers who can go on a moment's notice when the river drops into shape. Traveling anglers, however, can easily make the drive up to the Sauk only to find her running high and un-fishable for days on end. Stick around until the Sauk is on the drop and you will find a river that seems to be built for fly-fishing.

A medium-sized river, the Sauk is big enough to allow for the long cast but intimate enough that you can cover the water quite thoroughly. In places it forms broad cobblestone runs, but these are interrupted in a few locations by boulder-strewn slots and pools. As you progress upstream, the river steepens, becoming more and more a stream characterized by rapids and riffles divided by rocky runs and choppy, steelhead-holding slots.

At high water, the river carries a gray-green glacial till but at low

Spey casting for steelhead on the Sauk River. Jeff Edvalds photo.

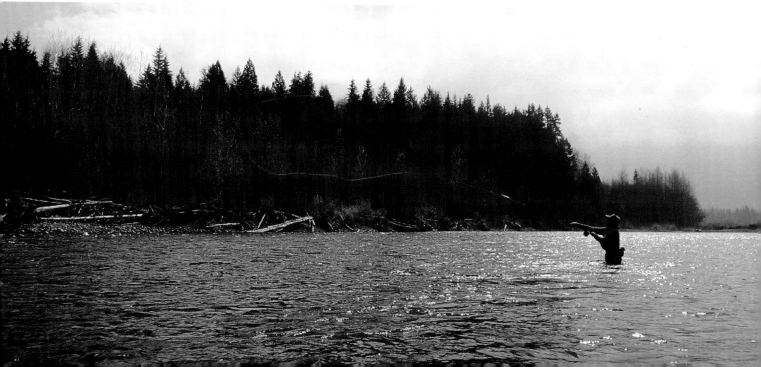

water, the Sauk clears quickly and becomes quite wadeable. Highly skilled oarsmen can float the river. The lower river often includes sweepers, log jams, and braided channels; the upper river offers more of the same at a faster pace. The lower drift starts at Sauk Valley County Park and covers the lower end of the Sauk plus several miles of the Skagit. Two take-outs are located between Concrete and Rockport, one on each bank at the fishing access areas. The float covers about 12 miles.

The upper and middle drifts start at any of the upriver launches and can run as far down as Sauk County Park. The Darrington to Sauk County Park drift covers 15 miles, which leaves only minimal time for fishing. You can cut the distance in half and fish some great water by launching or ending at the Hwy. 530 Bridge or a little farther upriver across from the mouth of the Suiattle River. To fish the upper end, use one of the two latter places as a take-out and launch up at Darrington.

Be sure to scout the rough launches before your trip and use caution on this river that has killed a few oarsmen over the years. Each new flood following a heavy rain tends to create new braids in the channel and new log jams and sweepers. If drifting the Sauk is in your plans, you might consider making that first trip with one of the guides that work the river.

Most fly-anglers fish the Sauk by driving along the river, parking at pull-outs and side roads, and walking to favorite runs and pools. Road access is good along Concrete-Sauk Valley Road, from a few places along Hwy. 530 and from several local roads.

Most of the fly-rod action on the Sauk occurs when the big natives arrive and when the catch-and-release begins in March. Often, good fishing continues to be good right up until the end of the season on the last day of April (again, be sure to check current regulations). January and February can be good as well, usually for the smaller hatchery steelhead, and October brings chum and coho salmon to the river.

Summer steelhead ascend the Sauk between June and August and fishing can be good at times if the water clears. Warm summer temperatures in the mountains results in the river being discolored by glacial melt, but anglers who fish early in the morning or on days when the river clears can find enough summer fish to keep things interesting.

Even during catch-and-release season, the Sauk can be a crowded river, both with drift boats and bank anglers. Guides work the river hard on many days and bank anglers sometimes converge on the stream in surprising numbers. You can escape some of the crowds by fishing above Darrington, although generally the fish will be more scattered.

To reach the Sauk River from the Seattle area, follow I-5 north to the Arlington (Hwy. 530) exit and follow the highway through Arlington and up the North Fork of the Stillaguamish to Darrington. From Darrington, continue north on Hwy. 530, which runs first along the west bank and then along the east bank before reaching Rockport.

North Fork Stillaguamish River (Snohomish County)

The North Fork of the Stillaguamish occupies a special niche in steelhead fly-angling lore. Only a few other Northwest rivers can boast of a legacy and history like that of the legendary "Stilly." This special stream ranks with the Klamath, Rogue, and North Umpqua—rivers whose great steelhead runs attracted dedicated, pioneering fly-anglers and in doing so defined our sport.

Thanks largely to exhaustive efforts by the Washington Fly-fishing Club, the North Fork of the Stilly became the first fly-only steelhead stream. Many of the region's noteworthy steelhead fly-anglers established cabins, homes, and camps near the river and its most important tributary, Deer Creek. Among them was Walt Johnson, the legendary "Sasquatch of the Stilly," so named for his ability to disappear from a favorite pool before prospective fishing partners and bystanders could track him down and discover his secrets. To this day, Walt Johnson's Stilly/Deer Creek-inspired patterns remain some of the most elegant and beautiful of all the classic steelhead flies. They include his Deep Purple Spey, Red Shrimp Spey, Spectral Spider, Lady Coachman, and Migrant Orange.

Steelhead still provide sport on the Stilly but the river and its primary

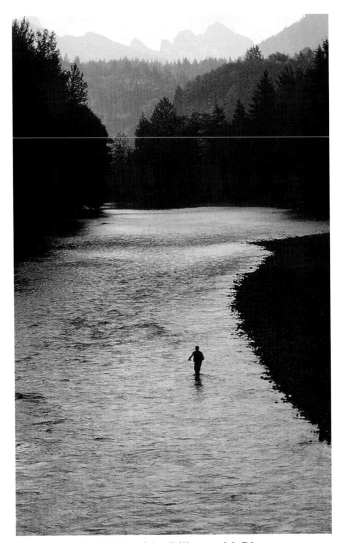

North Fork of the Stillaguamish River.

tributary, Deer Creek, have fallen victim to habitat destruction. Because of extensive logging between the 1950s and 1980s, the steep hillsides surrounding Deer Creek were denuded of the cover required to keep soil erosion in check. As the hillsides—prone to sliding because of their geologic history and composition—were denuded of stabilizing cover, slides became more frequent and more destructive. Deer Creek was subjected to increasing sedimentation, causing its once prime spawning habitat to fill in over time.

The big blow came in early spring of 1984 when a huge slide occurred at Deforrest Creek, a small tributary of Deer Creek. This massive slide remained brutally active for 10 years and remains active at a less destructive rate to this day. Pat Trotter wrote of this tragedy in the June 1995 issue of Salmon Trout Steelheader Magazine: "So what do you find in Deer Creek now, after all this? An over-widened stream channel, filled-in pools with little cover or structural complexity, high stream temperatures, reduced production of benthic organisms, and generally poor conditions for the survival of any freshwater life-history stage of salmonid. The indigenous race of summer steelhead, once the largest in Puget Sound, has been brought literally to the brink of extinction."

As a result of this catastrophe, the run of North Fork Stilly steelhead is now much comprised of hatchery steelhead. In fact, in his article for *Salmon Trout Steelheader*, Trotter points out that historically no summer steelhead occurred in the North Fork Stilly above Deer Creek—it was these natives, headed for their spawning grounds on Deer Creek, that provided the once spectacular sport on the North Fork Stilly.

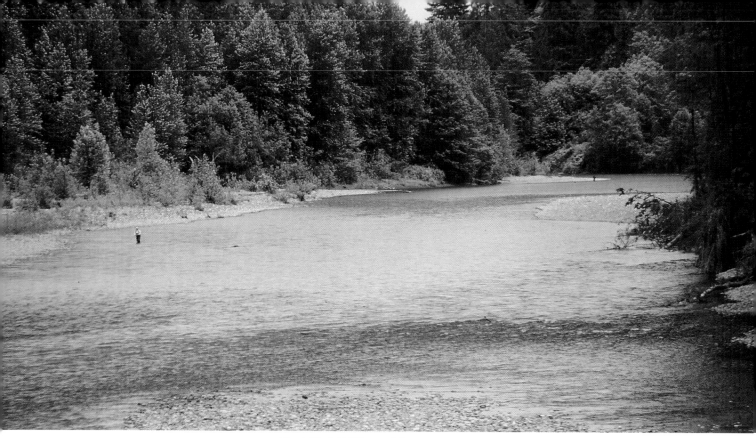

North Fork Stilliguamish. Dec Hogan photo.

This one race of steelhead was in fact responsible for one of fly-angling's most significant evolutions: Many great steelhead fly-anglers cut their teeth on these waters and during the heyday of the run—from the 1930s through the 1950s—many of these people built homes, cabins, and camps along the river, some just below the mouth of Deer Creek, others down at the famed Elbow Hole. Among them were Walt Johnson, Frank Headrick, the McLeods, Al Knudson, Enos Bradner, and Ralph Wahl. With such a concentration of serious steelhead fly-anglers on just a few miles of river it is no wonder that the North Fork Stilly and Deer Creek became synonymous with invention and innovation. Only in a few other locations—Northern California, the Rogue, the North Umpqua, for example—was so much gained and passed along to those of us who pursue steelhead today.

Summer steelhead still attract anglers to the North Fork; many are hatchery fish, but wild fish continue to return and fly-anglers continue to flock to the legendary pools within a few miles of Deer Creek, including Elbow Hole and Fortson Hole. Yet an old controversy has yet to be settled in the appropriate manner: Many North Fork regulars—including the likes of Walt Johnson and Alec Jackson—have for years pushed for a late-summer closure that would protect wild steelhead from anglers who drift heavily weighted nymph patterns under indicators.

All of the old-timers—those who have fly fished for summer steelhead for many years—will tell you that the sport is in bringing the fish to the fly, not in bringing the fly to the fish. Yet an increasingly popular method, inching its way north from the rivers in California, is the use of super-heavy flies fished dead-drift under bobbers. And while this method may have its time and place, surely August on the North Fork Stilly—like late summer on the Camp Water of the North Umpqua—is not one of them. The steelhead are simply too vulnerable and how much harassment can the remaining wild steelhead tolerate before their reserve of energy meant for spawning is depleted past the point of any hope for completing their life's mission? Despite being set aside long ago as the first fly-only steelhead river, the North Fork's hopes for a late-summer closure seem as distant as ever without support from the WDFW.

When you visit this special river, walk its quiet trails, cast over its storied pools, bear in mind its unique history, for the North Fork's steelhead captivated the hearts and minds of a generation of our sport's most notable anglers: Men who gave us techniques that were truly new and innovative; flies that were elegant, graceful, and productive; stories that

have shaped the nature of our art and left us a legacy to carry forth to future generations of steelhead anglers.

South Fork Stillaguamish

The South Fork Stilly offers both summer and winter steelhead. The winter runs begin as early as December, but this river discolors quickly following a rain storm, so during very wet winters fishing can prove impossible for weeks on end. Nonetheless, the South Fork receives less pressure than the North Fork and does offer lots of nice fly water. Boat access is available below Granite Falls, near Jordan and down at River Meadows County Park. Jordan Road parallels most the river up to Granite Falls: Follow SR 530 north out of Arlington and turn right on Arlington Heights Road. After a mile, turn right onto Jordan Road.

Skykomish River (Snohomish/King Counties)

A popular, productive, and scenic river, the only downfall for the beautiful Skykomish is its close proximity to the Seattle area. Nonetheless, fly-anglers who fish mid-week and who are willing to work at it a little can find elegant steelhead runs devoid of other anglers during the river's summer and winter seasons. When happenstance finds me in the Seattle area, the Skykomish beckons more than any other metro-area river, namely because the Sky offers an abundance of great steelhead water, from the long, slow cobblestone runs of the lower river to the glassy, boulder-studded chutes, tailouts, and pockets of the upper river.

More so than the other rivers in the area, the Sky runs a steep direct course, joining the Snoqualmie near the town of Monroe. Its lower 15 miles braid and meander, but the Sky's character changes quickly upstream from Gold Bar. In a span of about 20 miles, anglers can find a tremendous variety of water types. This elegant, free-flowing river, along with its stark, bold backdrop of precipitous crags and timbered mountains has inspired several generations of steelhead fly-anglers. One of the sport's most beautiful classic patterns—the Skykomish Sunrise—was created by George McLeod, at his father Ken's request, and named in honor of this magnificent river.

While the upper river and its forks are ideally suited to angling for summer steelhead, the Skykomish is better known for its winter or

"spring" steelhead. On March 1, the Skykomish goes to catch-and-release for the big native steelhead that arrive after the earlier run of one-salt hatchery fish has subsided. This catch-and-release season separates the meat-hunters from those who fish for pleasure. In short, the hordes disassemble and the lower river is purged of myriad bank anglers and drift-boaters pulling plugs and thoroughly working every inch of good water. March 1 signals the arrival of the fly-anglers and of the remaining gear fishermen who enjoy the hard pull of a big steelhead destined for release.

The popular stretch of the lower river extends from the town of Sultan down to the town of Monroe, a distance of about nine river miles. Highway 2 connects both towns from the river's north bank; Ben Howard Road follows the south bank, providing bank access in places and accessing the boat ramp upstream from Monroe (turn south across the river at Sultan or turn north on Ben Howard Road just south of the 203 Bridge in Monroe). The other take-out lies just below the river bridge on Highway 203 in Monroe, on your right as you pass over the bridge. The short drift between these two cement ramps accesses some productive fly water and allows fly-anglers to pick one or two runs to fish thoroughly.

Another launch (the Two-Bit Hole) is located on private property off Ben Howard Road below Sultan. The landowner charges 25 cents for access (look for the mailbox with the name Gwilt). This fee launch will save you about two miles on the drift down towards Monroe. Otherwise, the launch at Sultan serves as the starting point for trips downriver. One additional option is to launch up at Big Eddy, about nine miles above Sultan; this drift takes you through lots of nice fly water and through a Class II rapids. You can also float from Monroe down to the mouth of the

Snoqualmie Falls.

Upper Skykomish.

Skykomish, taking out at a very crude launch below the Hwy. 522 Bridge (four miles) or continuing down the Snohomish River some seven or eight miles to the ramp at Snohomish.

Despite its large proportions, the lower Skykomish is easy water for fly-anglers because its cobblestone/gravel bottom is quite free of the boulders and ledges that steal deep-swung flies on other winter steelhead streams. Its low-gradient channel offers easy wading and sure footing and its wide pools beg long casts with the increasingly popular two-handed rods along with the more traditional single-handed fly rods used to good effect by the region's pioneering anglers, including the McLeods. Should your fly snag bottom at the end of its swing, a little slack line will usually free it from the small rounded stones that comprise the river bed.

In places, the lower river braids, its channel shifting slightly with heavy flows; yet the nearby mountains offer the protection of freezing weather to hold in check the effects of sudden snowmelt and torrential rain in the valley. In fact, the Skykomish often drops into fishable shape when other area rivers are blown out for days.

The Skykomish, though perhaps better known for its big native winter steelhead that arrive during early spring, hosts a fine run of hatchery and native summer steelhead from June through mid-autumn. Following the snowmelt, the Sky drops and clears rapidly and summer fish migrate quickly through the lower river. They can be intercepted below Sultan, but the better holding water is found upriver and into the forks.

The South Fork of the Skykomish unfolds in a hurry, tumbling headlong down the Cascades from Stevens Pass through a steep canyon heavily laden with cobble and boulders. Highway 2 follows its course. The North Fork draws its headwaters from equally awesome country in the heart of the high Cascades. The two forks converge about eight miles upstream from the town of Gold Bar on Hwy. 2. Both forks produce winter and summer steelhead in good numbers and the river below the forks has historically ranked among the state's most productive steelhead rivers.

The North Fork flows unobstructed as far up as Deer Creek Falls, allowing anadromous fish unfettered access to the upper reaches. The South Fork, meanwhile, features a series of waterfalls that block upstream movement of all fish. However, the WDFW traps and trucks fish over the falls, opening up more than 100 additional stream miles to

A native steelhead about to be released on the Stilliguamish River. Jeff Edvalds photo.

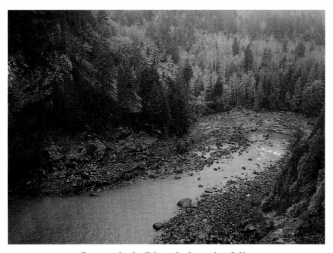

Snoqualmie River below the falls.

inhabitation by steelhead, salmon, trout, and char. The trucking generally begins in July and lasts until about the end of the year. Each year, anywhere from 700 to 1,000 summer steelhead are trucked to and released above the barriers in the South Fork, creating an excellent opportunity for fly-anglers to enjoy summer steelheading at its scenic best. Some of the most productive water flows from the town of Skykomish down to the Halford area.

The Skykomish, especially the lower river from Sultan to the mouth, hosts a sizable run of chum salmon during the fall and like big salmon runs just about anywhere, this one often brings out the worst kind of meat hunters. Fly-anglers wishing to tangle with the chums might consider trying to intercept the earliest spurts of fish. Look for out-of-the-way pools and runs that are difficult to access. Another place generally worth avoiding is Reiter Ponds below the forks—steelhead congregate here, but so do the gear anglers.

Only an hour or so from Seattle, the Skykomish Valley is the gateway to the river. Highway 2 arrives from the northwest and then follows the river through the valley and the south fork up the mountains. Interstate 405 and then State Route 522 (from Woodinville) takes you there from the metro area.

Snoqualmie River (King County)

A large, meandering river below towering Snoqualmie Falls, the Snoqualmie offers winter and summer steelhead during their respective seasons. Most of the fish are of hatchery origin, though some big winter natives arrive during March. The Snoqualmie is a favorite haunt of gear anglers and at times during the winter is quite overrun with them, especially in the short reach from the Tokul Creek Hatchery to Fall City, but also well downriver.

Summer steelhead smolt plants are not nearly so liberal as the winter steelhead plants, but enough summer fish arrive each year to make the Snoqualmie a popular river throughout the year. Fly-anglers should be willing to walk and to seek access to runs and pools bordered by private lands, or float the river between any of the numerous boat launches.

Some of the best water for summer steelhead is found just below Snoqualmie Falls Pool and is accessed from Tokul Hatchery off Hwy. 202 west of the town of Snoqualmie (on the north bank). The short stretch from the falls pool down to the launch at the hatchery gets you away from the boaters, but not necessarily away from the fishing pressure.

State Route 203 serves as the primary access route to the Snoqualmie and follows the north (east) bank from Fall City to Monroe, though it departs the river a few miles south of Monroe. Numerous local roads take you closer to the river, but in places you will need to seek permission to cross private lands and if you are willing to do so, you can find remarkable solitude on what basically amounts to a suburban river.

Near Monroe, the Snoqualmie meets the Skykomish and from that point downstream, the river is called the Snohomish. The Snohomish offers some good cobblestone bars where fly-anglers might find winter steelhead. Many of these bars are referred to as the Snohomish Plunking Bars, which should give some indication of the company your are likely to compete with on the more popular reaches.

Tolt River (King County)

A pleasant little tributary to the Snoqualmie, the Tolt River offers a modest but sometimes productive run of winter steelhead, along with an occasional summer steelhead and anadromous cutthroat. Best fishing occurs from December through February for the two-salt hatchery steelhead widely planted in the Snohomish system. Tolt River Road follows the north bank, heading east from SR 203 north of Fall City.

Pilchuck River (Snohomish County)

A tributary of the Snohomish, joining the large river at the town of Snohomish, the Pilchuck River offers a small run of winter steelhead in a small-river setting. Machias Road follows the river north out of Snohomish. The best fishing occurs from December through February, when the hatchery fish arrive in the Snohomish system.

Green River (King County)

Practically an urban stream, the Green River offers fair to good prospects for both summer and winter steelhead despite the river's proximity to the Seattle-Tacoma area. The trick on the Green River is to avoid the crowds, which assemble in direct proportion to the size of the steelhead runs in any given year and to the frequency of reports of good fishing.

Fly-anglers can find refuge in Green River Gorge downstream from Kanasket, but the usual Seattle-area tactics apply if you want solitude: Avoid weekends at all costs, be on the water early, fish during marginal weather and marginal water conditions and pray that the Seattle newspapers don't get wind of any good reports.

Winter steelhead fishing peaks from late December through February while the summer run remains consistent from June through September. Liberal hatchery plants largely sustain both fisheries. Fly-anglers would be well-served to leave the lower river to the plunkers and concentrate on the more attractive water upstream from the Highway 18 bridge, including Flaming Geyser Park, the gorge and around Kanaskat-Palmer Park.

West of Auburn, Highway 18 crosses the Green and just before

Facing page: Angler fishing a hole for steelhead on the Kalama River. Jeff Edvalds photo.
Below: Chris Rhoads fishing for steelhead on the Green River. Jeff Edvalds photo.

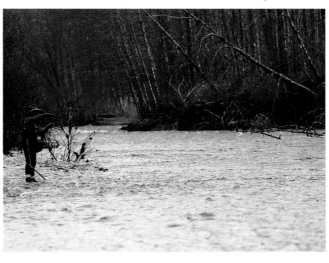

Steelhead on East Fork Lewis River. Scott Ripley photo.

doing so, a right turn from the highway leads to the Auburn-Black Diamond Road, which then crosses the river and heads east, accessing ever-popular Flaming Geyser Park as well as Whitney Bridge (turn right on SE 219th Street). The float from Flaming Geyser Park down to Whitney Bridge covers about three miles. During summer, this stretch is quite popular with the splash-and-giggle crowd so get on the water early. Walk-in access is good throughout Flaming Geyser Park, as well as above and below the park and from quite a few places along Green Valley Road, including Metzler County Park about five miles above Hwy. 18. A full day's drift, from either Whitney Bridge or Flaming Geyser Park, takes you down to the take-out upstream of the Highway 18 Bridge.

Above Flaming Geyser Park, the Green exits the gorge, which features lots of nice fly water. Accesses include Green River Gorge Park, the trail below the Highway 169 Bridge, or the Icy Creek access upstream from SR 169 (follow Green River Gorge Road east from Black Diamond or turn north on Franklin-Enumclaw Road about two miles south of the SR 169 Bridge).

The upper Green River, when you can find some peace and quiet, is a decidedly pleasant place, especially during the summer season, when steelhead occupy classic gravel and cobblestone pools, runs, and riffles. Lush stands of maple and alder line the river, whose clear waters are easily waded and easily covered by an average caster. Good dry-fly water abounds and persistent anglers who seek the shallow tailouts and glassy runs can rise the occasional fish to skaters. The Green's summer steelhead run from four or five pounds up to the rare trophy of 15 or more pounds. The winter steelhead, primarily of the two-salt hatchery variety, average seven or eight pounds.

Nisqually River (Thurston/Pierce Counties)

Any Northwest fly-angler can likely guess by looks alone that the lower Nisqually holds promise for sea-run cutthroat: Interstate-5 cuts across the Nisqually Delta about two miles upstream from the river's mouth, offering a fine over-view of the area. The Nisqually Delta, in fact, includes a state wildlife area popular with waterfowlers and a federal wildlife refuge that abounds in bird life.

At its other extreme, far to the east, the Nisqually draws its headwaters from sprawling Nisqually Glacier high on Mt. Rainier above Paradise Park. Given its origins, the upper Nisqually's glacial-gray till comes as no surprise. At the little town of Elbe, home of the Mt. Rainier Scenic Railroad, the Nisqually's turbulent flow is captured by 3,000-acre Alder Lake, whose dam blocks anadromous fish passage.

Historically, the Nisqually offers good runs of winter steelhead and small runs of summer fish. In recent years, however, the fish have all but disappeared. Meanwhile, the sea-run cutthroat fishing can indeed be productive and the Nisqually's run of chum salmon draws lots of attention.

The Nisqually Delta is easily explored by canoe or small boat (beware of tide changes and shallow mud flats). To reach the launch at Luhr Beach, exit I-5 at Exit 111 or 114. From Exit 114, follow Martin Way heading west; from Exit 111, turn right and then turn left on Martin Way. From either direction, follow Martin Way to a north turn on Meridian Road and continue north two or three miles to the public fishing sign and 46th Ave. NE. Turn right to Luhr Beach. McCalister Creek flows into the bay at Luhr Beach and offers saltwater action for sea-run cutthroat and chum salmon. The mouth of the Nisqually is about a mile to the east and about two miles downstream from I-5.

Although access to the Nisqually River is quite limited, salmon anglers can reach the river off the Old Nisqually Highway and at several other points south of I-5. The chum salmon run peaks during November; sea-run cutthroat arrive as early as late July and continue to ascend the river through mid-autumn.

Elochoman River (Whakiakum County)

Despite its small stature, the Elochoman River produces several thousand hatchery winter steelhead in a typical season. When the winter fish arrive in strength, usually late December through February, so too do the gear anglers, making for crowded conditions that generally force fly-anglers to seek the more remote reaches, which are few in number and limited in scope.

The Elochoman also hosts a run of summer steelhead and these are more attractive to fly-anglers because the crowds are not so much of a problem. The summer fishery peaks in June and July and continues through August and September when fall freshets often lure sea-run cutthroat into the river while rejuvenating the steelhead.

To reach the Elochoman, follow Highway 4 west out of Kelso to Cathlamet and then turn north on State Route 407, which parallels the river. The mouth of the river, which can produce good cutthroat fishing during the fall for boat anglers, flows through the whitetail deer refuge and reaches the Columbia a few miles west of Cathlamet.

Cowlitz River (Lewis County)

The massive Cowlitz River is the state's top producer of steelhead, not only because of its sizable runs but also because of its tremendous crowds of gear anglers. Hundreds of boats can descend on the river when the fish arrive, summer or winter. Should you find a quiet spot on the Cowlitz and fish a run or pool undisturbed, be sure to stop in at Blue Creek for a reality check: Several hundred gear anglers crowd in shoulder to shoulder on a quarter-mile stretch of river. More of the same awaits up at the Barrier Dam.

During a good year, the Cowlitz will produce more than 20,000 winter and more than 10,000 summer steelhead. Thousands upon thousands of gear anglers invade the river—from bank, drift boat, and jet sled—to catch those thousands of hatchery fish. Most of the time during the winter, the only hope for solitude-seeking fly-anglers is to explore the river for out-of-the way pools and to fish mid-week. During the summer, the same rules apply, but you can also explore the upper river, between Randle and Packwood, for fish that are trucked around the reservoirs and released upstream. Another good summer option is to head for the Kalama.

Kalama River (Cowlitz County)

A fine summer steelhead stream and one replete with fly water, the Kalama watershed draws its headwaters from the southwest slope of Mt. St. Helens and then rushes through precipitous forested canyons before gradually slowing as it approaches the Columbia River lowlands. This beautiful river, which annually yields between 1,200 and 3,000 summer fish, features a lengthy fly-only section from Kalama Falls down to Summers Creek. This fly-only section is popularly referred to as the "Holy Water."

Throughout the upper half of the river, which includes some great hike-in water, anglers can search out all manner of steelhead habitat, from pocket water to choppy runs to glassy tailouts. Included is lots of fine water for fishing skaters. Kalama River Road traces the river's path for most of its length, providing excellent access, although precipitous canyons require anglers to hike a considerable distance to fish some of the river's most remote pools.

On the lower river, anglers can drift any of several segments, accessing some productive fly water. The uppermost launch is the so-called Red Barn; the lowermost is the public access at Modrow Bridge, where the road from Kalama crosses the river and meets Kalama River Road. The drift from the Red Barn down to Modrow covers about five miles and there are several launches in between. Above the Red Barn area, the canyon begins to steepen, creating miles of great walk-in water where good access is the rule.

The summer fish trickle in as early as May, but the better fishing occurs between late June and late September when steelhead inhabit the fly water in strong numbers. The Kalama's summer steelhead average seven to 10 pounds, but each season fish from 15 to 18 pounds fall to fly-anglers. Salmon and cutthroat, along with winter steelhead ascend the Kalama as well, but the summer steelhead—mostly of hatchery origin—are of primary significance to fly-anglers.

Fall steelhead from East Fork Lewis River. Scott Ripley photo.

The Kalama, like most of the Northwest's top fly-rod steelhead rivers, has inspired some of its own fly patterns, among them the Kalama Special, originated by Mooch Abrams. Trey Combs relates that Abrams developed the pattern for sea-run cutthroat angling and that "his friend, Mike Kennedy, used the fly to such advantage for steelhead on Washington's Kalama River that it became known as the Kennedy Special." (*Steelhead Fly-fishing and Flies*).

...

Kalama Special

Tail:	*Red hackle fibers*
Body:	*Yellow chenille*
Hackle:	*Badger (or grizzly), palmered through body*
Wing:	*White bucktail*

...

To reach the Kalama River, follow Interstate-5 south past Kelso or north past the little town of Kalama and exit the freeway at Exit 32, Kalama River Road. Then head east along the river's north bank. Call the Greased Line Fly Shoppe in Vancouver for current reports on the Kalama and other southwest Washington rivers. Also, Prichard's Western Angler is located virtually on the Kalama's north bank, five miles upstream from Modrow Bridge.

South Fork Toutle River (Cowlitz County)

The Toutle River and its North Fork were devastated by the 1980 eruption of Mt. St. Helens, yet almost immediately after the eruption anadromous fish started making inroads towards re-colonizing the river system. Now, almost two decades later, the Toutle offers what appears to be an increasingly productive fishery for hatchery-produced summer and wild winter steelhead.

Prior to the eruption, the highly productive North Fork had been the most popular and most heavily fished of the two forks. However, the South Fork, having survived the eruption reasonably intact, now offers the better opportunity of the two, with both winter and summer steelhead available. Wild winter fish arrive in the South Fork during February and March while summer fish, mostly of hatchery origin, return from June through September. June and July are peak months.

The South Fork is accessible by a Weyerhaeuser Forest Road (4100) that turns south out of the town of Toutle and follows the river. To reach Toutle, turn east off Interstate-5 at the Hwy. 504 Exit at Castle Rock (north of Kelso). Route 504 follows the North Fork, whose ash-washed glacial till colors the water beyond fishable limits throughout much of the year.

East Fork Lewis River (Clark County)

Traditionally one of the best winter steelhead streams in the state, the East Fork Lewis also offers a strong and accessible run of summer steelhead. The summer fish, mostly of hatchery origin, attract the most attention from fly-anglers because the low flows of summer reveal in the upper river a stream whose elegant runs and pools beg floating lines and classic flies.

Summer steelhead arrive in the lower river by May or even late April, but the better fly-angling opportunity coincides with the low water of summer and early autumn. By late June, steelhead move into the upper river, upstream from the Battle Ground area and fishing often continues well into fall. Catch statistics show May and June as top months, but these numbers are somewhat misleading because much

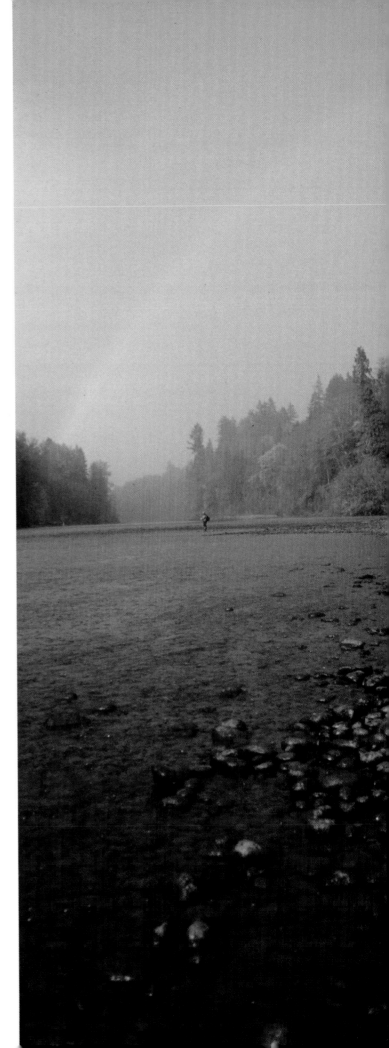

of the gear-fishing pressure occurs during those two months, especially on the lower river. By July, low-water conditions spoil the fun for many of the gear anglers, so late summer and early fall offer ideal conditions for fly-fishing the upper river.

The winter run, typically robust, attracts lots of attention from the gear anglers. Still good fly water abounds for those willing to put forth the effort when the river drops into shape between December and early April. Catch rates peak in December and January, mostly for hatchery fish, but some big natives arrive between late February and early April. Washington's state-record steelhead came from the East Fork in 1980—a huge buck that weighed almost 33 pounds.

Whether you fish the East Fork summer or winter, be sure to consult the current regulation synopsis. As with most steelhead streams, the East Fork and its management plan are in a state of flux owing in part to potential endangered species listings.

Access along the East Fork ranges from poor on parts of the lower river to good along the upper river. The lower half of the river flows largely through private lands and is accessed in a few places by local roads. A boat offers a distinct advantage. Above Louisville Park, access improves as County Road 12 (Lucia Falls Road) follows the river into the upper watershed. Still, a boat allows anglers to fish lots of water that is otherwise inaccessible.

Numerous county roads lead toward Lewisville Park, just north of Battleground. Exit Interstate-5 north of Vancouver at State Route 502 (about two miles north of the I-5/I-205 junction). Follow SR 502 north two miles then east to Battle Ground. Then follow SR 503 north toward the river and the park. To reach the upper river, continue a few miles north on SR 503 and turn right on Lucia Falls Road (County Road 12).

From the north, you can take I-5 to the SR 501 exit, turning east off the exit ramp and then turning south on NW 11th Avenue. Follow NW 11th to a left turn on NE 264th Street and drive a mile to a right turn on NE 10th Avenue, which will take you down to SR 502 leading east to Battle Ground.

County Roads approach the lower river between Battle Ground and La Center, but this end of the river is better suited to a boat. The short, popular drift from Lewisville Park down to Daybreak Bridge covers lots of good water, but float it mid-week (and even that won't assure you of avoiding the crowds). Daybreak Bridge is located on NE 82nd Avenue: From La Center, follow Country Road 42 to a right turn on County Road 48 and then follow CR 48 to a right turn on NE 82nd Avenue. From the south, follow SR 502 east from I-5 or west from Battle Ground and turn north on NE 72nd Avenue. A third ramp is located near the mouth of the river (Paradise Point State Park).

North Fork Lewis River (Clark County)

Generous hatchery plants make the North Fork Lewis a popular and productive steelhead and salmon river in both summer and winter. Most years in fact the North Fork yields more summer steelhead than the East Fork. Fly-anglers can take their share of the summer steelhead, but the North Fork generally attracts substantial crowds of gear fishermen. Solitude is rare on the North Fork and finding it requires that anglers fish mid-week, avoid the popular bank fishing areas and wait until the dispersal of the hordes of spring chinook anglers.

All told, the North Fork is a lengthy river, but only its lower 15 miles support anadromous fish because upstream passage is blocked by Merwin Dam, which backs up 4,000-acre Merwin Reservoir. This short section of river can yield several thousand summer steelhead during a good year. Because of limited bank access, a drift boat offers an advantage. Good launches are located at several places between Etna and Woodland.

State Route 503 follows the river's north bank from Woodland up to (and beyond) Merwin Dam. County Road 16 skirts the south bank and on both sides of the river public easements and local roads provide some access for walking anglers.

Left: Angler fishing steelhead on the
South Fork of the Toutle River. Jeff Edvalds photo.
Right: River scene on the North Fork Lewis
not far below Merwin Dam. Scott Ripley photo.

Above: Fisheries researchers on the Wind River. Scott Ripley photo.
Facing page: Fly angler on Wind River bridge of the Pacific Crest National Scenic Trail. Scott Ripley photo.

Washougal River (Clark/Skamania Counties)

A productive river for both summer and winter steelhead, the Washougal is also home to the Skamania Steelhead Hatchery. Skamania-strain steelhead have been introduced to many streams in the Great Lakes region along with certain rivers in the Northwest.

Summer steelheading in the Washougal extends from late spring through autumn, while winter steelhead catches tend to peak during December and January, with February through April quite productive as well. In short, steelhead enter the Washougal every month of the year.

The Washougal's close proximity to Portland and Vancouver assures that it will receive fairly heavy pressure from fly and gear anglers alike. Yet its proximity to the metro area makes the Washougal an easy evening or morning trip during the long days of June and July. Although the river rises and colors up quickly after a rain, it likewise drops and clears more rapidly than other area streams.

What's more, the Washougal offers easy access along most of its length with State Route 140 paralleling its north bank most of the way up to Salmon Falls, where the steelhead reach an impassable barrier. Boat ramps are located in Washougal and about eight miles upstream at the state access site. The other state access site, about three miles upriver from Washougal, offers only a rough gravel slide that really isn't worth trying. Instead float down to town, where a ramp is located near the bowling alley just off the highway between Washougal and Camas (3rd Street). Access is good along route 140, although private property is fairly extensive as well. A knock on the right door can get you on to some good steelhead runs.

To reach the Washougal River, follow Hwy. 14 east out of Vancouver to the town of Washougal. Look for the Washougal River Recreation Area sign at the main exit into town. Turn left (north) off the highway and head straight through town on 17th until you cross a bridge over the river. The road veers to the right and becomes Washougal River Road. Supplies and services are available in Washougal and upriver at Washougal River Mercantile.

Wind River (Skamania County)

A swift, scenic steelhead stream, the Wind River cascades through a deep timbered canyon before entering the Columbia near the town of Carson, some 40 miles east of Vancouver. Its proximity to the Portland/Vancouver area makes the Wind a fairly popular river for fly-anglers seeking summer steelhead.

Unfortunately, a substantial reach of the Wind River flows through private land, a situation which, coupled with the rugged and largely inaccessible canyon, makes fishing much of the lower river a near impossibility. Therefore, most fly-angling pressure is concentrated along a short section between Beaver Campground and Carson National Fish Hatchery, a dozen or so miles upstream from the little town of Carson. During summer, the steelhead stack up in this section. Because of low summer flows, not many fish are found above the hatchery area.

A medium-sized steelhead stream, the Wind River reveals myriad personalities that change with the seasons. Some sections offer ledge-bound chutes; others are classic cobblestone runs and pools. Still other stretches are studded with boulders and boiling with white water. During winter and spring, the river flows with a brute force that attracts serious white-water enthusiasts.

This is a true summer steelhead fishery: The fish enter the river between mid-spring and late summer. By June, anglers begin to work the river and fishing generally holds up through July. A hot August can bring a lull in the action, but the cool days of September can again spur good fishing.

Wind River fish underwater. Scott Ripley photo.

Watch the Bonneville Dam counts during April, May, and June. Much of the early summer steelhead passage over the dam is comprised of Wind River fish, along with Big White Salmon and Hood River fish.

Easiest access to the Wind is from Hwy. 14, along the Columbia River. Take the turnoff to Carson and follow Wind River Road; or follow the road up from the mouth (at the Wind River Recreation Area sign on Hwy. 14 east of Carson) and turn right at the main intersection in Carson. Carson Hatchery (a federal chinook salmon facility) is about 14 miles upriver, past the little village of Stabler. You will find ample camping space at the numerous national forest campgrounds in the area. The U.S. Forest Service maintains a visitor's center just west of Stabler on Hemlock Road.

From just downstream of Beaver Campground to up past the hatchery, the Wind River is easy to access. Just look for the myriad pullouts along the well-maintained paved road. Wild steelhead must be released, but hatchery fish predominate. Be sure to check current regulations regarding the Wind, as they have changed often over the years.

OLYMPIC PENINSULA RIVERS & LAKES

Washington's Olympic Peninsula ranks as one of the Northwest's—and the world's—most unique and special places. Thanks to a foresightful Theodore Roosevelt, and perhaps more importantly the multitudes who rallied behind the cause, much of the Peninsula's splendor was set aside as a national park early in the 20th century.

As such, the Peninsula ranks as a haven for some of the last large virgin stands of old growth coniferous forest to be found on the West Coast. The Olympic Range itself, dominated by several glacier-bound peaks, including Mt. Olympus, towers over the headwaters of numerous mountain streams whose flows converge to form some of the most historically productive anadromous-fish rivers in the Northwest. Streams such as the Elwha, Sol Duc, Hoh, Bogachiel, and Queets once hosted massive runs of all species of salmon and steelhead. These runs are much reduced now and in some cases are supplemented by hatchery plants. Still, the native salmon and steelhead that spawn in these waters comprise a treasure and a heritage that must be forever guarded by conservationists and anglers, and, one would hope, average citizens and politicians to boot.

The Peninsula's fly-angling traditions evolved somewhat recently in comparison to the rest of the Northwest. Syd Glasso is rightly considered the patriarch of Olympic Peninsula fly-angling and of steelhead fly-angling in particular. Glasso, a school teacher on the Peninsula during the 1950s and 60s, was the first North American tier and angler to adapt his steelhead fly ideas from Scotland's River Spey. The so-called Spey flies, among the oldest of recorded Atlantic salmon dressings, were characterized by their simple elegance, a hackle—often of rooster side tail feathers or heron feathers—palmered through the body, and wings of bronze mallard. Glasso borrowed the style but tied many of his patterns in bright colors that would show up well in the stained waters of the Peninsula rivers. His most enduring dressing, the Orange Heron, is popular throughout the Pacific Northwest.

Glasso's contemporaries were quick to follow his lead and included venerable Peninsula anglers Dick Wentworth and Jim Garrett along with mainland anglers like Walt Johnson who immediately recognized the inherent brilliance of Glasso's ideas. Several well-known fly-fishing guides earned their reputations on the Peninsula steelhead streams, among them J.D. Love and Bob Piggott. Largely upon the shoulders of these men falls the task of maintaining the legacy of the Peninsula's fly-angling traditions, for it will be a sad day when the tactics now widely employed further south by pseudo-fly anglers—bobbers, slinky lead, and flies with more lead than feathers—migrate to the classic streams of the Olympic Peninsula.

As much for its great rivers and winter steelhead, the Peninsula is famed for its rainfall, which on the west side approaches 12 feet a year.

Below: Elwha River. • Following page: Steelheading on the Sol Duc. Ken Morrish photo.

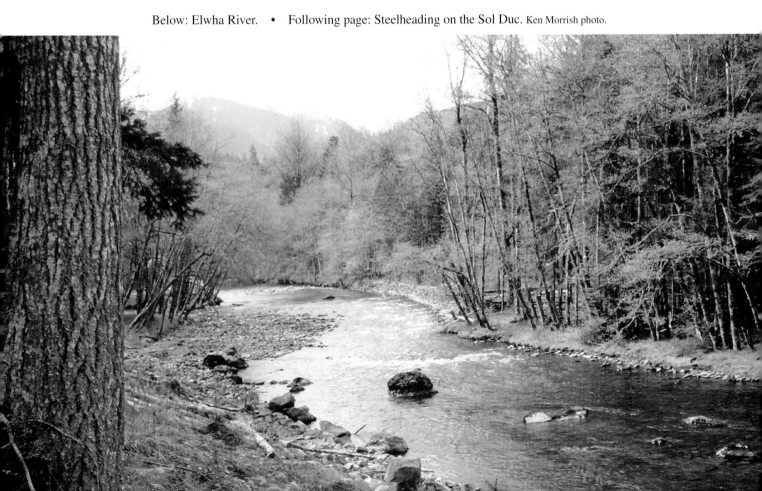

Such awesome amounts of rain leave traveling anglers at a disadvantage, for on the Peninsula, timing is everything. One could easily plan a week on the Peninsula to coincide with the arrival of native steelhead in March, then eagerly await the trip for months only to arrive and find the streams blown out for a week. More likely, though, anglers who can stick it out for a few days will eventually find dropping water, especially if they are willing to move around to the different streams, all of which fall, rise, and clear at different rates.

Perhaps the Peninsula's most unheralded season is summer. Despite massive rainfall the rest of the season, the Peninsula dries out quite nicely between midsummer and early to mid-autumn. The glacial rivers, like the Queets and Hoh, run milky glacial gray when summer heat exerts its influence on the glaciers above, in fact these streams become quite un-fishable during the hot part of the summer. However, when cold weather returns to the high country, the rivers begin to clear and summer steelhead, along with sea-run cutthroat, shake off their sleepy summer mood. This early to mid-autumn period affords great opportunity for fly-anglers to seek anadromous fish under the best possible conditions on the glacial-fed rivers.

Meanwhile, the snow-fed streams, such as the Sol Duc, run low and clear during summer—a mere trickle of their winter proportions. The summer fishing picks up in June and July, sometimes suffers a lull during August, and perks up again with the late summer/early fall freshets. Fly-anglers willing to walk the river trails can find solitude on the peninsula between June and October, especially in the fall when aggressive summer steelhead—including some fresh arrivals from tidewater—pounce on both wet and dry flies at a time when the tourism season has more or less expired.

Elwha River, Upper (Clallam/Jefferson Counties)

Although famous for its steelhead rivers, the Olympic Peninsula offers some fine trout fisheries with the Elwha River in Olympic National Park being chief among these.

The Elwha reaches deep into the heart of the Olympic Range: Its headwater source is the Elwha Basin immediately below Mt. Queets, Mt. Barnes, and Mt. Meany. On its northward course through the park backcountry, the Elwha picks up numerous tributaries, including Hayes River, Goldie River, and Lost River. Unlocking the Elwha's mysteries requires a serious backpacking effort that can cover many miles.

The prize is wild trout—rainbows, bull trout, and cutthroat. Surprisingly, the rainbows reach lengths of 18 or 20 inches although eight- to 14-inch trout are more typical. Pressure is generally light, at least for those willing to hike for their fishing. July through September is the best season on the Elwha, which swells with run-off during spring and early summer.

The 30-mile-long trail up the Elwha is generally not steep and passes four shelters along its route. The trail begins at Whiskey Bend near the south end of Lake Mills and heads mostly south before eventually swinging west, following the river as it bends around Mt. Dana and Mt. Wilder on the way up to the headwaters. Best fishing is from the Elkhorn area upstream, which is no surprise considering the ten-mile hike just to get to Elkhorn.

To reach the trailhead, follow Hwy. 101 west out of Port Angeles some nine miles until you reach the turnoff to Elwha Campground and Lake Mills. Then head south, past the campgrounds and around the east shore of Lake Mills until you reach Whiskey Bend. Additional trails follow the main tributaries to the Elwha. The Park Service can provide maps of Olympic National Park; another fine map of the region is a topo map produced by Trails Illustrated out of Colorado (1-800/962-1643).

Aldwell Lake (Clallam County)

The lower of the two impoundments on the Elwah River, Aldwell offers fair to good summer and fall fly-fishing for wild rainbows along with a few brook trout. Selective Fishery regulations discourage the serious meat hunters, so float-tubers can have some enjoyable fishing here with leech patterns, Carey Specials, and other wet flies fished on sinking lines. Evening Chironomid hatches sometimes provide dry-fly opportunities. Access to this 240-acre reservoir is off Hwy. 101 about five miles west of Port Angeles. The highway skirts the east shoreline—watch for signs to the state access area. Be sure to bring a boat or float tube.

Elwha River, Middle (Clallam County)

Thanks to Selective Fishery regulations, the six miles of the Elwha River between Lake Mills Dam and Aldwell Lake—the so-called Middle Elwha—offers good midsummer through autumn fishing for wild rainbows up to 16 or more inches in length. A typical specimen of these wild gems runs nine to 14 inches. Good caddis hatches during summer provide lots of dry-fly action and a hatch of October caddis (*Dicosmoecus*) erupts during the fall.

Instituted in 1984, the Elwha's Selective Fishery regulations had the immediate impact of relieving this easily accessible river of most of its traditionally heavy fishing pressure. With bait no longer allowed and with the limit lowered to two fish over 12 inches, fly-anglers quickly became the predominant presence on the river. These days, the Middle Elwha remains lightly fished, both because of its Selective Fishery rules and because most fishing effort on the Olympic Peninsula is aimed at anadromous species.

The Middle Elwha is easy to reach and is well worth a few hours of your time, whether you travel there specifically to try the river or fish it in passing on a steelhead or salmon trip. The road to Olympic Hot Springs follows the Middle Elwha. Take Highway 101 west out of Port Angeles, then turn left (south) just before crossing the river. Two campgrounds are located along the river.

Elwha River, Lower (Clallam County)

The Elwha offers fair to good prospects for winter steelhead along its lower five miles, although your chances here as elsewhere depend upon being on the river at the right time and then covering the water effectively. Salmon and sea-run cutthroat provide additional fisheries on the Elwha, which flows south to north out of the Olympics and meets the Strait of Juan de Fuca just west of Port Angeles.

A hydro dam about five miles up from the mouth blocks any further upstream movement of anadromous fish, so the Elwha's steelhead fishery is confined to that lower reach. Constructed in the early part of this century, the two dams on the lower Elwha blocked the annual migrations of all five species of Pacific salmon, both races of steelhead, sea-run cutthroat, and sea-run Dolly Varden. What remains of the fisheries is mostly a result of hatchery stocks. Future removal of the dams seems possible as of this writing, so anglers should keep an eye on this fishery.

Harvest numbers on the Elwha are down considerably from past decades, but then that is the case just about everywhere. Still, anglers record several hundred winter fish each season and quite a few summer fish as well. The first winter fish arrive early, so November and December can offer some good opportunity. The fish continue to arrive until the season ends in April (check current synopsis). Some years the number of wild fish taken approaches the number of hatchery steelhead recorded. The summer fish arrive in modest numbers beginning in June and while they are rarely abundant, you don't need many in the limited confines of the Elwha to create a decent fishery.

A catch-and-keep coho fishery runs through the month of October and attracts crowds of meat hunters. If you don't mind crowds you might find a few willing silvers fresh from the salt. For that matter, the Elwha attracts plenty of crowds during the steelhead season so try to fish mid-week and look for the out-of-the-way pools and runs.

Easiest access is from Elwha River Road and from State Route 112, which departs Hwy.101 just west of Port Angeles. From the access points, you can simply wander down the river, fishing the pools and runs that catch your eye. Discharge from the dam can silt the Elwha so have a back-up river in mind.

Sol Duc River.

Dungeness River, Upper (Clallam/Jefferson Counties)

The upper Dungeness River is an overlooked fishery where small native trout abound. Better known for the salmon and steelhead fisheries on its lower stretch, the Dungeness flows northerly from the east side of the Olympics and reaches the Strait of Juan De Fuca near the town of Sequim (pronounced "Squim"), east of Port Angeles. The uppermost reaches of the watershed, located within the Buckhorn Wilderness, are hike-in only; otherwise, Forest Service roads access the area. Lone Wolf Creek, a major tributary, also offers good fishing for small trout. Wait until summer flows stabilize, then visit the river between late June and late September. For specific directions, obtain a copy of a Forest Service/Park Service map titled, "Olympic National Forest & Olympic National Park."

Dungeness River (Clallam County)

The Dungeness, a medium-sized river, flows through a broad valley bearing the same name just west of Sequim on the northeast corner of the Olympic Peninsula. Winter steelhead are the main attraction for fly-anglers (along with good trout fishing on the upper river). The winter fish arrive from November through March, but check the current synopsis for the river's open season. Best fishing is in the lower 11 miles, from the Dungeness Hatchery to the mouth. Access is by a network of local roads to the north and south of Hwy. 101, which crosses the river west of Sequim.

Hoko River

The little-known Hoko River ranks as the first, and thus-far only, designated fly-fishing river on the Olympic Peninsula and one of only two rivers in the entire state so designated. This puts the little Hoko in lofty company with the North Fork of the Stillaguamish, whose seasonal fly-only regulations were the result of a monumental effort from a handful of dedicated fly-anglers and Fish and Game personnel alike.

The Hoko offers a similar story of dogged and determined effort on the part of some dedicated Peninsula anglers to set aside at least one portion of one steelhead stream as a fly-only, catch-and-release sanctuary. Indeed, the Hoko was not the first choice, but WDFW could not justify the implementation of highly restrictive regulations on the Peninsula's most famous and popular rivers—the Sol Duc, Bogy, and Hoh. Despite a rich tradition dating to the 1950s and 60s, winter steelhead fly-angling on the Peninsula rivers was until quite recently practiced only by a dedicated few who were always heavily outnumbered by gear anglers.

Because WDFW did not want to eliminate seasons already in place for the majority of anglers, the fly-anglers, which included longtime Peninsula residents like Jim Garrett and J.D. Love, were left with the task of finding a river or section thereof that would not present this hurdle. The solution came in the form of the diminutive upper Hoko, where eight miles of closed river was re-opened on a catch-and-release, fly-fishing-only basis. Despite the river's relative isolation and comparative inaccessibility and despite its lack of the fly-angling traditions carried by its more famous neighbors to the south, the Hoko now carries the banner for the Peninsula's fly-angling community.

The Hoko does in fact host a healthy run of wild winter steelhead. So anglers who seek her small pools and runs will at times be rewarded. However, don't expect the same experience as you would from one of the large rivers draining the national park, for the little Hoko is surrounded by brush and its waters are typically somewhat stained.

The fly-only section spans eight miles, from Upper Hoko Bridge (about 10 miles above the mouth) to Ellis Creek Bridge. Most of this reach flows through a roadless area and virtually all of it flows across private timber lands, where road gates can be locked with no warning. The lower end of the fly-only section is easy to reach—just follow Hoko-Ozette Road (Lake Ozette Highway) south from Hwy. 112 just west of Sekiu. A network of private logging roads reach the upper river just north of Lake Pleasant in the Sol Duc Valley, but consult a map and be aware of gate closures. Obtain a copy of the Trails Illustrated "Olympic National Park" map and the "Olympic National Forest and Olympic National Park" map available from the Forest Service or Park Service.

Sol Duc River (Clallam County)

The famed Sol Duc ranks among the state's best rivers for winter steelhead and for fly-angling for these magnificent fish. Along with the Hoh and Bogachiel, the Sol Duc also ranks as one of the state's most popular winter steelhead streams. Large native fish are the big attraction on this scenic Peninsula river, which flows westerly through its valley, eventually turning south to meet the Bogachiel a few miles from the Pacific.

Starting in December, hatchery steelhead arrive in the river. These are the smaller of the Sol Duc's steelhead and are followed between January and March by the big natives, some of which exceed 20 pounds. The river also hosts sizable runs of chinook and coho salmon; smaller runs of the other salmon. Summer steelhead arrive in modest numbers, typically beginning in June, and provide an additional fishery for fly-anglers. Sea-run cutthroat ascend the river after the first fall freshets.

For much of its length, the Sol Duc meanders alongside Hwy. 101, allowing for good access for walk-in anglers. A network of local roads provide some additional access points and three campgrounds are located along Hwy. 101 in Sol Duc Valley, each providing walk-in access to good fly water. The campgrounds, however, are not necessarily open during the winter. The Sol Duc offers plenty of walk-in bank access, but not much of it is particularly obvious. You must be willing to hoof it through the woods and along the riverbank, following trails that range from easy and obvious to barely visible.

Good maps of the area include the "Olympic National Park & Olympic National Forest" map available through the Forest Service or the Park Service. Another accurate and useful map is produced by Trails Illustrated (1-800/962-1643).

The Sol Duc clears more quickly than the other large peninsula rivers and winter storms exact their toll on water conditions only after a day or more, leaving the Sol Duc in fishable condition while the other streams are swelling to unruly proportions. What's more, the Sol Duc is a snow-fed system, not a glacial river like the Bogachiel, Hoh, and Queets. Hence it flows low and clear during the summer; higher but still clear between winter storms, typically with just enough color to get steelheaders excited at the prospects. Fortunately, the Sol Duc's upper watershed is encompassed by the Olympic National Park, affording the river complete protection from the ravages of man. During late winter, if you know where to look, you can spot spawning steelhead paired up on shallow gravel bars in the upper river.

The Sol Duc was one of the rivers frequented by Syd Glasso, the pioneering angler who introduced the Spey-style fly to steelhead and steelhead anglers. Swinging a well-tied Orange Heron or Sol Duc through an emerald-tinged pool on this river pays fitting tribute to Glasso's legacy.

Several float segments are available on the Sol Duc, none of which should be attempted by inexperienced oarsmen. Even those with strong boating skills might want to hire an experienced Sol Duc guide before running the river on their own. The Sol Duc offers an abundance of tumbling, rock-studded water in a well-established channel that—unlike the glacial streams—seldom shifts course. All told, the Sol Duc is a raucous affair that demands competence at the oars and familiarity with the drift. The lowest take-out is located at Lyendecker Park at the confluence of the Sol Duc and the Bogachiel west of Forks. La Push Road turns west off Hwy. 101 just north of Forks and arrives at the confluence after about eight miles.

The uppermost launch is at Klahowya State Park off Hwy. 101 eight miles east of Sapho. The next take-out is located at Bear Creek. The Klahowya-to-Bear Creek drift is a good option during high water because the flow might prove a little cleaner above Bear Creek's influence. Another launch is located below Bear Creek at the salmon hatchery and the next in line is at Salmon Road. The popular hatchery-to-Salmon Drive drift is referred to as the "Hatchery Drift," and the so-called Salmon Drive launch is located on Maxfield Road. Perhaps the most popular drift is the

Miles of trails allow anglers to explore the upper half of the Bogachiel River.

so-called "Shuwah Drift" from Salmon Drive down to the take-out off Whitcomb-Dimmel Road, near the Forest Service office. Popular with the guides, the Rayonier log-sorting yard offers a launch on private property, off Quillayute Prairie Road—check ahead to see if the gate is open. A few folks launch at a rough put-in at the Quillayute Prairie Road bridge.

Bogachiel River

The lovely and productive Bogachiel River lies to the south of Forks, Washington on the Olympic Peninsula. Its more famous neighbors—the storied Sol Duc to the north and the remarkable Hoh to the south—attract more attention much of the time, but the Bogy can be equally productive for winter steelhead. Its run of big native fish arrive from January through March, with the latter half of that span offering the best fishing.

The Bogy can be floated in its lower half, but those willing to walk can discover this river's hidden treasures by exploring its upper half along a trail on the north bank. Just north of the river's Hwy. 101 Bridge, Undie Road takes off to the east and leads a few miles up to a parking area. From there a closed logging road (closed by slides in recent years) and then a trail follows the river into lush forests. Tremendous rainfall pummels these dense Peninsula forests, but on those precious March days when the sun peaks from behind the omnipresent clouds, the trail up the Bogachiel becomes a decidedly pleasant adventure. On the weekdays one might walk this trail and not see another person.

When the Bogy drops into shape, follow the trail to the river's many elegant pools where a quiet cast straightens through river-born mist, dropping a classic Glasso-style Spey fly into green-tinged flows. Anticipation rules as always, but as the day wears on and the casts mount and the pools are covered head to tail, anticipation yields to contemplation and contemplation to appreciation—appreciation for a peaceful time and a special river.

While the big, late-winter natives provide the major draw for fly-anglers, the Bogachiel also offers a sizable run of smaller hatchery steelhead during December and January. The hatchery run brings droves of drift-boaters to the lower river and unless you like company, I suggest that you wait for the natives to arrive later in the winter. Summer steelhead ascend the Bogachiel in numbers sufficient to afford a marginal fishery between June and October. On the first freshets, sea-run cutthroat enter the Quillayute River and work their way up to the Bogy and other tributaries.

The lower half of the Bogy gets crowded with drift boats when the water drops into shape. Nonetheless, lots of good fly water awaits between the uppermost launch off South Bogachiel Road (an east turn south of the Hwy. 101 Bridge) and Bogachiel Rearing Ponds about nine miles downstream. A nice day's fishing awaits if you float from the WDFW launch, four miles down to Bogachiel State Park just below Hwy. 101.

Calawah River

The Calawah, somewhat overlooked in the shadow of the Sol Duc, Bogy and Hoh, flows under Hwy. 101 just north of Forks and dumps into the Bogachiel downstream from the hatchery west of town. The upper half of the South Fork Calawah flows parallel to and just one ridge north from the upper Bogachiel, while the North Fork Calawah parallels the Sol Duc River. The two forks converge just east of Forks.

The Calawah offers good runs of both winter and summer steelhead. Hatchery winters arrive during December and January and are followed by some big native steelhead in March and April. Summer steelhead ascend the Calawah from late May through early fall (the river is closed to fishing during the month of May). Like the Sol Duc, the Calawah runs clear because it has no glacial connection. Access is fairly good along FR 29, the east extension of La Push Road, which departs the highway on the north side of the Calawah, just north of Forks.

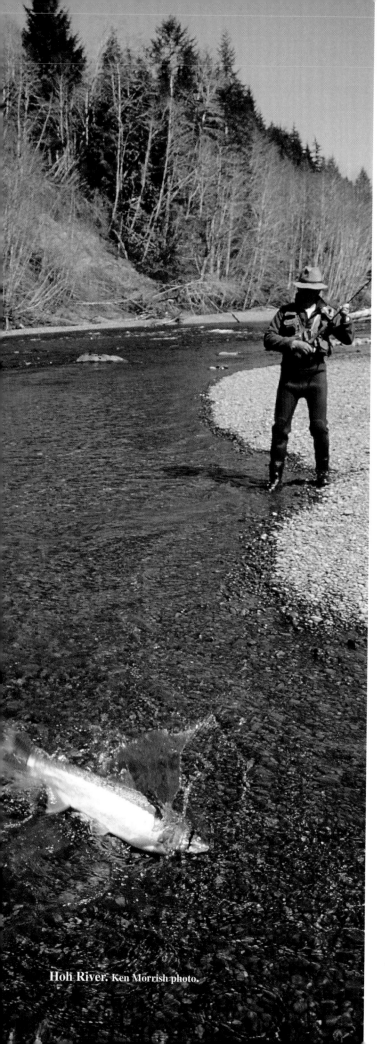

Hoh River. Ken Morrish photo.

The best access is from a boat, which can be launched at the confluence of the forks for a drift down to town or at the highway bridge at Forks for a drift down to the Bogachiel. Be aware that the river's often-quiet demeanor yields to some nasty water in places, including the rapids below Forks. You can drift down the Calawah and then down the Bogy, taking out at Leyendecker Park or upstream at a rough launch located at the public fishing access off Mora Road. Scout the whole thing first or go with an experienced guide your first time.

Hoh River

Among the most scenic and accessible of the Olympic Peninsula steelhead rivers, the Hoh offers big, native winter-run fish that arrive between January and March. Many of these three-salt giants weigh 14 to 20-plus pounds and what's more, the Hoh features countless runs and pools perfectly suited to fly-angling. In recent years, an annual harvest of nearly 2,000 fish has been typical for this river.

The Hoh gathers its headwaters from the glaciers on Mount Olympus and then flows almost 20 roadless miles through temperate rain forest. For nearly 20 more miles, Upper Hoh River Road follows the river between the Hoh Rain Forest Visitor's Center and Hwy. 101. On the north bank, downstream from the 101 bridge, Lower Hoh Road traces the river's remaining 15 miles to the Pacific, while the highway itself follows along on the south bank, mostly at a distance. A couple of launches are located on the upper river; three more ramps downstream from Hwy. 101.

The Hoh is a big river with wide gravel bars that shift with the seasonal floods. Cottonwoods often wash away, their trunks and limbs creating log jams. Warm weather melts the glaciers, contributing gray-green sediment to the flow that can make fishing futile. Likewise, a heavy rain swells the flow, sometimes to awesome green proportions. The key is to catch the Hoh on the drop during a dry spell or a cold snap. Find the right low-water conditions on a day between mid-January and late March and you will find the Hoh to be about as fly-rod friendly a river as one could hope to find during the winter.

Summer steelhead provide another fishery on the Hoh, with the action remaining consistent from June through September, with the best fly-rod opportunities early in the summer and during fall. Average annual harvest of summer fish varies considerably, from a couple hundred to a thousand or so. Warm weather at high elevation is the enemy during summer, as glacial melt colors the river. Nonetheless, good conditions prevail and even during July and August fly-anglers can sometimes cast floating lines over elegant runs and pools. The Hoh is not planted with summer steelhead smolts, but lots of stray fin-clipped fish from other streams migrate up the Hoh along with the river's natives.

In addition, sea-run cutthroat ascend the river between July and October. Dolly Varden inhabit the river in good numbers and the upper watershed offers fair to good fishing for small resident trout for those willing to hike the many miles to get to them in the heart of the Olympic Range.

Four Forest Service campgrounds are located along Upper Hoh Road (a fifth on the South Fork) and one below the Hoh River Bridge off Hwy. 101. The last five miles of the upper road are within the Olympic National Park, which requires an entry fee. Take your camera and visit the Hoh Rain Forest visitor center. From the visitor's center, anglers can hike upriver on the Hoh Trail. Steelhead run as far upriver as the High Hoh Bridge, 13 miles up the trail and lots of nice summer-steelhead water is accessible along the lower half of the trail.

Owing to its inclusion in the Olympic National Park, the upper Hoh and all of its many spawning tributaries, are afforded full protection and are thus quite healthy. The Indian nets remain a bone of contention, however, as they span the mouth of the river for extended periods each season

Queets River

As beautiful a river as one could hope to find, the Queets' timber-laden course takes it tumbling down through dense rain forest from its sources

The fly-rod-friendly Hoh River offers robust native winter steelhead.

high in the Olympic Range. Big native winter steelhead ascend the Queets from January through March and during a good year, anglers will beach several hundred of these fish. The river also hosts a modest but fishable run of summer steelhead, along with chinook and coho salmon and sea-run cutthroat.

What's more, the Queets offers a sanctuary of sorts for fly-anglers who tire of the vacation crowds on the Hoh River to the north. For the Queets offers nothing in the way of comforts or conveniences. During summer— and increasingly during the winter as well—the Hoh rain forest, with its well-marked attractions draws RVers and gawkers from all quarters. And why not, for the Hoh winds a scenic course through one of the nation's most awesome forests. For the fly-angler looking for solitude, however, the Hoh can at times prove a disappointment. Not so the Queets.

For almost all of its 50-mile course, the Queets and her old-growth rain forests are protected by their inclusion in Olympic National Park. The Queets Corridor was added to the park in 1953. Only the lower few miles of the river lie outside the park, but beyond the park boundary, the Queets flows entirely through tribal lands owned by The Quinault Nation.

Highway 101 crosses the Queets south of Kalaloch. About eight miles further east, Queets River Road turns north off Hwy. 101 and leads a rugged 15 miles upriver. Rugged might be an understatement, for Queets River Road is replete with nasty potholes, some which threaten to swallow whole vehicles and all of which prevent you from making any kind of time whatsoever unless you like frequent trips to the repair garage and to your dentist. The slow, tedious drive is worthwhile, however, for you soon enter a dense, soggy world of massive conifers and lush but manageable understory.

At the end of the road lies Queets Campground (no hook-ups), where hard-core winter steelhead anglers endure eternal wetness

for a chance to swing elegant flies through the numerous classic cobblestone/gravel pools and runs located all along the river. Foot access is good along the road assuming you don't mind busting through soggy understory here and there. Several turnouts lead to the river and to a couple of gravel launches for floaters. The precious few sunny days of March dry things out long enough to light up the river and its corridor in stunning shades of green.

During summer, anglers can ford the river (not necessarily an easy task) in the vicinity of the campground and hike upstream to fish miles of pristine steelhead water. The summer fish sniff out their natal river before the spring snowmelt runs its course; soon thereafter—typically by late June and July—the fish arrive in adequate numbers. Despite dry weather in late summer, the Queets maintains a good flow, owing to its origins on the glaciers of Mt. Olympus. For the same reason, the Queets rarely runs gin-clear and in fact, during occasional periods of hot weather, the stream dis-colors rapidly with the added load of glacial melt.

For those seeking solitude and a chance at Queets River summer steelhead, Autumn is the best time. If stable weather accompanies late September and early October, ford the river at the campground and hike upriver to spend a day or two fishing the beautiful pools and classic runs.

The 14-odd miles of river along Queets River Road are lightly pressured in comparison to the other major steelhead rivers of the peninsula. This is perhaps due in large measure to the road itself. Also, the Salmon River, which joins the Queets about two miles up Queets River Road, receives plants of hatchery steelhead. Owing to the presence of these hatchery fish from December through February, gear anglers (and fly-anglers) concentrate on the Queets from the Salmon River mouth down to Clearwater Road Bridge (a reach of about five miles). This section offers an easy float for a drift boat: The put-in is located about a mile past the Salmon River Bridge on a nice gravel bar.

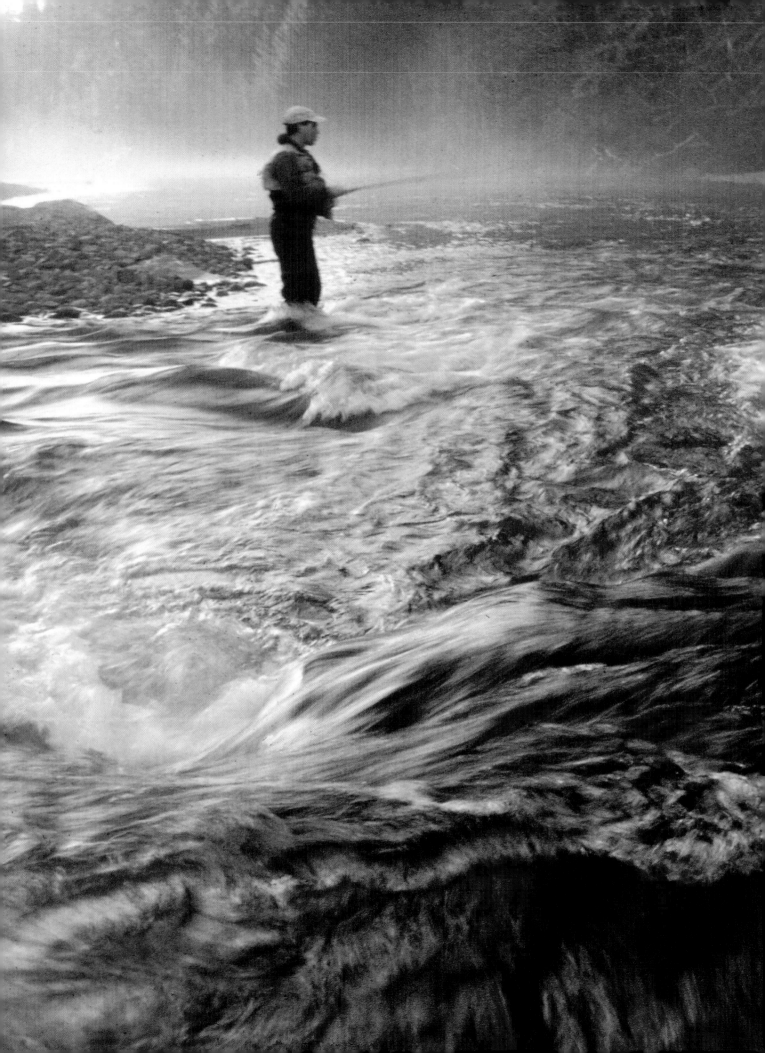

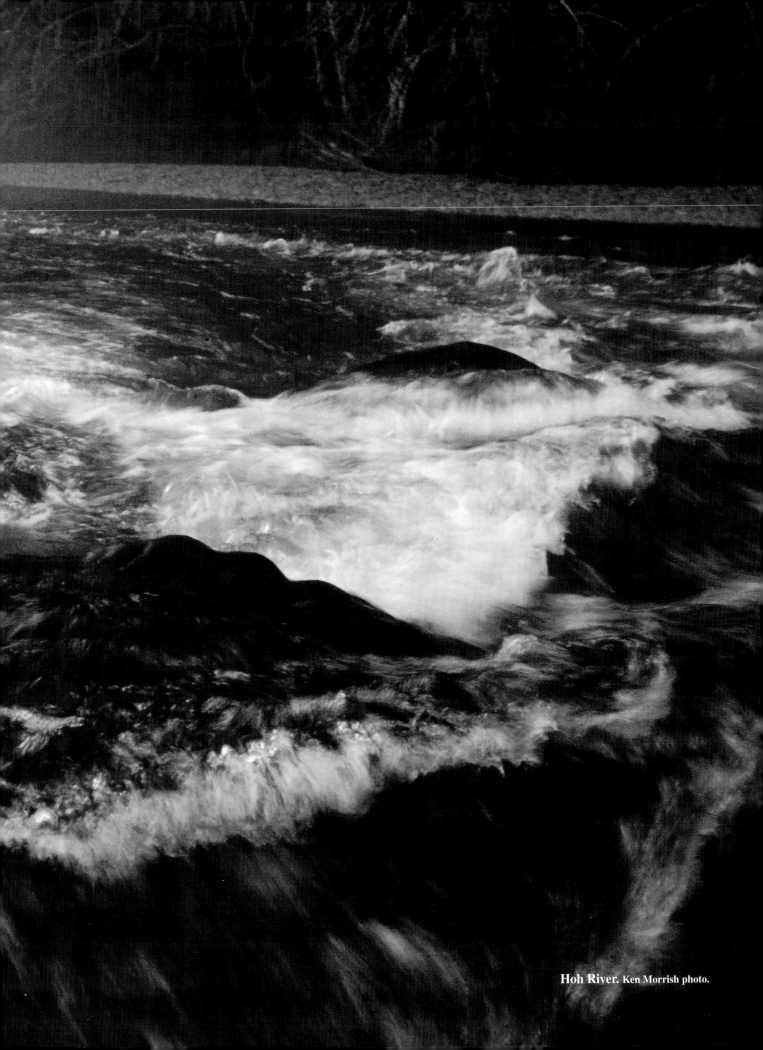

Hoh River. Ken Morrish photo.

Steelheading on the Bogachiel. Ken Morrish photo.

As you progress upstream the Queets begins to change character from a fairly broad and shallow gravel-bar stream to a moderately steep white-water affair with elegant pools and runs interrupted in turn by frothing rapids. When you reach the upper stretches, expect good pocket-water fishing for native trout and an occasional char.

Quinault River, Lower (Grays Harbor County)

The Lower Quinalt River, below Quinault Lake, flows almost entirely within the confines of the Quinault Indian Reservation, but non-tribal members can fish this remarkable river with a tribal guide. Thanks to strong returns of big, wild winter steelhead and to an aggressive hatchery operation based on Quinault stocks, the river may well be the best-kept steelhead secret in Washington. Most people don't realize that they can in fact fish the river if they hire a tribal guide.

The Quinault is reputed to offer some exceptionally large winter steelhead, with good numbers of fish exceeding 20 pounds. The smaller hatchery fish arrive in strong numbers during the early part of the season and these are followed in February and March by the big natives and by some equally impressive hatchery fish. As of this writing, the Quinault guides are little accustomed to fly-angling, but that fact shouldn't prevent you from considering a Quinault trip—you can simply help educate your guide for future fly-anglers. For a list of guides for the Lower Quinault, call the tribal office in Tahola at 360/276-8211.

Quinault River, Upper (Grays Harbor/Jefferson Counties)

In contrast to the gentle meandering nature of the Lower Quinault, the upper river tumbles rather quickly over its rock-studded cobble course

before finally slowing to form a classic cobblestone steelhead stream and entering scenic Quinault Lake. The Upper Quinault, also in contrast to the lower river, flows through public property, originating high on the mountains above Enchanted Valley deep in the heart of Olympic National Park. After exiting the park, the river then flows across state-owned lands down to Quinault Lake.

The Upper Quinault offers fair angling for winter steelhead, with peak catches occurring mid-February through late March. All of the fishing pressure occurs from just above the lake up to the national park boundary, above which the river is closed during winter. The open section is accessed by roads on both sides of the river. Like the Lower Quinault on the reservation, the upper river offers a chance at some truly giant winter steelhead, with 20-plus-pound fish available.

To reach the upper river, follow Highway 101 to Quinault Lake and turn east on either North Shore Drive or South Shore Drive, both of which lead along their respective sides of the lake before reaching the upper river. In a few places, both roads pull close to the river; the North Shore Road runs entirely through public lands while private property limits access to some extent on the south side. A mile or so inside the park, the roads intersect by way of a bridge over the river.

During summer, when the upper reaches of the river are open to catch-and-release trout angling, adventuresome fly-fishers can explore the pristine pocket water on foot along many miles of trail and along numerous tributaries. Consult the "Olympic National Forest/Olympic National Park" map for an overview and buy a copy of Trails Illustrated's "Olympic National Park" map for travel in the backcountry.

Clearwater River

The scenic little Clearwater River exists in the shadow of more-famous neighboring Peninsula rivers. Thus its modest run of native winter steelhead goes largely unnoticed. March is the best time for pursuing these

fish on the Clearwater, which also hosts small runs of chinook and coho salmon along with sea-run cutthroat.

Flowing southwest and then south, the Clearwater joins the Queets about five river miles up from the Pacific. To find the Clearwater, follow Hwy. 101 south from Forks or north from Hoquiam. The highway crosses the Queets south of Kalaloch and northwest of Quinault Lake. On the south side of the Queets, about five miles from the Hwy. 101 bridge and about 20 miles west of Quinault Lake, Clearwater Road turns north off the highway and accesses much of the river, first crossing over the Queets.

Bank access is available where Clearwater Road approaches the river and is easiest for those willing to walk and bust the brush. The river offers a nice float, but a long one for the short days of March so start out early and choose your water with care. The take-outs are at the mouth of the river and at the DNR's Clearwater Picnic Bar a little less than a mile above the river's mouth; the put-in—a rough, steep, unimproved hands-on type—is located on the north bank below the bridge crossing over the river about eight miles up from the Picnic Bar (on Clearwater Road). Expect tight quarters, including sweepers and log jams, along the upper end of the drift, before the Clearwater slows and widens in the valley below. The total drift covers more than 11 miles.

Humptulips River

A nice mid-size, fly-rod-friendly stream, the Humptulips offers decent runs of hatchery and wild winter steelhead, big chinook salmon, a few summer steelhead, and sea-run cutthroat. Chum salmon and coho salmon ascend the Humptulips as well, with the runs peaking in October or early November. The chinook arrive in September and October and attract a lot of attention from gear anglers, making the Humptulips a crowded river through most of the fall.

The native steelhead of late winter comprise the river's best offering. The big natives arrive during March and some specimens exceed 20 pounds. Fish mid-week under decent water conditions and a fly-angler has a fair chance at hooking a fish or two in the Humptulips each March. The run of smaller hatchery steelhead peaks during December and January. Sea-run cutthroat arrive with the first freshets of early autumn.

Bank access is somewhat limited on the Humptulips or at least that has been my impression so you may want to drag a drift boat along to explore the river. As of this writing, I have never floated the Humptulips, but have instead driven along the county roads, map in hand, looking for access to good fly water.

The Humptulips empties into the north side of Grays Harbor after a lengthy run from the foothills and ridges south of the Olympic Range. Hwy. 101 crosses the river about 23 miles north of Hoquiam. Just north of the Hwy. 101 bridge, McNutt Road takes off to the east and leads about a mile and a half to the uppermost boat launch (another is located about two miles below off East Humptulips Road). Rough access is available at the 101 bridge and downstream a short distance, a third popular ramp is located off the road to Copalis Beach. A half mile further down is the Humptulips Hatchery, a very crowded place when salmon are in the river. About six miles below the hatchery, another ramp is located off Humptulips Valley Road on the river's east bank. Two more ramps are located on the lower river, which is crossed by State Route 109 northwest of Hoquiam. The last take-out is a paved ramp off Ocean Beach Road near the river's mouth.

The East and West forks of the Humptulips produce steelhead as well, although not nearly so many as the mainstem (this may be largely a function of relative fishing pressure, which is much higher on the mainstem than in the forks). Both forks are somewhat troublesome in terms of access. Consult a map of the Olympic National Forest for details. The West Fork is floatable, with the uppermost launch located off Fish Trap Road via Donkey Creek Road. A seven-mile drift takes you to a gravel-bar take-out at Donkey Creek Bridge. To reach the Donkey Creek take-out, turn east about 3.5 miles north of the Hwy. 101 bridge over the river. Follow Donkey Creek Road until you cross the river, then turn left onto a dirt access road that leads down to the gravel bar. To reach the

put-in, continue on Donkey Creek Road just under three miles past the river crossing until you reach a left turn onto Forest Road 2263 (FishTrap Road). Follow FR 2263 a little more than two miles to the put-in.

Wishkah River (Grays Harbor County)

A small but rather lengthy tributary to the Chehalis, the Wishkah enters the larger river at the town of Aberdeen. Winter steelhead, along with coho and chinook salmon, provide the primary opportunities on the Wishkah, which offers some good fly water once you get above the tidal influence. Wishkah River Road follows the river north from Aberdeen. Sea-run cutthroat run the river as well and anglers can launch boats to fish the tidewater reaches of the Wishkah, casting to visible structure between July and September. With a small motor, you can launch at the public ramp on the south bank of the Chehalis off Boone Road in South Aberdeen. Another option is to launch about seven miles upriver: On the north side of the Chehalis, off Hwy. 101, follow G Street to a right turn on Market Street and then turn left on B Street, which heads north and then splits to the right to become Wishkah Road. The launch site is about five miles up.

Wynoochee River (Grays Harbor County)

A very nice summer steelhead stream, but one that is perhaps better known for its winter steelhead fishery, the Wynoochee River flows north to south from the south end of the Olympic Range, eventually surrendering its waters to the Chehalis River at the town of Montesano. The winter fishery peaks during February and March; summer steelhead arrive between June and September. Sea-run cutthroat appear as early as July, but fishing is best after a late-summer downpour. Likewise, a heavy rain during late summer or early autumn can trigger sleepy steelhead to resume activity.

The Wynoochee offers easy boating on its lower half and fair to good walk-in access from Wynoochee Road and a few other local routes. The lower drift begins at an unimproved gravel bar launch at Black Creek and covers about five miles down to Montesano (the take-out is located on the Chehalis River, just up from the mouth of the Wynoochee). This lower end of the river offers the least attractive fly water but it does offer lots of fish during the winter season. The middle drift covers eight miles from the Wishkah-Wynoochee Road Bridge down to Black Creek (or 10 miles if you start up at the Old White Bridge Site) and is quite popular with plug-pullers during winter. The upper drift begins at an unimproved access near the mouth of Schafer Creek and runs down to the take-out at the Old White Bridge Site, 12 miles below.

The upper drift, from Schafer Creek down, offers prime summer steelhead water, with an abundance of shallow riffles and runs. This section requires strong boating skills, however, as the many hazards include log jams, sweepers, boulders, and tight quarters in places. Lots of good water is readily available to the walk-in angler and by knocking on a few farmhouse doors you can gain access to pools off the beaten path. From Schafer Creek upstream, the river is lightly fished because access becomes more difficult—the perfect situation for fly-anglers who want summer steelhead runs, pools, and pockets all to themselves.

To get to the Wynoochee, follow Highway 101 west from Olympia, then turn left on Hwy. 8 and continue west on Highway 12 to Montesano. From the south, take I-5 to the Hwy. 12 exit north of Centralia.

Skokomish River and Hoodsport (Mason County)

The mouth of the Skokomish River is one of the most productive and popular chum salmon fisheries along Hood Canal, and in some years can provide furious action for sea-fresh chum salmon ranging from eight to more than 15 pounds. The mouth of the Skokomish is located at Annas Bay on the southern extent of Hood Canal ("The Great Bend"). Boat

Olympic Peninsula steelhead. Ken Morrish photo.

launches are located at the town of Union just north of the river's mouth and across the bay to the west at Potlatch State Park.

Just north of Annas Bay, along Hwy. 101, both wading and boating anglers can find good fly-rod action on chums returning to the Hoodsport Hatchery. The fish arrive in the fall, generally beginning around the first or second week in October. Beware of the weekends, however, as crowded conditions and a volatile mix of aggressive anglers—both gear and fly—can take a lot of the fun out the chum salmon fishing. If you don't like the idea of elbowing in with the crowd, then bring a small boat and fish mid-week during a heavy rainstorm. In addition to the free launch at Potlatch Park, there is a fee-launch located at Hoodsport.

The Great Bend area of Hood Canal also offers fair to good prospects for sea-run cutthroat, especially around the mouths of the creeks and rivers and along several of the beaches during summer and fall. If you're looking for a change, try casting saltwater streamers around the rock structure for black rockfish or around the pilings for perch.

Other productive saltwater chum locations include the mouth of Kennedy Creek in Tolten Inlet (off Hwy. 101 between Olympia and Shelton), the mouth of Johns Creek in Oakland Bay (off SR 3 northeast of Shelton), the mouth of Perry Creek in Eld Inlet, and various shoreline areas in Case, Carr, Hammersley, and Budd inlets.

Duckabush River (Jefferson County)

Largely surrounded by private farmlands, the Duckabush River flows into Hood Canal near Pleasant Harbor, some 15 miles south of Quilcene. A few winter and summer steelhead are taken each year, but not nearly enough to justify a lot of effort. Chum salmon and sea-run cutthroat comprise the more significant fisheries during the fall.

Dosewallips River (Jefferson County)

Although steelhead runs have dwindled substantially on the Dosewallips, this beautiful Hood Canal tributary still offers runs of chum salmon and sea-run cutthroat. The salmon fishing occurs during a short fall season below the Hwy. 101 bridge (check current synopsis) and sea-run cutts can appear anytime after the first freshet of late summer.

Cutthroat fishing is best in the lower river and is limited to catch-and-release action for limited numbers of wild fish. Winter steelhead still arrive in fishable numbers and the Dosewallips is a reasonable bet for anglers who can head out any time the water drops into shape between mid-January and late February. Small wild trout are available in the river's upper reaches.

The mouth of the Dosewallips flows through Dosewallips State Park, located along Hwy. 101 about 12 miles south of Quilcene.

Prices Lake (Mason County)

Located on the east side of the Olympic Peninsula, north of Hoodsport, Prices Lake offers good float-tube or small-boat fishing for rainbows, brook trout, and cutthroat, with an occasional fish reaching 20 inches or more. This is a shallow, 60-acre lowland lake, so the best fishing occurs before the water gets too warm and after the heat of summer subsides. Typically, Prices Lake opens at the end of April and closes October 31.

Because of its artificials-only, catch-and-release regulations, Price's Lake receives fairly light pressure, especially in the fall. To get there, follow Hwy. 101 to Hoodsport, then turn west on Lake Cushman Road. Follow Lake Cushman Road to Lake Cushman and continue north along the shoreline past Lake Cushman State Park. A half-mile past the park, turn right on a dirt road and continue two miles to the Price's Lake parking area (veer left when the road forks). A pull-out on your right, the parking area sits above a trail that leads down to the lake. Starting October 1, the road into the lake is closed to motor vehicles so those willing to hike in with a float tube can find total solitude.

Classic Washington Steelhead Flies
(tied by author except where noted) Jim Schollmeyer photography

Boxcar (Wes Drain)

Hook: Light wire salmon hook, size 2-10
Tail: Red hackle fibers
Body: Peacock herl
Wing: White calf tail or similar, tied wet-fly style
Hackle: Brown, dry-fly style

Drain's 20 (Wes Drain)

Hook: Size 1/0-6
Tag: Flat silver tinsel and fluorescent yellow floss
Tail: Golden pheasant tippet fibers topped with yellow toucan
Body: Fluorescent red floss
Rib: Flat silver tinsel
Hackle: Purple saddle
Wing: Gray squirrel tail over red cock-of-the-rock or similar (e.g. dyed golden pheasant crest)

Evening Coachman (Walt Johnson)

Hook: Salmon dry-fly hook, size 2-8
Tag: Flat silver tinsel and fluorescent orange floss
Tail: Golden pheasant crest
Body: Peacock herl divided by a band of fluorescent red floss
Hackle: Stiff dry-fly quality grizzly saddle

Golden Edge Orange (Harry Lemire)

Hook: Size 1/0-6
Thread: Orange
Tag: Flat silver tinsel
Tail: Golden pheasant crest
Body: Orange dubbing, seal or substitute
Rib: Flat silver tinsel
Throat: Guinea
Wing: Gray squirrel and bronze mallard
Topping: Golden pheasant crest
Cheeks: Jungle cock
Head: Orange tying thread

Grease-Liner (Harry Lemire)

Hook: Size 2-8
Tail: Brown deer hair
Body: Black or burnt orange dubbing (or other colors)
Hackle: Grizzly, tied wet-fly style and sparse
Wing/Head: Deer hair (same as tail) flared at front to form head

Killer (Frank Headrick)

Hook: Size 2/0-4
Tag: Silver tinsel
Tail: Orange hackle fibers
Body: Red wool
Rib: Silver tinsel
Hackle: Red
Wing: Black bucktail
Shoulders: Jungle cock

Lady Coachman (Tied by Walt Johnson)

Hook: Size 2-8
Tag: Flat silver tinsel then fluorescent red floss
Tail: Cerise hackle fibers
Body: Peacock herl divided by fluorescent pink wool
Hackle: Light fluorescent pink
Wing: White bucktail or similar

Lady Hamilton (Ralph Wahl)

Hook: Gold up-eyed hook, size 2/0-6
Tail: Red goose primary section
Body: Red floss
Rib: Embossed silver tinsel
Wing: White then red bucktail
Head: Black with white/black painted eye

Mcleod Ugly (Ken McLeod)

Tail: Red Hackle fuzz
Body: Black
Rib: Grizzly hackle
Wing: Black bucktail or similar

Migrant Orange (Tied by Walt Johnson)

Hook: Size 2/0-6
Tag: Fluorescent orange floss over flat copper tinsel
Tail: Fluorescent orange hackle fibers, long
Body: Fluorescent orange wool
Rib: Flat copper tinsel
Wing: Fluorescent orange bucktail

October Caddis (Bill McMillan)

Hook: Partridge Wilson or similar, size 6-12
Body: Orange-tan dubbing (or other colors)
Wing: Mottled turkey segments, tied tent-style
Collar: Spun deer hair

Orange Heron (Syd Glasso)

Hook: Size 4/0-4
Tag: Flat silver tinsel (optional)
Body: Rear two-thirds orange floss, front third orange / dubbing (seal or substitute)
Rib: Flat silver tinsel, medium or wide
Hackle: Blue-eared pheasant or similar heron substitute
Throat: Teal
Wing: Four orange hackle tips
Head: Red

Prichard's Comet (Al Prichard)

Tail: Hot orange bucktail or similar
Body: Silver oval tinsel
Hackle: Red and yellow mixed

Purple Peril (Ken McCleod)

Tag: Flat or oval silver tinsel (optional)
Tail: Purple hackle fibers
Body: Purple wool or chenille
Rib: Silver
Hackle: Purple
Wing: Dark natural brown bucktail

Purple Spade (Tied by Alec Jackson)

Hook: Alec Jackson Spey Hook, Nickel, No. 3-7
Tail: Fine deer hair
Body: rear two-thirds, purple-dyed peacock-herl chenille; front third, purple-dyed ostrich herl chenille
Head: Fluorescent orange

Red-Butt Spade (Tied by Alec Jackson)

Hook: Alec Jackson Spey Hook, Nickel, No. 3-7
Tail: Fine deer hair
Butt: Red-dyed peacock-herl chenille
Body: Peacock-herl chenille
Collar: Badger hackle, soft
Head: Fluorescent orange

Red Shrimp Spey (Tied by Walt Johnson)

Hook: Size 1/0-6
Body: Fluorescent orange floss with red seal fur dubbing over (or substitute)
Rib: Flat silver tinsel
Hackle: Brown ring-necked pheasant rump palmered through body
Throat: Red hen hackle
Wing: Narrow red hen hackles set low over the body and a topping over

Skykomish Sunrise (George & Ken McCleod)

Hook: Size 2/0-8
Tail: Mixed red and yellow hackle fibers
Body: Red chenille or wool
Rib: Silver
Hackle: Mixed red and yellow
Wing: White polar bear or similar
Head: Red

Sol Duc (Syd Glasso)

Hook: Size 2/0-4
Tag: Flat silver tinsel
Tail: Golden pheasant crest
Body: Rear half fluorescent orange floss, front half hot orange dubbing (seal or substitute)
Rib: Flat silver tinsel
Hackle: Yellow schlappen or similar, from second turn of tinsel
Throat: Teal
Wing: Four hot orange hackle tips and a topping

Spectral Spider (Tied by Walt Johnson)

Hook: Size 4/0-6
Tag: Copper tinsel and fluorescent orange floss
Tail: Fluorescent orange bucktail or hackle fibers
Body: Fluorescent orange wool, thin
Rib: Copper tinsel
Wing: Fluorescent orange bucktail topped with a strand of fluorescent orange wool

Wahlflower (Ralph Wahl)

Hook: Upeye, No. 2-8
Tag: Silver
Butt: Orange floss
Body: Chartreuse floss
Rib: Silver twist or oval
Wing: Squirrel tail, dyed yellow
Throat: Orange hackle fibers

Winter's Hope (Bill McMillan)

Hook: Partridge Salmon (Code N or M), size 2-6/0
Body: Silver tinsel
Hackle: Light blue then purple, long
Wing: Two yellow hackle tips inside two orange hackle tips
Topping: Golden-olive calf tail fibers, sparse
Head: Claret thread

Additional Steelhead Flies for Washington Waters

Bomber

Hook: Light wire salmon/steelhead, size 2-6
Tail: White calf tail
Body: Spun deer hair
Hackle: Grizzly, palmered through body
Wing: White calf tail

Macks Canyon (Doug Stewart)

Tag: Gold
Tail: Orange hackle fibers or dyed golden pheasant crest
Butt: Hot orange
Body: Black
Rib: Gold oval
Hackle: Black
Wing: White topped with orange hair
Cheeks: Jungle cock

Maxwell's Purple Matuka (Forrest Maxwell)

Hook: Salmon/steelhead, size 2/0-4
Tag: Flat silver tinsel
Body: Black dubbing
Rib: Medium or wide silver oval
Wing: Four purple hackles, tied Matuka-style
Collar: Purple hackle

Skunk

Tag: Silver
Tail: Red hackle fibers or dyed golden pheasant crest
Body: Black: chenille, wool, or dubbing
Rib: Silver oval
Hackle: Black
Wing: White

Spawning Purple (John Shewey)

Hook: Alec Jackson Nickel, size 1.5-7
Body: Fluorescent flame single-strand floss
Wing: Four or five "spikes" of purple marabou
Hackle: Purple
Cheeks: Large jungle cock
Collar: Guinea, dyed hot orange

Sea-run Cutthroat Flies

Borden Special (Robert Borden)

Tail: Mix of yellow and hot pink hackle fibers
Body: Hot pink rabbit dubbing
Wing: White arctic fox tail
Hackle: Yellow then hot pink

Doc Baker Cutthroat (Leonard "Doc" Baker)

Tag: Flat silver tinsel
Tail: Mallard flank fibers
Body: Fluorescent orange floss or wool
Rib: Medium silver tinsel
Hackle: Yellow
Wing: White marabou

Johnson's Beach Fly (Les Johnson)

Tail: Orange hackle fibers
Body: Fluorescent Orange wool
Hackle: Brown
Wing: White hair
Head: Fluorescent orange

Knudsen Cutthroat (Al Knudson)

Tag: Silver tinsel
Tail: Red hackle fibers
Body: Yellow chenille or wool
Rib: Medium silver tinsel
Hackle: Red
Wing: White over red hair (bucktail, calf tail, polar bear, etc.)

Knudsen Spider (Al Knudsen)

Tail: Mallard flank fibers
Body: Yellow chenille
Hackle: Grizzly hackle then three turns of mallard flank

Purple Joe

Tail: Red hackle fibers
Butt: Fluorescent orange wool or floss
Body: Purple chenille or wool
Wings: Two badger hackles
Hackle: Badger

Selected John Shewey Stillwater Flies for Washington Lakes and Reservoirs

Bloodworm Emerger

Hook: 2XL light wire, size 12-18
Body: Pheasant tail dyed crimson
Rib: Fine wire
Head: Fine peacock herl and foam bubble to float the fly

Bloodworm Larvae

Hook: 2XL light wire, size 12-18
Body: Pheasant tail dyed crimson
Rib: Fine wire
Head: Fine peacock herl

Bloodworm Pupa

Hook: 2XL light wire, size 12-18
Body: Pheasant tail dyed crimson
Rib: Fine wire
Gills: White Antron
Head: Fine peacock herl
Wingcase: Pheasant tail fibers, dyed crimson

Callibaetis Krystal Spinner

Tails: Micro Fibetts, divided
Body: Light gray-tan dubbing
Wings: A few strands of Krystal Flash (pearl) tied spent
Hackle: Grizzly, wrapped through wings and over dubbed thorax, clipped flush below
Head: Same as body

Diving Damsel

Tail: Marabou
Body: Marabou
Rib: Fine wire
Legs: Partridge hackle, dyed green
Head: Metal bead

Nevada Leech

Hook: Streamer, size 1/0-4
Tail: A few strands of Krystal Flash and a rabbit strip
Body: Mohair yarn
Head: Spun rabbit hair

Shewey's Damsel

Hook: 2XL nymph, size 8-12
Tail: Marabou fluff
Body: Marabou fibers wrapped on shank
Rib: Fine wire
Thorax: Marabou fibers wrapped on shank
Legs: Partridge dyed light green
Wingcase: Lemon wood duck

Sleeze Leech

Hook: Streamer, size 2-6
Tail: A few strands of Krystal Flash
Body: Dubbed fur, seal or similar
Wing: Thin rabbit strip, tied down fore and aft

Strip Damsel

Hook: 2XL or 3XL
Tail: Sparse tuft of rabbit strip fur
Body: Seal dubbing to match natural
Eyes: Melted mono eyes

Super Scud

Hook: 2XL wet fly, size 10-16
Shellback: Mix of wood duck and Krystal Flash
Body: Rabbit dubbing, loop-dubbed onto Krystal Flash and picked out
Rib: Fine wire

Thin-water Leech

Hook: Streamer, size 2-10
Tail: Marabou, sparse
Body: Dubbed, sparse and picked out
Rib: Fine wire, optional

Selected Trout Dry Flies for Washington Streams

CDC Mayfly Dun

Tails: Micro Fibetts or hackle fibers, divided
Body: Dubbing to match natural
Wing: CDC plumes bunched and clipped

CDC Mayfly Emerger

Tail: Z-lon or similar tied as trailing shuck
Body: Dubbing to match natural
Wing: CDC plumes bunched and clipped short

Compara-dun

Tails: Micro Fibetts or hackle fibers, divided
Body: Dubbing to match natural
Wing: Deer hair

Elk Hair Caddis

Body: Dubbed fur
Hackle: Grizzly or to match body
Wing: Elk hair

Humpy

Tail: Elk hock or moose mane
Shellback: Elk hock or moose mane
Body: Thread, floss or wool
Wings: Natural elk or white calf tail
Hackle: Grizzly/brown mixed

Light Cahill

Tail: Light ginger hackle fibers
Body: Light cream dubbing
Wings: Lemon wood duck
Hackle: Light ginger

Maxwell's Jughead

Tail: Deer or elk, stacked and tied short
Body: Orange or yellow yarn
Hackle: Brown, palmered and clipped short
Wing/Head: Spun deer hair

October Caddis

Body: Orange dubbing
Hackle: Brown, reverse palmered over body
Rib: Fine wire
Wing: Deer or elk, with butt ends left for head
Collar: Brown and grizzly hackle mixed

Parachute Adams

Tail: Grizzly/brown hackle fibers
Body: Gray dubbing
Wing: Post of white calf tail or Antron yarn
Hackle: Mixed brown and grizzly

Royal Wulff

Tail: Mouse hair or elk mane
Body: Peacock herl, divided by a band of red floss
Wings: White calf tail or body
Hackle: Brown

Sparkle Dun

Tail: Z-lon tied as trailing shuck
Body: Dubbing to match natural
Wing: Deer hair

Stimulator

Tail: Dark elk hair
Body: Yellow or orange rabbit dubbing
Hackle: Furnace, palmered through body
Rib: Fine wire
Wing: Elk hair
Collar: Grizzly hackle palmered through orange dubbing

X-Caddis

Tail: Z-lon as trailing shuck
Body: Dubbed fur to match natural
Wing: Deer hair, tied short

Selected Trout Nymphs/Wet Flies for Washington Waters

Brook's Stonefly Nymph

Tail: Black goose biots
Body: Black wool yarn
Rib: Copper wire
Hackle: Mixed grizzly and brown, wrapped over thorax

Golden Stonefly Nymph

Tail: Tan goose biots
Body: Amber rabbit or seal dubbing
Rib: Copper wire
Wingpad: Turkey tail
Thorax: Same as body, picked out

Gold Ribbed Hare's Ear Nymph

Tag: Flat gold tinsel (optional)
Tail: Rabbit mask fur or partridge fibers
Body: Hare's ear dubbing
Rib: Gold oval tinsel
Wingpad: Turkey tail or wing segment
Thorax: Same as body

Green Rockworm

Body: Fine green wool or dubbing (loop-dubbed)
Legs: Partridge fibers
Head: Black dubbing, peacock herl or black ostrich

Partridge & Orange

Hook: Wet fly, size 8-16
Body: Orange silk
Collar: Two turns of natural tan dubbing (optional) then two turns of natural partridge hackle

Peeking Caddis

Body: Natural tan or dark gray rabbit dubbing, loop-dubbed or ribbed with fine gold oval
Thorax: Green or cream dubbing
Collar: Partridge
Head: Black ostrich

Peacock Carey

Tail: Natural pheasant rump fibers
Body: Peacock herl
Collar: Natural pheasant rump fibers

Pheasant Tail Nymph

Tail: Ring-necked pheasant tail fibers
Body: Ring-necked pheasant tail fibers
Rib: Fine gold wire
Wingpad/legs: Ring-necked pheasant tail fibers
Thorax: Peacock herl

Woolly Bugger

Tail: Marabou
Body: Chenille, dubbing or herl
Hackle: Saddle hackle, reverse-palmered through body
Rib: Fine wire

Zug Bug

Tail: Peacock sword
Body: Peacock herl
Rib: Fine gold or silver oval
Legs: Brown hackle fibers or partridge hackle
Wingpad: Lemon wood duck, clipped